An Economy *of* Abundant Beauty

We have made a breakthrough

from an economy of scarcity to an

economy of abundance.

Can we make the breakthrough

from an economy of abundance to an

economy of abundant beauty?

HENRY LUCE

An Economy of Abundant Beauty

Fortune Magazine and Depression America

MICHAEL AUGSPURGER

Cornell University Press ITHACA & LONDON

First published 2004 by Cornell University Press

Printed in the United States of America

Library of Congress Cataloging-in-Publication Data

Augspurger, Michael, 1971-
 An economy of abundant beauty : Fortune magazine and Depression America / Michael Augspurger.
 p. cm.
 Includes bibliographical references and index.
 ISBN 0-8014-4204-4 (cloth : alk. paper)
 1. Fortune. 2. Corporate culture—United States—History.
3. Art and society—United States—History—20th century.
4. American periodicals—History—20th century. 5. Professions—United States—History. 6. Businessmen—United States—History I. Title.

 PN4900.F67.A97 2004
 306.3'42'097309044—dc22

2004006698

Cornell University Press strives to use environmentally responsible suppliers and materials to the fullest extent possible in the publishing of its books. Such materials include vegetable-based, low-VOC inks and acid-free papers that are recycled, totally chlorine-free, or partly composed of nonwood fibers. For further information, visit our website at www.cornellpress.cornell.edu.

Cloth printing 10 9 8 7 6 5 4 3 2 1

CONTENTS

ACKNOWLEDGMENTS

Writing is a lonely process, and yet when the writing is completed you realize how many people have helped you along the way. First, I acknowledge the institutional help I received in writing this book. The University of Iowa, through its Iowa Fellows program and its Seashore Fellowship program, gave me the opportunity to spend two years writing the first draft. I completed the final major revision in Regensburg, Germany, and although my position as a Fulbright lecturer was not directly linked to this project, I thank the Fulbright Commission, the American Studies department at the University of Regensburg, and Udo Hebel for providing me with a year away from the bustle of the American university system. In addition, the American Studies department at Iowa provided me with support so that I could travel to the Smithsonian library in Washington, and the staff of Special Collections at the University of Iowa library was extremely helpful and friendly during the many days I spent in their reading room. Finally, I would like to thank Sheri Englund and the staff at Cornell University Press for their generous help and patience in the final stages of the project.

I owe a personal debt to friends and colleagues who either helped with writing or helped me recover from writing. John Raeburn provided comprehensive feedback on several drafts of the manuscript as well as consistent interest in my findings. Ken Cmiel gave me tremendous help in shaping and reshaping the overall narrative of the book, and Colin Gordon read several chapters and pushed me to integrate a more rigorous economic history into the manuscript. The anonymous readers for Cornell University Press were extremely helpful, particularly in getting me to broaden my vision and to work *Fortune* into the history of the interwar and postwar years. My fellow graduate students in Iowa's American Studies department were an amazingly supportive and helpful

bunch, and I particularly thank those who participated in reading and writing groups with me: Kevin Quirk, Russ Peterson, Barb Shubinski, Jennifer Rasin, Bill Bryant, Mike Lewis, and others. I offer additional thanks to Bill for his generous help in collecting and preparing the images for the book.

Finally, I want to thank family. Jim and Pat Simonsen both read parts of the manuscript, and the memory of Pat sitting in a chair at the holidays, smiling and laughing out loud as she read about *Fortune*'s high ambitions and petty squabbles "Did they really say that?"—helped me through a fair number of slow days at the computer. My own parents, Bill and Phyllis Augspurger, played a fundamental role. Many long discussions with my dad, both as a child and an adult, demonstrated to me that business people, despite the assumptions of much cultural studies work, really could have moral ambitions, and so provided much of the inspiration and direction for this project. My mom, who returned to the university to obtain a Ph.D. when I was a teenager, proved to me that writing a book should be no problem for a childless, grant-supported person like myself. And, of course, I want to thank my wife, Jane Simonsen, with whom I (almost literally) wrote this book, walking to the library on so many mornings and returning home in the late afternoon, glad on good days to have written a page or two. I could not have done it without her.

An
Economy
of Abundant
Beauty

INTRODUCTION

To open a *Fortune* magazine from the 1930s or 1940s is to confront a series of seeming incongruities. Here is a self-described "beautiful" magazine that devoted itself not to society life or fashion but to the grim world of business and industry in an era of economic disruption and tragedy; a magazine presumed to be a "booster" for business that printed scathing exposés not only of easy targets like the munitions industry but of U.S. Steel and the housing industry and the producers of women's clothing; a champion of corporate capitalism that acknowledged the right of unions to strike, supported higher wages, and called for federal programs ranging from social security to the Securities Exchange Commission. Beyond these economic tensions, however, the magazine's intense interest in art and culture, whether in the form of rare books or the art programs of the federal Works Progress Administration, seems inconsistent with its business focus. An essay on the American workingman might be illustrated not only by Margaret Bourke-White's industrial photographs but also by paintings by Reginald Marsh and Thomas Benton, and sculptures by Max Kalish. A piece on the bullfighting industry might be contributed by Ernest Hemingway and complemented by the art of Goya and Eduard Manet. Any one issue might contain an essay on major American orchestras, the revival of the craft of stained glass, or the state of American painting. Even the magazine's writers were poets and intellectuals, whether remembered, like James Agee, Archibald MacLeish, and Dwight Macdonald, or otherwise.[1]

How can we explain the seeming contradictions and tensions within *Fortune?* The temptation for many commentators has been to see its incongruities as signs of a magazine torn between a radical, artistic staff and a corporate editorial board, or as evidence of a boostering engine derailed by the Depression. In the seven decades since its founding, former

staff members and historians have established a standard account of the magazine's rise and fall as a journalistically inventive, socially critical journal. In 1930, eight years after he founded *Time*, as the narrative explains, Henry Luce created *Fortune* as a coffee table magazine for the extremely wealthy. When the worsening Depression made such conspicuous luxury untenable, however, literary staffers like MacLeish, Agee, and Macdonald, together with liberal-leaning editors such as Ralph Ingersoll and Eric Hodgins, infused *Fortune* with creative energy and a critical edge. MacLeish recalled fifty years later that "the magazine was saved from disaster only by altering its fundamental assumptions about the world." Macdonald quipped that *Fortune* became liberal in the mid-thirties because it represented a compromise between the conservative Luce and the radical writers. But according to this standard history, the change did not last long. When Luce, disturbed by the direction of the magazine as well as that of the nation, restated the magazine's commitment to capitalism in 1937, the volatile balance crumbled. The talented radical writers left, the Golden Age ended, and *Fortune* returned to its original role as the propagandistic voice of big business. "The years 1932–36," Macdonald summed up, "might be called the NEP [New Economic Policy] period in *Fortune*'s history, when it was necessary, in order to exist, to retreat temporarily from capitalism."[2]

This story, however, badly overemphasizes both the disruption created by personnel changes and the shifts in *Fortune*'s politics through its first twenty years. A better explanation for *Fortune*'s startling combination of a business focus with liberal social ideals, a critical edge, and a developed artistic vision is that these facets of the magazine were not incongruous at all. Indeed, the first major thesis of this book is that *Fortune*'s cultural interests and its particular modernism illuminate the relatively coherent worldview of its editors and readers. The magazine addressed not the interests of wealthy capitalists, but rather the concerns of a nascent community of "enlightened" business managers, a fact that helps to explain why the magazine, despite a hefty one dollar cover price, had within five years more than tripled Luce's original goal of thirty thousand subscriptions. The magazine is thus a crucial document of the rise of what has been called "corporate liberalism" from an idealistic minority view in the teens and twenties to the dominant American social force of the postwar years. And while historians have described the political history of corporate liberals, their larger vision of American culture and society remains largely unexplored. *Fortune*'s investment in culture sheds light on corporate liberals' assumptions about the

social responsibilities of business, the nature of democratic government, and the social and cultural role of the professional managerial class.[3]

Corporate liberalism had its origins at the turn of the century, as corporate executives, recognizing that highly competitive markets no longer necessarily served the interests of their companies, reengineered the economic machinery of the United States. The calamitous and repeated recessions of the Gilded Age had undermined not only profits but the social stability that business needed to function. Eschewing the cutthroat competition that constantly destabilized the marketplace, some larger corporations worked increasingly in the political realm to assuage industrial conflict and to level the dizzying swings of the economic cycle. Joining with segments of the emerging professional managerial class, corporate business interests sought to rationalize the market through scientific organization, market cooperation, and occasional government intervention. Corporations merged into larger units, and managers constructed complex centralized bureaucracies to organize these conglomerates. Corporate executives increasingly looked to the state to preserve their competitive advantages and to control unions, and the state expanded both to aid and to regulate these corporations. Finally, the size and authority of the professional managerial class exploded, as corporations and government sought the managers and technicians necessary to operate their organizations and their technologically advanced machinery. These sweeping social changes ushered in a new set of relations between the corporation, the state, workers, and the public—a set of relations known as organized capitalism.[4]

Corporate liberalism developed as the ideological justification for the new relations of organized capitalism. Many Americans, particularly in the early twentieth century, worried that the phenomenal growth of corporations threatened the health of American democracy and the functioning of the competitive marketplace. Corporate liberals, however, claimed these fears were unfounded. Instead, they insisted, the growth of corporations signaled a great opportunity. Celebrating rather than denouncing the newly tempered market, they insisted that the radical technological and organizational changes of the modern economy marked the rise of a "New Era" of widespread abundance and social well-being. To take advantage of these changes, however, society would have to adapt its values to the material conditions of organizational capitalism. Frontier individualism, the industriousness and thrift of the Protestant work ethic, and the open marketplace were not appropriate ideals in an advanced corporate society. The New Era

demanded not only cooperation in the marketplace but a higher stress on creating consumer outlets, a more socialized version of individualism, and, most important, a class of respected, socially responsible business leaders. George Perkins of the National Civic Federation, for example, using rhetoric that would become common in the twenties, argued in 1910 that "the officers of the great corporation" would have to play "the part of statesmen." While this rhetoric clearly aimed to raise the social status of the business-man, it was more than simple boosterism. Indeed, it also suggested a new understanding of the corporate social role. To demonstrate the new leadership of business, corporate liberals stressed the benefits of voluntary corporate self-government. After 1900, and particularly in the 1920s, many large corporations adopted voluntary programs such as trade associations, employee representation boards, and corporate welfare programs. The New Era corporation could not only make a profit, corporate liberals maintained, but it could also improve the social conditions of the United States.[5]

This reimagining of the role of the business manager points to a further aim of corporate liberals: they hoped to provide a new moral grounding for capitalism. Often advocating their policies using a combination of profit-based and moral reasoning, they imagined themselves both as paternalistic benefactors and progressive reformers. Some commentators, questioning the link between corporate liberals' moral rhetoric and their business practice, argue that corporate liberal policy can be explained almost wholly in terms of short-term self-interest. Welfare policies, such as health insurance or retirement accounts, for instance, aimed to improve employee loyalty and ward off government regulation. Certainly it would be fruitless to argue that corporate liberals acted altruistically. As they readily admitted, and even insisted, these managers adopted business policies that satisfied the self-interest of their corporations. Still, this does not mean that those policies were not morally motivated. Indeed, the moral ideals of corporate liberals worked to produce different market behavior not through altruistic actions, but by redefining self-interest. A "broader notion of corporate responsibility," as David Eakins argues, made corporate liberalism a "genuinely different" form of capitalist practice.[6]

Enlightened business leaders in the twenties, for example, argued that high wages, if enacted across industries, would actually boost profits and the economy as a whole. The practical aim of such a policy was to enlarge consumer markets in order to subsume rapidly increasing rates of industrial production. But many businessmen, like Owen Young, combined economic and moral arguments in justifying this policy. Workers, they insisted,

deserved a "cultural wage" that would buy not only food but also recreation, health, and education. This "doctrine of high wages," which certainly asked a corporation to look past the demands of short-term profit, produced real material changes: in addition to increasing wages and enacting corporate welfare plans in the twenties, many of these corporations worked to sustain their wage levels well into the Depression. At the urging of President Herbert Hoover, major employers, led by corporate liberals such as Young, Gerard Swope, and Walter Teagle, pledged in late 1929 not to cut wages. Only in late 1931 did wages finally fall significantly. Business commitment to corporate liberal theory pushed corporations to defy traditional definitions of "self-interest," at a significant short-term cost to themselves, almost two full years into the Depression. "The genuine if distorted idealism of the materialistic twenties," argues James Neuchterlein, "[rested on] an identification of self-interest, appropriately modified, with general social progress." This "appropriate modification" of self-interest distinguished corporate liberal business managers from the more conservative business forces of the twenties.[7]

The prominence of corporate liberal policies and ideals increased dramatically in the twenties. "There has been a change—an enormous change—within the last ten years," commented one director of the U.S. Chamber of Commerce in 1929. "We are acquiring a new industrial philosophy." As the reputation of business soared against the backdrop of the steady, if unevenly distributed, economic growth of the twenties, the rhetoric of business statesmanship, professionalism, and service became so common that some businessmen complained it had grown tiresome. The public not only increasingly accepted the legitimacy of corporate existence but began to imagine corporations as important social institutions. Most important, corporate liberal policies were increasingly praised and adopted. As many as 80 percent of the fifteen hundred largest companies had at least one welfare plan by 1926, and half had comprehensive programs. Employee representation plans (or company unions, from the labor point of view) were widely adopted as a means to stabilize employee relations and avert unionization. Even Hoover was a devoted supporter of the economic and moral possibilities of market cooperation and business associationalism.[8]

The debut of *Fortune* in 1929 not only capped this decade of corporate liberal expansion but also announced the growing ambitions of corporate liberals. The magazine was not the first organizational proponent of corporate liberal policies. *Forbes* had garnered a reputation in the teens and twen-

ties for its enlightencd business ideals, and *The Nation's Business,* the U.S. Chamber of Commerce, and others had provided more sporadic support. *Fortune* distinguished itself, however, with its glamorous appearance and hefty one-dollar cover price, as well as in developing an expansive, sophisticated vision of the New Era. Business, Henry Luce argued in 1929, was the dominant institution of modern civilization, the "largest planet in our system." It linked the corporate executive to the household servant, modern art to cigarette advertisements, and midtown Manhattan to the Utah desert. Yet, he complained, it had only trade magazines and specious booster journals to explore its complex ecologies. "Where is the publication," a later proposal asked, "that even attempts to portray Business in all its heroic present-day proportions, or that succeeds in conveying a sustained sense of the challenging personalities, significant trends, and high excitements of this vastly stirring Civilization of Business?" *Fortune,* directed at the "aristocracy of our business civilization," aimed to fill this publishing void.[9]

Fortune's expansive "Civilization of Business," as the phrase itself suggests, was not limited to the boardroom and the factory floor. In the New Era, business would be crucial not only to the technological and economic health of the nation but also to its social and cultural vitality. Early in the Depression, for instance, *Fortune* argued that the "servant problem" was as much an indictment of the nation's economic situation as the spectacle of full grain silos amid a hungry population. More than a simple upper-class blindness, however, this position grew out of a certain moralistic understanding of the marketplace. "Capitalism," the magazine insisted, "is supposed to provide wealth and make it easily convertible into human satisfactions." The inability to enjoy wealth, whether as the result of a failed system of domestic labor or of an inadequate cultural training, was as serious a problem as the inability to acquire the wealth itself. It was crucial, therefore, for *Fortune* to demonstrate and nurture the vitality of American culture. If, as business critics proclaimed in the twenties, the United States was indeed a nation of single-minded Babbitts, and if this young nation indeed had no true culture to complement its material success, then business was failing to live up to its potential. To counter this criticism, *Fortune* displayed an American culture intimately connected to the corporate world. It celebrated artists whose work rose from the conditions of an industrial society, and insisted that the businessman's embrace of high Culture would further his growth into statesmanship. The blossoming of American arts, it maintained, would signify the nation's entrance into the New Era. "We have made a breakthrough from an economy of scarcity to

an economy of abundance," Luce remarked later in his life. "Can we make the breakthrough from an economy of abundance to an economy of abundant beauty?"[10]

In the thirties and forties *Fortune* endeavored to make just such a breakthrough. Early critics, observing the magazine's copious use of full-color illustrations and artistic photographs, its modernistic layout, and its staff of former poets and literary authors, predictably placed *Fortune* in a tradition of lavish business-sponsored art. Some, noting the use of graphic art and literary nonfiction in the magazine, gushingly pronounced it "sumptuous as the pearly gates" and "the Aristocrat of Business." More antagonistic reviewers saw its conspicuous display of Culture as an ornamental parlor hiding the dusky backrooms of business. But as I have suggested, *Fortune* was not simply a decorated trade magazine. Its modernism, rather, was closer to Marshall Berman's definition: an "attempt by modern men and women to become subjects as well as objects of modernization." The magazine's attention to art was integral to its larger vision of a New Era that would be characterized by widespread material abundance and an accessible, democratic American culture, as well as business leadership and technological progress. Business and art, *Fortune* argued, were not only compatible but were also symbiotic: the failure of a business society to cultivate an advanced art would indicate crucial flaws in the priorities of its artists and its business people, and even its economic system.[11]

Of course, the events of history did not cooperate with the expansiveness and enthusiasm of the magazine's vision. *Fortune*'s founding coincided with the advent of the most extended and disruptive economic crisis of the twentieth century. The crisis, which had begun with the stock market crash of October 1929, soon involved much more than paper money. The gross national product, which had surpassed the $100 billion barrier by the late twenties, was cut nearly in half, to $55 billion, by 1933. Unemployment, which stood at 3.2 percent in 1929, did not dip below 20 percent from 1932 to 1935, and would not stay under 17 percent until the advent of the Second World War. The extent of the economic disruption of the thirties is perhaps best indicated by the fact that the most legislatively and politically experimental administration of the American twentieth century was headed by Franklin Delano Roosevelt, a previously traditional Democrat who had emerged from a distinguished East Coast aristocratic family. Roosevelt's administration not only reacted to the economic crisis with a flurry of legislation and a tremendous burst of spending, but it also initiated programs like the National Recovery Administration that, in significantly restricting the

operation of competitive markets, contradicted well-established American political traditions.[12]

These economic numbers and political changes, however, do not express the extent of the impact of the Depression on Americans' view of business and the market. The easy confidence in progress and economic growth that had been a defining characteristic of mainstream American thought, and that had been whipped into a frenzy of optimism during the late twenties, suddenly seemed foolhardy. Political and ideological assumptions about individualism and self-making appeared unrealistic in the face of massive unemployment and widespread hunger, and as the bad times continued into the mid- and late decade, radical and working-class politics, so long declared "un-American," gradually gained popular support. Journalists and artists, discovering an American underclass that, to a lesser degree, had always been there, turned topics like sharecropping and migrant workers into headline news, and in doing so exposed the dirty underside of the American economy. Public opinion of business had sunk so low by 1936 that the considerable economic power and influence that business wielded over the media could do little to stop Roosevelt from winning a landslide reelection under the banner of fighting "economic royalism." The depth of Americans' pessimism toward business and the economy in the thirties inverted the irrational optimism that had pervaded the previous decade.

These economic, social, and cultural disruptions forced *Fortune* to change its course. Trying desperately to adapt core corporate liberal ideals to the vicissitudes of the Depression and the Second World War, the magazine reworked its policies and rhetoric repeatedly. In the first years of the thirties, as yet unfazed by the Depression, *Fortune* echoed the corporate liberal rhetoric of the twenties. Insisting that business leaders needed to recognize their public role as business "statesmen" and to embrace the ethic of "service," the magazine focused on large corporations, welfare capitalism, and business associationalism as the keys to a stable but vigorous economy. Cultivating a New Era leadership that would combine the energy of the business world with the social responsibility of the professional class, the magazine endorsed an aristocratic business culture that encouraged broadminded behavior in the cultural arena and in the marketplace while simultaneously celebrating artists and professionals who embraced industry and the marketplace.

But as the Depression deepened the magazine began to back away from the corporatist ideals of organized capitalism. The glowing reputation of

the businessman that had gained prominence in the twenties had no place in the new decade, and arguments about the responsibility and "statesmanship" of business leaders became less and less tenable. But while the collapse warned the editors not to overestimate the power and good intentions of individual business leaders, it did not push the magazine away from its core ideals: *Fortune* did not cease to search for a moral basis for capitalism. Eschewing the paternalism of the elite coalition, however, *Fortune*, after 1936, adopted the inclusive rhetoric of democracy and populism. Acknowledging that conflicts of interest were endemic to a pluralist democracy, the magazine maintained that these conflicts were transcended by a unified national interest in material progress and political liberty. Rather than imagining a cultural field as an outgrowth of industrial civilization, the magazine now declared that both democratized high art and mass-mediated popular culture were essential to the "culture of democracy." Artists and intellectuals would need to use their powers to create "affirmative" visions of the American future that would unify a pluralist nation behind the banner of material abundance and capitalist values. In the years before and during the war *Fortune* extolled not the noblesse oblige of aristocratic Culture but the social glue of democratic culture.

After the war *Fortune*'s social and cultural ideals transformed themselves yet again, as the magazine weakened its commitment to the ideal of consensus pluralism with a new enthusiasm for professional authority. The magazine's democratic rhetoric and optimism for a unified American nation during the war linked it, despite significant political differences, both to New Deal liberals such as MacLeish and to the leftist coalition surrounding Henry Wallace. As Dwight Macdonald noted, there was a great deal of rhetorical and nationalistic similarity between Luce's influential "The American Century," and Wallace's response, "The People's Century." At the end of the war, however, the political disagreements between these groups were brought to the fore. The magazine, hoping to strengthen the political and social power of corporate liberal managers, increasingly stressed the importance of professionalization to the business world. Insisting on the need for a "free" space in which business managers could run the economy, *Fortune* aimed both to undermine the contributions of leftists to serious economic discussions and to boost the status of educated "expert" business managers. In doing so, the magazine contributed to a larger process of professionalization within the business community and within American society as a whole. Combined with the booming postwar economy, this change served to revive the reputation of business and to secure

the importance of university-trained business managers, creating what *Fortune* would soon herald as the "Age of the Manager." The election of Dwight D. Eisenhower to the presidency in 1952 cemented this victory, producing not only the first business administration in a generation but also signaling the new dominance of corporate liberal economic policies and social views. The vibrant labor-liberal coalition of the thirties, Michael Denning argues, was defeated in the postwar years by "the forces of 'The American Century.'" This book in part details the cultural and social ideals of a core component of these forces, and argues that a key part of this victory was the further professionalization of the American public sphere.[13]

•

The postwar triumph of corporate liberalism, however, was not complete. Despite the overwhelming political and economic victory of "forces of 'The American Century,'" *Fortune*'s artistic and cultural ideals faded from view after 1948. My second central thesis renarrates the conflicts within the American artistic sphere in the two decades before 1950, and argues that the same process of professionalization so crucial to *Fortune*'s political victories also explains the magazine's failure to establish its artistic vision. In placing so much stress on professional training, *Fortune* not only focused less energy on its cultural ideals but also implicitly acknowledged the professional authority of avant-garde critics and artists, such as the New York Intellectuals and the New Critics. Just as this newly institutionalized corps of literary critics solidified their cultural authority by declaring themselves apolitical specialists, *Fortune* surrendered its cultural vision when it recognized that, in endorsing an expert-controlled public sphere, business managers could secure substantial professional power.

Fortune's departure from the cultural field did not result from a lack of interest. Indeed, the magazine still lamented business's lack of cultural power in the postwar years. In November 1948, for instance, the magazine published a literary history of the American business manager. To tell this story the staff member John Chamberlain imagined the protagonist of Booth Tarkington's *The Plutocrat*, Adam Tinker, methodically reading twentieth-century American literature in search of an accurate portrayal of business. To his chagrin Mr. Tinker found nothing that satisfied him: "A distilled malevolence, a cold and frightening spite, went into the painting of practically every fictional businessman whom Mr. Tinker encountered." Business, this literature unambiguously asserted, corrupted genuine values, distorted the truth, and exercised unlimited power over American society. Puzzled by this unequivocal disdain, however, Mr. Tinker asked a book-

store clerk to explain the seeming contradiction between the accusations in American novels of rampant business abuses and the positive reviews of these novels in capitalist-owned newspapers:

> The clerk looked a bit startled. By way of a reply he recommended Mary McCarthy's *The Man in the Brooks Brothers Shirt,* a story of how a traveling salesman for a steel company had seduced an *avant-garde* girl novelist on a transcontinental train. Mr. Tinker couldn't see just what this story had to do with his question, unless the clerk was trying obliquely to suggest that the *avant-gardistes* had managed to dominate the literary world in spite of their fascist employers.

The cultural status of the avant-garde, Chamberlain suggested, belied their claims of repression and alienation. Contending that writers such as McCarthy "dominated the literary world," Chamberlain's essay, and the *Fortune* editorial that accompanied it, marveled that artists had somehow eluded, even overpowered conventional economic and social powers. For all its efforts at public relations, for example, business had failed to produce a figure as resonant as George Babbitt. "That old bird who said he'd rather write a nation's songs than its laws was way off the beam," Mr. Tinker lamented. "He should have said he'd rather write a nation's novels." The literati, apparently, had authority that even a chairman of the board could envy.[14]

If Mr. Tinker had had the opportunity to consult the literary sociologist Pierre Bourdieu, rather than a secondhand bookstore clerk, he might have received a more satisfactory answer to his question. The field of cultural production, Bourdieu would have explained, functioned as "the economic world reversed." For artists, cultural authority increased as they were able to distance themselves from business and institutional power. Newspapers that dictated the opinions of their artistic reviewers and capitalists who paid artists to produce public relations undermined their own attempt to garner cultural authority, because they applied the logic of "ordinary economies" to a field that "systematically inverts the fundamental principles" of those economies. The only way for business to acquire cultural capital would be to shift the entire cultural field away from the inverted economic ideals of the independent artist toward the rationale of the market. Mr. Tinker and his companions, Bourdieu would have insisted, would have to struggle with artists and critics to redefine the principles that controlled the field of cultural production.[15]

Disappointed, like Mr. Tinker, in the failure of business to match its commercial success with social standing and cultural respect, *Fortune* in the thirties and forties sought just such a redefinition. American artists of the twenties, with few exceptions, attacked business and middle-class life as alienating, empty, and materialistic. "In no country as in the United States," Harold Stearns wrote in his 1922 manifesto, *Civilization in the United States*, "have the tragic consequences of the lack of any concept of the good life been so strikingly exemplified." In revolt against this supposedly monolithic, stultifying culture, these artists often either produced scathing rebukes of American society or retreated into deliberately nonpolitical art. But *Fortune* formulated its own version of American art. The magazine's modernism stressed accessibility, worldliness, and harmony between commercial and aesthetic concerns. Dismissing expatriates and advocates of art-for-art's-sake as disconnected and impotent, the magazine worked to empower artists who embraced the commercialism and vitality of the modern industrial society. More generally it sought to penetrate the professional and aristocratic boundaries surrounding high art in order to make the status of art available to business and corporate professionals. In advocating its own artistic ideals, *Fortune* hoped both to express its own vision of a renewed American society and to wrestle cultural authority from those who "wrote the nation's novels."[16]

In the early thirties *Fortune* demanded rather narrowly that artistic producers should largely remain subordinate to the corporate values. But just as the magazine responded to the Depression by transforming its elite coalition into the more inclusive pluralist consensus, so, too, did it broaden its concept of art and culture. Recognizing the necessity of establishing a broad consensus in support of the principles of capitalism, the magazine competed with the New Deal and the leftist Popular Front in an attempt to control the definition of "American culture." But while the New Deal focused on the small town as the center of American life, and the Popular Front on the working class, *Fortune* celebrated the business-driven culture of modernity. The cheering crowds at a baseball game, the swirling masses of Coney Island, schoolchildren flocking into newly accessible art museums, families listening to Toscanini and the NBC orchestra on their radios: this, to *Fortune*, was American culture. And the link that connected these disparate images, of course, was business: the ticket for admission, the growth of radio technology, the corporate philanthropist. Reimagining mass media as the folk culture of modernity and insisting that high culture had shed its exclusionary boundaries, *Fortune* posited a vital American cul-

ture that grew from the imagination and daily lives of ordinary people. Still insisting that artistic and commercial values were compatible, *Fortune* in the late thirties complemented its political courting of a wide American public with a celebration of the democratization of artistic production and consumption.

This heady, Whitmanesque ideal of a populist culture, however, did not survive the postwar moment. After the war ended the critique of an unthinking mass culture returned in force, as did the social and professional boundaries that made high art as exclusionary as ever. As a host of cultural historians have demonstrated, this thinning of artistic paradigms and producers in the postwar era owed a great deal to a conservative cultural apparatus that smothered leftist political art. The political conservatism of the dominant schools of literary and artistic criticism, the red-baiting of the McCarthy era, and the consensus power of corporate liberals made it difficult for left-minded art to gain acceptance or critical support. But not all the submerged artistic ideals of the thirties were remnants of radical culture. By 1948 *Fortune* had largely withdrawn from the struggle over the cultural field, and its corporate liberal artistic ideals, like those of a wide range of political and social artists, disappeared from literary and artistic history. I argue that an increasingly professionalized public sphere, as much as the cultural conservatism of literary critics or fervent anticommunism, wilted the divergent artistic ideals of the thirties. This professionalization occurred in both the economic and artistic realms. Even as *Fortune* retreated from the cultural field while reasserting its expert business leadership, the New York Intellectuals and the New Critics withdrew from politics and successfully professionalized artistic criticism. And along with the disappearance of the thriving artistic and political movements of the thirties came the withering of *Fortune*'s vision of a harmonious and mutually beneficial relationship between business and art. "Bohemia and Philistia," Mr. Tinker concluded in 1948, "were apparently worlds apart, and neither country was fitted to understand the other."[17]

The success of professionalizing strategies for both corporate liberals and adversary artists leads to my third and final thesis: that the struggles for cultural authority between *Fortune*'s corporate liberals and the artists and critics connected to the *Partisan Review* represented in microcosm a larger contest for the soul of the professional managerial class. Because *Fortune* consistently articulated its understanding of the proper social role of both artists and corporate liberal managers, its discourse illustrates the strong

parallel between artistic and professional conflicts. In doing so it demarcated the lines of a struggle in the battle over professional managerial identity.

The professional managerial class emerged around the turn of the century, a product of the new social relations created by corporate capitalism. "Little noticed in the heat of the [eighteen] nineties," Robert Wiebe argues, "a new middle class was rapidly gaining strength." Comprised of professionals, intellectuals, scientists, engineers, business managers, and others, the professional managerial class was characterized by advanced education, scientific training, and professional organization. The growth of the class in the first half of the twentieth century was tremendous. In the thirty years leading up to 1940, the number of accountants in the United States multiplied more than sevenfold, from 39,000 to 288,000. Engineers grew from 77,000 to 297,000. Cultural workers experienced similar growth in the period. Professional writers more than tripled to 14,000, and university professors bloomed from 16,000 to 77,000. But despite this fantastic growth, or perhaps because of it, the class remained a diverse and scattered group, and its self-consciousness was poorly developed. Nevertheless, by the early twentieth century, a common economic position and, more important, a common culture, had solidified the unwieldy group. "If they were too diverse to feel cohesion as a class," Wiebe notes, "a remarkable degree of interaction . . . [as well as] similar spirit, similar experiences, even roughly similar aspirations, drew them together far more than chance alone could have explained." This common culture manifested itself in a number of ways. Intermarriage rates and occupational stability between generations show that members of the professional managerial class understood themselves, if unconsciously, as belonging to a class. Education, too, played a crucial role in professional managerial identity. The university served as the center of the class's common culture, and the experience of higher education manifested itself further in the preference of this class for "brain work." Class members also identified themselves through their geographical and cultural tastes, establishing spaces in the suburbs and articulating a self-definition through mass magazines at the turn of the century. These social institutions and demographic similarities succeeded in linking the disparate occupational and economic interests of the engineer and the intellectual, the doctor and the professional manager.[18]

Corporate liberalism owed much of its character to this new class. Capitalists and professionals, from the perspective of many of their members in the early twentieth century, were antagonists. On the one hand, profes-

sional reformers, in seeking to regulate and control the abuses of the capitalist system and in rationalizing the corporate workplace, threatened the authority of traditional business owners. Corporate organization and business values, on the other hand, often conflicted with the traditional vocational autonomy and anticommercial ideals of professionals. But not all businesspeople, or all professionals, saw the relationship between the two classes as a conflict. For capitalists and entrepreneurs able to recognize the long-term desirability of social stability and widely distributed wealth, managerial organization and progressive reform were desirable ends. Similarly, for professionals willing to temper their professional autonomy in exchange for influence within the corporate sphere, the conditions of organized capitalism allowed them not only to improve their financial and social situation but to apply their rational methods and expertise on a wide scale. More than this, the network of interrelations between business, government, and the professions meant that many inhabitants of the corporate world imagined themselves as *both* businessmen and professionals. The research scientist who had become a vice president, the artist heading up an advertising agency, and the manager who had graduated from a prominent school of business all combined an inculcation into professional culture with a career in the business world.

What developed particularly from this intersection of business experience and professional ideals was the moral aspects of corporate liberalism. Perhaps the most important way the professional class had separated itself from the capitalist and working classes in the late nineteenth century was by developing a set of ideals that stressed social responsibility, commercial disinterestedness, and professional autonomy. Professionals in nineteenth-century American life occupied an unsteady place. Unlike those in European nations, American professionals did not develop in close concert with state or religious institutions that could definitively delineate their social role. Hoping to secure the political privilege of a monopoly over a certain service, professionals worked both to gain public recognition as legitimate experts and to demonstrate their commitment to the public weal. As a result, an ideology of professionalism developed that stressed public service and distanced professionals from the selfish pursuit of wealth. The connection of the professions with science (though sometimes distant) fortified this ideal of disinterestedness by engendering a belief that the professional served truth rather than an employer, social mores, or economic and political power. This set of class ideals—the "true professional ideal"—encouraged doctors, lawyers, engineers, scientists, ministers, and professors to ap-

proach their jobs as "callings" that demanded disinterested objectivity, a devotion to public service, professional autonomy, and a rejection of material ambition.[19]

Unfortunately the same process of corporatization that provided new opportunities for lawyers, engineers, advertisers, professors, and managers also made it much more difficult to practice these nineteenth-century professional ideals. The conflict between a "calling" and the environment of modern corporate society created tremendous anxiety within the class and gave birth to competing models of professional managerial identity. Some professionals, comprising what Lionel Trilling would later dub "the adversary culture," fought the supposed compromise between professional and corporate values, and maintained that both the cultural and professional fields were "economic worlds reversed" in which artistic or scientific truth trumped commercial ambitions. Others' embrace of the marketplace allied them with capitalists. Most professionals, assuredly, wavered between these two poles. But in insisting that art and business could thrive together, *Fortune* celebrated the latter ideal. Arguing both implicitly and explicitly, both in its discourse on professionalism and that on art and culture, *Fortune* maintained that the professional managerial class would flourish only in partnership with a corporate society. In its early days, particularly, the magazine insisted that the professional should simply forgo the autonomy and social visibility of the traditional professional in exchange for the increased authority of the corporate employee.[20]

But just as the adversary culture exchanged the emotional distance and elitism that had dominated the twenties for political commitment and an embrace of the "forgotten man," *Fortune*, too, responded to the Depression by rearticulating its understanding of the ideal professional. Recognizing for the first time the disjuncture between business interests and the public interest, as well as the appeal of government work during the New Deal, the magazine broadened its understanding of useful professional work to include careers outside the corporate world. As the magazine embraced consensus pluralism in the late thirties and during the war, it proposed a new role for the professional class. Interpreting the continuing economic crisis as a loss of national direction and initiative, *Fortune* insisted that professionals, whether in the form of business managers, philosophers, or painters, needed to create a new inspiring vision of national purpose. Not rational planners or paternalistic leaders, these affirmative professionals would have to work with a pluralistic public to forge a nation unified in its desire for material progress and capitalist ideals. Not surprisingly a new vision of adver-

sary identity, exemplified by the staff member James Agee and most influentially articulated by the New York Intellectuals surrounding the little magazine *Partisan Review*, arose to contest this affirmative ideal. Distancing themselves from the political commitment of the mainstream Left as well as the corporate environment of corporate liberals, these writers and critics argued that the intellectual class had to distinguish itself through its critical independence, cosmopolitanism, and strident antitotalitarianism.

By the opening of the Second World War the affirmative ideal of *Fortune* and the adversary identity of *Partisan Review* represented two powerful competing ideals of professional managerial identity. The postwar years, however, did not produce a clear winner in this conflict. Instead, the professionalization of the public sphere, and the parallel triumph of both corporate liberals and the New York Intellectuals, signaled the formation of a new dominant understanding of professional identity. Chamberlain closed his "Businessman in Fiction" by chastising artists and intellectuals who failed to realize that "free capitalism, if highly imperfect, is still not only the most productive but also the least bloody system the world has ever known." Indeed, this is exactly the conclusion that a group of highly influential artists and critics reached in *Partisan Review*'s. 1952 colloquium, "Our Country and Our Culture." The United States, *Fortune* and *Partisan Review* agreed, had its problems but nonetheless was still the best the world could offer. Within such a world, it was the responsibility of the professional class to combine a dedication to critical independence with a pragmatic affirmation of American values and institutions. The effect of this agreement about the desirability of the American system was to move professional identity out of the public sphere and into the private realm. While both affirmative and adversary professionals before the end of the war had identified themselves primarily through their relation to the American corporate and governmental system, postwar professionals increasingly aimed to establish their individuality largely through personal tastes, whether artistic or otherwise. "Self-actualization," as the sociologist Michele Lamont calls it, not political commitment or vocational ideals, became the primary road to self-identity for the professional managerial class.[21]

Freedom, both *Fortune* and *Partisan Review* claimed in the postwar years, made the nation's flaws bearable. But both the adversary artists of *Partisan Review* and *Fortune*'s corporate liberals had more practical reasons to endure those imperfections. In eschewing democratic idealism in favor of an imperfect but livable world, they justified acceptance of increased specialization and professionalization, trends that, while creating intellectual

discomfort for both groups, also brought each increased authority within their fields. Just as the ideals of the New York Intellectuals and New Critics dominated the universities and the cultural sphere in the fifties, the managerial professionalism of corporate liberals became the dominant paradigm within the economic field. Thus the democratic pluralism advocated by *Fortune* in the late thirties and early forties gave way to a professional pluralism that succeeded in consolidating the authority of the professional managerial class. The price of this change, however, was a diminished, expert-dominated public discourse and a narrowed diversity of artistic production.

PART I

The Elite Coalition of Corporate Liberalism,
1929-1935

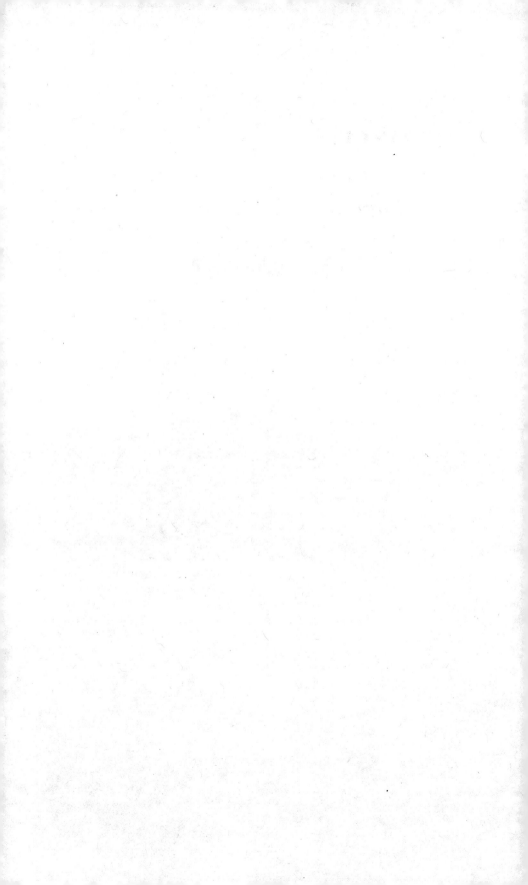

THE BUSINESS GENTLEMAN

In its first issue in February 1930 *Fortune* portentously announced its goal: "*Fortune*'s purpose is to reflect Industrial Life in ink and paper and word and picture as the finest skyscraper reflects it in stone and steel and architecture." Measuring 11¼ × 14 inches and often containing as many as two hundred pages, the magazine embodied this aim. The first issue claimed that the printing was "planned upon an economic scale which permits it to go beyond the technical limitations of most periodicals," and indeed in its first years no single press in New York could handle the entire printing process. The cover was printed on 125-pound weight paper, and the paper on the inside was of such quality and thickness that the binding had to be sewn by hand. But more than the physical object, the magazine's copious use of painting, literary writing, and artistic photography gave it a luxurious feel that few early reviewers failed to praise. The advertising firm Young and Rubicam, for example, applauded the magazine's beautification of business: "A Toast to You *Fortune*. . . . You've taken what are sometimes called 'prosaic business' and 'sordid industry'—you have viewed them with imagination, insight, and beauty. . . . No longer is business a column of figures, or work a daily grind. Here is epic enterprise, a panorama of romance, adventure, conquest—with beauty in factories and derricks." *Fortune* provided business with the elegance of the aristocracy and the allure of a Hollywood star.[1]

The magazine's luxurious ambience, like its self-aggrandizing sense of the centrality of business, might seem a cosmetic makeover hiding the ugly face of profit seeking. But just as the corporate liberal rhetoric of service originated from a coherent corporate liberal viewpoint, *Fortune*'s use of art and Culture, which seems so gratuitous to its central concerns, was intricately attached to its social and economic

Margaret Bourke-White, "Open Hearth at the Ford Motor Co.," *Fortune* 4 (*September 1931*): 45. Fortune *displayed its extravagance both in the size and number of its photographs and also in the artistic aspirations of those photographs. Margaret Bourke-White, the only visual artist on the original staff as well as one of the most well-known photographers in the United States in 1930, and a specialist in industrial photography, exemplified the magazine's ideal of the artist engaged with modern business society. Reproduced with the permission of the Estate of Margaret Bourke-White.*

aims. Seeing *Fortune* simply as a gaudy attempt to fool the public fails to recognize that the magazine was aimed at upper-level business managers and professionals. Corporate public relations campaigns in the interwar years, as Roland Marchand argues, sought to build managers' morale as well as to enhance the public image of corporations. *Fortune* likewise aimed its artistic discourse more at its business readers than at the public. "*Fortune* especially desires to attract those active, intelligent and influential individuals who have a relatively large stake in U.S. industry and commerce," declared a preface produced in the summer of 1929. "These individuals include the major executive—and also his friends (able doctor, politician, or lawyer) who are increasingly concerned with Business and with Businessmen." The magazine in the early thirties did serve as an epic advertisement. But rather than trying to dupe the citizenry, this advertisement aimed to convince its business readers of the desirability of corporate liberal ideals. By doing so the magazine hoped to nurture an elite coalition of statesman industrialists and corporate professionals whose sophistication and broad-mindedness would make business not only profitable and productive but also socially responsible.[2]

Fortune's cultural essays worked to solidify just such a class. The prospectus for *Fortune* asserted that the magazine would champion the ideal of the public-spirited businessman: "[*Fortune*] will attempt, subtly, to 'take a position,' particularly as regards what may be called the ethics of business. . . . [T]he line can be drawn between the gentleman and the money-grubber, between the responsible and irresponsible citizen." But the magazine did not simply urge its readers to be ethical businessmen. Using a discourse of class refinement and cultural distinction, *Fortune* cultivated a gentlemanly business culture. The magazine hoped that a humanist appreciation of Culture would spur businessmen's sense of noblesse oblige, and that a liberal education would cultivate an understanding of long-term social changes. Managers, broadened by their generalist knowledge, would eliminate the single-mindedness and materialism that not only plagued the reputation of business but resulted in "money-grubbing" business practices. Even more, *Fortune*'s artistic discourse aimed to build a corporate liberal community in which businessmen insisted on social responsibility not only from themselves but from others. Just as professionals prided themselves on their "professional ideals," and just as the aristocracy expected its members to act as community leaders and benefactors, business gentlemen, educated in the higher values of the arts and inculcated into a culture that expected responsible market behavior, would embrace the wisdom of cooperation,

service, and the wider distribution of consumer capital. By nurturing a business community that imagined itself as "Cultured," *Fortune* hoped to influence managers to act like gentlemen in the boardroom as well as in the dining room.[3]

Corporate Liberals and Business Reputation in the Twenties

The late twenties are remembered as a time of extravagant wealth and careless speculation. Particularly to those relative few who were invested in the stock market, money seemed to grow on trees. Between 1925 and 1929 the value of all the shares on the New York Stock Exchange blossomed from $34 billion to $64 billion. In 1928 alone the value of Radio Corporation of America stock grew from 85 to 420. Margin trading even made it possible to enjoy the fruits of the market without significant seed money. The historical events that followed the boom, therefore, have provided us with a ready-made morality tale. It was only appropriate, the story goes, that business people's heedless celebration of this wild economic growth ended in their expulsion into the desert of the Depression.[4]

But while clearly the enormous wealth created in the bull market of the late twenties in no way represented the meaningful gains in the economy, business enthusiasm for the New Era was not unwarranted. On the one hand, the wealth of the twenties has often been wildly exaggerated: clearly, not every citizen owned a new radio and a refrigerator. Indeed, the benefits of the growth in the twenties were poorly spread among the populace. Farmers suffered from low prices, debt, and overproduction throughout the decade. The wage gains of labor failed to keep pace with increases in worker productivity. As a result, by the end of the decade the gap between the wealthy and the poor was at record-setting levels. On the other hand, despite these failures, the record of economic and industrial growth in the twenties remains impressive. The gross national product increased steadily from $69 billion in 1921 to more than $103 billion in 1929. Newer consumer-driven industries like electronics, automobiles, and radio boomed, pulling older industries along with them: as the manufacture of automobiles, for example, more than tripled to an astonishing 4.5 million per year in the eight years leading up to 1929, steel production increased from 22 million to 63 million net tons. Industrial profits, which reached $5 billion in 1929, were built largely on the fantastic jumps in technology that pushed output per worker up 43 percent from 1919 to 1929. Even housing, an industry that would be widely condemned in the thirties, made significant

progress beyond the paper wealth created by real estate speculation: housing starts increased from 247,000 units in 1920 to more than 900,000 in 1925. Particularly for managers, professionals, and capitalists, the twenties produced impressive gains in production and spending power.[5]

Businessmen, not surprisingly, took much of the credit for these gains. But in imagining business as the driving force behind the decade's prosperity, they were not alone: the reputation of the business community in the twenties grew as steadily as the economy. After the peak of anticorporate sentiment at the turn of the century, many middle-class workers had gradually warmed to big business, and by 1929 large corporations had become an accepted part of the social landscape for most Americans. No single cause accounted for this change. On the one hand, the "dollar-a-day" managers, who had engineered the nation's prodigious industrial output during the First World War and were largely culled from the ranks of business, had emerged from the war, unlike Woodrow Wilson, with glowing reputations. On the other hand, the anticorporate critics of the Progressive Era had been exhausted and jaded by the Great War and its aftermath. Most important, though, the improvements in consumer wealth, as well as in other markers of quality of life, reconciled many middle-class people to the presence and size of corporations. Average real income grew 30 percent over the decade, and unemployment hovered between 1.8 and 5 percent in the last seven years of the decade. From the end of the war until the Crash, infant mortality rates plummeted from eighty-six to sixty-seven per thousand. By 1929 twelve million families had at least one radio, the volume of refrigerators sold had increased 150 percent through the decade, Americans owned twenty million telephones, and, needless to say, a wide range of citizens were driving the millions of cars produced each year. "Big business in America," argued the former muckraker Lincoln Steffens, "is producing what the Socialists hold up as their goal: food, shelter, and clothing for all." These largely middle-class improvements convinced the public that business was a productive force in American society, and the businessman worthy of admiration.[6]

Beyond this general approval, however, a cult of the businessman developed in the twenties that imagined business managers not only as the leaders of the U.S. economy but also as the directors of its social and cultural life. If "the chief business of the American people was business," as Calvin Coolidge famously opined, then the nation's chief executives were its heroes and models. Corporate managers, for example, in an age of sports and media celebrity, dominated the covers of *Time* magazine in the late twen-

ties. More startling, Henry Ford was voted by a group of college students as the third greatest man in history, trailing only Napoleon and Jesus Christ, and a larger group of citizens urged him to run for president in 1924. Furthermore, business success, through what one businessman called "the redemptive and regenerative influence of business," seemed to bring ethical, even spiritual, wisdom. When George Babbitt admired Zenith's tallest skyscraper as a "temple-spire of the religion of business, a faith passionate, exalted, surpassing common men," he was not alone; indeed, Frederick Allen claimed that such connections between religion and business were "one of the most significant phenomena of the day." In such an atmosphere, the corporate liberal Bruce Barton could name Jesus, who had sold his ideals through his parables and organized his disciples into a world-leading corporation, a prototype businessman. To many observers in the twenties, the businessman had not only left behind his soullessness but had received a special dispensation to lead the nation.[7]

This overwrought enthusiasm for the vision and goodwill of the businessman, however, also manifested itself in more sober tones. The corporate liberal rhetoric of service, cooperation, and professionalism gained increasing currency in the twenties. Owen D. Young, for example, argued that managers must begin to think of themselves as "trustees of an institution" whose beneficiaries included the public, workers, and stockholders. Chemical Bank's Charles Cason added that "the new business leader is a man of vision . . . [and] broad-minded. . . . Business can succeed only in the long run by acquiring and holding the good will of the public." Henry Luce dubbed this new American business manager the "tycoon." Tycoons, he explained, would be intelligent, articulate, highly educated, and moral, and their position as leaders of publicly owned corporations would make them "depositories of the public trust." But these proponents of the New Era insisted that the socially responsible business community was a goal for the future rather than a completed achievement. The rhetoric of statesmanship was as much a stimulus to improve business behavior as a celebration of the contemporary business community. Refusing to equate business values with religion, and maintaining that the present system still had major faults, corporate liberals nonetheless reiterated the belief that businessmen would be the most important public leaders of the New Era.[8]

Not everyone saw salvation in a skyscraper, however. Even the more tempered rhetoric of corporate liberals had its detractors. While the *New York Times* predictably dismissed Barton's writings as "little inspirational lectures

for people who need to be encouraged and enlivened," the *Nation* commented on a speech by Young by mocking the "'usual quota of dilettante liberals' ready to discover messianic traits in big business leaders." Indeed, a prominent section of the professional managerial class—particularly professionals, intellectuals, academics, and artists—often expressed a disdain both for the business person as an individual and for the corporation as a social institution. One part of this attack presented itself as a conservative defense of aristocratic values. "Standards," insisted Irving Babbitt, had to be upheld against the "full-blown commercial insolence" of American business society. H. L. Mencken, whose ideas in many ways opposed Babbitt's New Humanism, nevertheless shared with Babbitt a sense of a great separation between intellectuals and the masses. "The free man," Mencken asserted, must establish a space for himself and defend it "from the great mob of his inferiors." Other critics worried that the businessman's single-minded pursuit of wealth undermined the development of a full national culture. Harold Stearns argued that the United States stubbornly remained a "pioneer society" unable to appreciate objects or work without utilitarian value. This perception of the predominance of acquisitive values drove many young artists and writers, like Stearns, to flee to Europe in search of a nurturing environment. "America," charged Kenneth Burke, "is the purest concentration point for the vices and vulgarities of the world." Even John Dewey, who admired the technological power of U.S. industry, lamented in 1930 that the "business mind" was "immature" and "one-sided." Citing either an aristocratic disdain for the masses or a worry for the wholeness of the American character (and sometimes both), adversary professionals refused to be reconciled to the consumerism, advertising, and profit motive of the New Era.[9]

A key marker of this antagonism between business and the nation's cultural and professional leaders was the lack of interaction between the artistic and business worlds. "We have in America," the cultural critic Van Wyck Brooks lamented in 1915, "two publics, the cultivated public and the business public, the public of theory and the public of action, the public that reads Maeterlinck and the public that accumulates money: the one largely feminine, the other largely masculine." In large part, neither the artist nor the businessperson wanted anything to do with each other. Art critics expressed concern that art would be "tainted" with the surface values of commercialism. Modernist artists who aspired to high art recognition distanced themselves from the marketplace as much as possible, even as they strived to sell their work. Meanwhile, businesspeople dismissed Culture as

unproductive and feminine. *Fortune* reported that Henry Ford, for instance, had claimed he "wouldn't give a nickel for all the art in the world." "Wholly incompatible in their ideals," Brooks continued, "they still pull together, as the ass and the ox must. But the ass shows no disposition to convert the ox, nor the ox the ass . . . they are, in biological phrase, infertile with one another."[10]

Art and business, in fact, were, according to both aristocratic and professional traditions, antithetical. Art's standing as a marker of elite class status, for example, depended on its transcendence of the commercial realm. Lawrence Levine argues that beginning in the Gilded Age the "sacralization" of culture served to replace the caste distinctions that were disappearing in a democratic society. For the very rich, art was an opportunity for social distinction. The Guggenheims and Rockefellers, for example, gained reputations for charity and cultivation by supporting the high arts. But, as Harold Laski argues, these benefactors—even though they were often businesspeople—had inherited a tradition of aristocratic "leisured gentlemen" who achieved a fixed status because they did "nothing obviously for money." Their collections brought them status precisely because their interest in art separated them from pecuniary interests, and from the business sources of their income. "If the capitalist appetites could induce spiritlessness and philistinism," explains James Allen in discussing the tradition of cultural philanthropy in American business, "the capitalist would compensate by public generosity and cultural education." Businesspeople with more modest success, however, could not afford the artifacts, leisure, philanthropy, and education that paid for admission into this realm of aristocratic culture. Their lack of access to Culture, instead, signaled their lower-class standing and their supposed single-minded materialism.[11]

But it was not only the aristocratic rich who excluded business from the cultural realm. Many professional critics and artists also assumed that market values were opposed to art. However, these adversary artists and critics—ranging from Babbitt's New Humanists to Brooks's Young Americans, and from university scholars to literary modernists—used higher education and artistic expertise, rather than financial contributions and genteel appreciation, to separate themselves from the undistinguished bourgeoisie. Modernist poets and artists adopted increasingly nonimitative forms that made their work largely indecipherable to the uninitiated. Professional critics, anxious to protect their authority from amateur audiences, began to adopt the role of cultural gatekeepers, as Janice Radway argues, by "rendering the literary as a kind of special opacity produced by complexity, subtlety, and

intricacy of verbal organization, an opacity that demanded the hard work of the professionally trained, technically expert critic." By defining art in self-aggrandizing terms, professional artists and critics made it inaccessible to the businessman, and, in doing so, they asserted their distance from the market-place. Both aristocrats and professionals used Culture as a marker of their transcendence of a purportedly soulless and profit-obsessed business society.[12]

Corporate liberals took this denigration of business at the hands of upper-class critics and adversary professionals seriously. Corporate liberal rhetoric, for instance, clearly responded to criticism of the single-mindedness of the business community. By "midwifing new business ideals," as Bruce Barton claimed, the corporate liberal manager sought to refute the lingering skepticism of the New Era and justify the wealth and power of the business community. But corporate liberal ideals demonstrated their broad-mindedness in action as well as rhetoric. By the late twenties not only had the language of "service" and "business statesmanship" attained wide currency, but corporate liberal policies had also spread. Self-regulating trade associations, for example, aimed to level out disruptive economic cycles and provide steady work by fostering cooperation in the marketplace. Believing that cooperation between worker and employer was as important for efficiency and progress as cooperation between different corporations, many corporate liberal managers created "employee representation boards," and by the end of the decade these so-called company unions had sprung up in progressive companies as well as in corporations that primarily aimed to avoid a closed shop union. Further hoping to stabilize their workforce by developing a bonding relationship between employees and the company, numerous corporations provided employee stock plans, unemployment insurance, health care, and even recreational facilities to their employees: by the late twenties nearly 1 million employees at 315 companies had acquired more than $1 billion in company stock, and in 1928 nearly 6 million workers were covered with company insurance that had a value of almost $8 billion. Thus, although only a minority of American corporations had developed significant corporate welfare programs in the twenties, the investment was considerable: U.S. Steel, for instance, spent more than $10 million a year on various welfare plans, and other large corporations like General Electric and AT&T similarly committed themselves.[13]

Corporate welfare policies and the rhetoric of service constituted, in the twenties, the primary attack of corporate liberals on lingering criticism of business soullessness. The continuing perception of a wide gap between

business and art, however, marked the persistence of the denigration of the commercial field. A final way that corporate liberals responded to this critique, then, was to work to close the gap between "the ox and the ass," between art and business. Industrial design, for example, which aimed to professionalize the design of the products of capitalism, from teapots to stoves to trains, boomed in the twenties. The roots of industrial design were in functionalism. Adherents of the functionalist ideal, most prominently heralded by the German Bauhaus movement, believed that form should grow organically from function. Looking to warehouses, factories, and skyscrapers of American industry for inspiration, they suggested that avant-garde art could develop in modern, corporate environments. Although they rarely stayed true to functionalism's insistence on a lack of decoration, American proponents of industrial design were drawn to the commercial possibilities of "modernistic" design as well as its implicit insistence on a connection between business and art. The Chicago Association of Arts and Industries, for example, which would later invite prominent Bauhaus member László Maholy-Nagy to head its school of industrial design, announced in 1922 that it hoped to "impress upon the industries of the central west the great importance of improved artistic design as a national asset in world competition." Particularly after the International Exposition of Decorative and Industrial Arts in Paris in 1925, industrial designers in the United States popularized the straight lines and "streamlined" appearance that were meant to evoke an industrial feel. Even though such industrial aesthetics rarely embodied the equation of form and function or the embrace of standardization that design proponents celebrated in words, industrial design did produce a new argument that art and business, far from existing in separate worlds, were actually dependent on each other.[14]

While industrial designers looked to industry and business for a vision of the future, some corporations in the twenties turned to an older tradition of individual businessmen as aristocratic collectors and philanthropists in order to suggest New Era business values. As Roland Marchand argues, professional managers did not have the personal resources to distinguish themselves through their philanthropy, and so many sought to demonstrate their public-mindedness through their corporation. One result of this, beyond the corporate liberal rhetoric and policies, was a blossoming of institutional public relations in the twenties, in which corporations sought to establish themselves as "esteemed national institutions." The most common characteristic of these institutional advertisements, Marchand explains, was their "self-conscious creation as works of art." Not confined to any one artistic

style, these campaigns sought to tie the grandeur of Culture to a particular corporation: some featured distinguished oil paintings, others invited readers to request a framable copy of the advertisement, others alluded to classic literature, and some even included Latin or Greek text. The common message of this "institutional style," however, was that the corporation, like great art, embodied broadmindedness and social accomplishment.[15]

Both industrial design and institutional public relations campaigns point to a wider trend in the twenties: the mixture of art and business in advertising. Advertising in the twenties shifted from a focus on information to a more symbolic presentation of the product. Turning away from facts and reasoned persuasion, the ads attempted to connect a consumer item to an emotion or a lifestyle. Often the new symbolic advertisements suggested status or class improvement as a concomitant of the purchase. Aristocratic and modern art, weighted by decades of "sacralization," were ideal vehicles for this purpose. Advertising art directors aimed to create an aura of class around a product "by bringing art and commerce together." Even window display took on a modernist look in its spareness, cleanness, and straight lines. The use of art in advertising particularly matched the sensibilities of corporate liberals. Their sense of a New Era would have drawn them to design conceived of as modern. Their understanding of the growth of the consumer market, their willingness to break away from traditional business conservatism, and their desire to create a new image of the broad-minded businessman all would have encouraged an investment in what *Fortune* would call "good taste in advertising."[16]

For all these reasons—the growth of functionalism, the use of Culture in public relations campaigns, and the use of art in advertising—the chasm between art and business shrank in the twenties. But these trends advanced haphazardly and slowly. Industrial design remained a largely unestablished profession in the twenties, and functionalism primarily an avant-garde concern. Institutional public relations campaigns, meanwhile, were often dismissed as fluffy and ineffective. And while some advertisers, like Bruce Barton and Ernest Elmo Caulkins, who wrote a book entitled *Business the Civilizer*, felt a mission to improve the taste of the public and the behavior of business, others suggested that the use of art in advertising did little more than assuage professional advertisers' anxieties that in becoming admen they had sold out their talents. Only after the stock market crash in 1929 did corporate liberals receive a sophisticated, coherent national voice that not only supported the policies of welfare capitalism and the rhetoric of cooperation and service but also deliberately merged business and artistic con-

cerns in an attempt to create a new broad-minded business culture. *Fortune*, building on earlier business forays into functionalism, aristocratic high culture, and modernist art, argued that business could both create widespread material abundance and also nurture a genuine American culture. In so doing it aimed to convince businessmen and critics alike to imagine business as the central institution of the nation, and business managers as public-minded, professional leaders.

The Founding of Fortune

The greatest irony in *Fortune*'s history occurred in its opening moment. Just three days after Time Inc. announced the imminent publication of the plush business magazine, the stock market crashed. Historians and nostalgic staff members have noted this ready-made symbol, and declared *Fortune* a child of the Great Depression. But while the metaphor is admirable for its rhetorical power, it is deceptive as historical explanation. *Fortune* was conceived in an environment of persistent economic optimism, and for several years deemed the recession mildly uncomfortable but explicable, and certainly temporary. In the cold winter of 1929–30 Luce decided to publish the magazine on schedule, despite his admission that the "slump may last as long as one year." Even as unemployment mushroomed, banks closed, and the stock market failed to recover its losses, the magazine continued to operate under the belief that the U.S. economy had entered an extended age of prosperity. "Since the 1929 panic," Luce wrote in another venue in 1931, "various old style financial writers have had no end of sly sport sticking pins into the New Era theory. Because we did not make 5,600,000 automobiles in 1930 as we did in 1929, little significance is attached to the fact that we did make 3,500,000." Even in 1932 "New York in the Third Winter . . . of The Depression" remained dismissive of the need for any major changes, arguing that an out-of-towner could not even tell that the city was in the midst of a depression. The subheadline insisted that the routine had changed only slightly, and that the mood remained upbeat: "The *de luxe* speakeasy booms, the hotel languishes half empty . . . rents have come down, bridge lessons gone up, and the burlesque show flourishes. And life goes on." Until late 1932 the Depression seemed just a bump on the road to further progress. Because of this failure to recognize the depth of the Depression, *Fortune*'s pages in its first years represented the corporate liberal ideas associated with the booming twenties rather than the depressed thirties.[17]

Fortune, to be sure, was not alone in underestimating the Depression. The tendency of corporate liberals to overlook the seemingly short-term difficulties of 1930 and 1931 is best represented by the much-maligned re-action of Herbert Hoover to the crisis. Hoover had made his name in the first years of the century as a tremendously successful and profitable min-ing engineer. During the war he had increased his public renown as a bril-liant and efficient administrator, while serving as the director of relief ef-forts for Belgium and as the chief of the domestic Food Administration. Combining business enthusiasm and a penchant for scientific manage-ment with professional knowledge, internationalist ideals, and a humani-tarian spirit, Hoover was the ideal corporate liberal. As secretary of com-merce through the twenties, he had spent much of his energy promoting trade associations and preaching the benefits of "voluntary cooperation" and "associate individualism" to business audiences. Much more liberal in his approach to business than Calvin Coolidge, who had been an enthusi-astic proponent of a government that did as little as possible, Hoover's nomination for president in 1928 was even resisted by conservative business forces within the Republican Party.[18]

Once elected in 1928, Hoover remained true to his corporate liberal ideals in the face of a national crisis. Believing that business leaders were best equipped to lead the country out of the recession, he urged business not to cut wages in order to sustain consumer spending. Relying on volun-tarism in relief efforts as well as in the marketplace, he strongly resisted fed-eral contributions to state and local relief efforts. But the Depression deep-ened, and Hoover, blinded by a belief in the resiliency of the U.S. economy and his strongly held beliefs in self-reliance and voluntarism, was unable to gauge the depth of the collapse. Insistent, like Luce, in his economic opti-mism, and famously repeating that "no one has yet starved," Hoover seems not to have registered the disastrous consequences of the Crash. Within five months, unemployment had more than doubled to 3.2 million people and would reach 8 million by the end of 1931. More than 26,000 businesses failed in 1930, and 28,000 more in 1931. In the first two years of the Depres-sion more than 2,600 banks, representing some $2.5 billion in deposits, dis-appeared. This was no ordinary recession but the quickest, steepest drop in the history of the U.S. economy, and still Hoover turned to voluntarism. As state and local programs ran out of money, for instance, Hoover established the President's Organization on Unemployment Relief, headed by the cor-porate liberal executive Walter Gifford. But the committee did little more

than produce advertising campaigns urging citizens, as one ad put it, to "give as generously as you can to your local welfare and charity organizations." Depending still on associationalism in the marketplace, Hoover continued to work, as Robert McElvaine notes, to "use the government as a catalyst for voluntary cooperative action in the private sector." Hoover's corporate liberal faith in business leadership and in the strength of the New Era economy made the very real human suffering of the country invisible to him.[19]

Retaining a similarly blinding optimism, *Fortune* in the first years of the Depression ironically portrayed the enthusiastic idealism of New Era thought at its height. This fervor was embodied in a speech Luce delivered at the apex of the boom, in March 1929:

> Long since has business ceased to be a low and private and only regrettably necessary affair to be escaped when possible. Business is our life. It is the life of the artist, the clergyman, the philosopher, the doctor, because it determines the conditions and problems of life with which either artist or philosopher, let alone ordinary mortals, have to deal.

Fortune echoed this understanding of business. Business was not simply the base on which a superstructure of culture was built but the very center of American culture: "Business," as Luce argued, "is, essentially our civilization; for it is the essential characteristic of our time." By creating a magazine "about" business whose scope included almost all facets of American life, *Fortune* refused to confine business to the workplace, declaring that business structured U.S. society.[20]

In its first years the magazine articulated a historical narrative that explained the need for an increased public role for business. In its early years, the United States profited from the inventiveness and individualism of frontier capitalism. But the years after the turn of the century, *Fortune* insisted, had produced bewildering changes in the economy. "The truth," one essay averred, "is that the Industrial Revolution of a century ago and the Industrial Revolution of the contemporary world have no more in common than the springs of the Yellowstone River and that river's falls." These changes had been so severe that they had created a new set of relationships between government, business, workers, and the public, and indeed rendered the assumptions of unregulated capitalism obsolete. Having passed through the adolescent stage of rapid territorial expansion, U.S. business would have to grow up, and this maturity necessitated that business practice long-term planning and contribute to the public weal. "The day of pioneering is

over," explained AT&T executive Walter Gifford in 1926. "New conditions have called a new type of men to lead the new kind of business organization. . . . Instead of 'captains of industry,' the present requirement would seem to be 'statesmen of industry.'" Business would have to temper its selfishness with neighborliness, because private, selfish actions within an open market no longer served the public interest. In order to control the deleterious effects of industrial progress and to avoid unwanted government intervention, *Fortune* insisted that the wasteful and publicly irresponsible business practices of the first hundred years of the Industrial Revolution needed to be replaced by more efficient and socially beneficial planning. No longer an unorganized group of self-interested capitalists, business people needed to recognize their responsibility as public leaders.[21]

Depending like other corporate liberals on the statesmanship of business leaders, *Fortune* believed that voluntary measures such as business associations, corporate welfare, and employee representation plans should be the primary responses to the changes of the New Era. Worried about the inefficiencies of competition, for instance, *Fortune* argued that industrial cooperation in the form of trade associations would increase and stabilize the profits of its member businesses by ridding the market of competitive tactics such as price cutting. Indeed, increased cooperation, *Fortune* insisted, was not collusion but rather a sign of the evolutionary progress of the economy. "Cloak and Suit," for example, complained that the decentralized, "protozoan" organization of the women's garment industry, left it "without stability." The oil industry, another essay explained, was slightly more biologically advanced: it was "slowly emerging from that Neanderthal period of tooth-and-nail competition through which the railroads passed in the days of Hill and Harriman." The disappearance of competition signaled a more advanced species of manager. The latter essay claimed that Standard Oil's Walter Teagle, a leading spokesman for corporate liberalism, was "remarkable for his constant preaching, and practicing, of the doctrine of cooperation." This "novel" approach made Teagle a model of the "new" type of businessman: "Teagle is at present a phenomenon in the oil industry because he is more efficient than he is war-like, friendlier than he is hardboiled. In ten or twenty years, as the industry catches up with him, perhaps he will be less phenomenal." Maturity would inevitably convince other businessmen that cooperation provided more benefits than "tooth-and-nail competition."[22]

This celebration of cooperation indicated the magazine's tendencies toward corporatism. *Fortune* routinely defended monopolistic or oligopolis-

tic industries, arguing that large companies operated more efficiently and productively than small, tightly competitive ones, and produced more benefits for the public. A 1930 article on the Aluminum Company of America contended that the "radicals, alarmists and political opponents" who attacked the company's monopoly on aluminum production ignored its considerable technological advances and social beneficence. In fact, *Fortune* asserted, it was against the company's interests to shut down competitors or to bilk the public. A story on the Columbia and United utility companies further maintained that their recent merger held no danger for citizens. Instead, the merger reflected "the newer philosophy of industry": "union without conquest; amalgamation without destruction; a peaceful penetration with the lion and the tiger lying down together." Those wailing against business cooperation failed to understand the rules of the new economy.[23]

Voluntary measures, *Fortune* also insisted, promised to stabilize relations with employees. Corporate welfare programs aimed to increase worker loyalty as well as consumer wealth by providing services ranging from athletic facilities to stock ownership plans to retirement insurance. Corporate liberals maintained that these programs of "enlightened selfishness" would increase profitability and stability by improving employee relations, creating employee interest in the success of the company, and increasing consumer spending. In *Fortune*'s unprecedented three-part biography of Owen D. Young, whom the magazine described as "one of the first to evolve and articulate those conceptions of business which are now whole-heartedly shared by enlightened businessmen," *Fortune* glowingly described the unemployment insurance and profit-sharing programs of General Electric. The article affirmed the programs, arguing they were "far more rational than emotional" and had "amply justified [themselves] economically in the company's improved relations with its men." *Fortune* also engaged in its own corporate welfare. The profit-sharing program of Time Inc. even made some of its early staff members wealthy. As Dwight Macdonald, a *Fortune* writer later argued (resentfully), Luce felt that his workers "should trust [the corporation] to look out for your interests and see you get well taken care of."[24]

The focus on voluntary cooperation extended even to workers' right to representation. Recognizing the high costs of labor turnover and strikes, and fearing the loss of control threatened by the closed shop union, corporate liberals urged the creation of company unions and employee representation plans. These strategies, argued Bethlehem Steel's Charles Schwab,

provided "an unobstructed channel through which [employees' and managers'] unity of interest may be promoted." By instituting these plans and company unions, corporations hoped to increase worker loyalty and facilitate communication between workers and management without abdicating control over the workplace. But even outside unions were attractive to some corporate liberals. General Electric's president, Gerard Swope, contacted the American Federation of Labor (AFL) in 1926 in hopes that the large union might create a single union for the electrical industry, insisting that such a union would reduce management costs as well as guarantee "effective worker self-regulation and good behavior." (The conservative, crafts-based AFL, however, refused to consider industrial unionism.) *Fortune* affirmed corporate liberals' belief in the wisdom of encouraging employee representation. Several essays, for example, argued that unions had helped to control vicious competition in the garment industry by driving cheaper producers out of business. "No one," *Fortune* noted elsewhere, "not even the most old-fashioned of employers, would deny Labor's right to organize nor deny that often Labor's only bulwark against exploitation has been the union." Using the same combination of self-interested and moral argumentation that characterized much corporate liberal discourse, *Fortune* assented to labor's right to representation.[25]

The argument that business could stabilize competition and expand consumer markets through self-regulation rather than government intrusion, of course, depended on the increased public leadership capabilities of managers. Developing these abilities became a central concern of *Fortune*. But because service and cooperation were voluntary, it was crucial that a majority of managers invest themselves in these values if they were to have a significant effect on market behavior. These corporate liberal values had to become, in short, the core of a widely practiced business ethics. But corporate liberals received resistance from unbelievers. To convert business people to their faith, they proselytized often, and, as a result, the rhetoric of service and cooperation quickly became a cliché. But H. A. Overstreet, like the apostle Paul, preached that the saved must accept the inconvenience of living among those still finding their way:

> Despite the irritation I feel when I hear the much overused word "service" employed, I should be inclined to say that a very appreciable change in attitude is to be noted among business men. There is a certain psychological significance about this widespread use—even abuse—of the word "service," which needs to be noted. Let a man use a word fre-

quently enough and it will begin to get beneath his skin, even if it gets on the nerves of the rest of us. He begins to be "conditioned" by the word. He cannot thereafter quite ignore it. It becomes to an extent a part of his thinking. This, I believe, is what is happening among business men today.

Corporate liberals like Overstreet hoped to create a business atmosphere in which managers' adherence to service ethics was as habitual as an "Amen!" at a Methodist revival. *Fortune* adopted this attempt to improve the moral mood of business. But not satisfied to witness in the woods, the magazine imagined itself as an elegant cathedral that would both inspire and influence. By displaying a business culture that was both sophisticated and magnanimous, the magazine cultivated a gentlemanly culture that offered social status while demanding social responsibility. If the entire business community accepted this role as the leader of industrial civilization, *Fortune* argued, its acclaim and authority would match that of the medieval Catholic Church.[26]

Nurturing a Gentlemanly Business Culture

In a 1930 speech, entitled "Aristocracy and Motives," Henry Luce worried about the lack of motivation among the highly educated, managerial new middle class. "For the first time in the world's history we have a nation of 120 million people who have enough to live *on,* and for the first time in the world's history the best of those 120 million cannot find enough to live *for.*" Citing the "energetic Harvard man" and the "ablest seniors at Harvard or Yale," Luce clearly addressed the professional managerial class. "We are discussing not Napoleon," he explained. "We are discussing the marshal's baton which he placed in 10,000 if not a million soldier's knapsacks." The outlook for these officers was not encouraging. The "pure" aims of adversary professionals and artists—causes such as public health or education or art for art's sake—failed because "it is naive to assume that altruism can be the dominating motive in the lives of the majority of able and energetic men." Profit-seeking, however, offered no answer: "[Can] our best young men look forward to nothing except making money and having fun?" Luce's description of the United States sounded much like that of another critic grounded in the professional managerial class, Van Wyck Brooks: the nation, torn between uninspired practicality and cold idealism, offered

little opportunity for the fulfillment of the whole person. On the one side was the money and empty leisure of the businessman. On the other, the impossible goals of artistic and professional purity. Both Brooks and Luce searched for a motive that would merge these worlds into one.[27]

But whereas Brooks looked to socialism for a solution, Luce turned to the elite coalition of corporate liberalism. Raised in a missionary family in China, educated at Yale, and trained as a journalist, Luce was as much a professional as a businessman. In fact, he did not always believe that business was necessarily a positive institution. But he saw in business the possibility of a space for young, educated men to flourish as an essential part of the governing coalition in the United States. "The aristocratic principle," he argued, "may be recreated in America through what has always marched under the nicely middle-class name of business." The higher ethical standards of corporate liberals were particularly encouraging. "We are beginning to distinguish a little," he applauded, "between a man's importance to business and the amount of money he gets out of business." If business would more strongly stress the noble crusades in which it was already invested—"the cause of science, the cause of health, the cause of an efficient distribution of wealth"—it could serve as the aristocracy that the United States so badly needed. The corporate liberal coalition between businessmen and professionals offered the chance at the material gain, public status, and individual competition that both single-minded business and altruistic professions had failed to provide.[28]

In reconciling the power of the business community with the social ideals of the professional class, Luce and other corporate liberals proposed to a powerful but anxious group of professionals and managers a new way to imagine their place in American society. And as "Aristocracy and Motives" suggests, this reimagining was not intended only as a public relations move. Indeed, *Fortune* might fruitfully be seen as an extended product of Luce's dissatisfaction with the place of the professional class within a society in the process of restructuring itself: his hopes for an enlightened business culture grew at least partially out of a desire to see business show itself as a respectable site for professional ambition. Happily, however, Luce's concern that business provide a proving ground for talented young professionals dovetailed with his political hope that business would recognize its public responsibilities. The two worries offered to solve each other. On the one hand, if young educated men aspired to a career in business, then those same young educated men would have the opportunity to reform business.

On the other hand, if business reconceived its mission in socially responsible terms, then it would become an attractive career choice for talented professionals. The transformation of business would satisfy both professionals' search for purpose and the need for large corporations to recognize their increasingly public status.

In suggesting that the New Era was an opportunity for a reconception of business managers' self-identity, Luce imagined a corporate liberalism that entailed a great deal more than welfare capitalism and business associationalism. Instead, it was an attempt to cultivate a business environment that would reproduce in future generations the socially responsible ideals of corporate liberals, just as professional culture reproduced its autonomous ideals and the aristocracy passed down its noblesse oblige. For this reason, *Fortune* in the early thirties did more than simply ask individual business managers to change their commercial habits. It also sought to nurture a comprehensive gentlemanly business culture.

The magazine's strategy for doing this followed in part the path of corporate liberal organizing strategies in the twenties. For instance, *Fortune* accessed the same two models for a broad-minded culture: socially responsible professionalism and paternalistic aristocracy. The rhetoric of professionalism was particularly important, both inside and outside the magazine, as many corporate liberal businessmen were themselves professionals. The growth of the professional class was a central characteristic of American organized capitalism. Indeed, the influx of professionally trained managers into business was significant enough by 1930 that dividing corporate liberals into businessmen and professionals is impossible: most of them were both. Du Pont, for example, a pioneering firm in terms of corporate organization (despite the conservative politics of its owners), encouraged interaction between its managerial staff and its researchers, most of whom by 1920 had Ph.D.s. The result, as Olivier Zunz argues, was that by 1919 "many of these young graduates with engineering degrees . . . were running the organization." And while other organizations such as Ford depended significantly less on higher education in its selection of managers, market demands would force even Ford in the twenties and thirties to accept the importance of such emerging professions as public relations and personnel management. *Fortune* wholeheartedly supported this change. Criticizing the management of the aviation industry, for example, the magazine declared that the industry needed "fewer stockjobbers, pilots, and promoters in its management" and more skilled professionals. Organized capitalism in the United States took much

of its character from the intense interaction between capitalists and professionals.[29]

The importance of the flow of professional managers into business lay in the socially responsible ideals inculcated by the professional community. Professional values—rationality, an interest in the public weal, community responsibility, and scientific objectivity—formed the character of the most enthusiastic corporate liberals. *Fortune's* Henry Luce, for example, was deeply affected by a childhood spent in China as a missionary's son. The advertiser Bruce Barton, too, was heavily influenced by the social gospel of his father, a prominent Congregationalist minister. Other prominent corporate liberals expressed their attraction to the professional ideals of reform and public service as young adults: Gerard Swope came face to face with the nation's poverty as an instructor at Jane Addam's Hull House, and Owen Young, in his law school commencement address, entitled "Professional Honor," called for a higher degree of integrity and public service among lawyers. Not only did managers' professional training teach them to take a stronger interest in stability and the long-term health of the company, but their professional aspirations pushed them to justify their work in terms of the public weal. Corporate liberals' membership in a professional community led them to attempt to infuse business with a stronger moral purpose than profit alone.[30]

The increasingly influential presence of professional managerial class members encouraged corporate liberals to portray business culture in the language of professionalism. Julius Klein, a commerce expert in Herbert Hoover's administration, noted a change in business from a "general 'public-be-damned' attitude" to the outlook of a "profession which took its place with equal dignity and self-respect beside the law, medicine and the ministry." Similarly, Owen Young argued in 1927 that business "must assume the obligations of a profession." Echoing Luce's "Aristocracy and Motives," Walter Gifford of AT&T insisted that this professionalization of business created an arena in which the "best men" could compete for the good of the American progress as well as their own glory:

A profession is an occupation conducted on a high plane by a trained intellect having a special consideration for the public welfare. In this I class the profession of modern business management. And I would class it as the foremost American profession, for it is the profession directing the main stream of the energies of the nation. . . . I believe it to be the

profession which holds the highest intellectual challenge to men of
brains and a liberal education and the greatest opportunity for men of
constructive capacity.

The corporate liberal businessman, in combining the energy and centrality
of business with a "trained intellect" and "consideration for public welfare,"
redefined himself as a professional.[31]

But while the importance of professional roots and ideals was crucial to
corporate liberal self-identity, it was not the only key influence. Just as pro-
fessionals in the early twentieth century placed themselves above the self-
interest of the marketplace, so had the aristocracy imagined itself as in-
dependent of commercial concerns, and thus free to act in the public
interest. And although the connections are not as sustained as those with
the professional class, corporate liberalism does have some roots in the
American upper class. Seymour Lipset, for example, argues that a paternal-
istic liberalism of the Progressive Era grew out of "the established upper
class and sophisticated corporate wealth" as well as "college-educated
men," and William Dumhoff also locates the core of the "business liberal-
ism" of the twenties and thirties in the upper class.[32]

More important to corporate liberals than these biographical connec-
tions, however, was the metaphorical use of "aristocracy." Aristocracy, first
of all, represented a unified class of talented, admired, and powerful citi-
zens. The "aristocracy of worth," as Luce called it, or the "aristocracy of
skill," as a *Fortune* essay on fly-fishing dubbed it, represented a community
that had demonstrated its leadership skills in a fair, honorable competition.
Such an aristocracy would provide a site for the ambitions and talents of the
young, educated professionals. But following in the tradition of noblesse
oblige, the membership of an aristocracy also required a broad vision and a
dedication to the public weal. Corporate liberals adopted this claim to
broadmindedness as well as a paternalistic sense of obligation. "The best
upper class men in business," the banker Charles Cason noted, "are really
genuine in their belief in [service] and are consistent in its practice." Luce's
neologism "tycoon" originally referred to the Japanese aristocracy, and for
Fortune it expressed not only "the desire to manage and the ability to man-
age efficiently" but a "vision . . . not limited by the confines of any single
corporation." Providing a model for both ambition and social responsibility,
"the aristocracy of worth" joined the professionalism as a key source of cor-
porate liberal self-identification.[33]

Fortune followed corporate liberals of the twenties in using these two discourses to encourage conservative business people to adopt the enlightened behavior of the New Era. In selling corporate liberal business culture, however, the magazine stressed the very subject that professionals and aristocrats used to separate themselves from business: the magazine turned to art and Culture to make its case. In asserting an intimate connection between art and business, *Fortune* not only rejected a key marker of business's single-mindedness but hoped to improve business behavior on both the individual and social levels. As I have argued, a connection to art signaled the higher social status of both professionals and aristocrats. But in addition to separating them from commercial concerns, many professional and aristocratic critics believed that Culture helped them to cultivate a depth of character unavailable to businessmen. For professionals, for example, aesthetic appreciation symbolized the moral capacity and personal depth that separated their class from the capitalist and working classes. The nineteenth-century ideal of "character," which in its focus on autonomy, training, and self-abnegation had clear affinities to the "true professional ideal," was almost synonymous with cultural cultivation. But professionals in the twentieth century continued this association. An appreciation of culture, they claimed, not only provided enjoyment but also inculcated a long-term perspective, rational thinking, and objective judgment. Recognizing that material gain had to be balanced against the values of beauty, community, and comfort, students of culture supposedly developed a sense of a broader social landscape and of public responsibility.[34]

Fortune adopted this belief in the ameliorative effects of a generalist education. A better understanding of art, Luce believed, would improve the character of individual business managers. Luce ended "Aristocracy and Motives" with a quote from Edmund Burke. The aristocrat, Burke wrote, must be able "to have leisure to read, to reflect, to converse" and "to stand upon such elevated ground as to be enabled to take a large view of the widespread and infinitely diversified combinations of men and affairs in a large society." Aristocrats not only had to be honest, ambitious, and talented but reflective and thoughtful as well. To them, long-term goals had to carry more weight than immediate problems. Finally, aristocrats had to have a vision of the whole and an appreciation of ultimate aims. A strong liberal education, not a technical specialist's training, would provide business gentlemen with the intellectual tools necessary to lead effectively in modern society. Luce's conception of the tycoon relied similarly on increased cul-

tural knowledge. Public leaders needed to be tasteful, charismatic, publicly impressive, educated, and far-sighted: an appreciation and understanding of art, Luce felt, would cultivate each of these qualities. To better serve their role as public leaders, they would have to develop their education by "taking in a few less leg shows and a little more literature." "Cultivated citizen[s] of the world," tycoons would be more open to "artistic suggestions" and consequently would avoid the "grosser crudities of the present industrial scene."[35]

To encourage the acquisition of cultural skills, *Fortune* filled its pages with literary writing, generalist knowledge, and reproductions of art. Simply by reading *Fortune*, business readers would gain an elementary education, and perhaps a curiosity, in the artifacts of Culture. The magazine's attempt to nurture a sophisticated business culture reveals itself most fully in its discourse of collection and connoisseurship. Collecting had long been a primary cultural outlet for businesspeople. Nineteenth-century New England merchants like John Murray Forbes and Philip Hone had been benefactors of early American art. Gilded Age magnates like J. P. Morgan had gained aristocratic distinction from their collections. As I have argued, however, such philanthropy gained its prominence largely because it demonstrated the collectors' distance from the commercial sphere, rather than his submersion in it. Furthermore, by the 1920s collecting and connoisseurship had largely lost their appeal to business people, particularly those without inordinate leisure or funds. The historian Richard Hofstadter notes, for example, the increasing disdain among businesspeople for art after the turn of the century: "The more thoroughly business dominated American society, the less it felt the need to justify its existence by reference to values outside its own domain."[36]

But *Fortune* had a new use for collecting. Corporate liberals did not need to justify business's *existence*, but they did need to justify its claims to leadership and improve the qualities of that leadership. By renewing business interest in collecting, *Fortune* hoped to achieve both these aims. In its first three years, *Fortune* published nine major articles on collecting, addressing subjects such as books, Ming vases, jade, emeralds, and lace, as well as several more essays on the connoisseurship of wine and food. While the articles discussed average and extraordinary prices and the history of the market, they never explored in detail the economics of producers or dealers: in a magazine usually written for producers, these stories were unquestionably directed at the consumer. The magazine aimed to revive business interest in collecting both by demonstrating the opportunity it provided for

status and by giving basic instructions on how to collect. These essays offered an introductory knowledge of the subject and actively encouraged the reader to begin collecting. The author of "Maksoud of Kashan and Mrs. McCormick of Chicago," on Persian rugs, for example, aimed "to work his own enthusiasm into his description of the object and impart a kind of contagious eagerness to the run of his words," and full-page color reproductions of rugs sought to generate a similar enthusiasm. Newly exposed to this beauty, readers would aspire to join the aristocracy that truly appreciated great art: Edith McCormick, J. P. Morgan, John Rockefeller, and Elbert Gary, for instance, were all listed as major collectors of rugs.[37]

By instilling in businesspeople an enthusiasm for collecting, *Fortune* hoped to replace the single-minded materialism of old-style capitalists with two new characteristics: a generalist approach and an appreciation of non-material "value." Admiration of generalist knowledge suffused *Fortune*. The magazine constantly praised artists who combined aesthetic skills with business ability, and celebrated business managers who had begun their careers as lawyers or engineers. The magazine deliberately crossed boundaries in order to demystify specialist knowledge: "Sand into Glass," for instance, opened by explaining what glass was in the varying terms of the chemist, the artisan, the layman, and the workman. A caption in another essay marveled, "Little would the debutante, on whose shoulder this orchid might be pinned, suspect that it is a cross of Mossiae and Warscewiczii, that its full name is Enid Cattleya." The world was a complex web sectioned off into artificial compartments, and *Fortune* loved to show how those compartments were connected. To further instill generalist knowledge, *Fortune* taught its readers about the intricate processes of modern industry, economics, and technology. A series of photos might explain a serpentine mass production process, or an article might describe how an autogiro flew, how the stock market worked, or how a diamond was cut. "Most Americans are familiar with silhouettes of famous [skyscrapers]," opened one piece, "And if the crowds around the cellar holes are to be trusted, most Americans have also a lingering interest in the uses of dynamite and the facility of an Italian with a wheelbarrow. But the number of Americans who have any conception of the problems involved in the construction of these walls is not so great." *Fortune* imparted its "contagious enthusiasm" to readers by explaining technical, esoteric, or complex issues in layperson's language.[38]

But business managers displayed their broadmindedness most clearly by cultivating their cultural tastes. An interest in literature, painting, and fine food revealed a personal depth not normally developed by business activi-

EARLY 16th CENTURY MEDALLION CARPET FROM NORTH-
WEST PERSIA.—This is one of the great rugs of the world. Only two
or three carpets of this type are known to exist: one in the Metropolitan
Museum in New York. Bought in 1910 for less than $20,000, the Metro-
politan could conservatively estimate the present value of this piece at
from five to ten times that sum. [*Complete design on page 46.*]

Detail of Persian rug, early-sixteenth-century medallion carpet, Fortune 2 *(October
1930): 47. The article "Maksoud of Kashan and Mrs. McCormick of Chicago" included
not only a number of large photographs of Persian rugs, such as the one shown here,
but also a separate portfolio of full-page, color photographs.* Fortune *encouraged its
readers to think of such portfolios as works of art in themselves, and indeed to think of
the magazine itself as a permanent addition to a library. Advertisements soon appeared
in the magazine offering to bind a subscriber's back issues. Reproduced with the
permission of the Metropolitan Museum of Art, Frederick C. Hewitt Fund, 1910
(10.61.3). Text and page layout © 1932 Time Inc. All rights reserved.*

ties. Artistic acquisition, one essay explained, created an "incommensurably rich life": "To have seen the rare precious things that man has made is a remembered experience; to own an El Greco or a Goya, a room of Gobelins, a library of first editions or a brace of rubies, a collection of lace, china, old glass, antique furniture or armor, a few casks of amontillado and a cellar full of fine clarets—that would be more than an experience; that would be an adventure." Collecting offered business people a chance to expand their experiences beyond the world of business, and *Fortune* implored them to accept it. Fortunately such depth often coincided with business success, as an essay on wine demonstrated:

> [America's] substantial people have immense respect for the man of wealth who adds to his business acumen and his flair for sport a knowledge of the niceties of wine. Indeed no other hobby of the business man is so definitely and quietly aristocratic. The small banker does not know whether Chateau d'Yquem is red or white (or indeed whether it is a wine), but he knows that the great banker does.

In J. P. Morgan, claimed another piece, collecting had forged a "certain union of pecuniary sagacity and educated refinement which was scarcely to be found in any other part of society." By expanding the number of business managers who displayed this type of generalist acumen, *Fortune* hoped to decrease both the appearance and reality of single-minded business behavior.[39]

The business gentleman would also be able to differentiate price from value. A preoccupation with price, an article on precious gems warned, demonstrated one's lack of depth. "Diamond Jim" Brady, for example, a railroad tycoon who thirty years earlier had been known to parade around the Waldorf-Astoria Hotel in New York City, had been an "impressive figure." He had "wanted to shine," and for that purpose he had chosen the correct stone. Unfortunately, Brady was now "remembered as a travesty of taste." Eating fish with an especially rich sauce, Brady had once commented, "That's so good that I could eat it on a Turkish towel." Only a man with such a crude, immodest appetite would outfit himself only in diamonds. Instead, *Fortune* encouraged its readers to seek a more restrained and elegant beauty. While the diamond was certainly more expensive, the article countered, "from the standpoint of *value*, the lordly diamond must yield to the colored gems." *Fortune* further separated price from value by indicating the capricious, feminine nature of price fluctuations. On the one hand, the quick shifts in the price of rare objects were comparable to the er-

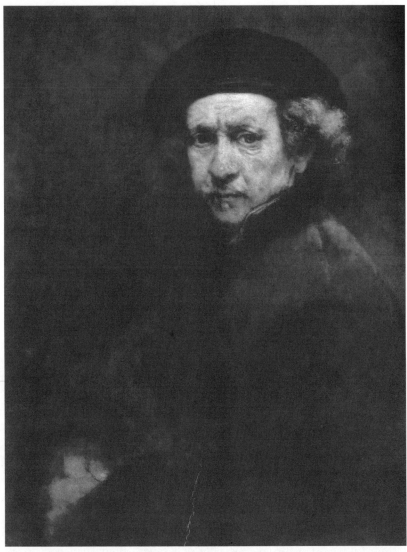

Rembrandt van Rijn, Self-Portrait, Fortune *3 (April 1931): 40. Paintings such as the one shown here lent* Fortune *an air of luxury and also reinforced a sense of the personal depth and social status that might be acquired through collecting. Reproduced on a full page, with the simple caption "Self Portrait—Rembrandt, From the Collection of Andrew W. Mellon, Washington D.C.," this image did not even accompany a major article. A note on "Certified Rembrandts" in the front pages of the magazine, however, did list a number of Rembrandt owners, most of whom were, like Mellon, prestigious businessmen, and also briefly discussed the process of certification. Image © Board of Trustees, National Gallery of Art, Washington, D.C.*

ratic consumer trends that *Fortune* bemoaned in its discussions of the women's fashion industry. On the other hand, the intrinsic beauty of the collector's objects, like men's garments, were more stable and dependable. It was not women's vanity, a desire to outdo a neighbor, or a wish to be on the cutting edge of fashion that drove serious collectors: it was the pursuit of beauty. Just as long-term planning and investment was superior to the money-grubbing of the speculator, the stable value of a collectible piece meant more than its fluctuating price.[40]

Selling a Business Modernism

If business managers acquired an appreciation of fine art and a liberal education, *Fortune* argued, they would mature into the aristocracy of business demanded by the new economy. But in attempting to convince businesspeople to pursue a cultural education, the magazine took on a difficult task. The exclusiveness of the cultural realm effectively made the layperson incompetent. Since few businesspeople had any significant literary training or the leisure time of the very rich, the inaccessible sacredness of Culture left them insecure and defensive in the face of high art. Sensing that his mind is not as sharp or pure as that of the professional, *Fortune* lamented, the businessman "suffers from an inferiority complex, which, fortunately, he will outgrow."[41]

To convince business readers to develop a generalist education, and thus invest themselves in corporate liberalism, *Fortune* displayed to its readers the increased status available through the gentlemanly business culture. As already noted, advertisers in the twenties had moved away from logical argument in their ads towards impressionist, symbolic suggestion. *Fortune* learned a great deal from these artistic advertisers. Like them, *Fortune* linked a mundane idea—in this case, business—with the aura of a more glamorous one—Culture. The magazine, far from merely reporting on news of the business world, sought to convince its readers that its vision of the enlightened business manager was worth buying: it was an advertisement for a reformed, sophisticated business culture. *The Christian Science Monitor* recognized this in its 1930 review of the new magazine: "Trailing the romance of big business they have not hesitated to follow the path of those who have something to sell. . . . The job has needed doing, for beauty and the business man have been strangers too long." It is fitting that *Fortune*, which learned so much from advertisers, including the use of color, photography, "modernistic" illustration, and later, in the thirties, social sci-

entific surveying, would adopt this symbolic style of presentation to improve the social standing of business.[42]

The selling of the gentlemanly business culture began with the physical object of the magazine. The art director Thomas Cleland, who before and after his stint at *Fortune* was an advertising designer, designed the magazine as an assertion of the aesthetic superiority that the wealth of business could provide. In addition to its unusual size and quality, the magazine outstripped any other magazine of the day in its use of color; further, its use of full-page reproductions of photographs and paintings was extravagant. But more important than this display of status, *Fortune* sought to ease business readers' anxieties about art by demonstrating that Culture was not antagonistic toward their values and interests. The magazine offered businesspeople art that was neither aristocratically anticommercial nor professionally exclusive. Instead, it stressed experience, objectivity, and pragmatism—the values of business—and did so in opposition both to what Luce called the "insignificant snobberies" of outmoded aristocracy and to the intellectualism and self-seclusion of professional critics. To remake culture for corporate liberal uses, *Fortune* wrested it from those who insisted that it could only exist away from the corruptions and commodification of everyday life. In selling art to the business community, the magazine insisted on the masculinity, modernity, and economic practicality of collecting and of connoisseurship.[43]

First, *Fortune* had to establish art as a masculine pursuit. Apparently separated from the masculine public sphere, art was often seen in the early twentieth century as part of what Brooks called the "largely feminine" world of the "cultivated public." Artists themselves, as Susan Burns argues, were often represented as flighty, eccentric, and emotional, and turn-of-the-century art critics even worried that art for art's sake aestheticism could "degenerate" into immorality and homosexuality. But *Fortune* rejected the idea that art had to be feminine. On the one hand, the magazine dismissed both the excessive innovation of the self-proclaimed avant-garde, which tended to be "emasculated by thought," and the lack of innovation in academic and Victorian art, which had devolved into "paint pots and frothy fantasies." The magazine insisted, on the other hand, that between these extremes lay a genuine American art that had discarded its feminine tendencies and embraced the masculine world of business.[44]

Working to redefine art as masculine, *Fortune* stressed the technical skill needed to create it. To position themselves more prominently in a business-dominated society, Burns explains, practical artists and art schools in the

early years of the century stressed technical competence, collaborative work, and professional organization in order to demonstrate their similarities to the masculine business world. The technical artist, as one illustrator insisted, was more of-the-world than the fine artist: "[Fine artists] are aesthetic, rich in sentiment and poetic feeling, with an honest love of nature," this illustrator acknowledged, "but they are not virile, and, as a rule, do not know their business." The self-conception of advertisers, illustrators, and journalists as more masculine than their pure art fellows persisted into the twenties and early thirties, and *Fortune* adopted this tradition. The work of craftsmen better matched the masculine business ethic with which the magazine's readers identified, and in its collecting essays *Fortune* focused almost entirely on craft arts rather than fine art. Of the six major collecting articles in the first two years of publication (on Rembrandt, Ming arts, jade, Persian rugs, precious gems, and emeralds), five report on products that were collaboratively made, largely conventional in form, and/or anonymously produced. Disregarding the language of aestheticism—genius, influence, and inspiration—the magazine discussed convention, material, collecting history and market value. The essay on jade noted that "to the European, the carving of jade, sensitive though it may be, has always seemed to lack something of artistic integrity. For the material, not the craftsman, is master." But *Fortune* rejected this European judgment and praised the anonymous jade craft workers who "never blew their own trumpets and are not known." Modern exemplars of this masculine craft ethic were the artistic models for *Fortune*, and the magazine insisted that the businessman would be surprised to learn that the contemporary designer or commercial artist was often no "'long-haired artist,' but rather a conventional enough looking gentleman who displays as keen an interest in sales figures as in line and color values."[45]

Furthermore, *Fortune* stressed a business art free of feminine decoration. "The Executive and His Office" declared that what the home was to the woman, the office was to the man. And whereas in years past this meant that the home had been decorated more attractively, in recent years the "office may be in better taste than his house." The "simpler and more vigorous" lines of the skyscraper had inspired a business aesthetic of "greater cleanliness, better air and light, and light, more restful design," and this aesthetic had been successful enough to warrant including a model of a modern business office in the Metropolitan Museum of Art. This masculine aesthetic dominated the magazine's collectibles as well. The subtlety of the colored gems improved on the faddish and ostentatious sparkle of the dia-

mond. The design of great Persian rugs was "clear, pure, compressed." And Ming vases had a "ruggedness of technique" which disappeared in later centuries as "workmanship became finer, more perfect, degenerated at last into the baroque and rococo." By stressing the work of craftsmen over that of individual artists and the "vigorous," clean lines of good design, *Fortune* deliberately worked to assure its reader that there was no danger of degeneration in the development of artistic tastes.[46]

Second, *Fortune* insisted that art and culture were not dusty remnants of the past but vibrant parts of the modern world. Both aristocratic elitism and academicism of the early twentieth century looked to the past for inspiration. Indeed, the very act of collecting suggests a nostalgia for the past. Walter Benjamin in "Unpacking My Library" wrote that the "collector's deepest desire" was to "renew the old world." Collecting and connoisseurship in *Fortune*, however, were presented as modern. In "Wine," *Fortune* explored the vineyards of France, and marveled at the modernity of the traditional art of wine-making. Noting the glass pipes and machinery through which the wine traveled in the production process, the article exclaimed "even to this highest altar in the temple of Bacchus the machine age has come!" Part of *Fortune*'s appreciation of the craft of wine making and the joy of connoisseurship was a recognition that the wine came from an industry that was not traditional or a refuge of preindustrial society but an enthusiastic participant in modernization. Even a story on the art of Ming China proclaimed that the prodigious production of the ancient pottery town Ching-te Chen "would satisfy many a modern executive."[47]

On the individual level, too, the connoisseur was a modern. A story about the menu at the main banquet of the London Naval Conference in 1930 introduced the reader to the "man behind the wine," George Reeves-Smith. *Fortune* lovingly described the meal as a boldly but tastefully planned affair, but Reeves-Smith was not an aristocratic connoisseur. Instead, he was a professional, a skilled engineer, and a businessman. He simultaneously managed three large hotels in the London area, and did so not only expertly but actively. *Fortune* described one of his hotels, Claridge's, as "one of the bulwarks which British aristocracy expects to find always ready to be leaned upon," but Reeves-Smith had redesigned even this in the "most striking and advanced art moderne." Finally, when he traveled to New York, he "reveled with unashamed delight in the speed welter of New York." He was, essentially "a business man whose fortune has been built on the taste buds of his tongue." Like Reeves-Smith, the *Fortune* con-

noisseur embraced the mechanization, speed, and size of the modern world.[48]

Finally, *Fortune* insisted that collecting could be financially rewarding. The work of art has often been deliberately separated from markets and commodification. While collectors cherish the uniqueness of an object, the responsibility of its preservation, and its transcendent beauty, the collectible's commodity status has been largely repressed as an irrelevant and unfortunate necessity. Walter Benjamin portrayed the collector as an individual nostalgic for intimate relationships with objects instead of alienated relationships dominated by the exchange value of commodities. The collector, he argued, frees the collectible object by taking it out of commodity circulation. But *Fortune* rejected the anticommercialism inherent in this understanding of collecting. Instead, it celebrated the position of the collectible object within a larger commodity market. Rather than imagining the collector's object as a "priceless" treasure, *Fortune* gladly equated it with other items on the market and blurred the lines between art and business. Art, no less than any other commodity, was caught up in the web of a business-centered world. "Rembrandt's Painting of Solomon's Mother," for instance, began by noting in the subheadline that "in less than two centuries its value has increased 2,000 per cent." The story examined the ownership history of the painting in order to understand "the markedly human process by which man gradually invests those objects whose great value is indefinable with a value which he can appreciate and compute, money value." Of the six major collecting articles in the magazine's first two years, four discussed, in detail, not just the prices of the objects (all six did that), but also the process of valuation through which prices were determined. To further reassure readers that collecting was a business decision as well as a hobby, the collection articles would list the most successful and expert collectors in an area, many of whom were successful and recognizable businessmen. *Fortune* insisted that knowing the difference between an original Ming vase and an imitation did more than make you cultured: it made you money.[49]

Through its discourse on connoisseurship, *Fortune* aimed to draw its readers into a gentlemanly business culture, both by demonstrating the status of the broad-minded aristocrat and by cultivating in its readers a character-building generalist education. But this attempt to create an aristocracy of business was only one aspect of *Fortune*'s cultural discourse in the early thirties. The corporate liberal rhetoric of aristocracy was accompanied by

persistent references to professionalism. But because many of the managers in the business community of the twenties had connections to the professional managerial class, *Fortune*'s relationship to professionalism was more complicated than its largely metaphorical celebration of a modern aristocracy. As I argue in the next chapter, in proposing an elite coalition between corporate capitalists and professionals, the magazine entered a struggle over the proper social role of the professional class. Describing the benefits of entering the corporate world for both professional managers and artists, *Fortune* not only sought to pull its readers into a corporate liberal business culture but to define the identity and ambitions of the professional managerial class.

THE CONTEST OVER PROFESSIONAL IDENTITY

A short time after a portrait of the *New Yorker* appeared in *Fortune* in 1934, an enigmatic statement in the *New Yorker* signaled the beginning of a public feud between the two magazines. "The editor of *Fortune*," E. B. White wrote in the Comment section, "gets $30–a-week and carfare." The conflict would reach its acme two years later, with the *New Yorker*'s publication of Wolcott Gibbs's stinging biographical essay on Luce. But on reading *Fortune*'s essay, the source of the antagonism is, at least initially, as unclear as White's return volley. Generally positive, the essay acknowledged the wit and eloquence of White and James Thurber, and praised the editor Harold Ross as a genius. Ross, *Fortune* acknowledged, though a bewildering and unorganized man, had an "amazingly right instinct . . . for detecting what is phony" and his "judgment of values, of importance, of timeliness, of effectiveness [was] exceptional to the point of brilliance." He had recognized a great publishing opportunity and made it work. The *New Yorker*, *Fortune* concluded, was a "*good* magazine."[1]

But this applause jarred on the ears of the *New Yorker* staff. The writers and editors prided themselves, as did many American writers and artists, on their distance from the commercial sphere, and *Fortune* had deliberately praised the *New Yorker* in ways that offended this artistic sensibility. Rather than focusing on the *New Yorker*'s literary excellence, *Fortune* had celebrated its "commercially stable formula." Ross's most impressive innovation, the magazine insisted, had been his recognition that a small, elite, urban audience would make his advertising space extremely valuable: "To the Manhattan department store, to the impresario of a new fad, whether in low-heeled shoes or high-priced liquor, *The New Yorker* is a boon and a blessing and has been ever since a few months after it was founded in 1925." Even the strange

opening sentence of the essay bitingly suggested that the magazine was more a commercial scheme than an artistic endeavor: "Harold Ross's father was not a Mormon. But his uncle joined the Church to get trade for his Salt Lake City grocery store." Demonstrating the magazine's success in a commercial realm it claimed to ignore, *Fortune* even published staff members' impressive (and exaggerated, the *New Yorker* claimed) salaries. White's funny, if childish, one-line reply acknowledged this insinuation of hypocrisy, and returned the insult. Better, White effectively rejoined, to be a high-paid sellout than a low-paid one. *Fortune's* tribute to the *New Yorker* as a brilliant financial scheme was a back-handed compliment to a staff that purported to maintain an artistic distance from commercial affairs.[2]

The feud between *Fortune* and the *New Yorker* developed from more than a simple conflict of personalities. The friction, in fact, mirrored a larger struggle within the professional managerial class. The staffs and audiences of both magazines came from the same segment of American society, but their understandings of their place in that society were strongly opposed. Both staffs, for instance, hailed largely from midwestern, middle-class families and from prominent universities. As Harold Ross acknowledged, there was even "a considerable duplication of writing talent" between the two magazines. Furthermore, while both claimed to be addressing an elite readership (corporate executives and New York society), neither staff had significant personal connections to those elite groups, and their successes grew from their ability to attract a wider audience. The *New Yorker*, notes Mary Corey, attracted "a new class of cosmopolitans" who had recently moved to urban centers, and half of its 125,000 subscribers in 1934 lived outside New York City. Similarly *Fortune* had gained a much wider audience than it had originally hoped for. By 1935 the magazine had more than tripled its initial circulation goal of 30,000, and three years later its advertisements claimed that, while 130,000 individuals subscribed to the magazine, an incredible (and probably overestimated) two million people read it. Originally imagined as magazines for a select elite, the readerships of the two magazines—like their staffs—actually were composed of aspiring members of the professional managerial class.[3]

But despite these similarities, the focus and tone of the magazines were radically different. Whereas *Fortune* prided itself on recording the history of the "largest planet" of the modern solar system, the *New Yorker* was apolitical and whimsical. Whereas *Fortune's* talented staff toiled in anonymity, the *New Yorker's* James Thurber and E. B. White were, to borrow the name of Thurber's weekly column, the talk of the town. Each staff had its own alba-

tross as well. *Fortune* staff members, on the one hand, suffered the exclamations of their friends, who asked the *Time* reporter Robert Griffith, "How *could* you go to work for Luce?"; or worse, the silence described by the writer Dwight Macdonald: "Nobody bothered talking about 'selling out' while I was on *Fortune*—you don't talk about rope in the house of the hanged." The *New Yorker* staff, on the other hand, attracted accusations of dilettantism. Afraid of being described as "fairies slapping at wrists," *Fortune* taunted, the editors were "extremely sensitive" about the word "whimsey." In other articles, *Fortune* gleefully charged the *New Yorker* with effeminate irrelevancy, jabbing that its "paths were not those of reality," and scoffing that it pursued its "brave, and bravely accomplished, assignment of keeping the smart woman up to date on smartness—books and ballets, wisecracks and hats." To the *New Yorker* staff, *Fortune* writers had sold their talent to an anonymous corporate juggernaut; to *Fortune* workers, the *New Yorker* staff had relinquished its real responsibilities for an effeminate world of gossip and literary dilettantism.[4]

In this context, the feud between *Fortune* and the *New Yorker* makes more sense. The magazines, largely originating from and read by an emerging, ill-defined professional managerial class, represented competing class self-definitions. The *New Yorker*'s cosmopolitan, up-to-date professionals prided themselves on their social wit and their distance from the crass business world. But to the professionals at *Fortune*, this sensibility was effeminizing. If the educated middle class wanted to play a significant role in modern America, the magazine maintained, it would have to give up its supposed autonomy from the political and economic spheres. The magazine urged its readers to reject the claim that the corporate world was corrupting and indeed insisted that professionals could flourish in business. The corporate professional, *Fortune* argued, both retained the public ideals and status of the professional and also gained the power and responsibility of the corporation. A stubborn allegiance to the "adversary" ideals of the *New Yorker* guaranteed not purity but irrelevance.

It is only appropriate that, in making this argument, *Fortune* turned to art, the very field that for the *New Yorker* exemplified the purity of professional motives in the face of a commercialized modern society. In the early years of the thirties *Fortune* printed lush reproductions of paintings, cutting-edge photography, and literary writing not only to demonstrate the compatibility of a business society with a vital cultural life but also to serve as a credential that the magazine was a true representative of professional concerns. Even more, it celebrated a model of a corporate artist whose pro-

ductivity and talent were spurred on, rather than corrupted, by a business society. Challenging the assumption of adversary professionals that art transcended business, the magazine used its artistic discourse to convince readers of the mutual benefits created by the merging of professional ideals and the corporate environment.

The Ideal of the Corporate Professional

Professional ideals, which developed in the nineteenth century as a way for independent professionals to gain trust and status within their local communities, retained considerable cultural power in the twentieth century, in terms of both professional managerial self-identification and social status. Engineers, for example, held an esteemed position in the American imagination through the twenties. More than one hundred silent films and best-selling novels between 1897 and 1920 featured an engineer as the hero. This engineer-hero, Cecilia Tichi argues, "combined rationality with humanity" to inspire admirers with the possibilities of technology while reassuring them that individual needs and desires would not be forgotten in the construction of a new society. The potential of the hero-engineers, however, lay not in their individual greatness, but in their adherence to professional ideologies. These heroes, Tichi writes, were "not figures of idiosyncratic genius, but types of a new professional class." They adhered to all the tenets of the professional ideal: in addition to providing technological leadership and displaying an interest in the public good, hero-engineers were "impervious to corruption" and rejected any "political or financial influence liable to compromise [their] work or liable to endanger those whose safety depend[ed] on it." Autonomously directed, they built only according to the needs of the project and the people who would use it.[5]

Other professionals enjoyed similar public esteem in the early twentieth century. Until the late thirties, Thomas Haskell argues, "virtually all thinking Americans shared the basic . . . assumption that professionalism offered a way of life morally superior to that of the marketplace." Two early major British works on professionalism—R. H. Tawney's *Acquisitive Society* (1920) and E. M. Carr-Saunders and P. A. Wilson's *The Professions* (1933)—strongly praised professionals for their public service and disinterestedness. Meanwhile, professors and physicians stood atop American polls measuring the social standing of occupations in the twenties and thirties. "In the twenties," Herman Krooss maintains, "the word 'profession' had the same grandiose

aura that would later be associated with the word 'science.'" Americans' belief that professionals worked "above" the confusion and greed of the marketplace provided those professionals with unparalleled social status.[6]

By the twenties, however, the emergence of corporate capitalism had drawn many professionals into bureaucratic and commercial workplaces, and this change complicated the practice of professional ideals. While independent professionals of the nineteenth century had pursued public confidence largely as individuals, professionals in the 1890s and later began to organize themselves into professional groups that could wield political and social power. More important, the blossoming of corporate capitalism required a new breed of educated managers, engineers, and scientists who could understand and control the technological and organizational complexity of this new world. The increased collaboration required of professional organizations, government-business cooperation, and complicated technology meant that the professional could no longer consider himself simply an educated individual trying to serve his local community. The formation of this "institutional matrix" challenged the autonomy, disinterestedness and anticommercialism of the professional ideology.[7]

Indeed, professional ideals often fell victim to the requirements of the corporate workplace. Even in the nineteenth century, for instance, engineers recognized the tensions involved in working for a corporation. They struggled, David Noble argues, "to attain professional autonomy and define standards of ethics and social responsibility within a context of professional practice that demanded subservience to corporate authority." In this conflict, however, the requirements of the corporate workplace quickly gained the advantage. Even in the early years of the twentieth century, corporations gained substantial control over the university system, and the business-led reform of the patent system effectively ended the career of the independent inventor. Engineering reform efforts in the first two decades of the century, which tried to redirect engineers' energies toward public service rather than corporate profit, strangled themselves in their contradictions. Even when business embraced a reformer like Frederick Taylor, who had intended that his "scientific management" would increase workers' wages and leisure time, it discarded idealistic aims in favor of higher profits. By 1950, Noble suggests, the independent professional of the nineteenth century had been transformed into a "domesticated breed of engineer" who had sacrificed autonomy, public service, and even brilliance to the corporate values of anonymity and congeniality. In engineering, the conflict be-

tween professional ideals and corporate control resulted in a one-sided victory for business.[8]

Similarly managers with roots in the professional class had to adopt their ideals to the profit motive. The prominent business historian Alfred Chandler argues that one of the defining changes of corporate capitalism was the "managerial revolution" that separated corporate management from ownership. The influx of professional managers into corporations distinctly changed the look of corporate hierarchies in the early twentieth century, and these managers fully considered themselves professionals. "Their approach to their work," Chandler demonstrates, "was closer to that of lawyers, doctors and ministers than to that of the owners and managers of small traditional business enterprises." This self-identification significantly affected their workplace behavior. As I have argued, these professional managers were more likely to emphasize the long-term health of the company (instead of immediate profit) than were direct owners, and were also more interested in keeping their facilities fully employed. But the professional identity of managers had a limited effect. While both a long-term perspective and a desire for full employment created a more stable and socially beneficial economy, the managers' primary allegiance was always to the corporation rather than to the public, to efficiency, or to maximum distribution and production. The continued dominance of the profit motive has led some commentators to downplay the importance of the separation of management and ownership, and historians such as C. Wright Mills have even denied that the professionalization of management had any significant effect on the practical behavior of managers. In any case, it is clear that even after the managerial revolution, managers' freedom to make decisions was severely limited by the prerogatives of profit.[9]

Regardless of whether a particular group of professionals successfully defended their professional ideals, there is little doubt that a significant conflict existed between professional prerogatives and corporate organization. The economic historians Scott Lash and John Urry go so far as to claim that a "class struggle" between capitalists and the professional managerial class emerged after the turn of the century. By the twenties the "true professional ideal" had sustained significant damage. The marriage of business and the professional class had forced professionals to compromise their independence and adapt their ideals to the needs of the corporate family. And yet the myth of the public-minded professional was still strong enough in 1928 to help Herbert Hoover, nicknamed the "Great Engineer," to ascend to the presidency. Professionals retained the status that resulted from their sup-

posed autonomy and anticommercialism, even as those values become more and more difficult to sustain. The discontinuity between self-identity and corporate reality created a potent anxiety among the professional managerial class.[10]

The conflict between the *New Yorker* and *Fortune* roughly displayed two different reactions to this anxiety. On the one hand, a significant group of artists, intellectuals, and other professionals, like the *New Yorker's* writers, maintained that they could work honestly and productively only with independence from commercial pressure. This response to professional managerial anxiety, emanating from what Lionel Trilling later called the "adversary culture," upheld the professional commitment to autonomy, public service, and anticommercialism in the face of the increasingly dominant culture of corporate capitalism. Adversary professionals, arguing for vigilance against encroaching business values, drew upon a long tradition of anticommercial sentiment in order to preserve the cultural status accorded to those who remained independent of the marketplace. Shunning economic selfishness, at least in public, these adversary professionals, writes Norman Podhoretz "directed an assault against the spiritual and cultural power of business" in order to combat the spiritual emptiness of modern society.[11]

On the other hand, *Fortune* insisted that the corporate environment did not threaten professional ideals or status. Rejecting the ideal of the adversary professional, the magazine instead provided its readers with a model of a corporate professional. On the sale of the *New York World* to the Scripps-Howard chain of newspapers in 1931, Luce denigrated as irrational and childish professionals who claimed that business necessarily destroyed the integrity of a profession (in this case, journalism):

> Now there is a certain breed of professional culturist which I believe is to be found swarming upon lecture platforms, and which is continually making faces at the press. . . . Your culturist derives exquisite satisfaction from believing that he has pronounced ultimate damnation on the press simply by saying that the press is big business. In spite of his specialized ignorance of the subject, your culturist has no difficulty in identifying big business with stupidity, crassness, insensitive efficiency, and to put not too fine a point upon it, prostitution.

This "bad logic" automatically equated business with corruption, and assumed that professionals were above market concerns. But, in fact, Luce and *Fortune* insisted, no facet of American life transcended industry. "Almost every major occupation of our people," contended the "Preface to *For-*

tune" in 1929, "links with Business. . . . 'Business is the focus of our national energies.'" To demonstrate how thoroughly industry interlaced itself through American life, this preface pointed to the entrance into the market of supposedly autonomous professionals and artists:

> Even the Professions, once almost entirely set apart from "trade," impinge increasingly on business. . . . Statecraft heeds its counsel and aids its extension. . . . Science is the right-hand ally of Industry. Law, on the left hand, advises and organizes in the interest of Business. . . . Education changes its systems to train the men of Business. . . . The Arts give Business temples for workshops and palace rooms for offices. Advertising broadens the usefulness and sells and beautifies the products of Business. (Ellipses in original.)

By highlighting the connections between business, the professions, and art, *Fortune* dispelled the illusion that commercial concerns tainted "purer" artistic and professional realms. Instead, commercialism linked the professional to the larger American society. The "snob who looks down on 'trade'" not only failed to achieve purity but also severed the artery that connected him to the heart of his society.[12]

Particularly in the early thirties *Fortune* sought to legitimate the acceptance of corporate capitalism by dramatizing how the corporate professional could flourish as an enthusiastic participant in the business world. The magazine praised most enthusiastically those professionals who learned to combine their expert knowledge with business know-how. Owen Young, for example, was a lawyer strongly imbued with professional ethics. He called his young "scholarly days" the "most satisfying period of his life" and declared that "the great lawyer of the future will be the man who has the faculty for seeing right." But these ideals did not keep him from the marketplace. On the contrary, *Fortune* explained, it was his ability to "speak the language of business as well as that of the lawyers" and his "thorough knowledge of legal principles and a growing ability to apply them to practical, commercial situations" that brought him success. Similarly toasted were the engineer who had learned to sell his own product, the university dean who had exploited the commercial benefits of summer school, or the group of performers who demanded financial control of their performance. Even entering the marketplace of ideas demonstrated an admirable worldliness. The university professor usually appeared as an effeminate bookworm whose esoteric work forbade any communication with the world outside his discipline. But when *Fortune* occasionally printed the signed work

of an academic, it was typically announced with a caveat: "Dean Charles Edward Clark . . . is a 'professor' of the new type. That is to say he is a man who uses his professional position not for retreat from the world but for attack upon its problems."[13]

To insist that such professionals were betraying their ideals, *Fortune* argued, was to wallow in outdated conceptions of professional transcendence. Only two generations past, for instance, the head of the New York Bar had been a "gentleman of great professional learning and dignity." Moving effortlessly among divorce suits, criminal defenses, and contract law, he had charmed juries and court attendants, and inspired in his clients a quiet reverence. But by 1931 a new type of leader had ascended. The new head of the Bar, the magazine claimed, was not an individual. It was "any one of a half-dozen or more highly organized and subdivided law firms." In their offices, "the smell of fresh air and efficiency" had replaced the odor of old leather-bound books. No longer the star on the courtroom floor, the great lawyer was now "merely a member of the cast." This monumental change, *Fortune* reported, had been greeted with great cries of outrage and sorrow. One Harvard Law dean had derisively named his fellow lawyers the "Client-Caretakers for the Absentee Landlords of Modern Business," and other critics had used unrepeated, perhaps unrepeatable, "briefer phrases" to express their protest. But *Fortune* argued that the change was "neither good nor bad but merely (like the wane of the horse) inevitable." The objections were founded on two misconceptions: "the first an extravagant, exaggerated, and not unsentimental idea of the dignity and importance of the practice of law, and the second a snobbish and antiquated picture of the lack of dignity and comparative *un*importance of business." For *Fortune*, the idea that a lawyer automatically deserved a greater authority and status than a businessman was (like the horse) a leftover from an earlier age. The lawyer may have been more learned and powerful than a local shopkeeper, but in the present day "the shopkeeper's business has attained a size, a value, and an influence which overshadows any individual attorney, whatever his skill."[14]

The best way to understand the dignity of the corporate professional, *Fortune* asserted, was to discard the irrational ideal of the transcendent professional. "Properties vs. Principles," for example, compared the work of the applied and pure scientists. But instead of contending that the two were closely related in order to surround corporate work with the aura of science, which, the article complained, "apologists" for applied scientists tended to do, *Fortune* maintained that the two undertakings were completely different. Whereas the researcher looked for scientific truth, the main concerns

of the applied scientist were mass production and profit. This difference meant that the industrial scientist dealt with little new science: the new industrial product "represents an application of the principles of the science to about the extent that the adding machine represents an application of the principles of mathematics." But having made this division between the adversary and the corporate professional, *Fortune* did not conclude that pure research was more honorable. The work of the industrial researcher was intrinsically valuable, and did not require the glow of scientific truth to justify it. "The industrial chemist has recorded a performance and achieved a stability which makes superfluous any aroma of magic or mystery." Corporate professionals did not need to absorb their status from a tradition of professional ideals that did not apply to a new era. Their capitalist-inspired goals—increased production, reduced unit cost, higher profits—deserved admiration in themselves.[15]

But even in rejecting the traditional aggrandizement of the professional's public service over the business person's selfish motivation, *Fortune* claimed that corporate professionals enjoyed an increased social and organizational responsibility. The "umbilical artery" that attached the modern law office to the business world had not destroyed but had enhanced the dignity and power of the profession. Even the ability to be socially useful had grown: "Mr. Francis Lynde Stetson's invention of no-par-value common stock is one of many evidences of a kind of constructive work at least as valuable to society as the breaking of a will." The New York lawyer might no longer be the "prima donna," but his intervention in "problems of exceptional difficulty, complication and importance" gave him a new relevance. Other corporate professionals created similar benefits. The industrial chemist was "making to society a contribution of unquestioned value." The journalist who joined the corporate United Press served the public interest by pushing forward the "progress of journalism from fable toward truth." Although "the scientist regards [him] as a mechanic" and "the public [was] virtually unaware of his existence," a corporate engineer like Charles Kettering of General Motors, who had invented the self-starter, could aid millions of motorists. In fact, *Fortune* proclaimed, Kettering's devotion to progress and impatience with "stagnant minds" made him "one of the few really epic characters in the American scene." By dissolving traditional professionals' divide between business and public interest, between capitalist profit and professional ideals, *Fortune* declared that the corporate professional could simultaneously serve both.[16]

On the surface it might seem that *Fortune*'s discussion of professionals'

place in the business world was merely an attempt to convince professionals to accept the constraints of the corporate environment: business required the expertise of these workers, and so it sought to legitimate corporate work for professionals in the interest of morale and recruiting. But to draw this conclusion is to forget that *Fortune* was not created primarily by entrepreneurs or capitalists. None of the major players in the production of the magazine in its first years, from editors like Luce, Parker Lloyd-Smith, Eric Hodgins, and Ralph Ingersoll, to writers such as MacLeish, Agee, Macdonald, Wilder Hobson, and Edward Kennedy, had their primary training in the business world, and most had no experience at all. Indeed, Luce famously quipped that "it is easier to turn poets into business journalists than to turn bookkeepers into writers," and his staff reflected that discovery. Written and edited by professionals who themselves had entered the corporate environment of Time Inc., the magazine represented an attempt to merge professional values with this environment. It aimed to understand both how professional ambitions could be fulfilled in this marketplace and how the forces of corporate capitalism could be turned toward more socially beneficial ends. It sought, in short, to understand the role of the professional managerial class—journalists as well as managers, artists as well as engineers—in the modern world. When we keep this in mind, *Fortune*'s portrait of the corporate professional emerges not as an attempt by business forces to dupe professionals into sacrificing their community values, but rather as an attempt by corporate professionals to understand and justify their own social positions.[17]

Part of this confusion stems from the difficulty of understanding who professionals actually were. Clearly, by 1929, it was no longer a simple task to divide professionals from businessmen. On the one hand, entrepreneurial business ideology and organizations persisted. The traditional entrepreneur, who both owned a company and ran its operations, continued to be an important part of the American economy, and these often smaller companies, forced by circumstances to focus on short-term costs, tended to support traditional business politics: high tariffs, low regulation, and no unions. Individuals and families, such as Henry Ford and the Du Ponts, also retained control of some large corporations, and the political ideals of these family corporations were idiosyncratic and unpredictable. Ford, for instance, combined a devotion to high wages and a paternalistic attitude toward his workers with a hatred of government and a rejection of urban consumer society, whereas Pierre Du Pont balanced a highly organized, professionalized managerial workforce with intellectual dedication to lais-

sez-faire individualism and social Darwinism. In such companies corporate liberal policies and ideals appeared sporadically, if at all.[18]

In other corporations, on the other hand, both within and outside the manufacturing sector, the presence of corporate professionals was felt much more strongly. Corporate-directed professions such as personnel management, public relations, advertising, and engineering experienced enormous growth in the first half of the twentieth century, and often made it difficult to separate the businessman from the professional. Was the owner of a journalistic enterprise, like Luce, a businessman or a professional? How about a personnel manager, whose university education had encouraged him to think of his work in terms of science and social progress, sitting at a bargaining table with union leaders? Or an engineer who was promoted to the vice president of research? Clearly these individuals were both, and such mixtures became more and more frequent in the twentieth century, as larger corporations increasingly depended on technological research, governmental and legal knowledge, and bureaucratic organization. Personnel management, for example, appeared as a profession in the years after the turn of the century, and blossomed particularly in the Depression. Many of these managers, who struggled for power with traditional workplace organizers such as production managers and foremen, were trained by their university education to seek efficiency and to welcome reform. They were, Sanford Jacoby argues, in part progressive reformers. Even many of the artists and illustrators who worked for advertising agencies imagined themselves as both businessmen and professionals. Simultaneously justifying the commercial ends of their work to other artists and embracing modernist styles to demonstrate their autonomy and education, these figures exemplified the persistence of professional anxiety.[19]

But in the thinning of the line between business and professional work after the turn of the century, the two most important groups were engineers and trained managers. Industrial research laboratories first appeared in the decades before 1900 but numbered 819 in 1921, and their workers were increasingly drafted from Ph.D. programs. By 1920 there were 197,000 scientists and engineers in business, and by 1940 the number had more than doubled to 439,000. The résumé of a prominent researcher like Frank Jewett might include not only positions at Bell and at AT&T but also stints at MIT and in government. On the other end of the educational spectrum were the business managers. The increasingly complex organizations of corporations required increased training, and business schools

boomed in the first half of the century in order to supply corporations' de-
mands for competent leaders. While the University of Pennsylvania's
Wharton School remained the only business school in the United States
into the 1890s, by the twenties postgraduate education was well esta-
blished, and by 1940 there were 110 professional business schools in the
country. Moreover, these schools, although often pressured to provide
technical training, often saw themselves, as one early president of the
Wharton School noted, as providing an education that would "broaden
and liberalize [businessmen], enlarge their views, widen their outlook,
quicken their sympathies, beget and increase a public spirit." Business
schools, together with organizations such as the American Management
Association, which was founded in 1923, not only bolstered the managers'
status as professionals but were important incubators of corporate liberal
ideals.[20]

The result of the combined growth of these corporate professions was
that, whereas in 1900 approximately 50 percent of younger big-business ex-
ecutives were primarily either capitalists or entrepreneurs, by 1925 more
than 70 percent were either engineers, lawyers, trained managers, or other
professionals. By 1950 the number would approach 85 percent. *Fortune*, in
celebrating the importance of the corporate professional, addressed these
workers, who, like many of those of the magazine's staff, were straddling the
border between business and professionalism. Its model of the corporate
professional insisted that this mediating position was not one of compro-
mise, but of opportunity.[21]

The Adversary Response to Professional Managerial Anxiety

Fortune's vision of professional managerial identity, of course, did not go
uncontested. If *Fortune* represented the possibilities of the corporate profes-
sional, the *New Yorker* exemplified the adversary position. Cosmopolitan in
its tastes, liberal or apathetic in its politics, and distantly ironic in its tone, it
embodied with H. L. Mencken's *American Mercury* the intellectual taste in
the late twenties for distance from commercial, bourgeois, Midwestern
America. "Not," its motto proclaimed, "for the old lady from Dubuque."
But while the *New Yorker* certainly belonged to the adversary culture, its
ideals did not describe its boundaries. The only fundamental belief linking
the great variety of writers, artists, engineers, journalists, and others, who
may aptly be described as adversary professionals, was a sense, whether

vague or systematic, that the emergence and rise of corporate capitalism offered a significant threat to the autonomy necessary for successful professional work.

The roots of the adversary culture reach into a Romantic tradition in Western art that opposed Culture to the commercial realm. Looking back over almost two hundred years of writing, Trilling noted that "any historian of the literature of the modern age will take virtually for granted the adversary intention, the actually subversive intention, that characterizes modern writing." The American "transcendent intellectual," according to Christopher Wilson, created art by shunning the distractions, interests, and petty disputes of the everyday world. More particularly, this individual genius rejected the market and its prosaic surroundings. For such an artist, "writing could not be conceived as labor, but only as something derived from inspiration." This deliberate segregation from wider society aggrandized the artist as a disinterested and far-sighted prophet, but it also left these idealized American artists outside mainstream culture. The adversary ideal, as Wilson writes, "separated much of American literary ideology from the driving impetus of bourgeois society—the ideal of productivity."[22]

As *Fortune* was being founded, this adversary ideal continued to be central to American artistic and intellectual identity. In fact, in the twenties it dominated literary culture. The disillusionment of the war and the blandness of the return to "normalcy," Frederick Allen noted in 1931, created a "newly class conscious group" out of the "bright young college graduate." No longer interested in the social injustices that had inspired young professionals during the Progressive movement, these highbrows-in-revolt were instead "united in a scorn of the great bourgeois majority" and "saw themselves as fighting at the last ditch for the right to be themselves in a civilization which was being leveled into monotony by Fordismus and the chain-store mind." This story, though tired from its many retellings, still contains its kernel of truth. Whether we dismiss this antibourgeois, antibusiness sentiment as fad or embrace it as the emerging sensibility of a new generation, it dominated artistic and intellectual discourse. As much as any other texts, Sinclair Lewis's novels of the twenties reveal the impressive widespread appeal of this critique. But in creating the passionate doctor Martin Arrowsmith, the engineer-turned-businessman Sam Dodsworth, and the once aspiring lawyer George Babbitt, Lewis did more than just satirize bourgeois rituals. Rather, he also described the crippling anxiety and loss of autonomy created by professionals' encounter with corporate capitalism. Echoing Babbitt's lament that "they've licked me . . .

licked me to a finish," Dodsworth looked back in regret at the compromises that led to his business success:

> *They* had taken from him the pride in pioneering which was one of his
> props in life—and who *They* were, he didn't know. . . . *They* were part of
> a booming industrial flood which was sweeping over him. *They* would
> give him a larger house, a yacht, but *They* would not give him work that
> was really his own.

The alternative to middle-class philistinism, Lewis told his readers, was to be found in the persistence of professional ideals in the face of that industrial, corporate "they," and in the insistence on productive, autonomous "work that really was [their] own."[23]

But centrality of the adversary identity to the artistic field of the twenties and early thirties is demonstrated by the fact that it manifested itself in smaller, marginal intellectual communities as well as in this dominant culture. For instance, even as they rejected modernists' "Cult of Unintelligibility," the socialist writers surrounding the *New Masses* were still inspired by an adversary vision. Directly rejecting *Fortune*'s portrait of the corporate professional, for example, Lewis Corey's *Culture and the Crisis* maintained that under capitalism professionals could either serve as "the cultural lieutenants of the capitalist class" or be exploited in their own right, and insisted that only under socialism would they be "liberated to perform freely and creatively their particular craft function." The problem of the "new class," as Michael Denning argues, was a key part of this left-wing intellectual culture. On the other end of the political spectrum, Irving Babbitt, the leader of the New Humanist movement, argued that American society's business-fed "quantitative view of life" had not only created a generally shallow culture but had made creative intellectual work and good leadership increasingly impossible. As the nation's university system had been reconceived as "training for service and power" rather than as liberal "aimless" education, the institution responsible for creating the leadership class was "in danger of becoming a vast whir of machinery in the void." Finally, like New Humanism, the Regionalist movement aimed at what John Crowe Ransom called an "effective defense against Progress." More often a romanticization of the ideal of local culture than a true embrace of small town life, regionalism was at heart a critique of an increasingly anonymous, corporate society. Manifesting itself in a wide variety of forms, the adversary sentiment dominated the American artistic culture of the twenties and early thirties.[24]

But while the adversary culture was particularly strong in the artistic field, it is crucial to recognize that it was not limited to this community. A similar spirit developed among other professionals in the late nineteenth and early twentieth centuries. In the face of corporate bureaucracy, these professionals insisted on their autonomy, arguing that the truth of science, rather than commercial demands, directed their work. The adversary professional, furthermore, shunned material selfishness in favor of a commitment to the public weal. To some observers, these traits, combined with technical knowledge and scientific objectivity, seemed to make professionals the ideal leaders of a nation in danger of both anarchic democracy and autocratic corporate control. Thomas Haskell contends that thinkers such as C. S. Pierce, Emile Durkheim, R. H. Tawney, and others saw in the professional community a "countervailing market" that would encourage a more ethical way of life within an industrial society:

> It is a market in which people compete not for money, but for the affective currency of criticism: fame instead of disgrace; honor in place of shame; compliments, not complaints, about the technical worth of one's work. What each competitor strives to accumulate in this special "countervailing market" is not capital, but reputation, a stock of favorable impressions of himself and his work in the minds of his peers.

In establishing this "economic world reversed," the adversary professional, like the adversary artist, rejected the commercial world for one supposedly more spiritual, more compassionate, and more satisfying. Almost certainly, as Haskell argues, autonomous professionals did not live up to the ideal of a market completely separate from pecuniary concerns; nevertheless they insisted that they sought to (whether in good faith or not), and received much of their status and cultural power from appearing to do so.[25]

Supported by these ideals, adversary professionals aimed to direct and control the whirlwind of social change created by corporate capitalism. William Sullivan describes the importance of professional ideals in the Progressive movement: "Professionalism became one of the pillars of the Progressive movement by providing, in the professional career, a design for living that promised to give individual occupational achievement moral meaning through responsible participation in civic life." Many of the prominent public crusades of the Progressive Era—public health, education, and settlement houses, to name a few—depended on the occupational expertise of the professional classes. And while some of these progressive professionals, like Herbert Croly and Frederick Taylor, joined corporate lib-

erals in imagining progress through the expansion and control of the forces of corporate capitalism, many others not only fought the social abuses of individual capitalists but also saw the size of corporations as a threat to the values and structure of American life. Corporate "bigness," they feared, would smother the autonomy and community of small towns and workplaces. For such professionals, a closer interaction with corporate capitalism encouraged an earnest defense of their values rather than a capitulation to bureaucratic needs. And even when the movement faltered after World War I, the influence of Progressive ideas and missions remained a strong part of the professional self-image.[26]

Thorstein Veblen's *The Engineers and the Price System*, which was originally written in 1919 but was reprinted several times in the early thirties, provides a classic example of the adversary thought that arose outside the artistic sphere. Veblen argued that capitalists and engineers were working at cross purposes. The owners, wishing only to enrich themselves, aimed to stabilize industry by "sagaciously retarding" production. The engineers, however, struggled to create the most efficient production possible through constant technological innovation. But since the owners controlled industry, the great productive potential of the United States was being sacrificed to capitalists' profits. The solution to this destructive problem, Veblen argued, was for engineers to recognize their class solidarity. Neither capital nor labor, and so distanced from the traditional industrial squabbles over private gain, this new "corps of technological production specialists" were in a position to take control of industry as "keepers of the community's material welfare." Veblen urged engineers to stop acting as "providers of free income for the kept classes" and take up their responsibility as the disinterested protectors of the public welfare. Engineers' scientific training, shared values, and relative homogeneity meant that a common cause—the effort to restore American progress—could solidify the already budding class-consciousness of engineers.[27]

But, as Veblen recognized, the chances for truly revolutionary change were small. Clearly few professionals could act completely on their professional ideals. The protagonist of Lewis's *Arrowsmith*, for instance, decides after much struggle to reject the corrupt and commercialized medical establishment so that he can pursue his own research unhindered. To do this, however, Arrowsmith literally has to retreat to the backwoods: he and a partner set up a laboratory in the middle of an unspoiled forest. Yet the popularity of Lewis's novels in the twenties demonstrates how resonant this romantic vision of escape from the corporate realm was. And although we can

never be sure how readers reacted to Arrowsmith's retreat or to other expressions of adversary sentiment, it is reasonable to assume that such texts inflamed, at least momentarily, their allegiance to their professional inheritance. Even if few professionals managed to abandon their spouse and achieve professional autonomy in untouched nature, or even to retain significant control over their own workplace, many artists and professionals continued to pine for such independence. Vocational autonomy, anticommercialism, and public service appealed to them both as desirable ideals and status markers.

The romantic nature of the adversary stance, combined with a sense among many adversary professionals that any victories over seemingly inevitable corporatization and bureaucratization would be minor, meant that adversary sentiments were rarely as systematically explained as Veblen described them in *Engineers*. Furthermore, there was a great deal of variety among adversary ideals. While some, like socialist thinkers and Veblen, considered the political sphere to be central to the adversary battle, others, such as many American expatriate writers, considered politics to be another interference with autonomy. Some adversary professionals, like Lewis, minimized or even jettisoned the public responsibility of professionals in favor of the ideal of autonomy. This variety, however, should not obscure their mutual allegiance to the key adversary belief: that a corporatized, bureaucratic society was overwhelming the autonomy necessary for successful professional work, whether in literature, science, or law. Adversary professionals, despite their differences and sometimes romantic strategies, all agreed that the corporatization of the United States had to be fought.

Powerful in its emotional force, if not always in its practical strategies, the adversary ideal presented professionals with an alternative sense of the social role of the professional managerial class. It was this adversary camp to which *Fortune* responded in advocating its corporate professional. But in its attempt to overwhelm the adversary ideal, *Fortune* did not simply defend its corporate boundaries. Moving into enemy land, the magazine sought to occupy and control the stronghold of adversary ideals: American artistic culture.

Art and the Corporate Professional

By 1922 Edward Bruce, the son of a social-minded Baptist minister, and a 1904 graduate of Columbia Law School, had forged a successful career advising American businesses in Asia. Nevertheless, as *Fortune* related nine

years later in "Portrait of a Contented Man," he decided to switch careers. In becoming a full-time painter, however, Bruce did not completely leave his earlier life behind. Even as he studied under Maurice Sterne in the Italian countryside, he retained the habits of Manhattan:

> For eighteen years Mr. Bruce had been a man of business. He had discovered that by routining each day into a set number of hours, his productivity was increased. He continued, now that he was painting, to follow the same routine. It never occurred to him to wait for some evocative inspiration or urge. The bankers and lawyers he knew could never afford to. Neither could he. . . .
>
> He spent three years in Anticoli. Sterne admired his routine, but suffered from it, for Bruce forced *him* to follow it. During the Bruce *régime*, Sterne produced more than during any other years before or since. He relates the fact with a touch of sadness.

Fortune celebrated Bruce's merging of business methods and artistic aims. By eschewing the romantic mythology of inspiration, it argued, Bruce had achieved success as a painter. One painting won a prize at the Carnegie International Exhibition. The French government bought another. "While many of his friends argued against his businesslike tempo," *Fortune* quipped, "other people began to buy his paintings."[28]

On one level *Fortune*'s story on Bruce, like its *New Yorker* exposé, was an amused, if slightly juvenile, jab at the artistic temperament. But just as the *New Yorker* essay did, *Fortune*'s retelling of Bruce's rise to prominence represented a volley in the battle over the social role of the professional managerial class. As I have maintained, *Fortune* worked to persuade professionals that the corporate environment was hospitable to their ideals and ambitions. But professionals, like businesspeople, could not be convinced of the wisdom of corporate liberalism through logical argument alone. Just as the magazine had turned to Culture to sell its elite coalition to business readers, it used an extended discussion of contemporary American art and artists to convince professionals to embrace the corporate environment. Essays such as "Portrait of a Contented Man" did this in three ways. First, they attracted professional readers by providing them with cultural knowledge that would credential them as members of the professional managerial class: reading about Bruce and other artists, the *Fortune* reader could stay current on contemporary American art. At the same time these articles certified *Fortune* as a product of a professional sensibility: the magazine's interest in art demonstrated that it had in mind the interests and ambitions of the pro-

Portrait of Edward Bruce, Fortune 3 (May 1931): 73. *Here is the businessman artist at work. The lack of "artistic" clothing or pretensions, as well as the factory landscape in the background, testify to the artist's production ethic and business sensibilities.*

fessional managerial class. Finally, in featuring artists like Bruce, these essays complemented *Fortune*'s more direct presentations of a model of corporate professional behavior, and celebrated this behavior as a way to avoid the unnecessary choice between corporate society and professional ideals. Culture provided a language through which the magazine could talk to its readers about what it meant to be a professional.

•

While businesspeople in the early twentieth century had a largely antagonistic relationship with art and literature, Culture was central to professionals' identity. Professionals shared with art an investment in the "economic world reversed." The class distanced itself from the materialist business arena, as well as from the unreflective masses, not only through its anticommercialism and devotion to scientific truth but also through its appreciation of the fine arts. This connection to culture, like the genteel ideal of "character" and the vocational autonomy of the professional, purportedly provided professionals with a personal depth unavailable to other classes. As the professional managerial class moved into the corporate environment, the importance of culture as a status marker for the class increased. The flood of bureaucracy eroded professional autonomy, and capitalist values seeped into the most anticommercial enclaves. The increasing lack of differentiation between the workplaces of professionals and those of businesspeople made avocational status markers such as Culture even more important, even as professional artists and critics made cultural knowledge increasingly specialized. An appreciation of culture indicated that professionals, even if they worked within a corporation, retained not only the distinction of their supposedly more independent past but also the broader "character" of their predecessors. While professional values such as autonomy, anticommercialism, and public responsibility were clearly not rooted in artistic appreciation, cultural literacy more than anything else symbolized the traditional public-mindedness and higher education of professionals.

Considering its standing as both a developer of "character" and as a sign of professional status, it is little wonder that artistic knowledge became a widely sought commodity. Beginning as early as the turn of the century, cultural producers, ranging from booksellers and magazine editors to illustrators and advertisers, recognized a new market for accessible but "serious" art. Members of the professional class, increasingly specialized and bureaucratized in the workplace and unable to devote excessive spare time to artis-

tic cultivation, sought ways to retain the individuality of the autonomous professional. The middlebrow industry emerged out of this crisis of distinction. "*Vanity Fair*'s clear social function," Michael Murphy notes of one middlebrow outlet, "was to keep its mass upper-middle-class readership culturally up-to-date. For three dollars or so a year, it would mediate the vagaries of high-modernist aesthetics to a popular audience." The Modern Library, Jay Satterfield adds, aimed its wares at a "civilized minority" of educated professionals, distinguished by their independence, curiosity, and thoughtfulness. The middlebrow industry, including symphonic radio shows, newspaper literary supplements, "popularized" philosophy and history, "slick" magazines, and book clubs, made the badge of Culture available to professionals who did not specialize in art or intellectual affairs.[29]

Fortune was not a middlebrow outlet: it was not primarily a producer or distributor of culture, and it had a much more distinct set of topical, political beliefs than middlebrow sources. Nonetheless its shared interest in attracting a professional audience led it to adopt some of the features of middlebrow art. Aiming, like middlebrow outlets, to credential professionals outside the artistic field, the magazine's "business modernism" shared the middlebrow aggrandizement of generalist cultural education and its dismissal of the abstract and overly theorized avant-garde. Furthermore, both insisted that art remain connected to the world: redefining art as modern, masculine, and commercial, for instance, *Fortune* called for art that was forceful, popular, and vital, that, like medieval stained glass, "possessed a decorative vigor, a luminous pungency." Most important, because both addressed nonspecialists, they focused on accessible art; but because both aspired to contemporaneity, they also were often led toward "modern" mannerisms. The result, famously dubbed "sophisticated kitsch" by Dwight Macdonald, was more aptly described by the *Fortune* painter Laurence Sisson as "designed realism." This penchant for art that was self-consciously stylized while remaining figurative and recognizable characterized the magazine's paintings and watercolors as well as its essays and photographs, from the early thirties into the fifties. Nearly always modern, but never quite cutting-edge or abstract, *Fortune* matched its own description of the middlebrow *Cosmopolitan* magazine: it "takes up ideas which have outgrown the small intellectual circle in which they originated, [and uses] them when they are ripe for the larger and less intellectual circle" of its audience. Showcasing accessible versions of contemporary artistic and literary styles, *Fortune*, like middlebrow producers, provided its readers with the generalist cultural knowledge emblematic of the professional class, while

avoiding the intimidation and specialized language of professional criticism or the avant-garde.[30]

Fortune's treatment of the political artist Diego Rivera illustrates the way the magazine educated its readers about contemporary art. Rivera's work appeared in the magazine multiple times in the thirties, but the most notable example came in February 1932, when the magazine published a full-page, color reproduction of Rivera's fresco of New York City, "Frozen Assets." The work is divided into three layers: it depicts the industrial skyline and shoreline of the city, a warehouse in which hundreds of people sleep under the watch of a guard, and a bank in which another guard is closing a large vault. The fresco is obviously a work of social critique. The parallel between the guards looking over the two different forms of "frozen assets" critiques not only the inhumane conditions in which the people are sleeping but also the failure of business to use its capital to stimulate growth. The work, which Rivera created for his one-man show at the Museum of Modern Art in New York, caused a small controversy at the time, and the art historian Terry Smith calls it a "clear provocation." Reproducing such a piece, the magazine claimed respect as a culturally astute, socially aware, and politically independent institution: in short, it demonstrated its professional credentials. Furthermore, it kept its readers "culturally up-to-date." "Diego Rivera is, as everyone knows," the short accompanying essay began, "the leading painter of frescoes of his time and perhaps the first great painter of the modern American continent." *Fortune* ensured its readers that they were among the everybody who knew.[31]

By helping readers to see the mural through its own corporate liberal lens, *Fortune* also minimized the risk that readers would be offended or confused by the work. The essay assured them that Rivera's work was accessible, both visually and politically. On the one hand, Rivera's public mural style displayed the "designed realism" of other *Fortune* illustrations: its manner is undeniably modernist, but the content is not obscured by abstraction or extreme stylization. On the other hand, *Fortune* insisted that Rivera's art, rather than emphasizing exploitation and alienation, sought understanding and engagement. Earlier in his career in revolutionary Mexico, Rivera had been a Communist. But this ideological commitment had only been an expression of his admirable concern with the "world's social meaning." In 1928, when his Communist comrades "offered the choice between ideology and art which Communism sooner or later imposes upon all its painters," Rivera "chose art." His newer paintings, stripped of ideology, expressed a more agreeable "fundamental human loyalty":

Ernest Hamlin Baker, Walter Clark Teagle, Fortune 3 *(March 1931): 34. Baker's portrait of the corporate liberal executive Walter Teagle illustrates both the modernistic styling and figurative recognizability of* Fortune's *dominant "designed realist" style.*

What is here reproduced is not a sermon on the city of New York, nor an Essay on Man. Diego's work is not symbolic. It is legible. And its speech is speech equally comprehensible to the Indians of Morelos and the industrialists of New York.

Backgrounding Rivera's revolutionary ideals, *Fortune* even opted not to print the highly critical name of the piece. Instead, the magazine painted Rivera as an artist actively engaged with industrial civilization, who created works that were both publicly accessible and socially conscious.[32]

But it is not sufficient simply to dismiss this as a case of middlebrow whitewash of the difficulties of high art. Indeed, the critical politics of the piece are unmistakable, even given *Fortune*'s commentary and the absence of a title. That the editors chose to publish this work suggests how important it was that the magazine establish itself as an independent voice. Presenting itself as both a provider of the "culturally up-to-date" as well as a thoughtful, critical journal, the magazine could attract professional readers and establish itself as a professionally minded media source. Professional readers, who might otherwise be suspicious of a business magazine, would be assured that *Fortune* and corporate liberalism shared their autonomy. More than this, *Fortune* demonstrated to its readers that corporate liberalism had the same concern with "fundamental human loyalty" and with the "social meaning" of industrialism that even a radical artist did. By no means promoting the politics of the piece, the magazine celebrated Rivera—and itself—for recognizing that the radical artist and the "New York industrialist" could have a productive, "legible" discussion about both the relationship of the artist to modern society and about the moral basis of corporate society. Having encountered the art firsthand, the reader, too, could join in the conversation.

.

In addition to offering its readers artistic cultivation and professional credentials, *Fortune*'s cultural discourse added to the magazine's promotion of corporate professional ideals. Janice Radway argues that middlebrow "developed as a kind of social pedagogy for a growing class fraction of professionals, managers, and information and cultural workers." The similarly directed but distinct "social pedagogy" of *Fortune*'s cultural discourse grew from the ideals of corporate liberalism. Providing examples of artists flourishing within the commercial sphere, the magazine demonstrated how corporate professionals could successfully adapt their ideals to the "business civilization." Pierre Bourdieu suggests that conflicts over artistic hierar-

chies, by bringing the class struggle between the professional and capitalist classes into the public arena, ultimately molds "the definition of human accomplishment." However, *Fortune*'s cultural discourse had a more modest purpose: to redefine *professional managerial* accomplishment. In doing so, it sought to heal the rift within the professional class and to foster an elite coalition that minimized the conflicts between professional ideals and the corporate environment.[33]

The development of the artistic field followed the pattern of other American professions in the early twentieth century. As the cultural field experienced the same corporatizing and nationalizing processes that were transforming other professional realms, the amateur "man of letters" that had dominated nineteenth-century images of the artist gave way to two opposed visions: one of commercial artists, journalistic authors, and other mass media "hacks," and the other of independent but esoteric adversary scholars and artists. This schism within the cultural field (which was, of course, not as clear-cut in practice as in theory) replicated the larger collision between professional ideals and the corporate environment. *Fortune* exploited this parallel between professional and artistic conflicts in order to convince professionals to accept corporate values. The magazine sought to delegitimize the powerful adversary tradition in the arts by featuring craftsmen and commercial artists who favored technical skill and modern methods over inspiration and artistic autonomy. Just as the anticommercial ideals of adversary professionals isolated them from a business civilization, the conventional divide between financial and artistic worlds made the art-for-art's-sake artist irrelevant to mainstream culture. Just as the professional could enter the corporation while remaining civically responsible and autonomous, the artist could adapt to the needs of a business audience without giving up artistic integrity. In arguing that the commercial artist would gain a new relevance and masculinity by abandoning the voluntary isolation of the adversary culture, *Fortune* hoped to validate corporate professionals' compromises with the business world.[34]

Fortune's primary assertion about contemporary art was that it should be the art of the business civilization: artists could no more successfully transcend the dominant institution of the era than other professionals could. "In an age of cogs, cams, and crankshafts," announced an essay on the designer Norman Bel Geddes, "the esthetic fabric will be as closely allied with such mechanisms as was the Gothic fabric with whittling and carving tools or the Egyptian fabric with slave labor." *Fortune*'s photographers, led

by Margaret Bourke-White, sought the beauty and epic proportions of factories and other industrial subjects, while various sculptors, painters, and writers dramatized the developments and individuals of business. The photographs or watercolors illustrating corporation stories, usually executed in a "designed realist" manner, sought not only to provide information about their subjects but also to demonstrate their artistic potential. "With a logic which seems inescapable," the magazine proclaimed that "any modern estheticism must embrace the machine with all its innuendoes."[35]

These "innuendoes," not limited to matters of style, also pressed artists to adopt their methods to the business-centered society. Like Edward Bruce, *Fortune* artists complemented their artistic expertise with a business sensibility. Adella Prentiss Hughes, for example, the main patron of the Cleveland Orchestra, "combined the artistic perceptiveness of a musician with the efficiency of a locomotive," while her conductor, Nikolai Sokoloff, displayed "a curious synthesis of temperament and practicality in his makeup." "No unworldly craftsman is Mr. Polachek," another essay argued of an accomplished ornamental metal designer, "whose astuteness in business matters is amply demonstrated by the growth of General Bronze." Other stories underscored the work ethic and prodigious production of various craftsman: a glass maker who created enough designs to keep 600 assistants busy making them, or a muralist who could cover 2,600 square feet in six months. Modern artists even adapted new technologies into their work. Organ makers, vintners, stained glass artists, and decorative metal makers, among others, had not only increased their profits with technology but improved the quality of their products. Finally, *Fortune* artists accepted the authority of the market. In dismissing, with Geddes, the "esthetes" who "snobbishly" proclaimed that art must be kept innocent of commercial considerations, these artists enlarged the artistic audience by making their products accessible and attractive. Wurlitzer, for example, had succeeded because while other organ makers insisted on retaining a "pure" organ sound, Wurlitzer had explored the desires and tastes of a wide-ranging public. "It is not enough to say that no other organ manufacturer has succeeded in reaching the great American heart: none but Wurlitzer has so much as tried."[36]

Commercial artists embraced business aesthetics, methods, and markets. And as with the corporate professional, *Fortune* asserted, this acceptance of the corporate environment did not compromise the integrity of the artist. The key reason for this was that art that rejected the nostalgia of romanti-

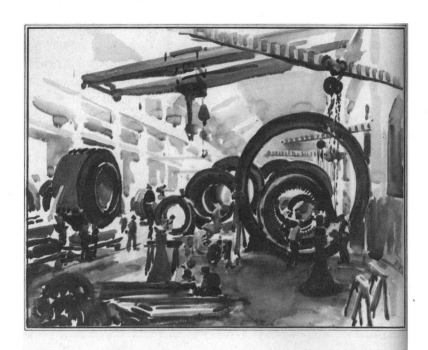

Assembly Floor at Schenectady

Here General Electric Fits Together Many of Its Giant Motors and Generators

A Water Color by Vernon Howe Bailey

Vernon Howe Bailey, Assembly Floor at Schenectady, Fortune *3 (February 1931): 38. Contemporary art,* Fortune *insisted, should arise from the conditions of contemporary society. In the early thirties, particularly, the magazine warned that artists who ignored industrial and business activities were condemning themselves to the margins. In publishing images like the one shown here,* Fortune *both encouraged artists to approach business topics and demonstrated the aesthetic possibilities of industry. Text and page layout* © 1931 Time Inc. All rights reserved.

cism and addressed the modern, business-centered world would inevitably appeal to the citizens of that world. Business, Luce noted on more than one occasion, was to the contemporary world what the Church had been to the Middle Ages. If modern artists would only recognize this, their art would be as publicly celebrated and widely understood as the stained glass in a thirteenth-century cathedral. Simultaneously rejecting and fearing the criticism that the cultural deficiencies of the United States resulted from the single-mindedness of the business community, *Fortune* urged artists to find inspiration in the industrial world. Introducing the work of Max Kalish, the magazine fumed:

> Max Kalish's bronzes of linemen and steel workers and iron forgers and electric riveters are a commentary, and a most destructive commentary, upon the work of Mr. Kalish's contemporaries, both in bronze and in oil. Whatever their substantial merit as sculpture, his pieces prove conclusively that there exists in America the material for a primary and unspoiled art and that the insipid provincialism of native American painting, its staleness, its gawky search for sensation, its uninventive inventivenesses, its dependence upon importations of manner and importations of substance, have no necessity outside the minds of American artists. . . .
>
> Max Kalish is a Pole. He is not a great sculptor. But he is a very considerable reproach to American art.

If American artists would simply develop an art grounded in the spirit of the contemporary world, *Fortune* claimed, they would find both an enthusiastic audience and a source of inspiration.[37]

In its first years *Fortune* attested to the compatibility of corporate and professional values by aggrandizing artists, like Bruce and Kalish, who were "content" in a corporatized and industrialized world. In rejecting the claims of artistic transcendence put forth by the *New Yorker* and other adversary groups, it entered the site of a continuing battle over professional credentials. Because the conflict within the artistic field is so active, Bourdieu argues, and because conversations about art interest many outside the cultural field, the cacophonous warfare over artistic criteria makes audible this larger social contest: "The field of cultural production is the area *par excellence* of clashes between the dominant fractions of the dominant class [capitalists and corporate professionals] . . . and the dominated fractions [adversary professionals]." Invading the territory of the adversary profes-

sional, the magazine developed and reinforced its vision of professional managerial identity.[38]

Professional Leadership in the New Era

Fortune's intense interest in the class identity of professionals had deeper roots than its hope to find an appropriate relationship between the professional class and American corporate capitalism. Indeed, as I argued in the previous chapter, Luce's assertion that business could serve as a site for professional ambition dovetailed with his hopes for a transformed American economy. Professionals offered just as much to the corporate economy as the corporate world offered professionals. As the economy revolutionized itself, *Fortune* argued, corporate leaders could adapt their behavior to the new conditions. This process of adaptation, if it were to be successful, would have to be strongly influenced by the long-term planning, rational thought, and public-mindedness of the corporate professional. Following in a tradition of professional-led "rational reform," *Fortune* displayed in the early thirties a relatively untroubled belief in the promises of organized capitalism. The expert managers of the elite coalition, it proclaimed, would reengineer American social organizations and drive the nation into the New Era. No figure embodied the magazine's faith in the rational reform of corporate professionals more than one of the corporate-based professionals that emerged in the twenties, the industrial designer.

The idea of rational reform, like corporate liberalism, had its roots in the professional managerial class during the Progressive Era. More specifically, it began within engineering professional organizations. While engineers garnered widespread popular admiration in the early twentieth century, this regard, as Donald Stabile points out, did not always translate into a "broader social role." The increasing dependence of corporations on engineering expertise, some engineers argued, should have allowed engineers to rise even higher within corporate hierarchies. These proponents of a "systematic science of industrial management" maintained that engineers' scientific background and supposed classlessness would allow them to organize the economy in a fairer, more efficient manner than traditional capitalists could. "It should need no argument," Alexander Humphrey noted in his presidential address to the American Society of Mechanical Engineers in 1912, "to demonstrate that the leaders in the [engineering] profession are as a class those best qualified to advise authoritatively in connection with the efforts to solve many of the most serious problems of the day." Frederick Taylor,

the quintessential reform-minded engineer, hoped to end the nation's "waste of human effort" by reducing the "awkward, inefficient and ill-directed movements" of laborers to a small set of scientifically determined, efficient steps. The time and money saved, Taylor declared, would improve workers' living conditions, increase profits, and allow laborers and capitalists alike to form a new conception of industry as a cooperative effort. Given authority over the factory and the market, engineering reformers claimed they could reconstruct the U.S. economy according to a scientific model.[39]

Not all rational reformers were engineers, however. The scientific management strategy of Taylor and other engineers inspired a set of reformers, less directly connected to engineering, who saw in applied science a metaphor for social reform. Including figures such as Thorstein Veblen, Herbert Croly, and Walter Lippmann, these reformers hoped to rebuild public policy and civic administration through the application of social science and supposedly apolitical scientific principles. Surveying the revolutionary industrial growth and the accompanying social disruption of the early twentieth century, these thinkers concluded, as John Jordan writes, that "social problems in a technological age . . . were of a different order and magnitude compared with what had confronted the reformers' predecessors." A corresponding revolution in social organization would be needed to ease the economic inequality, labor strife, and urban chaos of the American turn-of-the-century. To bring about this change, the rational reformers tried to adopt the scientific method of the engineer. Rejecting the inefficiencies and inequalities of traditional politics and the sporadic, undirected progress of capitalism, they chose, in the words of Lippmann, "mastery" over "drift." "We shall be making," Lippmann noted in the rhetoric of functionalism, "our own house for our own needs, cities to suit ourselves, and we shall believe ourselves capable of moving mountains, as engineers do, when mountains stand in their way." Imagining social strife as a problem that could be solved through social scientific knowledge, a long-term vision, and thoughtful planning, Lippmann and others hoped to engineer a social structure appropriate to a technological era.[40]

In the twenties the ideals of rational reformers further institutionalized themselves in the social sciences and major philanthropic organizations of the decade. But rational reform reached its apogee during the early thirties. Faced with the confounding coexistence of widespread poverty with a tremendously productive industrial system, many critics hoped to engineer an economic system that would more equitably and logically distribute the gains of American industry. The most obvious manifestation of this ratio-

nalist ambition was the technocracy movement. Inspired by Veblen and Taylor, technocrats argued that experts and engineers, better than capitalists, were equipped to govern a complex machine society. Relying on a theory of "cultural lag" which claimed that social and political structures had fallen behind industrial progress, technocrats looked forward, as one leader asserted, to "government by science" and "social control through the power of technique." In the early thirties these technocrats, led by Howard Scott, Harold Loeb, and Walter Rautenstrauch, inspired a large following, and *Fortune* shared many of their ideas. Technocrats' sense of "cultural lag" replicated the corporate liberal belief that the material conditions of the New Era economy required a new business and social ideology. Their pursuit of increased market stability, greater productivity, and a wider distribution of wealth matched corporate liberal goals. The magazine even printed guest essays in the early thirties by Stuart Chase, Lewis Mumford, and Arthur Salter, three leading voices for technocratic ideals. Most important, though, *Fortune* embraced the foundation of rational reformers' thought: that the scientific method and long-term, centralized planning would create an efficient and fair social and political structure. In stressing the "scientific organization of labor, standardization both of material and of products, [and] simplification of processes and improvements in the system of transport and marketing," John Stromberg concludes, *Fortune*'s commitment to "rationalization" had strong affinities with technocratic ideals.[41]

But in arguing that by 1933 the magazine had established itself as a supporter of technocracy, Stromberg overstates the case. While technocrats and most rational reformers assumed that government would lead the reconfiguration of social and political structures, *Fortune* belonged to a smaller rational reform movement that looked to the corporation as the most immediate example of the possibilities of large-scale efficient organization. This ideological difference proved to be critical in the early days of the New Deal. When Roosevelt took office in 1933, as Ellis Hawley argues, three different groups sought to convince the new president that they had the solution to the puzzling collapse of the economy. The antitrust movement, wary of bigness and further organization, argued that a competitive economy should be restored through decentralization. The second group, which included the technocrats and most rational reformers, sought to achieve a "collectivist democracy" through "purposeful national planning." The third group, however, while also depending on rational planning, rejected the ideal of a strong centralized government. These reformers instead imagined a "benevolent capitalism" that would be organized by

corporations. Imagining a system of business associations backed by government authority, these proponents of a "business commonwealth" laid the ideological and institutional groundwork for what would become the primary economic reform of the early New Deal, the National Recovery Administration (NRA). But this group of reformers had not suddenly appeared in 1933. Their commitment to "cooperation," corporate leadership, and rational reform was clearly grounded in the same corporate liberal ideology that served as the foundation for Herbert Hoover's vision of associationalism, for the "business statesmanship" of the twenties, and, of course, for *Fortune*. To *Fortune* and other advocates of corporate liberalism, rational reform, enacted under the auspices of corporate management, provided the answer to the inequities, inefficiencies, and disruptions of a society in transition from laissez faire to organized capitalism.[42]

Fortune's attraction to rational reform had its roots in more than just its hope for a more stable marketplace and for steadier profits. Indeed, as for other rational reform proponents, its ambition to reengineer the economy grew from its investment in the expertise and social ideals of the professional managerial class. The figure that exemplified to *Fortune* the possibilities of rational reform was, for example, not only a professional but also an artist. The functionalist industrial designer, who combined a commitment to the profit motive and to industrial production with a devotion to social progress, rational planning, and technological innovation, provided *Fortune* with a metaphor through which it could portray the reorganization of the modern American corporate society into "the business commonwealth." But designers did more than embody the economic and social opportunities offered by the mixture, in corporate liberalism, of professional authority, imaginative planning, corporate initiative, and the profit motive. As professionals and artists firmly entrenched in the corporate environment, they represented the crucial role that the professional managerial class would play in the corporate liberal reorganization of the economy.

It is easy to imagine the appeal of functionalist design to *Fortune*. Functionalism began in the early twentieth century at the Bauhaus, a groundbreaking German school of design. Bauhaus designers, taking their lead from the pioneering American architect Louis Sullivan's dictum that "form follow function," argued that a skyscraper of steel and glass should have a different aesthetic than a marble temple. Eschewing superfluous decoration, and merging utility and beauty into a single efficient aesthetic, they demanded that every part of an object be necessary to its usefulness. For *Fortune*, these ideals had a number of attractions. First, functionalism con-

firmed that a truly modern art had developed within industry. Second, the indebtedness of the Bauhaus to U.S. industrial architects reversed the flow of artistic inspiration across the Atlantic and, in doing so, proved that the United States was capable of producing cultural as well as material excellence. Most important, functionalist design proposed a way to unify the interests of business with the efficiency of the engineer and the eye of the artist. Affixing a third term to the unity of utility and beauty, the magazine echoed Geddes in regarding "beauty, utility and profit as mutually beneficial elements, as linked perhaps in a fundamental unity."[43]

The Simmons bed, for example, demonstrated this harmony. Bogged down with a nostalgic connection to older styles, overly tolerant of various frauds perpetrated by unscrupulous dealers, and twisted by shifting fashions, the profits of the archaically organized American furniture industry had suffered. But functionalist design, in the form of the Simmons metal bed, presented a solution to this industrial failure. These sturdy beds, *Fortune* explained, were extremely practical, both in manufacture and in use. But that was not all. The shift in design had not only "simplif[ied] the task of the manufacturer" but had also "arrest[ed] the public attention." While some manufacturers claimed that consumers did not want a plain metal bed, the Simmons bed had "demonstrated conclusively that the public would buy standard lines of furniture nationally marketed." And beyond its efficiency and profitability, the Simmons bed improved American aesthetics. Presented with a plethora of derivative styles, Americans had had only a vague sense of what they wanted from furniture, and as a result their tastes were unformed and incoherent: "the hybrid appurtenance which might be labeled fake, upholstered, geometrical Sheraton reinforced with steel tubing and garnished with Golden Oak." This uncertain taste contributed to Americans' dissatisfaction with their furniture purchases. But as the public recognized just "how serviceable and sleekly handsome modern furniture . . . based on metallic strength and linear simplicity" was, it could be better served by the industry, which could then "satisfy those desires with orders and profit." Modernization of industry in the functionalist style created efficiency, profit, and beauty.[44]

A single functionalist design, *Fortune* argued, could reinvigorate an entire industry and transform the nation's productive capabilities into consumer satisfaction. But the magazine concerned itself with more than practical design. Functionalist theorists, like other rational reformers, tended to project their technical thinking onto the social world: the crisp logic of functionalist design often encouraged utopian thoughts. Seeking the "natu-

ral logic" of a building or object in order to harmonize people with their environment, functionalists hoped to create a unified "machine age," in which industry and art, efficiency and beauty, and abundance and spirituality would exist in mutually beneficial relationships. Walter Gropius, for example, an influential figure in the Bauhaus, even wrote that the Bauhaus aspired to "the building of a new concept of the world" by "the architects of a new civilization." Lewis Mumford argued that the machine must be assimilated not "merely as an instrument of practical action but as a valuable mode of life." For these thinkers, industrial design provided a model for remaking the world.[45]

Fortune was not immune to such utopian thoughts. Although it obviously rejected the socialism of Mumford and the Bauhaus, *Fortune*, like them, saw more in functionalism than efficient, beautiful products. Design that integrated art and industry represented the advent of a unified, abundant, and beautiful business civilization. Replacing outmoded traditions with innovative, efficient ideas appropriate to modern conditions, functionalism promised a transformed society. Designers "plotted and planned . . . in disregard of tradition, convention, and even experience." The results razed the barriers between nature and technology, between art and industry, and between the alienated citizen/worker and society. A functionally designed building, for example, could satisfy not only the "technical needs of the machinery" but also the "human rights of the worker" and "the striving of the architect after harmony." Devising products, factories, homes, cities, and even social organizations according to logic rather than tradition, designers worked toward the corporate liberal vision of an economy that produced leisure as well as profit and beauty as well as material abundance. Functionalist designers, in short, were harbingers of the New Era.[46]

This projection of the possibilities of functionalist design onto larger social issues underlay *Fortune*'s celebration of the Simmons bed. The three advantages of the Simmons bed—its efficiency, its profitability, and its coherent "machine" aesthetic—mixed the science of the engineer, the salesmanship of the businessman, and the taste of the artist. But beyond these advantages, *Fortune* maintained, the efficiency of the Simmons bed provided a powerful parallel to the organization of the modern corporate age. "If [the industry] learns no other lesson from modernism than the elimination of the unnecessary (i.e., the unprogressive retailer), it will have benefited inestimably." The logic of functionalism could not be limited to design. Instead, it implied an equally strict rationality for economic and social organization. "The elimination of the unnecessary" would apply not only to

derivative traditional styles but also to outmoded social and economic forms.[47]

In celebrating the possibilities that the industrial designer offered, *Fortune* also presented its readers with an image of the expert's role in these changes. For industrial design to ease the problems of corporate capitalism, the magazine contended that business owners had to grant designers the authority to institute their ideas. Even when design innovation required significant investment and short-term losses, *Fortune* asserted, these costs were overwhelmed by the advantages of designers' long-term planning. The problem was, however, that in a largely conservative business world designers' radical ideas were often ignored. Cutting-edge designs were tabled or compromised, because conservative company presidents did not think they would sell or feared the high costs of retooling the production line. But *Fortune* argued spiritedly that the designers should have more control over the product. Geddes complained that "commercial specialists have been slow and reluctant to entrust certain aspects of their business to imaginative specialists." This "industrial sabotage" stunted the ability of industry to solve the nation's problems. Even in package design, which was more difficult to separate from sales efforts than other types of industrial design, the magazine supported designer autonomy. The ability of a package to help sell a product was a major criterion in its success, and so the reaction of the public to a particular design was crucial. Nevertheless, *Fortune* insisted that designers be provided more autonomy to develop "modern" styles. The designer's artistic experience, combined with a scientific understanding of color and line, would produce objectively better packages. "The more competent a designer is, in fact," *Fortune* lamented, "the more his designs are apt to frighten the manufacturer by their modernism." To retreat to older, largely sentimental aesthetics would be to forgo all the economic and cultural advantages of rational design.[48]

Designers' hypothetical authority to overrule commercial and industrial concerns grew from their claims to both artistic autonomy and scientific expertise. *Fortune* insisted that these qualities should empower designers to overrule the conservative tastes and short-term profit goals of business owners. For one, the designer simply knew more about color, line, and beauty than the manufacturer, and it was sentimental folly for that manufacturer to ignore such artistic expertise. "Executives who would not dream of writing their own ads," complained one story, "continue to use packages designed by the revered founder of the company." Given the short-term demands of the market and the "innate conservatism of the American businessman in

matters of art," individual designers had to be granted control over their work to ensure the "honesty" of functionalist design. Likewise, *Fortune* often bestowed on designers the badge of scientific authority. The best designers, like the pioneering package designer Joseph Sinel, approached "[their] 'problems' with the personality of an engineer or scientist." Industrial design was not a matter of "haphazard" empirical guesswork but rather laboratory tests involving engineering, physics, even psychology. "Casehardened empiricists may sniff at mechanical color contrivances," *Fortune* asserted, making what to modern readers might sound like a caricature of its own argument. "But the days of their sniffing are numbered. . . . Toward the mathematical expression, the scientific colorist now feels his way." Scientific specialization gave designers an expertise that could not be equaled by an untrained businessperson. The line between the designer and the innovative engineer, in fact, was quite thin. "There Are No Automobiles," for instance, claimed that the modern car was still a "horseless carriage." Functionalist thinking was changing this, however. By employing the "laboratory spirit" and abandoning piecemeal solutions and traditional forms, innovative engineers and designers were creating cars that would fit modern functions and materials.[49]

Not surprisingly, in proclaiming the need for business owners' to recognize the authority of designers, *Fortune* elided the inevitable friction between designer autonomy and market values. The tension between selling and functionalist ideals leaked into most of *Fortune*'s articles about functionalist aesthetics. On the one hand, *Fortune* maintained that only a truly functional design, not just a surface-level alteration of style, would produce significant changes. On the other hand, the magazine was unable to ignore the needs of the managers who were hiring the designers. Recognizing (sometimes) that simply reiterating its faith in the unity of beauty, use, and profit would not solve this problem, the magazine suppressed these tensions in the same way it explained the failures of the New Era and the business gentleman: by projecting the public triumph of functionalism into the future. For the present, *Fortune* often advocated temporary and limited compromise on the part of the designer. Rather than see his designs thrown away as "too advanced," the package designer was encouraged to "compromise somewhat, keeping far enough ahead of the times to be effective but not so far as to become terrifying." In the long term, however, a full public acceptance of "Modernism" would dissolve the conflicts of interest between sales people and designers. According to *Fortune*, the public needed only time and exposure to the new design before it would wholeheartedly

embrace an aesthetic that was objectively more relevant, coherent, and beautiful than the hodgepodge of sentimental styles that were current then in the United States. The public, as "The Bed Significant" stated, merely needed to be "made conscious of what it really wanted." In a piece that won *Fortune*'s "Industry and Art" essay contest (and a $1,000 prize), Catherine Bauer described the popular reaction to a functionalist apartment complex in Germany:

> The public, shocked at first, rose to the occasion, used their eyes, and presently discovered for themselves that Mr. May's unornamented concrete blocks were not only full of light, air, and modern convenience, but actually far handsomer than the unachievable cottage ideal that they may have been hazily cherishing.

By producing exemplary products and deliberately exposing people to functionalist design, the designer could correct citizens' false aesthetic tastes, and in doing so, and make functionalist design profitable.[50]

This recognition of a temporary conflict between rational, efficient designers and the marketplace was of limited importance, however. Because it projected the arrival of a solution in the near future, it failed to disrupt the key message of the magazine's discourse on functionalism and the industrial designer: that *Fortune*'s New Era would not only produce an efficient, stable economy and widely distributed abundance but that the expert knowledge of professionals would be a central factor in leading the nation there. Professionals' anxiety about their role within corporate capitalism would be solved, like the industrial designer's conflicts with the marketplace, by the arrival of the New Era. Like its larger discourse on commercial art, *Fortune*'s discussion of functionalist design sought to convince its readers that corporate liberalism not only provided a way for the professional class to eliminate the tensions between its ideals and the corporate environment, but it also offered an opportunity for professionals to gain new authority as members of an elite coalition between corporate capitalists and the professional managerial class.

CORPORATE LIBERALISM IN CRISIS

Fortune could not ignore the Depression forever. Herbert Hoover, insistent in his optimism and his devotion to voluntarism, had ignored even the pleas of his own relief advisers, and his name had soon become synonymous with indifference and cruelty. In 1932 conditions only worsened. In the spring of that year a Senate probe into business practices discovered a host of what today might be called "irregularities," including the fact that J. P. Morgan and his partners had paid no federal income tax for two years. That summer U.S. federal troops, led by General Douglas MacArthur and armed with tanks, a cavalry, and bayonets, drove out of Washington, D.C., a camp of nearly ten thousand former soldiers who were requesting immediate payment of a veteran's bonus. Even worse, when the economy hit a low point that winter, unemployment reached over 25 percent and relief agencies began to run dry: large cities like Atlanta and St. Louis simply cut families off the relief rolls, blacks often received no aid at all, and in New York the monthly pay averaged just over eight dollars a month. As a dangerously angry mood began to emerge among the working class, farmers, and the unemployed, *Fortune* recognized that no references to the New Era or business cycles were capable of softening the sudden poverty worrying a significant proportion of the citizenry.[1]

Not surprisingly, the rhetoric and voluntaristic policies of corporate liberalism eventually succumbed to the Depression. "Service" and "business statesmanship" faded along with the prosperity, and, by 1932, most corporations had dropped their corporate welfare programs. One might easily imagine that these changes signaled the end of corporate liberal ideology. To do so, however, is to fail to recognize the coherence and substance of corporate liberal ideals and thus to overstate *Fortune*'s transformation. The severity of the Depression certainly created an altered tone in the magazine.

As Robert Elson notes, a "marked change in *Fortune*'s emphasis" occurred around 1933. But corporate liberalism, more than simply a manifestation of speculative exuberance of the twenties, represented an earnest attempt to adapt business attitudes to the changing conditions of corporate capitalism. Luce and other corporate liberals were searching for a legitimate moral basis for capitalism as well as a stable, efficient marketplace. The Depression, if anything, intensified these searches. While forgoing the self-regulatory policies of the late twenties and dropping its focus on high culture and aristocratic wealth, *Fortune* continued to explore ways to reconcile business and public needs in response to a "new" capitalism. The changes in *Fortune*'s policies display not "an alteration of fundamental assumptions," as Archibald MacLeish would later claim, but the adaptations of a coherent corporate liberalism to a shifting political and social environment.[2]

Indeed, until the dissolution of the National Recovery Administration in 1934–35, the magazine insisted that centralization, cooperation, and scientific planning would allow corporate managers and other professionals to lead the nation down the road to progress. The key changes, however, were the magazine's recognition of the need for government intervention and its new, broader view of the nation. Forgoing its hope for a business-centered society, *Fortune* acknowledged not only the limits of business leadership but also the variety and size of the American population. Still devoted to the planning and stability of the elite coalition, the magazine celebrated the increasing role of government and public professionals, as representatives of the public, in shaping this coalition. The business-centered society, embodied in the voluntary business association, gave way to a nation-centered commonwealth, exemplified by the business-government cooperation of the NRA.

Only under the weight of the collapsing NRA in 1934–35 did the magazine's faith in the power of cooperation and organization finally begin to crack. As business turned away from the New Deal in the second half of Roosevelt's first term, corporate liberals lost their sense of direction. Never again would *Fortune* so unproblematically combine its hope for a rationalized and planned society with the principles of capitalism and individualism.

The Collapse of the Business-Centered Society

The economic crisis of the thirties forced *Fortune* to recognize the failures of voluntary business leadership. Whereas in its first years the magazine had often linked corporate and public interest, after 1932 it began to

recognize the spuriousness of this equation. The magazine defended Alcoa's aluminum monopoly in 1930 but, four years later, indicted the corporation for using "every advantage of size and wealth and integration to worry its less fortunate rivals." Another essay admitted that "the Pennsylvania [railroad's] behavior and a national view of transportation problems cannot be expected to coincide except by accident or compulsion. It is not by consecrating yourself to so vague a concept as the 'public interest' that you build up the greatest railroad system in the U.S." And perhaps the most famous *Fortune* story of the decade, "Arms and the Men," attacked European munitions makers for their role in encouraging war against the interests of their own nations.[3]

But this recognition of the separation of corporate and public interest was less an assault on business than an acknowledgement of its limitations. Business was not a villain: it was just not as powerful as *Fortune* had claimed. "The indictment of the corporate manager," the magazine insisted, "results mostly from a confusion of corporate size with corporate power." This was the very confusion that had led corporate liberals in the twenties to believe they could control the economy through self-regulation. But the Depression disabused corporate liberals of this illusion of power: "So long as we are operating under a competitive system, and so long as the corporate president loses his authority the instant he leaves the confines of his own corporation, you cannot look to the corporate manager for leadership." The real achievement of corporate management in the twenties had not been social and political leadership, but the "best automobiles and the best canned tomatoes and the best bathtubs and the best telephone and electric-light service in the world." The question of how to bring these products to as many Americans as possible, *Fortune* now insisted, would have to be addressed by both government and business.[4]

Nothing demonstrated this ideological shift away from the business-centered society more than the magazine's rejection of the ideal of a gentlemanly business culture. In the first years of the thirties *Fortune* had sought to create a business aristocracy that would bring American business into the New Era. This attempt to use ethics and culture to control economic leadership, however, points to the key weaknesses of corporate liberal strategy in the twenties and early thirties. In attempting to ease competition and inefficiency by changing the personal behavior of managers, *Fortune* ignored the actual structure of the market. Particularly as the economy collapsed, business people, even those who strongly professed corporate liberal ideals, were unable to make long-term, "responsible" decisions in the face of a

market that remained fiercely competitive, and corporate liberals had no structural authority to enforce their voluntary agenda. Furthermore, in its efforts to create as large a coalition as possible, *Fortune* failed to define adequately the relationship between gentlemanly behavior and the profit motive. As a result, it did not provide a recognizable model for reacting to economic crisis. When the Depression forced managers to choose between profit and "service," between survival and "gentlemanliness," most had no option but to work for the short-term health of their own company. The problem with the self-regulation of the twenties, *Fortune* lamented in retrospect, was that "only 60 per cent of the agreers were gentlemen. Thirty per cent merely acted like gentlemen. And 10 per cent neither were nor acted like gentlemen." Held together only by gentlemanly obligations, voluntary trade associations and corporate welfare programs virtually disappeared as the Depression deepened.[5]

The first problem with the gentlemanly business culture was that it proposed a personal solution to a structural problem. Corporate liberals in the twenties, as I have argued, had to defend themselves against accusations of single-mindedness and shallowness. They did this primarily by portraying business gentlemen as cultured, professional, and broad-minded: the rise of business statesmen such as Owen Young and Walter Teagle proved that the age of Babbitt was slipping away. More serious business critiques of the interwar years, though, were aimed at the economic system itself. Critics such as Thorstein Veblen, John Dewey, and Adolf Berle even agreed with corporate liberals that a profound and potentially beneficial change had occurred in the structure of capitalism. These critics, however, insisted that the revolutionary size of the corporation demanded not a new business culture but new regulatory structures that would control corporations in the interest of the public. Oddly, however, the response of corporate liberals to this critique was the same as their defense of businessmen's single-mindedness. Their solution to the problems of the New Era was always formulated in personal terms. Eschewing the structural changes suggested by Veblen, Dewey, and Berle, they claimed that enlightened leadership alone could ease the nation into the New Era. The central corporate liberal policies of the twenties depended almost exclusively on the voluntary measures of broad-minded executives, such as business associations, corporate welfare programs, and employee representation boards. As corporate managers devoted themselves to service, corporations themselves would become more ethical and even personable. In articles such as "A.T. & T as Citizen," *For-*

tune gave "testimony to the place, substantial yet intimate" that corporations "hold in American life." Like the "trustee," corporations would jettison the selfishness and impersonal materialism of a passing age, and assume a socially responsible place in a thriving American civilization.[6]

To their credit, corporate liberals did realize that in a consumer economy both the public and business would benefit from a more stable economy and a wider distribution of wealth. But in the twenties neither corporate liberals nor the wider business community were willing to subject themselves to any outside authority in order to realize these changes. Since corporate liberals refused to abdicate any corporate control, service and trusteeship were ideas that depended exclusively on the gentlemanly behavior of individual managers. Thus the response of corporate liberals to the social mockery of Lewis and Mencken served also as their answer to political critics like Veblen and Dewey. It is fitting that Mencken blamed many of the failures of the United States—its "third-rate" heroes, its corrupt political system, and its substandard culture—on the "lack of a civilized aristocracy." An aristocracy, he insisted, would provide a set of stable standards and an opportunity for innovation unhindered by the innately conservative masses. *Fortune* hoped that the same business aristocracy that would banish the embarrassing crassness and selfishness of the "booboisie" would also transform corporations into beneficent and responsive social institutions without significant outside regulation.[7]

The second major fault of *Fortune*'s cultural strategy was its ideological vagueness. In its efforts to make collecting attractive to business people, for instance, *Fortune* insisted that investment was an important motivation in collecting. But this idea was in tension with the magazine's assurance that taste revealed itself in the ability to separate value from price. The latter implied that price was misleading and faddish, while the former celebrated the coexistence of aesthetic value and exchange value. An article on Rembrandt tried to walk a line between these two ideas. While it acknowledged—in accord with the "tasteful" separation of price and value—that there could be no "direct connection between the financial and aesthetic value of a work," the article asserted that each value did influence the other. In fact, *Fortune* argued, this intertwining of the price and value had been a benefit both to financiers and to admirers of art. The financial success of one Rembrandt painting—it had been sold in 1913 for $200,000—had reenlivened critical evaluations of the work, and brought it back into the sight of critics. The object's entrance into the commodity market, far from ruining

the uniqueness of the painting, had both shown it to be a successful investment and made it even more special and noteworthy as a work of art.[8]

In other cases, however, profit-minded business practices hindered the long-term goal of connecting business to "gentlemanly" culture. "Good Taste in Advertising" examined the conflict between advertisers who favored "dignity" in advertising and those who celebrated the profits of the hard sell. *Fortune* sided against Lucky Strike and other hard-selling advertisers, declaring that "when everything that can be said for the Lucky Strike type of advertising . . . is said, one feels that the element of good taste cannot be so disregarded without a result which is, on the whole, regrettable." Predictably the magazine favored "gentlemanly" ads for their long-term efficacy and good taste. And yet, even within this essay, *Fortune* undermined its judgment by repeatedly praising the selling success of the Lucky ads. "The cigarette series [of ads] unquestionably possessed one vital quality which frequently is fatally absent from *nice* advertisement. That was the quality of force, of power." Business readers would have finished the article certain that hard-sell ads would be better for their bottom line. Profit and taste, price and value, were not always easily reconciled.[9]

The confusion between these two ideas parallels a weakness in the economic ideas of corporate liberals. Just as *Fortune* posited a transcendent value to an object while still celebrating its presence as a priced commodity, corporate liberals pledged allegiance to service while insisting that the profit motive was essential to further progress. And just as "Good Taste in Advertising" seemed unsure of how taste and advertising effectiveness fit together, the relationship between service and profit was muddled. "Precisely what 'service' meant," writes Herman Krooss, "remained a riddle throughout the [twenties]." Some corporate liberals, like Edward Filene, argued that it consisted of producing a good product using fair business practices; others, like Bruce Barton, saw it primarily as a way to imbue business with a set of nonmaterialist values; still others, like Owen Young, imagined a more committed service that grew from a complete change in the role of the manager. Each of these positions insisted that profit and service were compatible, but the relationship between the two was different in each. Similarly *Fortune* attempted to reconcile commercialism and value but never seemed sure of how to do it.[10]

Fortune's organizing strategy compounded this ideological ambiguity. In order for cooperation and service to be effective in rationalizing markets and creating a consumer economy, corporate liberals felt that they needed to create a business culture that unified all businesspeople. Rec-

ognizing that the single-minded materialism of conservative business was unsatisfying and unstable, but not wanting to alienate those conservatives, *Fortune* and corporate liberals rallied around inclusive but vague terms like "gentleman," "service," and "value." The positive result of this strategy was that corporate liberal rhetoric was quite common in the late twenties and early thirties. And, as Roland Marchand argues, the corporate articulation of service ethics likely did change behavior to some degree: H. A. Overstreet's hope that business managers would become more civic-minded through the simple repetition of the word "service" was surely overly optimistic, but the corporate liberal desire to change behavior by shifting the tone of business culture seems a tenable strategy. But because of the vagueness of the rhetoric of "service," few of those who spoke it were committed to the more substantial corporate liberal ideas of people like Owen Young, Gerard Swope, and Henry Luce. In declining to specify the meanings of "service" and "gentleman," corporate liberals created a large coalition. But the vagueness of the relationship between these ideals and profit gave those ideals little practical power in the face of an economic crisis. Too few of the businesspeople speaking corporate liberal language were willing to make substantial changes in the name of "service."[11]

When difficult times arrived, most corporations dropped their corporate welfare programs and ignored any restrictions imposed by trade associations. Even in the twenties the expense and management of corporate welfare limited its use to large prosperous companies. Likewise, trade associations suffered from their inability to enforce trade agreements and the reluctance of individual companies to abdicate their sovereignty to either the association or a government overseer. In addition, both these strategies for market stability were undermined by continued competition: unilateral implementation of corporate welfare created higher costs than competitors', and, as Colin Gordon notes, corporations often saw industrial organization as an "opportunity for exploitation and competitive advantage." The Depression only exacerbated these problems, as companies searched for any competitive edge or way to cut costs. Even plants with well-established welfare programs found themselves the object not only of labor activism but also of their workers' violent anger. When the Depression deepened, business dropped the self-regulatory strategies of corporate liberalism: union-management cooperation, corporate welfare, and business associationalism. Echoing *Fortune*, Myron Taylor acknowledged that, despite its size and corporate liberal strategies, U.S. Steel was "at the mercy of business

just like any other corporation." The Depression awoke corporate liberals
from the dream of business leadership.[12]

By 1933 *Fortune* had recognized the failure of a gentlemanly business
culture to improve the social responsibility of business managers. "U.S.
Corporate Management" reconciled itself to some form of government in-
tervention in the economy, and reasoned that, in a profit system, it was fu-
tile to try to temper business managers' single-mindedness. With the bitter
sarcasm of one recently disillusioned, *Fortune* looked back on the corporate
liberal ideal of gentlemanly service:

> Perhaps we need an industrial Legion of Honor with a ribbon for the so-
> cially sensitive manager to wear on his chest. Perhaps the man who paid
> the highest wages should be the newspaper headliner and not the man
> who made the biggest mergers. Or perhaps there is nothing in any such
> theory, and the corporate system is rooted in the acquisitive instinct and
> not in the general good.

With this recognition, the magazine gradually dropped its articles on col-
lecting and connoisseurship. While five major essays appeared in 1930, and
three each in 1931 and 1932, the last two were published in 1933, and one of
those was a tongue-in-cheek article about collecting cigar labels. In addi-
tion, other pieces on gentlemanly culture, such as those on large gardens,
hunting clubs, and trout fishing, disappeared. "It might have been differ-
ent," *Fortune* noted, "if the boom had been sufficiently prolonged for the
corporate managers to have mellowed into something approaching an aris-
tocracy, but it takes at least a generation of security before any group of in-
dividuals develops a class consciousness." *Fortune*'s attempt to nurture an
American aristocracy had been disrupted by the Depression.[13]

The Emergence of the Nation-Centered Society

Abandoning the ideal of a business-centered society, corporate liberals
moved toward the Americanism that would dominate public discourse in
the United States in the late thirties. While MacLeish overstated the extent
of the ideological change at *Fortune*, he did identify its direction:

> The first *Fortune*, the *Fortune* of the prospectuses, had been conceived in
> the spirit of Calvin Coolidge's famous and fatuous remark that "the busi-
> ness of America is business." The second *Fortune*, the *Fortune* of the

great depression, changed the quip to read: "the business of American business is America."

In other words, whereas the old *Fortune* was to have concerned itself with business for the sake of business, the new *Fortune* would report on the world of business as an expression—a peculiarly enlightened expression—of the changing world. Indeed, the new subject of the magazine was the United States itself, as an economic unit and as a culture. The original concentration on individual businesses and elite culture was now complemented with stories on politics, national economics, and social issues. In 1930 a full 50 percent of feature articles concentrated on business and 14 percent on elite culture, while only 9 percent addressed national economics, social issues, or politics. In 1935, however, the percentage of business articles had slipped to 43 percent, those on elite culture had disappeared, and the space devoted to economic, social, and political essays had tripled to 30 percent. A concentration on the concerns of the elite classes began to give way to an interest in American social movements, political debates, and even folk cultures. In the early days of the New Deal *Fortune*'s broadened vision of the nation replaced its earlier understanding of a business-centered society.[14]

But even as the magazine's hopes for voluntary business leadership faded, corporate liberalism did not disappear. During the short life of the National Recovery Administration, in fact, it was the law of the land. After the experience of the twenties, the difficulty of enforcing trade association agreements encouraged many corporate liberals to turn to the government for help. In 1931 the corporate liberal president of General Electric, Gerard Swope, published the "Swope Plan," a blueprint for a program of federally regulated trade associations or business cartels. The NRA, the centerpiece of Roosevelt's "first" New Deal, federalized the private business organizations of the earlier decade and, in doing so, replicated in practice many aspects of the "Swope Plan." The NRA initially promised to give corporations a great deal of control over the economy. Outmaneuvering and out-resourcing antitrust and government planning proponents in the struggle for Roosevelt's favor, big business leaders took control of the NRA's authority to create "fair codes of competition," and worked to stabilize markets through price and production controls. Trade associations not only formulated their own rules, but they were also granted the necessary government power to enforce those rules: in theory, business would retain control but would gain the authority of the state. Not surprisingly, in its first months many business

leaders optimistically imagined the NRA as the "triumph of industrial self-government." Bruce Barton, for example, praised the NRA as cultivating "group thinking amongst businessmen." *Fortune,* too, expressed a strong faith in Roosevelt and the NRA, maintaining that Roosevelt was firmly grounded in "American" principles and that the NRA was designed "to preserve a profit system operating under the eye of a kind of public conscience."[15]

Corporate liberals' cooperation with the New Deal, however, was not limited to the NRA. In 1933 *Fortune* called for a board of corporate executives and government representatives that could create legislation "not in restraint of trade, but in restraint of unregulated production and competition." In a matter of months, secretary of commerce Daniel Roper would create just such a board, the corporate liberal-dominated Business Advisory Council (BAC), headed by Swope. The BAC, as Robert Collins notes, aimed to assemble a group of "far-sighted businessmen with a broad public conception of the obligations of business," who would establish a line of communication between the business community and government. Furthermore, *Fortune,* along with other corporate liberals such as Swope, Young, and Walter Teagle, consistently supported the federalization of social welfare programs such as unemployment relief and social security. By increasing consumer wealth and "even[ing] out the competitive disparities resulting from two decades of private and state-level experimentation with work benefits," Colin Gordon notes, these programs served practical business interests. But just as corporate liberals in the twenties had combined practical and ethical reasoning to justify their programs, *Fortune* often expressed the need for housing, unemployment, and old-age relief in terms of moral necessity. "The tenement history of [New York City]," contended one *Fortune* story, "is one of the most shameful of human records." *Fortune* in the first years of Roosevelt's presidency routinely maintained that government, whether in the form of social welfare programs or larger regional projects like the Tennessee Valley Authority or the Port of New York Authority, could help to rectify the inequalities created by capitalism.[16]

But unlike the stand *Fortune* defended in the late thirties and forties, before 1935 the magazine continued to glorify with few reservations the possibilities of centralized planning and large bureaucratic organization: although viewing the United States as nation-centered rather than business-centered, still it imagined the nation as "centered" rather than wholly pluralist. For example, the magazine continued to celebrate what Marshall Berman called the "titanic work of economic development,"

whether in the form of a dam, a skyscraper, or a huge factory, as a symbol of the transformation of a chaotic laissez-faire economy into the organized New Era. This fascination continued into the Depression, even as the focus moved from business to government projects. Major stories about Russia (1932) and Japan (1933), and entire issues devoted to Italy (1934) and Japan (1936), marveled how these countries were "shaped anew by a self-conscious effort at economic modernization." Especially after 1933 features on government projects such as the Port of New York Authority (1933), the Tennessee Valley Authority (1933, 1935), and Hoover Dam (repeatedly) admired the work of "public agencies, with none of the vices of bureaucracy, engaged in remedying the evils of unrestricted competition by proving factually and in action that those evils are avoidable." With enthusiasm equal to its support of earlier capitalist "development," *Fortune* celebrated public efforts to order imaginatively the chaos of a competitive market.[17]

In rejecting the business-centered society and devoting increased attention to the works of the federal government, *Fortune* was responding to the undeniable shift of energies in the United States in 1933 and 1934. The first spring of Roosevelt's administration brought an "immense sense of movement" to a nation whose despondency had reached a peak the previous winter. Even Luce was caught up in the excitement, exclaiming to MacLeish, "My God! What a man!" after the two had met with the newly inaugurated president. While business's reputation plummeted, Washington, D.C., became the center of national activity. The historian William Leuchtenburg likened the activity of the spring of 1933 to the building of an expert-staffed army: "From state agricultural colleges and university campuses, from law faculties and social work schools, the young men flocked to Washington to take part in the new mobilization." *Fortune* agreed, maintaining that just as engineers had been drawn to Detroit in the twenties, these professionals entered government service impelled "in part by the excitement in Washington, and in part by the lack of excitement elsewhere." Even university admissions deans reported that students, no longer interested in business courses, were seeking out classes that "would point them toward 'the brain trust.'" As Washington, not Detroit or New York or Pittsburgh, became the center of the nation's attention, *Fortune* shifted its gaze as well.[18]

This new emphasis created a changed sense of the ideal corporate professional. As I suggested in the previous chapter, *Fortune*'s article about the painter Edward Bruce in 1931 exemplified the magazine's attempt to convince professional readers to adapt their values to a business civilization.

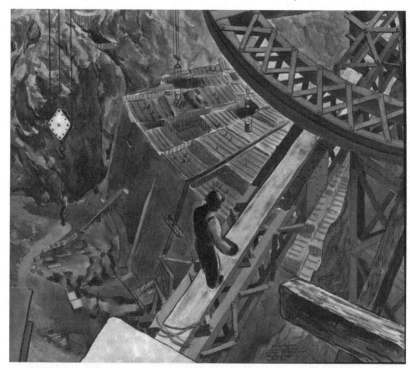

Stanley Wood, Knee-high to Its Future, Fortune 9 (May 1934): 93. As the Depression deepened, Fortune began to celebrate not only the monumental projects of development capitalism but also those of government agencies. The magazine also recognized the legitimacy of artists whose work was not directly connected to industry, including those who received state support. A portfolio of paintings by Stanley Wood of the Public Works of Art Project, which accompanied an essay on the Boulder Dam, exemplified these two broadenings of Fortune's vision.

But if it had followed up on Bruce in 1934, the magazine would surely have told a different story. By 1933 Bruce had gained sufficient notoriety to be noticed by the U.S. government, and in that year President Roosevelt appointed him director of the Public Works of Art Project. Bruce's move from businessman painter to federal arts manager paralleled a shift in the balance of power within the elite coalition. As *Fortune* retreated from the idea of a business-centered society, it proposed a broader relationship between the professional and the corporate environment. The magazine widened its understanding of the legitimate arena for professional activity. Still insisting that professionals must actively engage themselves with the present world, it acknowledged that their expert planning and social responsibility would be well utilized in government service as well as in the corporate environment. Accompanying this change was a reformed sense of the relationship between the market and the artist. The *Fortune* artist after 1932, like the government professional, mixed a healthy understanding of the benefits and operation of the commercial system with a newfound autonomy and public acclaim. As the easy reconciliation of the capitalist environment and professional values associated with the business-centered society faltered after 1932, *Fortune* promoted a more complex understanding of the relationship between capitalism and professionalism within the elite coalition.

In the first years of the New Deal, public service as a career for young professionals garnered considerable enthusiasm from the magazine. Felix Frankfurter, for example, echoed Luce when he argued in *Fortune* that public work provided a worthy challenge to talented members of the educated class. Its reward, he claimed, was "not money, but opportunity for men of genuine ability to do really useful work and to try their mettle on problems worthy of their best power." The magazine defended the "widely published names" of the intellectuals in Roosevelt's administration, arguing that these men were pragmatic, public-spirited professionals who in the long run would help business succeed. Indeed, *Fortune* argued that the professional class should enter government at all levels. Praising the British foreign service system for the opportunity it provided talented, well-educated young men to serve their government and gain the status of the "highest-grade citizens," the magazine proposed a similarly professionalized system in America. Finally, *Fortune* celebrated the potential contributions that noncorporate professionals outside the state could make to business and the public. The magazine even celebrated academic pursuits—anthropology, archeology, and "pure" science—as long as professors communicated their findings with the general public and focused on large questions rather than

specialized trivialities. Often referring to a "younger group" of professionals who combined personal ambition, idealistic public service, and pragmatic techniques, *Fortune* expanded the limits of its world to include the public as well as the commercial sector. In providing a sense of motivation for young, talented middle-class men and in promising to improve the fairness and efficiency of American capitalism, an influx of young professionals into the public sphere would duplicate the advantages of the business aristocracy.[19]

Fortune's artists, like professionals in the mid-thirties, branched out from the corporate world, both in patronage and subject. Much as it had praised the New Deal for providing "useful work" to young professionals, *Fortune* lauded the Public Works of Art Project for "recognizing [artists'] dignity as useful members of the State" and encouraging "a new, self-aware, indigenous, and powerful movement in art." While the magazine's argument that art should be masculine, modern, and relevant did not change, the spectrum of desirable subjects broadened from industry to the wider American political and cultural scene. *Fortune* reproduced a series of Grant Wood murals, based on Daniel Webster's statement, "When tillage begins, other arts follows," that stressed the importance of small communities and individuals over business. Yet the magazine heralded the murals as a "comprehensive" portrait of America. And while the magazine continued to include photographs and paintings of factories and industrial processes, the crisp industrial style of Margaret Bourke-White's industrial photographs increasingly shared the spotlight with regionalist and American scene styles. Finally, *Fortune* began publishing collections of paintings unrelated to industry. Sample collections from the 1933 Chicago World's Fair, the Museum of Modern Art, a traveling exhibition of Soviet art, and contemporary U.S. painting, for example, all appeared in the mid-thirties. Artists no longer had to adapt their subject, technique, or style to business in order to be recognized by *Fortune*.[20]

The expansion of the "real" world brought a much wider range of artists into *Fortune*. In the first years of *Fortune* the editors had focused on two types of contemporary artistic production: businesses that produced commercial art on a large scale (General Bronze, Wurlitzer organs, stained glass, film) and the usually obscure artist who had taken industry as his subject (Max Kalish's statues of workers, Sheldon Pennoyer's paintings of trains, Griffith Baily Coale's Manhattan shipyard mural). By the mid-decade, coverage of these two types of "industrial" art faded as the magazine began to emphasize well-known individuals who worked collaboratively and were commercially successful but who were less visibly connected to

industry. Lesser-known painters continued to illustrate articles, but those il-
lustrations were now rarely supplemented with information about the artist.
Reproductions of collections, however, introduced readers to contemporary
modernist painters, some of them well known. Meanwhile, after 1932, fea-
tures on large-scale commercial art, such as the theater business, radio, and
film, focused less on aesthetics and more on economics. For example,
while "U.S. Organ" in 1931 had been structured around the debates be-
tween "modernism and classicism" among organ makers, listeners, and
players, "Here Are the Steinways and How They Grew" paid little attention
to the art of making or playing pianos, and instead chronicled the firm's
success in retaining a good reputation and solid sales in a "hard-pressed,
muddled industry." Similarly "And All Because They're Smart," a June 1935
essay on CBS, celebrated that network's phenomenal growth in financial
terms, while mocking NBC's contention that its purpose was to "dissemi-
nate culture to the masses." *Fortune* no longer assumed that corporations
would be primary sources of contemporary art.[21]

The recognition that the interests of art and business, like those of the
public and business, were not always in unison spurred *Fortune* to encour-
age a balance between artistic vision and business values. On the one hand,
the magazine acknowledged that there was no coincidence of artistic and
commercial needs. Features on "low arts," such as cartooning and bur-
lesque, lamented the effects that "scrambling for any kind of dough" can
have on art. "The Business of Burlesque, A.D. 1935" opened by suggesting
that the stripper was in some ways "an artist." On the other hand, the essay
closed on a note of realism: in an environment of low wages and shaky prof-
its, "creative art—even of the lowest order—is not likely to flourish." While
the *Fortune* artists of the early thirties adapted their work to the needs and
values of business, the new ideal artists produced their art independently
and were successful because their audiences recognized the quality of that
work. Good jazz, for example, "has never been dependent on widespread
popular favor. It is played because certain men like to play it, and it is
played in public because a sufficient number of laymen have always shared
the musicians' pleasure." Rather than catering to business, artists appealed
to their audience through quality.[22]

But the magazine's portrayal of the publishing industry illustrated that
the tension between commercialism and art by no means implied that they
could or should be completely separated. Publishing, *Fortune* claimed, was
a business "overly sentimental about itself." Publishers were too attached to
traditional, fussy manners to modernize their industry and often allowed

their sentiments to trump their business sense. As a contrast, two essays argued that two book publishers—Doubleday, Doran, and Company and Simon and Schuster—rejected the "dry-rot and dilettantism" of most houses. Instead of sitting on a stale backlist and selling it to the same elite audience, these two publishing companies searched out "new fields to conquer," and used aggressive "schemes" and "stunts" to sell more books. The article on Simon and Schuster compared the company favorably with the "hardboiled" Doubleday, Doran and Company, and quoted Sinclair Lewis's opinion of the latter to demonstrate their business-mindedness: "I like you. You're so God-damned *commercial.*" This financial aggressiveness gave these two firms a masculinity lacking in the industry as a whole. Publishing was a "tumultuous little world [that] has an unhealthy quota of fussy old men and effeminate young ones," but Nelson Doubleday was a "great rock unmoved by the swirling tides . . . a man six feet five inches tall, who weighs 220 pounds, who has shoulders like a wrestler and a waist like a movie star." The word "vigorous" appeared repeatedly to describe commercial literary ventures: Richard Simon and Lincoln Schuster were "young, vigorous, full of ideas"; Doubleday's book list was "vigorous and highly salable"; *Cosmopolitan's* editor, Ray Long, had "shrewd, vigorous tastes"; even comic strips provided a "crude but vigorous satire." An embrace of the commercial world allowed cultural producers to escape the still effeminate world of aesthetes and academics.[23]

To demonstrate the ideal balance between business and art, the magazine spotlighted well-known artists, such as Duke Ellington, Walt Disney, and a host of contemporary painters who embraced the mood of modern industry—hard work, collaboration, legibility, and commercial success—while retaining a more firm sense of artistic integrity. *Fortune* marveled at Ellington's clever management and impressive profits, and Disney had proven himself a shrewd businessman. The art of both, too, depended on a complex collaborative effort: in Ellington's band, for instance, "each man has his say," and a Disney cartoon required a factory-like production line. Yet each managed to balance its "industrial" characteristics with a profound personal vision. Both Ellington and Disney worked in businesses whose products, *Fortune* asserted, were often unremarkable and sentimental. But Ellington differed from Rudy Vallee and Guy Lombardo in that he offered "rich, original music, music of pulse and gusto, stemming out of the lyricism of the Negro and played with great virtuosity." Disney bettered his money-chasing competitors by remaining an "artist and a craftsman." Grant Wood's murals, too, embodied this balance of corporate organization and

individual expression: "This work of art is no mere blare of the imagination: it is the product of an imagination humbly and willingly subjected to the criticism of a group imagination, and to the hard facts of contemporary history" and yet "the whole appears to be—and is—the work of one artist." *Fortune*'s new ideal artist succeeded in overcoming the tensions between artistic and market values to produce work that was both honest and connected to the "real" world.[24]

•

The idealistic young professionals working in government, academic, and artistic circles, however, were not the only new group whose energy grabbed the attention of *Fortune* and the nation during the first Roosevelt administration. The plight of the unemployed, the anger of farmers, and the rise of labor radicalism all made the population outside the elite coalition impossible to ignore. The spectacles of breadlines and the Bonus Marchers' expulsion, of swirling Oklahoma dust and crowds of farmers protecting foreclosed farms, of striking workers overturning streetcars in Milwaukee and shutting down the textile industry simultaneously in twenty states all brought "the people" to the forefront. Suffering from unemployment, drought, and instability, the nation's lower classes began to demand the attention of their employers, the government, and the media.[25]

This "discovery" of the American working class and underclass was nowhere as strong as in the artistic community. The documentary form sought not only to show the nation the faces of the average man but, as Laura Browder writes, to create a "kinship for the reader with other Americans." This aim captivated artists from Sherwood Anderson to Edmund Wilson, from Margaret Bourke-White to Walker Evans. In 1933 the film *I Am a Fugitive from a Chain Gang* portrayed the horrific experience of an innocent man in a southern prison system. Political exposés like *The Plight of the Sharecroppers* spurred an outpouring of material on the effects of the farming crisis, including Bourke-White and Erskine Caldwell's *You Have Seen Their Faces* and Pare Lorenz's *The Plow That Broke the Plains*. The documentary style became so prevalent by the mid-thirties that it has often been described as *the* style of the American thirties. But the often rural-directed documentary was balanced by a complementary interest in the urban underclass. Mike Gold's *Jews without Money* and James Farrell's Studs Lonigan trilogy, for instance, spurred the proletarian literature movement, which blossomed particularly in the mid-thirties. This desire to understand the urban underworld inspired not only these leftist realist novels but also the *noir* of Horace McCoy's *They Shoot Horses, Don't They?*, the

ghetto pastoral of Henry Roth's *Call It Sleep*, and the seamy underworld of Raymond Chandler's crime novels. Although directed at different populations, Marcus Klein writes, both the proletarian and documentary modes were "celebrations of the vitality and morality of the lower depths" of U.S. society by artistic professionals. Seeking to identify the reader and the writer with the rediscovered "forgotten man," both formats asserted, with Granville Hicks in his introduction to the 1935 anthology *Proletarian Literature in the United States*, that "American workers, farmers, and professionals are the true nation."[26]

Fortune joined these artists in their interest in the forgotten man. The emergency of the Depression justified the staff's desire to expand the boundaries of their writing to include social and political issues. The social and economic disaster, in the words of MacLeish, "made [*Fortune*] a general magazine in fact, whatever it was in name . . . [and] encouraged *Fortune*'s writers . . . to enlarge their frontiers." After 1932 *Fortune* expanded its editorial scope to include the concerns and lives of those outside the elite classes. As the Depression deepened, the magazine's focus on the "aristocratic" members of society gradually yielded to a broader concern with the everyday lives of the unemployed, laborers, and farmers. The documentary mode became central to *Fortune*'s reporting and photography. The documentary mode fascinated the staff, members of which would produce in the late thirties perhaps the three most notable word/photography books of the decade—Archibald MacLeish's *Land of the Free*, Margaret Bourke-White's *You Have Seen Their Faces* (with Erskine Caldwell), and James Agee's *Let Us Now Praise Famous Men* (with Walker Evans).[27]

Fortune's expanded vision of the people displayed itself most clearly in its reporting on the Depression. As late as the start of 1932, *Fortune* looked at the economic collapse and saw few signs of despair. "New York in the Third Winter" reported that although business was down in the city, everyday life had not changed significantly. "Wandering about the city looking for Disaster, the visitor from out of town will very likely find no more than he would have found in New York in any other winter." A more experienced observer might note that the cab drivers were less garrulous, but even the natives' talk of bad times was "more likely to be faintly facetious than downright dejected." The feature's illustrations displayed this lightheartedness in the American debut of the Polish caricaturist, Zdzislaw Czermanski. His full-page drawings with the titles *Harlem, Exchange Place, Second Avenue*, and *Park Avenue* showed few signs of the Depression. Even when he portrayed the working class, he lightly poked fun at their chaotic surroundings

Harlem

*Zdzislaw Czermanski, Harlem, Fortune 5 (January 1932): 44. Prior to mid-1932 Fortune
imagined the Great Depression as a temporary inconvenience. Its understanding of
street-level struggles was thin and even light-hearted, as in this cartoon illustrating the
article "New York in the Third Year of the Depression." Text and page layout © 1932
Time Inc. All rights reserved.*

and blithe lack of direction. Czermanski, *Fortune* praised, "daintily piles one tiny fact upon another until he has built, with infinite drollery, the whole crazy structure of life." Through *Fortune*'s eyes, the streets of New York exhibited not the "spectacle" of despair that newspapers painted with unemployment numbers but a quotidian scene assuring that, in hard times, "life goes on." Even when it printed a photograph of a breadline, the magazine played down its importance, noting that the Welfare Council had condemned breadlines as "'sentimentalism' and 'advertising.'" It was better, *Fortune* agreed, not to see such disturbing sights.[28]

Within a year, however, the magazine began to open its eyes. In September 1932 a groundbreaking story on relief efforts, "No One Has Starved," began by excoriating short-sighted "relief" programs in South Florida in which counties solved their homeless problem by driving the unemployed to the county line. No longer could the problem be hidden by deliberate blindness, *Fortune* proclaimed. The essay's full-fledged support of federal efforts to alleviate the effects of the Depression indicated an important shift in *Fortune*'s politics. But it also announced the magazine's new way of seeing. The first page of the article was a full-page drawing by Reginald Marsh. No lighthearted caricature, the picture showed a crowd of people—workers and managers, women and men, whites and blacks—staring at the viewer. This documentary pose, characteristic of such iconic photographs of the thirties as Dorothea Lange's "Migrant Mother" and Walker Evans's sharecroppers, disallowed the viewer the escape of dismissing the subjects as invisible, undeserving, or less than human. "The people," whose suffering had been invisible in "New York in the Third Winter," had entered *Fortune*. "No One Has Starved" was replete with pictures and statistics—not just from New York but from cities and states across the country—that detailed the extent of the Depression. It showed the "spectacles" that, according to the earlier article, had not existed: unemployed mobs, police tear gas bombs, communist rallies, and people living in water pipes, shacks, hay stacks, warehouses, and caves. The caption to a drawing of a Hooverville revealed *Fortune*'s new willingness to peer outside its environment:

American suburbia has added to its Lake Forests and Englewoods and Shaker Heights and Brooklines and Bryn Mawrs a new and bitter designation and a new and ugly scene. The scene is that poignantly presented here by Reginald Marsh: the filthy and evil-smelling shacks which have grown up out of packing cases and tin cans and sheet iron beyond the

Reginald Marsh, untitled drawing of a crowd, Fortune 6 (September 1932): 18. The article "No One Has Starved," introduced by this Reginald Marsh drawing, announced the magazine's new ability to see "the people." Notice the range of types and classes represented in the drawing. © 2003 Estate of Reginald Marsh / Art Students League, New York / Artists Rights Society (ARS), New York.

tracks and among the vacant lots and under the gas tanks of the indus-
trial towns.

Fortune had discovered an America that existed outside the suburbs of the
elite coalition.[29]

In 1932 and later *Fortune* published, at first sporadically and then with in-
creasing regularity, essays and photos highlighting the lives of the working
and lower classes. The magazine, for example, presented the "Faces of Har-
lan County" during a miners' strike, chronicled the increasing number of
homeless travelers in the early Depression, and presented a series on the
"Life and Circumstances" of individual farmers, workers, and merchants.
Articles such as these, together with the magazine's new attention to public
professionals, demonstrated a broadened understanding of the American
nation. As the next chapter shows, this expanded vision would play a key
role in *Fortune*'s rethinking of corporate liberal ideals in the late thirties.[30]

Before that could happen, however, the magazine would have to
weather the storm of the mid-thirties. As the NRA collapsed, the Depres-
sion continued, and business antagonism towards the New Deal height-
ened, corporate liberalism experienced a crisis.

The End of the New Era

Corporate liberals' recognition of the depth of the Depression was slow,
but at least initially their reaction to the New Deal was politically adept.
Faced with the plummeting status of business and a new administration
ready to prove its willingness to take unconventional measures to end the
Depression, they were able to outflank both conservative business oppo-
nents on the Right and antitrusters, government planners, and labor on the
Left in lobbying for their version of change. And even considering that
the NRA was set up to satisfy as many of these parties as was possible, it was
the business planners who were able to gain control of the NRA in its every-
day affairs. *Fortune*, too, adapted well to the changes during the first half of
the first Roosevelt administration. Not only could it celebrate the possibili-
ties of the NRA, but it was able to adapt successfully many of its previous
economic and cultural positions to the altered conditions of the thirties. The
nation-centered vision acknowledged a loss of the importance of business,
but the magazine continued to provide a coherent understanding of the role
of the professional class within modern social relations and to promise the
emergence of a reformed corporate capitalism.[31]

These victories, however, were neither particularly satisfying nor lasting. Corporate liberal planners, as Ellis Hawley explains, "frequently despaired of agreeing on a specific scheme" and "worried constantly about creating an apparatus that might be used against them." *Fortune* spotted a similar anxiety, reporting that even pro-NRA businessmen fretted that they were adopting a "social experiment . . . advocated by Dangerous Radicals." Furthermore, while voluntary associations and welfare capitalism might have garnered occasionally dismissive responses from other businessmen, the NRA attracted the sustained criticism of conservative business forces, represented by the National Association of Manufacturers and the American Trade Association Executives, as well as accusations that it would empower labor unions and nurture big government. Given this uncertainty, it is not surprising that much of the initial enthusiasm for the NRA drained away at the first sign of trouble. By the time consumer groups and small business revolted against the poorly organized program in the spring of 1934, the advocates of the associationalist plan within the Roosevelt administration were in full retreat. By 1935 mainstream business had turned on what it now called "governmental regimentation," and the ideal of industrial self-government faded into the margins of American history. But because there was no reasonable agreement on which business strategy should replace the NRA, corporate liberals largely scattered: some of them moved into the New Deal government, some continued to theorize about politically impossible cooperative experiments, but most turned, like Luce, toward more traditional competitive ideals and against both government regulation and Roosevelt himself. "After the fall of 1934," Kim McQuaid concludes, "corporate liberalism lost much of its stature within the councils of government and organized business."[32]

Fortune reflected this uncertainty among corporate liberals. Increasingly the magazine's staff and editors clashed. On the one hand, it is easy to overstate the leftist sentiments of the staff. Macdonald, whose 1934 *Fortune* essay on American Communism mocked the "social success" of the party and complained that much of what had been written by Communists was "nonsense," did not become serious about radical politics until about 1935. Similarly James Agee remained apathetic to the political scene through much of the thirties, and his "radicalism" was always individualistic and idiosyncratic. Even MacLeish, who was the most politically active member of the staff, had strong affinities with corporate liberal ideals. On the other hand, the increasingly strong political feelings of the staff conflicted with the magazine's business focus. "Under the pressures generated by [political] polemics," re-

called the writer Charles Murphy, "the *Fortune* staff began to break up and melt away." Dwight Macdonald resigned in 1936, claiming that his essay on U.S. Steel had been "bowdlerized" by the editors. In the same year the stalwart corporation story writer Edward Kennedy and Agee, both alcoholics, stopped producing usable material. MacLeish battled *Time's* Laird Goldsborough over the Time Inc. policy toward the Spanish Civil War, and he finally resigned from *Fortune* in 1937.[33]

Meanwhile, the business community was becoming increasingly suspicious of anything that smelled of the New Deal. The founding of the Liberty League in the summer of 1934 signaled the beginning of a business backlash against Roosevelt. While the League's level of venom seemed to be in indirect proportion to its popular support, it represented a return for many businessmen from advocating experimental business-government cooperation to the traditional business language of competition and libertarianism. In such an atmosphere *Fortune* risked losing its readers' attention. Although in critiquing strikebreaking or praising social security the magazine simply applied older corporate liberal ideals to new conditions, in the polarized environment of 1935 such sentiments likely seemed too liberal to many businessmen. Advertising sales representatives protested to Luce that they were having trouble selling ads for a magazine that seemed to some businessmen to have a bias against business. Similarly, after printing "Arms and the Men," *Fortune* felt obliged to respond to complaints that the magazine was "going leftist" by stating that the magazine "doesn't plan to join a crusade" and reaffirming its dedication to objective, "full" reporting. Even *Fortune* at times seemed unsure of its direction. In June 1935, for example, one essay dismissed Owen Young's "lengthy pronouncements upon the profits of public service," and in August the magazine announced that it was creating an award for "industrial achievement" that sought to demonstrate that business achievement was built on "public interest" and was "not measurable by the sole and simple yardstick of profits." Corporate liberalism had lost much of its coherency in the collapse of the NRA in 1934–35, and the conflicts and disillusionment at *Fortune* in the mid-thirties reflected this loss of direction. By 1936 the magazine's mission no longer seemed clear.[34]

PART 2

American Pluralism and Affirmative Leadership,

1935-1945

CONSENSUS PLURALISM AND NATIONAL CULTURE

As the Depression moved into the mid-thirties, corporate liberals entered a difficult period of intellectual disorientation. The disintegration of the NRA in 1935 signaled the loss of a viable middle ground between business and the New Deal. While business accused Roosevelt of creating a hostile business environment, business anger had become so strong that, according to the *London Economist*, it was "choking the whole industrial and financial machine." Business now saw the New Deal as embodying neither the rational planning of the technical elite nor the friendly assistance of an aristocratic Franklin Roosevelt, but as an expression of an irrational, grasping populist government. A nearly unprecedented burst of congressional energy in the summer of 1935 did not help matters. This "second hundred days" began with the passing of Social Security legislation that the United States Chamber of Commerce had condemned as doubtful in its "propriety as well as its constitutionality." A new tax bill, though weakened considerably by business protest, still raised estate and capital stock taxes and levied an excess profits tax. The Wagner Act, which protected the right of unions to organize and outlawed unfair labor practices, became law despite violent opposition from the business community. Finally, the million-dollar effort of power companies failed to derail the Public Utilities Holding Company Act. While some corporate liberals, like those on the governmental Business Advisory Board, continued to lend selective support to New Deal programs such as Social Security, the New Deal's map for future growth looked increasingly like foreign territory to most businessmen.[1]

The road signs outside Washington were not encouraging either. The surge of radicalism within the labor movement in 1934 did not peter out, and the passage of the Wagner Act not only demonstrated labor's political power but

also gave the union movement important new legal advantages. The formation of the Committee for Industrial Organization and the advent of the sit-down strike further fueled industrial organizing, and by 1937 labor had won major victories over General Motors and U.S. Steel. And if the rise of labor and the second New Deal were not enough to worry businessmen about their loss of control of the populace, the startling rise of two populist figures in the mid-thirties probably did. The Louisiana senator Huey Long, known for his demagogic control of Louisiana politics and Robin Hood–like politics, created a nationwide Share the Wealth Society in 1934 and had enough national support to encourage talk of a presidential run. Charles Coughlin, a Catholic priest whose radio show reached more than thirty million people a week, combined his anticommunism and anti-Semitism with venomous attacks on both the New Deal and the business community. The popularity of these two figures seemed to many critics, both inside and outside business, to be a harbinger of American fascism or communism. Finally, the persistence of miserable farming and industrial conditions radicalized both farmers and the unemployed. The socialist-led Southern Tenant Farmers' Union, for example, founded in Arkansas in 1934, fought the abuses and poverty of the sharecropping system in the South, while Upton Sinclair's campaign for the governorship on an "End Poverty in California" platform drew nearly a million votes in the same year. The omens of a popular revolt against the capitalist system appeared wherever businessmen might travel.[2]

Roosevelt's 1936 reelection campaign served as the final indication of the collapse of business control. Lambasting business with the harsh rhetoric of "economic royalism," Roosevelt jettisoned any attempt to capture the business vote and chose instead to court an increasingly radical population. His overwhelming success at the polls, unimpeded by an almost complete lack of support from either business or the mainstream press, indicated the new power of the public to compromise business autonomy. *Fortune*, sensing this power, abandoned its hope for an elite coalition. "Wall Street," noted one journalist before the 1936 election, "is pinning its hopes on the defeat of Mr. Roosevelt. If that hope fails, practical businessmen must need be practical." The magazine accepted this advice. Beginning in 1937, instead of nurturing an aristocratic leadership class *Fortune* reimagined American society as a conflicted group made up of self-interested actors. Within that society business would be forced to compromise with other interests. In 1938 an editorial reasoned:

In the breakdown of the economics of free capitalism, business is con-
fronted with a *realistic political fact*: namely, that a majority of the Amer-
ican people, with the penniless third as a nucleus, are beginning to mea-
sure the virtue of their Government mainly in terms of the guarantees it
makes concerning their income. . . . Here is no question of moral turpi-
tude, but an objective question calling for an objective answer.

The New Deal had attained unprecedented popular support, and this sup-
port translated into governmental power. Business had no reasonable
choice but to accept compromise with the public will.[3]

Fortune, however, worked to turn this defeat into a victory. Out of its
forced pragmatism grew a positive corporate liberal vision of the nation as a
pluralist consensus. Rejecting not only the unfriendly regulation of the New
Deal but also the business cooperation of the New Era, *Fortune* reimagined
competition as indispensable to economic progress. But this acceptance of
conflict as a necessary part of long-term overall growth was not limited to the
economic realm. In the political and social arenas it translated into a recog-
nition of the conflicting interests of various social groups. The visible dissat-
isfaction of unions, farmers, and the unemployed, increasingly channeled
through government, clearly indicated that business and public needs dif-
fered significantly. An elite coalition, no matter how enlightened, could not
adequately represent the perspectives of all these citizens. But this disagree-
ment did not portend the disintegration of the nation into antagonistic polit-
ical camps. Instead, *Fortune* maintained that a larger national purpose
would override the minor conflicts endemic to a pluralist community. The
magazine insisted that the key to an abundant America was intelligent com-
promise, civil conversation, and a patient, long-term vision. "The American
economy," the above editorial closed, "can be established only by Business
working with Government, and Government working with Business, over a
long period of years, toward a progressively higher standard of living derived
from the incentives of private enterprise." If emotional, irrational rivalries
could be subdued, a national interest in technological progress and in the
wide distribution of consumer wealth would overwhelm the relatively minor
conflicts of interest of a pluralist nation.[4]

But *Fortune* needed to convince both its readers and the larger public of
the benefits of this vision of pluralist consensus. It had to galvanize public
support for capitalism by nullifying New Deal criticism of corporations,
and show conservative businesspeople the advantages of compromise with

government and of an increased distribution of wealth. *Fortune*'s strategy for gaining this support found inspiration, ironically, in the New Deal. Using mass media and mass culture, Roosevelt seemed to have nurtured a national mood conducive to increased government activity. The populist rhetoric and public spectacle of the New Deal seemed to have convinced many Americans to make a personal investment in the federal government. After 1935 *Fortune* copied the New Deal's strategy of cultivating a politically advantageous national mood. To promote the idea of a United States that was grounded in capitalist ideals, the magazine imagined a unified national culture that defied class lines. The boundaries that had formerly separated popular and high culture, *Fortune* asserted, were disintegrating, as Americans recognized the richness of both. This simultaneous celebration of diversity and unity, of high and low, mirrored the populist culture of the New Deal. But while the New Deal culture celebrated government as the representative of the people, *Fortune*'s corporate liberal culture held up capitalism as the fundamental center of American life. Both "folk" and "high" cultures, the magazine claimed, had their foundation in the capitalist system. In their leisure as well as in their work, both the working and the upper class profited from industrial progress. The merging of high and low cultures signaled a new American consensus built on a common interest in business success.

The Intellectual Reconsolidation of Corporate Liberalism

Although businessmen had feared that Roosevelt's reelection forewarned the rise of a socialist state in the United States, in reality the domestic politics of the last years of the thirties were dominated not by leftist triumphs but by ideological uncertainty and political stalemate. Considering the Democrats' nearly unblemished victory in 1936, this might seem surprising. Not only had the president clinched the electoral college by the stunning margin of 523 to 8, but Democrats had also won 26 of 33 races for governor. In 1937 the Senate was comprised of 76 Democrats and only 16 Republicans, and the former party dominated the House of Representatives, 331 to 89. Nevertheless the New Deal had effectively passed its climax even as the new Congress convened. The reasons for this oddly timed end are multiple. First, the president made enemies of both Republicans and Democrats in ill-fated and arrogant attempts to restructure the Supreme Court and the administrative branch. The Democratic Party was further split by liberal Democrats' campaigns for labor rights, housing support, and antilynching

legislation, which angered southern Democrats and nullified the party's significant numerical advantages. More generally, the nation's enthusiasm for reform waned. Polls demonstrated a strong popular desire for a more conservative course, particularly after many blamed the so-called Roosevelt recession of 1937 on the failure of New Deal policies. Finally, the growing sense of the inevitability of war turned the attention of many critics and politicians away from domestic reform toward foreign policy. The seeming mandate of the 1936 election was left unfulfilled.[5]

The end of the New Deal, however, was not the only sign of political exhaustion after nearly a decade of economic hardship. While the labor movement, which continued to build on the gains of the Wagner Act, serves as an exception to this generalization, New Deal liberals, business conservatives, and the radical Left all suffered from a lack of direction late in the decade. New Deal liberalism lost much of its political energy as Democratic unity declined and the reforms of the first Roosevelt term failed to heal the economy. "The Roosevelt administration in [the late thirties]," Alan Brinkley concludes, "no longer had the political capital—and at times, it seemed, no longer the political will—to sustain a program of reform in any way comparable to its earlier efforts." Conservative business forces, taking advantage of this loss of momentum, repealed some New Deal measures such as the tax on undistributed profits, and largely canceled out the liberal factions within Roosevelt's administration. But even this limited success drew most of its energy from a hatred for Roosevelt and his policies, and in simply repeating the ineffective clichés of laissez-faire ideology these businessmen failed to develop a positive vision of change that could garner significant public support. Finally, while the leftist coalition surrounding the Popular Front gained a brief burst of energy from its antifascist campaigns surrounding the Spanish Civil War and the rise of Hitler, the behavior of the Soviet Union and the Communist Party created widespread confusion and infighting. Stalin's Moscow Trials, which condemned many earlier heroes of the Soviet Revolution as traitors, and then the 1939 Soviet-Nazi treaty, which led to abrupt, seemingly inexplicable changes in the Party line, strained the allegiance of many American leftists, and the resulting widespread political reevaluations destroyed any hopes for a unified Left. In this sense the disintegration of corporate liberals after the collapse of the NRA only mirrored a widespread tendency toward hesitancy and intellectual confusion in the late thirties. Few political communities seemed wholly convinced that they had tenable solutions to the tremendous economic, social, and military problems facing the nation.[6]

Such a moment of exhaustion, however, can also serve as an opportunity for reorganization. New Deal liberals, for instance, as Brinkley argues, redefined their primary goals in these years. Moving away from their earlier tendency to attack capitalism, many liberals began to focus instead on building and sustaining the welfare state, and on protecting workers and consumers from the inevitable disruptions of the free market. A similar reorganization occurred at *Fortune*. As the war approached, the magazine developed a new understanding of its core ideals. Indeed, in the late thirties, the magazine played a leading role in the articulation of a renascent corporate liberalism. Consumer abundance, technological innovation, and corporate power continued to light this vision. Refracted by the experience of the Depression, however, the magazine refocused corporate liberal attention on competition, growth, and pragmatic compromise between competing social interests.

In 1937 Luce, who had been busy creating *Life*, gave himself over to *Fortune*, which one biographer called his "passion." Like many other corporate liberals, Luce had grown increasingly contemptuous of the New Deal, and his ideas clashed with the New Dealers and leftists on *Fortune*'s staff. Although Luce did publish articles with which he disagreed, he also argued that the magazine should have a "general coherence and a general sense of direction," and he believed that *Fortune* had lost both. After reorganizing the corporate structure of Time Inc. in the spring of 1937, he suggested that Eric Hodgins, the new publisher, should restate the magazine's principles. "*Fortune*," Luce declared, "shall have a platform with two planks. One plank it already has—the free and fearless journalism of inquiry. I suggest that it also acknowledge a bias in favor of private enterprise." After Hodgins balked at the idea, complaining that the two principles were difficult to reconcile, Luce turned for support to Russell Davenport, the new managing editor. In November 1937 Davenport sent a letter to the staff:

> I think we must develop an editorial definition. . . . It seems to me absolutely urgent that *Fortune* define or redefine itself in such terms as to reassure the American businessman . . . that our world is his world and not the world of either Stalin, or Mussolini, or Trotsky, or even John L. Lewis or Mr. Roosevelt; that our basic principles are in a rough way his basic principles, the liberal principles upon which he has been reared; and that when we undertake to criticize him we do so as a member of his party.

Davenport's and Luce's editorial declaration that *Fortune* was "for Private Capitalism" established a direction for the magazine into the war years.[7]

The editorial statement also created a newly inspired and directed magazine. Luce told a group of bankers in 1937 that they were "enlisted in a war" for business and freedom. Davenport adopted a similar zeal for the corporate liberal cause. One staff writer, John Jessup, recalled that Davenport "thought *Fortune*, like himself, had a mission on earth" to "settle every conflict that seemed to obstruct the fulfillment of the American dream." Another writer, Charles Murphy, claimed that Davenport made *Fortune* into a "spokesman for change." Indeed, Davenport's enthusiasm for the corporate liberal cause would make him a primary catalyst for the Republican nomination of Wendell Willkie in 1940. This sense of a "mission" gave the magazine a more coherent political content. To explicate and develop the new corporate liberalism, *Fortune* even published a series of editorials entitled "Business-and-Government" between 1938 and 1940, the first editorials ever printed in a Time Inc. periodical. In the late thirties the magazine's copy generally toed what Jessup called "the Luce-Davenport party line."[8]

This "party line" shared many of the corporate liberal aims of the twenties, particularly the desire to stabilize the market and increase consumer spending while retaining corporate control of business. It continued, too, to search passionately for a moral basis for capitalism. But the Depression had reworked *Fortune*'s ideas and rhetoric. First, the regulatory ambitions of the late New Deal pushed Luce and Davenport to reestablish their commitment to industrial growth and to the profit-driven capitalist system. Clearly reacting to the mood of uncertainty and hesitancy in the political sphere, *Fortune* complained repeatedly that politicians, intellectuals, and businesspeople all lacked faith in the possibility of economic growth. The New Deal was the primary villain. "We know," Luce told a group of Ohio bankers, "that private capitalism functions only under conditions of confidence and that today there is little confidence. . . . Franklin Roosevelt has made most businessmen feel that he does not like business—that he does not like Industrial Enterprise." But business was not innocent either. Corporations, *Fortune* feared, by refusing to invest and innovate, would bring regulation and even socialism on themselves.[9]

To encourage a productive renaissance and to combat the pessimistic ideas of liberal planners, *Fortune* embraced "liberty" and the competitive market. Liberty, the magazine argued, was the central value of the United States and of its fecund American dream. This liberty was defined con-

stantly in economic terms. The United States flourished in its first 150 years because its assurance of this liberty had nurtured "the capitalist imagination." This imagination, driven by the profit motive, was at the root of all material and social progress, and *Fortune* argued that an exit from the Depression could only be found by rediscovering it rather than stifling it. Returning to a liberalism of "the Jeffersonian type," *Fortune* even argued now that corporate size could be a hindrance to profit rather than a road to a New Era of cooperation. The profit motive, "as natural and inevitable a drive as hunger or sex," created the abundance of capitalism, not planning, or even cooperation.[10]

This new dependence on individual liberty and the free marketplace did not imply laissez-faire capitalism, however. *Fortune* asserted that to negotiate and compromise with government was both pragmatic and desirable. While corporate liberals in the twenties had argued that public interest and corporate interest were identical, *Fortune* now accepted that the two often diverged. Learning from its experience with trade associations and the Depression, now the magazine freely admitted that one could not depend on business to consider the public welfare. The solution to these divergent interests, however, was not acrimonious rhetoric but pragmatic compromise. On the one hand, while government, as a representative of the public, had a right and responsibility to "umpire" markets, it needed to think in terms of constructive rather than punitive controls. Business, on the other hand, should work not to keep government out of business, which was impossible and even undesirable, but to keep it "enlightened and well informed concerning the requirements of successful private enterprise." The "momentous struggle" between these two forces, therefore, was not the result of irreconcilable differences but rather of a "profound misunderstanding . . . [which] arises from both sides." A corporate liberal administration would intervene in business in order to help industry produce benefits for society rather than stultifying it with regulations. By federalizing social welfare and laying out ground rules for competition, government could help to spread the benefits of capitalism as well as stabilize the marketplace, eliminate the advantages of cutthroat competition, and assure that all companies helped to pay for the social safety net now demanded by workers and corporate liberal ethics. The health of the nation depended on a working relationship between the forces of democracy and those of capitalism.[11]

Wendell Willkie, a utility executive who would soon become a *Fortune*-groomed candidate for U.S. president, provided perhaps the most poetic evocation of the spirit of the magazine's consensus pluralism. The corpora-

tions and public groups involved in conflicts about the utility industry, he said in *Fortune* in 1937, represented "social forces quarreling finitely under the benign sky of American progress." Although there were disagreements with the polity, he implied, the overall advantages of industrial growth eventually subsumed inevitable, minor conflicts of interest. Rejecting progressives' insistence that the core narrative of U.S. history had been a battle between the people and business interests, Willkie and *Fortune* declared that the struggle between business and the public was one of historical circumstance and shifting interest, a "finite" quarrel within a "benign" group effort toward American progress. But if this vision of the United States was to be successful politically as well as aesthetically, corporate liberals needed to do more than formulate poetic images. The key task was to persuade the public of the truth of the vision. Business, in short, would have to convince voters that it could protect public interest better than a state-run economy. To demonstrate that business and the American public had a consensual interest in the success of capitalism, *Fortune* once again turned to culture.[12]

From Culture to culture: Politicizing American Life

In 1935 Kenneth Burke delivered a controversial speech to the American Writers' Congress, an event sponsored by the Communist Party. The initial argument of "Revolutionary Symbolism in America" was that Communists should replace the symbol of "the Worker" with the more inclusive "the People." With the coalition-building Popular Front still a year away, Burke was condemned for watering down the proletarian spirit of the Communist Party. But Burke urged his listeners, whom he suspected would be angered by this specific suggestion, not to overlook his larger argument about propaganda in general. If the party was to prosper, Burke said, it must formulate a "propaganda by inclusion." On a basic level Burke simply meant that a symbol such as "the People" would have a wider appeal than "the Worker," and so would increase the support for communism. Equally important, however, a "propaganda by inclusion" would "include" the entire living environment. This "complete propaganda" would construct an imaginative culture through which the public would understand, and even develop a passion for, communism. The complete propagandist would surround the cause "with as full a cultural texture as he can manage, thus thinking of propaganda not as an over-simplified, literal, explicit writing of lawyers' briefs, but as a process of broadly and generally associating his political alignment with cultural awareness in the large." Such an effort could pro-

vide a "unifying principle" that would not only create popular support for individual political issues but would also cultivate a personal allegiance more powerful than any single rational argument.[13]

In the same year the corporate liberal spokesperson Bruce Barton delivered a speech before the National Association of Manufacturers that oddly mirrored Burke's. "Industry and politics," scolded Barton, "are competitors for the confidence and favor of the same patron, the public. Politics knows it; industry, for three years, has acted as if it did not." While the New Deal had been selling itself to the public, business had only complained, and, as a result, government was threatening business autonomy. Barton argued that capitalists needed to recognize the power of the public. He urged business to campaign not only for individual products but for capitalism itself. The story of business progress "should be told with all the imagination and art of which modern advertising is capable." Like Burke, Barton insisted that a unifying political movement needed emotional appeal as much as logic. "The heart of the electorate is not going to be set on fire by the bald promise to discharge Government employees and slash expenses. Nobody loves a comptroller; history records no instance of great masses laying down their lives for an auditor." And like Burke, Barton hoped to attract a wide range of people through an "inclusive propaganda." Business, he said in closing, "must make its appeal not to the Anybodys of its own circle, but to Everybody." Businesses needed to regain the "hearts" of the public.[14]

Barton and Burke wanted more than just single-issue campaigns. Both compared their propaganda to advertising, in its emotional appeal and its attempt to "associate" their cause with certain values and sentiments. But even advertising, limited to a single product, was a "rudimentary" demonstration of "inclusive" propaganda. Barton and Burke envisioned something more comprehensive. They hoped, as Erika Doss argues of Barton, to build "collective national *cultures*," around business and communism, respectively. The way to gain the long-term political advantage in a mass democracy, each insisted, was to cultivate an appealing, politically charged social community. Indeed, by redefining "Americanness" according to their own social and ideological interests, corporate liberals and Communists hoped to assure themselves of political power.[15]

This attempt to cultivate a unified national community that would embody a set of political ideals was the culmination of two decades of American intellectual interest in the idea of culture. For the Young American thinkers like Van Wyck Brooks and Harold Stearns, this interest manifested itself in a desire to identify or create a set of established artistic and social

traditions that would provide the nation and its artists with a sense of unity and direction. Among regionalists, Harlem Renaissance thinkers, and the radicals surrounding the *New Masses*, the fascination with culture often meant a search for a genuine, organic American community whose wholeness would contrast the disjunctures of an urban, corporatized society. Finally, the idea of culture gained increasing acceptance within social science, as many American anthropologists, led by Franz Boas and his students, sought to discover the "personality" of their subject communities. All seeking to understand the "patterns" that defined group unity and behavior, these widely varying intellectuals worked in the teens and the twenties on what Susan Hegeman calls a "shared 'cultural' project."[16]

The growth of the idea of culture reached its fruition in the thirties. The decade, Warren Susman argues, witnessed the "popular discovery of culture." Cultural anthropology, for example, began to reach a nonspecialist audience, first through Margaret Mead's 1928 *Coming of Age in Somoa*, and then through other texts such as Stuart Chase's *Mexico: A Study of Two Americas*, Ruth Benedict's *Patterns of Culture*, and even Constance Rourke's *American Humor*. All these works, whether focused on the United States or not, sought to understand through ethnographic work the distinguishing and unifying aspects of American culture. More directly political, the decade's journalism and literature is full of attempts to "discover" America, particularly in travel journals like Lewis Adamic's *My America* and Sherwood Anderson's *Puzzled America*, and in photography books like Margaret Bourke-White and Erskine Caldwell's *You Have Seen Their Faces* and Archibald MacLeish's *Land of the Free*. The documentary mode of these books was deeply indebted to contemporary anthropology's conception of ethnographic research, and, as Marcus Klein observes, even their names highlight the rediscovery of some genuine, unified American community, often grounded in the "Americanness" of ostensibly marginal citizens. These anthropological and documentary discourses, taken together with the more general rise of a unifying "national-popular rhetoric" in politics, are evidence of the widespread appearance in the late decade of what Hegeman calls a "sense of an overarching 'America,' a new perception of national coherence." An inclusive, accessible American culture promised to unify a nation divided by the ostensibly foreign influences of modernity, whether represented by "economic royalism," the uncontrollable market, or the threat of European war.[17]

But while Susman argues that the idea of a holistic culture was "domesticated" in the late thirties, Barton's and Burke's speeches reveal that behind

the inclusive rhetoric of culture lay distinctly different political aims. Domesticated culture, Susman maintains, served conservative forces, at times against the designs of its proponents, because it stressed group belonging at the expense of ideological specificity. Commitment to a national community, no matter how defined, encouraged adaptation and finally acquiescence. But it is important not to overlook the ideological commitments that did exist within these different communities. In examining the similar approaches to national culture and "Americanism" among radicals and New Dealers in the late thirties, Laura Browder largely agrees with Susman that the tendency to see society through a "cultural lens" tempered radicalism. At the same time, however, she suggests that there remained a core difference between radicals' model of culture, which was based on class conflict, and the multicultural model of the New Deal. MacLeish's "America Was Promises" or *Land of the Free*, for example, clearly adopted a vision of a unified, dignified American populace, but his "America" had been betrayed by the "Empire Builders," and needed to fight back to regain its powers. This consensus based on class conflict clearly separates itself, for instance, from the "America" of the later Farm Security Administration photographs, which focused on the pleasantries of small-town life and the successes of New Deal programs, and promoted, as Terry Smith argues, an "unantagonistic classless consensus." The stress on unity and commitment to the nation may have blurred the political rhetoric and ideals of various groups, but the core political beliefs remained. Barton's speech, and *Fortune's* discourse in the late thirties, further demonstrate this point. Built on the multicultural model but different from the New Deal and the Popular Front in important ways, *Fortune's* vision of a capitalist consensus provided yet another ideological basis for an "American culture." Not inherently conservative, the political use of "culture" could accommodate vastly different visions of the United States.[18]

The widely shared assumptions about the desirability and possibility of a unified national culture, therefore, obscured but did not solve the central political conflicts of the era. Actors on both the political Left and Right acted in the late thirties to solidify their own definition of "Americanism," and to build national cultures on specific ideological platforms. The most prominent faction in this struggle was, of course, the New Deal itself. Anticipating the pluralism of the late thirties, Roosevelt early in his administration insisted that government leadership must define a "united purpose" and the "dominant public need" out of "the confusion of many voices." Immediately on taking office in 1933, the president sought to personalize his

relationship with the nation. His first fireside chat, a week after the inauguration, attracted an audience of 60 million people, and throughout the decade travelers in the United States commented on the deep, personal devotion of much of the population to Roosevelt. Even the National Recovery Administration promoted itself as a community event: it held parades, commissioned songs for itself, and encouraged businesses to display its ubiquitous Blue Eagle with the community-building slogan, "We Do Our Part" (the Eagle appeared on *Fortune*'s masthead in the fall of 1933 and remained there for two full years). Roosevelt's admirers, like MacLeish, saw the New Deal as a program capable not only of economic reform but of building a "new relationship between the people and the government."[19]

The Federal Arts Projects (FAP) of the Works Progress Administration (WPA) were at the heart of this effort. The theater program, for example, attracted an audience of 30 million people in four years. Ostensibly apolitical, these performances created a social culture around New Deal events even when the performances did not celebrate government programs (which they often did). But more than just staging events, the FAP aimed to pull Americans into the artistic process itself. By 1940 the program had eighty-four community art centers in operation. These centers, staffed by WPA employees and directed toward what the FAP called "culturally deprived citizens," served 350,000 people a month. In addition, the WPA provided many artists with full-time work, and, particularly since these artists often worked collaboratively or taught, they could define themselves as socially productive civil servants rather than producers of elite art. In creating such participatory social communities around government institutions, the FAP intended not only to improve the artistic sensibility of the nation but also, as Jonathan Harris argues, to demonstrate to audiences, participants, and artists the "strength and vitality of a national culture . . . unified by a common bond of citizenship." Even when they did not draw a crowd, the programs promoted this national bond. The post office murals of the Arts Project, the widely published Farm Security Administration photographs, and the tourist guides and local histories of the Writers Project, for instance, spread images of a national folk community while implicitly linking this community to the actions of the federal government. The New Deal, these programs proclaimed, *was* the people.[20]

But the New Deal was not the only group to attempt to create a national culture favorable to its political aims: the radical Left also embraced the culture concept. Most obvious was the Communist Party's officially created Popular Front: "Communism," the radical Left proclaimed, "is twentieth-

century Americanism." This new attempt to cultivate a radical culture re-
sembled the proletarian ideal celebrated by *The New Masses*, but, like
Burke's symbol, "the people," it was more inclusive and less "foreign" to the
majority of citizens. Rallying around a program of antifascist activism, sup-
port for organized labor, and class-based politics, the Popular Front sought
to include liberals as well as radicals and, in doing so, as Judy Kutulus notes,
succeeded briefly in widening the appeal of the Communist Party. But the
Popular Front strategy was "inclusive" in Burke's deeper sense as well. On
the party level, the Popular Front staged local events such as parades, lec-
ture series, and conferences to consolidate the Left by nurturing a commu-
nity imbued with leftist political ideals. More important, a large contingent
of Left-leaning writers, actors, musicians, and other artists, by helping to
form and supply material to the growing mass culture apparatus in the
United States, engaged themselves in what Michael Denning calls "the la-
boring of American culture." This "cultural front," composed of a broad
range of radicals and progressives, created a widespread popular culture
based on social democratic ideals. The culture of labor, Denning argues,
helped the radical Left form a powerful, if eventually unsuccessful, histori-
cal bloc in the late thirties and forties.[21]

Corporate liberals, rallied by Barton but most consistently led by *For-
tune*, joined these two antagonists in envisioning a culture friendly to their
political goals. In 1935 Barton implored business to begin an advertising
campaign that would convince citizens to identify themselves with busi-
ness. The crisis of the mid-thirties inspired large corporations to follow Bar-
ton's advice. As Roland Marchand demonstrates, the primary means toward
this end was a strategy of public relations that sought to associate business
with the "common folk." Launching a "counterattack against the New
Deal," corporations addressed the public not just as consumers but as vot-
ers. One such campaign was the J. Walter Thompson Company's "Primer
of Capitalism—Illustrated." This series, illustrated with childlike drawings,
claimed to simplify the complexities of capitalism by reducing "capital" to
its root word, "cattle": "The cow," one advertisement proclaimed, "is the
mother of Capitalism." Through this metaphor, the advertisements argued
that private capitalism both produced and distributed wealth more abun-
dantly than any state-managed economy could. Another in the series asked,
"Who gets the fruits of Private Capitalism?" and answered with a simple il-
lustration: a farmer milking his cow while others—an old man, a pin-striped
capitalist, a small boy, a laborer, and a small-town businessman—wait in
line with their pails, smiling patiently. The capitalist might earn more—

after the elderly had been cared for—but everyone would get a share. Through such campaigns, often "folksy" in their language and appeal, corporate liberals aimed to reach "the people" and build support for the American capitalist system.[22]

Fortune enthusiastically celebrated the boom in corporate public relations, but it insisted on an "inclusive" propaganda: business, it argued, had to do more than romance the public with clever advertisements. "The year 1938," the magazine mooned, "may go down in the annals of industry as the season in which the concept of public relations suddenly struck home to the hearts of a whole generation of businessmen, much as first love comes mistily and overpoweringly to the adolescent." But it warned pie-eyed suitors that public relations, like love, required commitment and sacrifice. A 1938 editorial lamented that business, despite its successes with production and efficiency, continued to be the villain in American society. The "supposed cure" for this undesirable situation, *Fortune* reported, was "all sorts of promotional activity, from commercial advertising to after-dinner speeches." But this condescending, superficial activity had proven its limitations. "The people suspect that behind his promotion copy, behind his handsome anterooms and affable receptionists, the Businessman is up to something." As a result, *Fortune* advocated a "new concept of public relations" that would get past the surface and display the deep influence of business on American society. Public relations was not simply a matter of clever or down-home advertising copy. "*Basically,*" another editorial opined, "*public relations is action.*" Business needed not only to tell the people that its success was their success, but it also had to demonstrate the importance of business to people's everyday lives.[23]

In some ways this "new concept" of public relations echoed the "service" rhetoric of the twenties. Businesses, *Fortune* argued, had to realize they were "public utilities," because the lives of the people were so intertwined with the successes and failures of business. As a public utility, a business had to consider its effects on the community. But where "service" had been idealistic and paternal, the new public relations was pragmatic and cooperative. While "service" in the twenties had been envisioned as a moral choice, public relations was a political necessity: "[Businesses] are surrounded by the people and the interests of the people. They cannot exist without the people, and they must therefore learn how to exist *with* the people." By acting responsibly, by compromising the short-term profit motive with public opinion, and by pointing out the positive benefits of business activity, business could convince the people that it served their inter-

Who gets the fruits of Private Capitalism?

The real test of an economic system is: *How many people share its benefits — and how big are the individual benefits?* Of course, there are some who, through good fortune or extra ability, get more out of *any* system than others do. Under state capitalism there are leaders and sub-leaders who have extra pay and extra privileges—often giving them power far greater than any power in the hands of private capitalists. In Russia, for instance, the few available cars and radios and telephones are apt to be in the hands of the "officials."

How many people share the good things of life in America— the things most of the world calls luxuries?

The American system of private enterprise —private capitalism—gives individual initiative a chance to make the most of natural resources. As a result:

The United States has one radio for every six persons . . . more per capita than any other country . . . a total almost as great as the rest of the world combined.

The United States has one telephone for every seven persons . . . Europe has one for every 35 . . . we have more than the rest of the world combined.

Electrical refrigerators—like most other electrical appliances—are enjoyed by more people here in the United States than in all the rest of the world put together . . . one of the reasons is that our average rates for electricity are the lowest.

We have almost a half again as many autos as all the rest of the world . . . a car for every five persons . . . a seat for every man, woman and child in the country.

We have so many of these comforts and luxuries that it is clear that the leading private capitalists can't possibly use them all—as the "officials" do in dictatorships.

Statistics may lie, but common sense tells us that it takes a large proportion of our 30 million families to drive 26 million cars and listen to 21 million radios. By almost any yardstick which can be selected, America leads the world both in total wealth and in the distribution of wealth among the masses.

* * *

A PRIMER OF CAPITALISM—ILLUSTRATED

The paragraphs above are adapted from *"A Primer of Capitalism—Illustrated."* Those who must deal with public opinion as it affects American business may find the technique of this new Primer interesting. Like the *"Brookings Primer of Progress"*—now in its sixth edition—the Primer of Capitalism will be sent free upon request. Address: J. Walter Thompson Company, 420 Lexington Avenue, New York, N. Y.

J. Walter Thompson Company

NEW YORK CHICAGO SAN FRANCISCO LOS ANGELES ST. LOUIS SEATTLE · MONTREAL TORONTO · LONDON PARIS ANTWERP
THE HAGUE BUCHAREST · BUENOS AIRES SÃO PAULO · CAPE TOWN · BOMBAY · SYDNEY · Latin-American and Far Eastern Division

J. Walter Thompson Company advertisement, "Who gets the fruits of Private Capitalism?" Fortune 16 (November 1937): 147. Public relations became a primary concern of corporate liberals in the late thirties as the continuing Depression convinced many Americans to question the wisdom of capitalism. But while most public relations relied on traditional appeals such as that expressed in this advertisement, Fortune envisioned the creation of a national culture conducive to capitalist growth. Reproduced with the permission of the J. Walter Thompson Company.

ests better than government. The "service" paternalism of the corporate liberals of the early thirties had been replaced by the consensus pluralism of the late thirties.[24]

To create support for this new relationship within American society, *Fortune* embraced the broad culture of the "inclusive propagandist" rather than the commercial art and elite Culture of the early thirties. The magazine had used art before as a rhetorical tool. Its collection articles, for example, had aimed to induce gentlemanly behavior in the marketplace. But the elite Culture of the early thirties, like the "Worker" of the Left, stressed class division rather than consensus. Furthermore, like "the Worker," elite Culture had used the language of class to challenge the unconverted to change. But the "propagandist of inclusion," Burke argued, utilized less combative, more persuasive means: "Plead[ing] with the unconvinced . . . required him to use *their* vocabulary, *their* values, *their* symbols." The rhetoric of the early thirties, for example—"the gentleman," "aristocracy," and "Culture"—was foreign to business, and persuaded largely through social anxiety. *Fortune*'s consensus culture of the late thirties, however, returned to the traditional American vocabulary of "competition," "progress," and "liberty," and attracted businesspeople and the larger public alike through optimism and pride. Even now, some sixty years later, the Whitmanesque exuberance of *Fortune*'s single issues on New York City (1939) and the USA (1940), for instance, have a vitality that the early issues do not. The wide-ranging contents of *Fortune* in the late thirties served as a "complete" propaganda that aimed to create a corporate liberal culture characterized by pragmatic action, economic optimism, business-government cooperation, and national unity.[25]

Creating Consensus (Through culture)

To cultivate its particular vision of consensus pluralism, *Fortune* had to demonstrate both the diversity and unity of the United States. Although these tasks were never clearly separated, of course, it is helpful to describe this process in terms of two phases. The first phase, which, as the previous chapter demonstrated, had begun as early as 1932, involved moving away from the narrow ideal of the elite coalition and acknowledging the autonomy and dignity of the entire citizenry. This widening of *Fortune*'s vision continued into the late thirties, so that by 1940 *Fortune* could claim in its USA issue to paint a "self-portrait" of the nation, from its businessmen to its underclass. The second phase focused on the unifying work of culture. The

class distinctions that had marred American cultural development and splintered the nation, *Fortune* insisted, were disappearing and were being replaced by a national culture that displayed the same organic wholeness for which the Young Americans, regionalist critics, and Boasian anthropologists had yearned. Just as corporate liberal policies promised to solve the disjunctions created by the "Second Industrial Revolution," American culture, no longer divided into artificial "highbrow" and "lowbrow" categories, offered to heal the fractured communities of modern society.

But while both these processes—the demonstration of diversity and the celebration of unity—also characterized the cultures of the New Deal and the Popular Front coalition, *Fortune*'s "culture of democracy" separated itself from these competing political ideologies. "The people" of the New Deal and the radical Left were defined largely in opposition to the wealthy classes. But *Fortune*'s "people" included a wider spectrum of Americans, and the magazine turned its documentary eye on the rich as well as the downtrodden and working classes. Similarly, whereas the New Deal and leftist visions of consensus focused on small towns and the working stiffs, on citizenship and activism, on the traditional folk and labor cultures, *Fortune* featured the business-driven cultures of modernity, whether represented by radio, Coney Island, or the Museum of Modern Art. The commercial and urban spheres, not foreign influences that had corrupted the organic culture of the disinherited "people," were central to the magazine's consensus pluralism. While all three groups sought to build national cultures, the political values driving *Fortune*'s vision made it distinct.

The introduction of the *Fortune* survey, whose broad demographic focus and statistical method saturated the magazine in the late thirties, exemplified the maturity of the magazine's changed way of seeing. Before the survey appeared in 1935, *Fortune* declared, "journalists, politicians, and drugstore prophets . . . ascertained the state of the people's opinions by declaring their own." Indeed, the magazine had built its elite coalition on just such a narrow class focus. Within such a perspective, public opinion did not seem overwhelmingly important. The technical knowledge for such a survey, as *Fortune* acknowledged, had existed for years, but no one thought of accommodating an advertising and marketing technique to journalism: "It seems to have occurred to no publisher . . . that there appeared regularly in the [advertising] pages of his own publication a device capable of journalistic adaptation which might conceivably prove as important to him as the development of the great telegraphic news-gathering agencies." But then *Fortune* opened its eyes to a wider public. After the doc-

umentary form revealed the heterogeneous vitality of the American public, and electoral developments forced *Fortune* to acknowledge its political power, the magazine recognized the ability of surveys to help it to understand the political mood of the nation. From political polling it was only a short step to surveys of broader cultural opinions and trends, which the magazine imagined as opportunities to allow the democratic populace to speak its mind. By the late thirties the survey was a monthly feature that addressed such comprehensive issues as business opinions, the expectations of Americans about government ("a Magna Charta for U.S. democracy," as one survey declared itself), and public attitudes toward race, war, and even topical issues like youth culture and child rearing. Understanding and portraying the broad American public had become a central facet in *Fortune's* journalistic mission.[26]

By 1937 the magazine also had a fully developed documentary style. William Stott argues that social science writing in the thirties struggled to balance quantitative methods with more subjective approaches that examined "flesh-and-blood" reality. *Fortune* succeeded in incorporating both methods into its examinations of the broad American experience. On the one hand, the magazine boasted that it could overcome the dearth of accurate statistics on the Depression through extensive research and quantification. The publication of "Unemployment in 1937" demonstrated the magazine's commitment to these methods. Declaring that "there was only one way to study the conditions of poverty, relief, unemployment, and unemployability," the magazine sent field crews into eleven different American communities for eight weeks, and each crew documented the lives of "a hundred or more different marginal families." The article even included a seven-page appendix in which it revealed the statistical results of its study. This scientific approach, the article proudly repeated, "reduced the element of human judgment to a minimum." On the other hand, however, the article aimed to get past numbers to "know something about the *nature* of unemployment." Sprinkled among the statistics were stories of individual workers on relief. More important, the copious photographs in the article were almost exclusively individual or group portraits. While news wire photographs of anonymous crowds had dominated the 1932 essay "No One Has Starved," "Unemployment in 1937" featured named individuals and its captions detailed their individual lives. "The fastest wheel cutter Seth Thomas ever had . . . is Joe Lyons, even when he is drunk," read one caption. "Joe was once on WPA. But Seth Thomas took him back the minute business got better." Only by interacting with individuals could *Fortune* answer the

difficult questions about the "nature" of unemployment, for example: "Are the reliefers bums?" "Do they ask for too much help?" "Did industry fire them because they could not do their jobs?" among others (to all of these questions, the magazine answered "no").[27]

In the late thirties *Fortune* simultaneously sought the individual American citizen and the whole American citizenry, the diversity of democracy and the unity of the nation. One photograph from the unemployment essay, taken by William Houck Jr., exemplified the characteristic mix of emotional and statistical documentation. A black sharecropper, shot from a low angle and with high contrast, gazed thoughtfully into the distance. The picture suggested the romanticized style of Margaret Bourke-White's *You Have Seen Their Faces*, as did the opening sentence of the caption: "NOBODY KNOWS THE TROUBLE I SEEN, NOBODY KNOWS BUT JESUS . . ." But the punch line of the caption, less visible but equally important, upset this sentimentality: ". . . and maybe a couple of social-service workers." The caption described the life of the man, William Davis, in staccato, statistical prose: "Sharecropper. Pays one-fourth, owns own mules. Wife and child away. Begging for work, extremely poor." He was, the magazine reported, "as typical as one man could be of a large number of marginal Negro workers . . . all through the cotton states." Davis was both the sentimental subject of direct-experience documentary and the representative subject of statistical analysis. Other texts aimed for a similar balance. A 1939 story on migrant workers contained two parts: a socioeconomic analysis of the problem, and "Along the Road," a collection of prose from the reporter's notebook designed to provide "firsthand information on the migrant laborers' way of life." A series of stories, between 1935 and 1939, on individual workers and farmers entitled "Life and Circumstances" aimed to find a typical individual and yet show what made his or her life unique. "It is just as impossible to describe an average farm as it is to describe every one of the 6,500,000 [in the United States]," noted one "Life and Circumstances" essay. "But it is possible to tell a good deal about one farm—a farm."[28]

But while these stories, like the majority of documentary work from the thirties, focused on the unemployed and on rural life, *Fortune* documentary distinguished itself by its interest in the lives of city dwellers, professionals, and the wealthy. Rejecting the common assumption that documentary discovered a "more enduring set of values" that opposed "urban-industrial American civilization," as the historian David Peeler writes, the magazine sought out the diversity of the city as well as the coun-

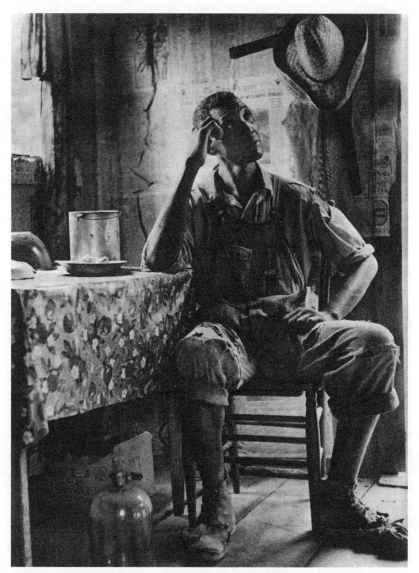

William G. Houck Jr., "*NOBODY KNOWS THE TROUBLE I SEEN . . .*," Fortune 16
(*October 1937*): *99. By the late thirties* Fortune *had developed a mature documentary
style that combined the sentimentalism and individual focus of photographs like this
one with the statistical analysis of the* Fortune *survey.*

try. The New York City issue, for instance, contained documentary-style stories on a range of small demographic groups—cab drivers, strip show performers, and cosmopolitans. All these were part of the "people": "New York," one essay boasted, "contains more Negroes, more Jews, more Irish, a greater multitude and variety of racial and national groups—and more Americans—than any other city in the world." Considering *Fortune*'s intended audience, it is not surprising that the magazine interested itself in the wealthy as well as the downtrodden. In 1940 Davenport wrote an internal memo supporting the magazine's interest in how people, "especially the rich," live their daily lives. An essay like the "Servant Problem" could look into the homes of the wealthy to discover evidence of "many of the major problems of the day." Even when the magazine turned to rural life, it often interested itself in a wider spectrum of people, as in its documentary piece on a county agricultural agent in 1938 or its economic survey of Oskaloosa, Iowa, which addressed a wide range of citizens (and utilized nine *Fortune* staff members) in its attempt to determine the "net profit of an American community." In picturing the "people" who could be unified into a national culture, *Fortune* included a wider range of citizens than the New Deal or the Popular Front coalition.[29]

But while the *Fortune* survey exemplified the magazine's discovery of diversity, its next journalistic innovation represented its hope that this vital diversity might coalesce into a national consensus. First appearing in March 1939, the *Fortune* Round Table collected a small group of businessmen, academics, engineers, farmers, union leaders, and lawyers with a range of political, economic, and regional perspectives for a weekend-long conversation about a selected topic. The editor of the Round Table, Raymond Buell, then published a report summing up the discussions. Like the survey, the Round Table gained critical approval and became a regular feature of the magazine. But the remarkable characteristic of the Round Table was its philosophical grounding. The goal of the symposium was not argument but agreement:

> The *Fortune* Round Table is neither a discussion nor a report. It is, with the exceptions noted in the text, *the unanimous expression of men who, in their public and private utterances, are known to disagree concerning the subject selected.* It is based upon the theory that Americans, no matter how embroiled in controversy, no matter whether they represent—as these men do—big business, little business, finance, politics, science,

agriculture, or labor, can speak as one man upon certain fundamental principles.

To *Fortune,* a "fundamental" consensus subsumed the minor misunderstandings and conflicts of interest that were creating political strife in the United States.[30]

The Round Table serves as a microcosm of *Fortune's* corporate liberal project in the late thirties. The magazine recognized the right of diverse American groups to sit at the table. It then urged these groups to see through their political and regional differences to their American core. This core was a vision of widespread material abundance and cultural maturity created through technological progress and the capitalist system. Once it was clear that this was the goal for everyone at the table, *Fortune* reasoned, all could work together to formulate the means to reach that goal. As one Round Table reader responded, "I believe what I learned in algebra class a good many years ago: if you can state a problem correctly and formulate the equation, the solution is comparatively simple." In the late thirties *Fortune* worked deliberately to define and enlarge the area of agreement. "We have the satisfaction," the magazine boasted as it noted praise for the first Round Table, "of having done a small bit in the herculean job of bringing business and government points of view into alignment."[31]

But as the remainder of this chapter will show, intellectual discussion was not the only tool the magazine used to chip away at the "herculean job" it had set for itself. "American culture"—a broad mix of mass entertainment and highbrow culture, of native invention and adapted old-country traditions, all linked to the business world—would help to unify American diversity. The division between highbrow and lowbrow culture was at heart a class division. Artistic knowledge separated the wealthy and the educated from the undistinguished bourgeoisie, not to mention the "masses." Businesspeople had developed their antagonism toward art largely because this social divide often assigned them, despite their relatively high income, to the latter categories. But in the twenties and early thirties corporate liberals worked to reposition themselves within this social divide. By teaching businesspeople "gentlemanly" behavior and rebuilding the artistic hierarchy according to commercial values, corporate liberals sought to establish business as the elite segment of the United States.

In the second half of the thirties, however, *Fortune* celebrated American culture as a source of unification rather than differentiation. American elite

arts and popular culture, it claimed, were converging. On the one hand, the consumer economy, even in the midst of the Depression, was making elite culture, from ballet to paintings, more accessible to the public. On the other, *Fortune* argued that mass culture was not mindless entertainment, but rather was the folk culture of a democratic, capitalist society. These two tendencies legitimized the lowbrow and the highbrow, and also dissolved their divisive class implications.

By heralding the democratization of high culture, *Fortune* sought to prove that the benefits of capitalism extended to "the people" as well as to elite society. Bruce Barton insisted in 1935 that business had to convince the public that market capitalism, not a state-run economy, would provide the most benefits. To support such an argument, *Fortune* showed how the lifestyle of the wealthy was spreading, even in the difficult thirties. In the early thirties articles about the social activities of the wealthy, like hunting clubs or fly-fishing, had served as primers for readers aspiring to "gentlemanly" behavior. Later, however, similar essays, sometimes absurdly, celebrated the accessibility of those same activities to a larger group of citizens. Private tennis courts and swimming pools, for instance, once an "expensive mark of caste," now cost the suburban family "less than one-tenth as much" as they had once cost the English gentry. The millions who had taken advantage of this progress, *Fortune* claimed, equating material distribution with political access, were "a good illustration of the democratic process." Similarly the "democratization of yachting" had replaced the snobbish "Hollywood-Victorian edifice of yachting" with a popular sport enjoyed by a wide range of ages and classes.[32]

Elite Culture was enjoying a similar "democratization." Even the staid, stuffy protector of "the Beautiful," the art museum, was opening itself to its community. "The Pied Piper of Toledo" celebrated both the proliferation and the redefinition of art museums in the United States. While in the past only the largest cities had notable museums, *Fortune* counted 201 public art museums in 1938. Moreover, these institutions no longer willfully intimidated the uninitiated, but instead welcomed them with classes and activities. "The museum," *Fortune* claimed, "is now a community enterprise, a part of the educational system, for both adults and children." These changes reflected a larger social shift: "Art—in the appreciation of which the U.S. is supposed to be lacking—has been democratized." The Toledo Museum of Art was an exceptional example of this trend. Its classrooms were filled with children and adults learning to create and appreciate art. The classes were "fun—fun enough to lure [the children] away from the

clean autumnal air and the whistles of the football fields." Attesting to the
director's commitment to making the museum "in every sense a community venture," the magazine happily reported that the museum's visitors
each year outnumbered the population of Toledo itself. A similar success
story drew *Fortune* back to New York. Like the Toledo museum, the Museum of Modern Art (MOMA), which several years earlier had attracted
more than one hundred thousand people to its Van Gogh show, presented
"a highly dramatic demonstration of the public's interest in modern art."
But while the Toledo Museum of Art appealed to the public through its education program, the New York museum did so through its presentation,
"an informal and dramatic technique for exhibiting and explaining things
in a way that makes people want to look at them." In addition, the museum
"tries as hard as it can to bring modern art to the general public" through its
ancillary activities, such as its circulating exhibitions, publications, libraries, and classes. Despite the wide gulf separating MOMA and the
Toledo museum in terms of funding, location, and regional population,
Fortune saw both institutions as exemplifications of a significant spread of
high culture in the United States.[33]

This democratization advanced the corporate liberal goal of turning material abundance into leisure and enjoyment. MOMA, for instance, was
"helping to reestablish the long-lost liaison between the artist and the public—to the invigoration of both parties." Toledo's Museum Creed, meanwhile, announced that "no city is great unless it rests the eye, feeds the intellect, and leads its people out of the bondage of the commonplace." To
achieve this state, its educational program aimed not to "create great artists"
but to "develop an appreciation and understanding of art, which children as
well as grownups can carry into their daily lives." *Fortune*'s enthusiastic support for the arts projects of the Works Progress Administration grew from
this desire to build an appreciation of art among the public. The projects,
Fortune exulted, "have tapped a vein of artistic ability the existence of
which no art critic in America had even suspected." Like the two museum
essays, "Unemployed Arts" marveled at the number of spectators that even
highbrow presentations drew: a performance of *Macbeth* in Harlem, for
instance, played for a total audience of 120,000. The arts projects, even in
their first year, had "worked a sort of cultural revolution in America" by immediately expanding the potential audience for art from "a small group of
American millionaires who bought pictures . . . because the possession of
certain pictures was the surest and most cheaply acquired sign of culture"
to a "true American audience." Art in the WPA, *Fortune* marveled, was a

Norman Taylor, "*TOLEDO SCHOOL CHILDREN SCURRY . . .*," Fortune 17 (*January 1938*):
69. *The "democratization" of high culture meant that the art museum was not a display
area for valuable but obscure art. Instead, it was a place for the citizenry both to find
their "Saturday fun," as the caption to this photograph of the Toledo Museum of Art
noted, and to develop their intellectual and social depth.*

"living thing." The United States, aided by federal unemployment support, was finally developing the "raw material of new creative work" and community education necessary for a healthy artistic culture.[34]

But despite its support for the WPA, *Fortune* generally insisted that business played a crucial role in the democratization of high culture. MOMA, for instance, offered the "provocative spectacle of the thickest pillars of conservative society upholding a distinctly radical artistic cabal, and upholding it not merely with cash but also with vigorous effort." Toledo's museum was built on the profits of a glass magnate who, in corporate liberal style, turned his business wizardry toward the "cultural necessities" of the town. An essay on the world-famous conductor Arturo Toscanini explained how corporate sponsorship was in the process of creating a new age of Culture. In its long history, *Fortune* asserted, the symphony orchestra—"the most exalted medium of human self-expression"—had never been able to pay for itself. As a result, it had depended on a series of patrons, either the landed gentry or the extremely rich. But broadcasting had changed that. In the late twenties advertisers had begun sponsoring performances, the networks had hired orchestras, and symphonic music became a regular feature of the radio. Until 1938, however, the effort to create a larger audience had encouraged the symphonies to play "trivial stuff" rather than truly great music. But NBC, in hiring Toscanini and creating a world-class orchestra to perform with him, had "completed the democratization of symphonic music." "The finest orchestra in the world," led by a demanding and uncompromising artist, was to play a series of broadcasted public concerts.[35]

But more amazing, *Fortune* argued, was that the sponsor of these events was not a public institution or a wealthy individual, but a corporation that believed it could make a profit on the concerts. Two conditions made these landmark concerts possible. First, an audience that could appreciate fine art had developed in the United States: *Fortune* reported the "startling fact" that "of all the people in the U.S.—Negroes, poor whites, farmers, clerks, and millionaires— . . . more than one-fourth . . . knows this short dynamic Italian who has always scorned publicity and builds his music to please only himself, and incidentally the recondite connoisseurs." As the "The Pied Piper of Toledo" reported, the United States had surprisingly become "a nation of art-lovers." But just as important, a responsive, imaginative system of business existed that could recognize the business possibilities of fine culture, and provide the capital and energy to realize those opportunities. "No Medici, setting out to stuff his palace with all the glories of Renaissance art, used more loving judgment and lavish determination than the N.B.C. in

creating an orchestra for Toscanini." The convergence of democratic taste and capitalist progress was finally creating a living art equal to the great cultures of the past.[36]

The "democratization" of Culture introduced a larger public to an exclusive but highly regarded art whose growth had been stifled by its insularity. The second part of *Fortune*'s "inclusive propaganda" applauded a complementary but converse trend. American popular culture had regularly been dismissed as vulgar and empty by cultural critics. In the late thirties, however, *Fortune* asserted its value as the American "folk" culture. Perhaps most important, popular culture was a crucial element in building a consensus within a diverse nation. "The Melting Pot," for instance, suggested that New York's diverse groups of immigrants and blacks represented a "new American race." The tumult of the immigrant United States, like the muddle of the Jewish East Side, resembled "not a quaint Baltic village, nor yet a ghetto, nor yet a Babel, but a thick, keyless palimpsest, on which scraps and hints of a dozen European cultures alternately glow, fade, merge, and make a sort of promise of sense." This "promise of sense" was an American nation that collected the energy of these people and cultures without dissolving into disarray. The close of the essay suggested that this promise depended primarily on the connections forged by mass culture:

> The significant fact about New York's foreign groups is not that they are so foreign, but that they are so American. A Lithuanian, an Arabic, a Hungarian, an Italian, a Croatian, a Russian, a Greek, a Spanish, and a Polish paper in New York all carry the Tarzan strip, the sole purpose being to build circulation. . . . There are eight clubs in the Lithuanian Sports Federation, but they all play baseball. There is a Polish orchestra called the Chopinettes, but it plays swing music. The bookkeeper in the office of the tri-weekly *New Yorkin Uutiset* speaks Finnish to the editor, but she wears the same color lipstick that Brenda Frazier does. And what ever happened to the Irish? New York has a society for every county in Eire, four Irish-American newspapers, and even classes in Gaelic. But what New Yorker mistrusts the cops because they are Irish? Or the firemen? Or Al Smith? All kings' sons. Enemies of kings.

Daily life—particularly popular culture—transformed immigrants into Americans, and, in fact, into the self-governing citizens of democracy.[37]

But while both the WPA and *Fortune* sought consensus through popular culture, the magazine, of course, aimed to connect this culture with business. In 1938 *Fortune* published a story on Coney Island, "the empire of the

nickel." Ostensibly the piece addressed the economy of the area, but at the heart of the story were the workers and the thousands of New Yorkers who visited the amusement parks. "The voice and color of Coney Island are its people." The essay detailed a day in the life of the community, opening with the drab and shoddy architecture of the town, continuing with the voyeuristic adventure-seeking crowds at the beaches and the chaotic night life of the Bowery, and closing as the lights of Luna Park turned off. But rather than lamenting the vulgarity of the scene, or even condescending to its lowbrow pleasures, *Fortune* embraced the democratic diversity and small-time capitalism of this "playground of the masses." In such a micro-cosmic America, the crowds provide the greatest entertainment:

> [Into Coney Island] the subway pours the people of New York and its vis-itors—young girls with firm high breasts and pretty legs and shrill, discor-dant voices—hat-snatching adolescents and youths on the make—chil-dren in arms and children underfoot and children in trouble—harried scolding mothers and heavy-suited, heavy-booted fathers—soldiers and sailors and marines—virgins and couples in love and tarts—Gentiles and Jews and in-betweens—whites and blacks and orientals—Irish and Ital-ians and Poles and Swedes and Letts and Greeks—pushing, plodding, laughing, jostling, shrieking, sweating, posing—shedding their identities, with their inhibitions, in the voice, the smell, the color of Coney Island.

The illustrations, painted by Robert Riggs, added to this celebration of the people. A two-page, full-color scene on the beach, dominated by flesh, communicated the chaos and crowding. Smaller drawings portrayed the en-thusiasm of individual hawkers, and the violent and sexual energy of tourists. But all the drawings focused on the excitement and experiences of the crowd. *Fortune's* portrait of popular culture emphasized not the sim-pler, small town of the WPA but the whirling energy of business-driven modernity.[38]

This mix of popular culture and capitalism, *Fortune* acknowledged, was not without its problems and contradictions. "Big League Baseball," for instance, wrestled with the fact that the combination of business and sport within the "Great American Game" had created a manic mixture of loyalty, cynicism, rage, and joy. On the one hand, the illustrations and language of the article celebrate the hopeful, devoted fans who bonded around their team: a community built around local partisanship and the nostalgic "fever of the sandlots." The bulk of the prose, on the other hand, featured the busi-ness of baseball. Unfortunately these two aspects of the game—the intense

Robert Riggs, Steeplechase, Fortune 18 (August 1938): 67. The caption to this Robert Riggs painting read "STEEPLECHASE—WHERE THE CROWD PUTS ON THE SHOW." The same might be said of Fortune's understanding of the national culture and national economy in the late thirties. The magazine envisioned the "people"—including not only the downtrodden and working class but also the rich—as the motive force of the country.

local pride of the fans and the capitalist motive of the owners—often clashed. "Just because every fan regards his team as a personal possession, he subconsciously disputes the owner's right to it." The fan has to "forget that they have paid money to see men perform for money in the money-making interests of still other men." But the essay concluded that this tension only made the game more American. The game's "fetish of success," for instance, expressed both its regional pride and its capitalist nature. The nature of the game, in *Fortune*'s eyes, depended on the strain between objective profit seeking and subjective team loyalty. The article closed:

> As long as the U.S. remains a democracy, baseball will voice the democratic emotions of the crowd. But equally, as long as the U.S. remains a democracy and therefore sanctions private enterprise, baseball will be rigidly controlled by private capital. The two facts may be complementary, or may be contradictory; but whichever they are, they express, on a smaller scale, the basic character of the nation itself.

The popular culture of the United States would not be "American" without a strong relation to business.[39]

The Culture of (Capitalist) Democracy

By 1940 *Fortune* was declaring victory. The United States, a nation ostensibly skewered by differences in race, region, class, and politics, was actually unified in its support of capitalist abundance and progress. In its single-subject issue on the USA, the *Fortune* survey asked the public to describe themselves and their country, and the results convinced the magazine of an American consensus: "Here are assembled and set side by side the self-portraits of each class, and they betray striking family likenesses of which the people themselves may not be aware—likenesses that are probably closer than among the different classes of inhabitants of any other great land in the world." The survey revealed to *Fortune* that Americans did not recognize class differences, that they had abundant optimism for the future, and that their "faith in material gains" did not impede a "greater devotion to intangible values." In short, the survey reflected back to *Fortune* its own corporate liberal vision of the United States.[40]

"The Culture of Democracy," the essay on American culture in the USA issue, similarly projected the nation through a corporate liberal lens. The development of a unified American culture, the magazine claimed, had played a crucial role in the creation of a new consensus. Two characteristics

of that culture had made it an active force. First, the culture had developed naturally and in concert with the business environment. Second, and a factor related to the first, the culture had dissolved the pernicious wall between elite and popular culture, and had created a whole out of diverse parts. The United States, *Fortune* announced, finally had an original, appropriate, cohesive, and "great" culture.

"The Culture of Democracy" was illustrated by more than seventy photographs from daily life in the United States, all captioned with Walt Whitman's poetry. But on the first page *Fortune* chose to reproduce John Turnbull's 1786 painting, *Battle of Bunker Hill*. The caption, also from Whitman, acknowledged the influence of Europe on American art: "I see the European headsman, He stands mask'd, clothed in red, with huge legs and strong naked arms." But the Revolutionary War scene symbolized a second American Revolution. After 170 years of colonialism, the United States had achieved cultural sovereignty: the particular conditions of the nation had finally cultivated an exceptional culture. The most important condition was the business environment. "There can be few phenomena," the essay opened, "more characteristic of U.S. culture than that a magazine devoted to business should attempt to measure it." American culture and business, not just "parallel aspects of the same people," had grown in an intimate dialectic that had thoroughly shaped both:

> Business has increasingly used the vehicles of culture to forward its own growth. The expressions of the culture have gained in richness and variety not only because of the subsidy business has provided but because the culture has found new outlets in meeting directly the exigencies of business. Finally, the major vehicles of culture are businesses in themselves . . . businesses that reach out to the remotest routes of the R.F.D. [rural free delivery], that slip confidently into penthouse apartments, or draw millions from home to crowd the centers of towns.

The radio, more than the Arts and Crafts and folk movements together, had made art available as part of everyday life. The press had fostered new arts, such as the comic strip and news story, "the most versatile medium of native belles-lettres." Hollywood's new political and tragic films indicated the "growing maturity of the people" and of the industry. Furthermore, the connection between business and culture ensured "that the arts themselves are kept in tune with the people." Artists and the public, now meeting in the marketplace, could each encourage artistic growth in the other. Busi-

ness and culture, part of the organic American whole, would progress together into a bright future.[41]

This "wholeness" also manifested itself in the merging of high and low culture. *Fortune* explained that the "culture" of which it spoke lay somewhere between the high culture of Europe and the quotidian culture of anthropology. The "culture of democracy" was more deliberate and more developed than simple "folkways," but also more vital and democratic than Culture. The combination of skilled craft and popularity obscured any "sharp line" between elite and popular arts:

> The fine arts of Europe are like a stalactite, glistening high on the ceiling of a limestone cave; while the folk arts resemble a squat, bulky stalagmite far below on the cave's floor. But in the U.S., owing to some peculiar virtue in the lime in that part of the cave, the stalactite and stalagmite have rapidly joined in a single column, so closely knit that even the probings of an expert cannot tell for certain where the two parts come together.

By unifying the experiences of a diverse public, this column kept the enormous American democracy from collapsing. "A new composite orchestra . . . binder of years and climes . . . ten-fold renewer," read one caption, illustrated by musical scenes ranging from an orchestra to a swing band, from a barroom dance to stadium concert, and from the New York City Rockettes to a hymn sing. "Despite the size of the country and the millions of people scattered over it," *Fortune* claimed, "there has come to be a cultural unity as close and as flexible as ever was in those cradles of democracy, the city-states of Greece and Italy, and the cantons of the Swiss." The national culture *Fortune* nurtured and publicized throughout the late thirties was providing Americans with a common ground.[42]

Van Wyck Brooks complained in 1916 that American culture was split into the highbrow and the lowbrow. The hostility between art and business, between "the ox and the ass," had stymied the development of what Brooks called "the whole man." In the conclusion of "The Culture of Democracy," *Fortune* looked back on those times. In 1930 Sinclair Lewis had accepted the Nobel Prize, but in his acceptance speech he had explained ruefully that artists in the United States suffered from a sense that they did not matter. But now, according to *Fortune*, that feeling was disappearing. Alluding to Brooks, the article proclaimed: "In a few years, indeed while [Lewis] was speaking, the culture of the U.S. has been coming of age." In the ten years

of *Fortune's* existence, American culture had made great strides, discarding its European baggage and mending the split between the high and the low, the stalactite and stalagmite. "The old man with the goatee and the funny clothes is one with the farmer who stalks, hat in hand, into the rural art center five miles from his home." The oneness of the artist and farmer, however, was not limited to culture. Indeed, this oneness extended into the social and political realms, where minor conflicts of interest and value dissolved into the whole of pluralist consensus, into a shared desire for capitalist-driven material abundance and an optimistic belief in the inevitability of American progress. "The Culture of Democracy" closed with a quote from Walt Whitman, the very poet who, in Brooks's social and cultural vision, had prophesied the coming national union between the highbrow and the lowbrow, between "the ideal" and "the real":

> Fresh come, to a new world indeed, yet long prepared,
> I see the genius of the modern, the child of the real and
> the ideal,
> Clearing the ground for a broad humanity, the true America, heir of
> the past
> so grand,
> To build a grander future.[43]

AFFIRMATIVE VISIONS AND ADVERSARY DOUBTS

Climbing from the mat after its unexpected fall in 1929, the American economy in early 1937 seemed on the verge of regaining its fighting form. Before it reached its feet, however, it collapsed again. This second major slump, the so-called Roosevelt recession, discouraged corporate liberals. They had rolled with the punches of the initial recession, arguing that it represented merely a temporary setback. But this second downturn threatened to be a knockout. Mired in a dangerous transition between a producer economy and a consumer economy, the nation no longer seemed destined for recovery. "All the evidence," Luce wrote in 1937, "indicates that we have come to a critical climax in the affairs of men; that the outcome is highly uncertain; and that the alternative is either a century of brilliant human accomplishment or a century of disaster and decay." Luce worried particularly that his fellow citizens were accepting stasis and want as the conditions of the modern economy. The health of the nation, he felt, depended on a widely held vision of progress and growth, just as the economy depended on the confidence and aggressiveness of producers. The country, slowed by its own pessimism, needed to embrace a "vision of vaster productivity." Loaded with reserve strength but down in the count, the United States urgently needed something to fight for.[1]

The *Fortune* editor and poet Archibald MacLeish, animated by the same faith in progress and in the potential of material abundance, reached a similar diagnosis of this second recession. The Depression, MacLeish claimed in 1938, was not at heart an economic collapse. The nation could in theory supply the material needs of its citizens. Rather, it was a crisis of the spirit, a failure of imagination:

Last year and the year before that and the year before that year men used to talk of the paradox of starvation in the

midst of plenty. The implication was that we starved because there were evil men who wished that we should starve or incompetent men who were unable to provide us with food. But truly it was not at all this that the paradox of starvation in the midst of plenty implied. The true implication of the breadlines under heaped-up wheat elevators in Minneapolis was the failure of the people, of ourselves the people, to imagine the world in which we wished to believe.

Like Luce and *Fortune*, MacLeish saw the Depression as a stalled transition to the New Era. The potential for tremendous growth existed but remained frustratingly out of reach for a nation that had been unable to adapt its social organizations and values to new conditions. The United States, MacLeish insisted, needed to "imagine the world in which we wished to believe," to identify an inspiring national purpose that would heal a country crippled by apathy and uncertainty.[2]

Responding to the continuation of the Depression as an indication of a crisis of imagination, Luce, MacLeish, and *Fortune* formulated a new "affirmative" role for professional leadership. Faced with a seemingly endless recession, an apathetic citizenry, a political stalemate, and the prospect of a second world war, they sought to articulate a national purpose. At the center of this national purpose was the "calculability of abundance": the sense that contemporary society and industry could, if properly organized, provide every citizen not only with daily necessities but also with luxuries. This idea, Luce claimed, inspired not only intellectuals but the "hearts of the people":

> The businessman who feels and feels rightly that he is being thwarted, the intelligent industrial worker who feels that there should be out of all this machinery and capital and genius a solid $2,000 a year for him, and the gullible old lady who feels that the skyscrapers of New York and the great mills of Pittsburgh and Cleveland and Chicago should somehow provide for her simple little wants—all these, as well as the theoretical socialist or the practical humanitarian whose soul is shocked by the spectacle of dire want in the midst of plenty—they are all responding in different ways to . . . the calculability of abundance.

The importance of material abundance to *Fortune*'s understanding of the New Era led the magazine to return again and again to the topics of national economic planning and innovation, particularly concerning the postwar economy. But *Fortune* also insisted that technical plans would mean

little without the energy and direction provided by a broad and inspirational vision of the national future. The creation of this vision would be the responsibility of intellectuals, artists, critics, and journalists. "Poetry alone imagines," MacLeish argued, "and in imagining creates, the world that men can wish to live in and make true. For what is lacking in the crisis of our time is only this: this image." By providing not only a blueprint for the reconstruction of the economy but also an inspiring picture of the future, the affirmative professional could avert the paradoxes created by an economy of abundance repressed under a system designed for scarcity.[3]

This liberal dream of social progress and national unity, and the accompanying understanding of the role of the affirmative artist, however, did not appeal to all cultural professionals. The *Fortune* staff member James Agee, for instance, rejected the faith that well-distributed material abundance would provide a more beautiful environment and a more content populace. "Two Songs on the Economy of Abundance" (1936), for instance, dismissed corporate liberals' optimism that the uneven technological and material advances of the industrial age would eventually be transformed into a more leisurely, equitable American society. The much heralded New Era, "Red Sea" suggested, would never arrive:

How long this way: that everywhere
We make our march the water stands
Apart and all our wine is air
And all our ease the emptied sands?

Asking a question that had no answer, Agee dismissed the belief of corporate liberals that wealth could be turned into "wine" and "ease." Americans, supposedly a chosen people, had progressed and progressed but had collected no real rewards. The New Era of abundant wealth and beauty, like a distant promised land, was a mirage.[4]

In rejecting the optimistic spirit of the "calculability of abundance," Agee also spurned the ideal of the affirmative artist. While Archibald MacLeish exemplified the magazine's new cultural professional in the late thirties and early forties, Agee modeled an alternative, adversary artist. Fearing that the nation's material abundance heralded not an era of beauty, ease, and unity but instead an age of conformity, alienation, and desperation, Agee aimed his art at the destructive "equilibrium" of middle-class society. Renouncing the reform efforts, nationalistic idealism, public involvement, and artistic accessibility of the affirmative intellectual, he considered it a professional duty to remain outside mainstream society. Only by oppos-

ing the supposed progress and social reform dear to liberal affirmative artists, Agee felt, could adversary artists hope to refocus their audiences on the deeper existential problems that hollowed out contemporary society.

But despite Agee's rejection of reform, he retained political aspirations. In fact, Agee argued, by undermining middle-class complacency and re-connecting their audience to the "real," adversary artists could have "radi-cal" effects. Many contemporary critics, like Richard Pells, have agreed that Agee produced truly radical work because, more than addressing a political or social issue, he "disrupted normal patterns of feeling and behavior" and altered our "view of life." But the political commitments of adversary artists demanded that they reject short-term reform politics and replace inspira-tional leadership with distanced criticism. Imagining gradual material im-provements as irrelevant, unlikely, and even undesirable, Agee remained largely uninvolved in the political sphere. He concentrated instead on a pri-vate art that aimed to guide its audience toward the real and on the devel-opment of a complementary practice of cultural criticism. The cost of the "radical" artist's opposition to the symbol-creating artists of the Popular Front, the New Deal, and corporate liberalism was a withdrawal from polit-ical discourse.[5]

The Search for a National Purpose

MacLeish's aspirations for the poet often seem overblown. His oft-re-peated belief that the "great poetic labor of our day" was to create "an image of mankind in which men can again believe" sounds self-aggrandizing even if we read the poet as a metaphor for the professional writer and thinker. In-deed, his aggrandizement of poetry came under harsh criticism, and it is difficult not to agree with Malcolm Cowley, Harold Laski, and others that MacLeish attributed to poets a "quasi-religious power." But this criticism makes it even more surprising that Luce agreed with MacLeish. In a talk on journalism in 1939 Luce compared his work to that of an artist. Journalism at its best, he said, created coherence out of the "fragments of human expe-rience," and did so for a large audience. Luce then referenced MacLeish's ideas about poetry as public speech to explain the journalistic motive. "After several decades of art-for-art's-sake," he explained, "we are beginning to understand once again that it is only a small art which is confidential and that great art or greatly attempted art is that which carries a message to many beleaguered hearts." Luce's expectation that cultural professionals would provide optimism and purpose to the general public also surfaced in

an exchange with MacLeish in 1943. MacLeish had asked Luce to publish his essay, "The Unimagined America," in *Life*, but, in a remarkable letter, Luce declined:

> Yours is a call to the imaginators to imagine. Not all men are equal in their talents or responsibilities—in imagination or otherwise. Jefferson spoke of the "consent of the governed"—he did [not] ask that all men should be equal in their facility to phrase or imagine a Declaration [of] Independence. May we not speak of the need for wide popular "consent" to the to-be-imagined life? But before men can consent to the image, the image must be at least partly fashioned and they must have a look at it.
>
> The article *Life* wants from you is *your* act of imagination when you have made it and drawn it. That we will publish with bells if you will let us do so.
>
> You see how cruel I am—for I am saying your article is a call to yourself. (But at least I know something of the pain of it.) . . . So, Arch, call for the prophecy—but more, *be* the prophet.

Luce asserts MacLeish's as well as his own responsibility ("But at least I know something of the pain of it"), as poets and journalists, as cultural professionals, to "imagine" a new America. Professional leaders, including artists, journalists, and other "imaginators" as well as business managers, politicians, and technical experts, needed to produce a "prophet" who would pen a Declaration of Independence for the American economic revolution.[6]

MacLeish was one of the first writers hired at *Fortune*, and was almost unanimously acknowledged as the most productive and distinguished staff member of the magazine's first decade. Returning from Paris in 1929 as a moderately successful poet, MacLeish deliberately rejected the disconnection of expatriate art and put his energy into his work at the magazine. His enthusiasm for the engagement of *Fortune*'s corporate professional and his endorsement of an enlightened business culture often led MacLeish, a social liberal and strong supporter of the New Deal, into full agreement with *Fortune*. In 1932, for example, he wrote an open letter in the *Saturday Review of Literature* that reiterated the central concerns of corporate liberalism. "To the Young Men of Wall Street" urged capitalists to reform the market by imbuing it with a more meaningful motivation than simple greed. The leaders of industry had seized power, MacLeish complained, but had failed to lead. In order to fend off a noncapitalist, repressive alternative, he

demanded that the new generation of businessmen reject their fathers' complacency and imagine a more inspirational capitalism that could counter the emotional appeal of communism and fascism. Looking to business managers as the natural leaders of the United States, MacLeish argued, "[America] requires of its governors a conception of capitalism in which a man can believe—which a man can oppose in his mind to those other and no longer visionary conceptions [e.g., fascism and communism]." The "New Capitalism" of Henry Ford and Owen Young, MacLeish asserted, had offered a vision of a "fairer distribution of wealth without the laborious and dangerous bureaucracy of state control," and businesspeople needed to continue to develop such a morally sound capitalism.[7]

Through his tenure at *Fortune*, MacLeish had a hand in many of the magazine's defining statements: from his early series on "Skyscrapers" to his celebration of the WPA arts projects in "Unemployed Arts," from the New Capitalist "American Workingman" to his ground-breaking unemployment piece, "No One Has Starved," and from his appraisal of the early New Deal "What's to Become of Us" to his defense of liberty and the rule of law, "The Case against Roosevelt." A devoted capitalist, he sought a middle road between statism and laissez-faire. In a parallel fashion, he supported a shift from the rugged individualism that had allowed the exploitative "Empire Builders" to flourish in the nineteenth century to a belief in a socialized individual who retained the rights of freedom but also recognized the responsibilities of social living. Most notably, however, MacLeish shared with corporate liberalism a powerful vision of an inspired, organized nation. In the first half of the thirties, MacLeish and *Fortune* shared an enthusiasm for both the "young men of Wall Street" and the "young men" of the New Deal, and, like Luce, MacLeish was immediately captivated by the energy of Roosevelt's first administration. And although MacLeish's admiration lasted longer than that of his boss, their mutual enthusiasm for Roosevelt revealed their shared desire for a strong leadership to snap the nation out of its apathy. While Hoover had seemed to wait passively for the Depression to fix itself, Roosevelt had burst into action. Famously declaring, "we have nothing to fear but fear itself," he dismissed the national anxiety and uncertainty which Luce and MacLeish felt threatened the technological and organizational explorations necessary for progress. Though the initial strategies of the New Deal were politically unproven and ideologically incoherent, they were dynamic and inspiring. Even after turning against him, Luce admitted that Roosevelt had revived "the art of government" by rejecting the inane

American political tradition of "doing nothing." "From the human point of view," MacLeish added in 1934, "it is almost irrelevant whether or not Mr. Roosevelt's particular attempt to break out of the cage is successful. What is important is the attempt—and the reaction to that attempt on the part of the people of this nation."[8]

Perhaps no piece demonstrates the compatibility of MacLeish's government-based social liberalism with the expansive energy of corporate liberalism better than the exceptional 1935 *Fortune* essay, "The Grasslands." On the one hand, the piece is a celebration of the communitarian values of the liberal Left and the bureaucratic reform of the New Deal. The common landscape of the Plains, MacLeish claimed, had created a common economic interest, and had also nurtured the "cooperative social and political instincts" and the "socialized mentality of the corn belt." MacLeish praised the New Deal programs working to recover the Plains from the waves of expansion and exhaustion that had "murdered" the landscape, and argued that intelligent government, exercised through the Departments of Agriculture and the Interior, had started to temper the excesses of uncontrolled capitalism and expansion. On the other hand, the article was by no means a criticism of exploration and growth. Like so many other *Fortune* essays in the late thirties, it celebrated the expansive energy of the frontier. "On that vast plain," MacLeish wrote, "alone under the enormous silence of the sun, to have sent the steel beak of the plow into the immemorial sod is somehow, whether wisely or foolishly, to have accomplished the destiny of man." To have *not* moved west, MacLeish suggests, would have been a betrayal of a natural inclination for progress. While the destruction created by physical frontiers had to be replaced by more imaginative frontiers, entrepreneurial adventure remained a necessary accompaniment to the community spirit and government expertise of the New Deal. The "story of the grass" was not only a narrative of American frontier expansion and overextension but was also a parable of the wisdom of a society built on the middle road between capitalist energy and social responsibility, frontier exploration and thoughtful preservation, private enterprise and public leadership.[9]

The similarity between the New Dealer MacLeish and the corporate liberal Luce had its limits, however. MacLeish's dependence on poets, artists, and writers to create new values distinguished his ideas from the more business-centered concerns of Luce and *Fortune*, in which the mantle of leadership was more often placed on business managers, corporate professionals, and, at times, government officials. More significant, as *Fortune* moved

farther away from the New Deal policies in the late thirties, the political rift between corporate liberalism and MacLeish widened. MacLeish remained devoted to Roosevelt, whereas Luce lambasted the president's changes in policy directions and discouraging attitude toward business. Particularly frustrating for MacLeish was Luce's refusal to take sides in MacLeish's bitter battle with the foreign affairs department of *Time* over that magazine's not-so-subtle support for the Fascists during the Spanish Civil War. Perhaps the biggest disappointment for MacLeish, however, was the magazine's major reconceptualization in 1937. The editorial voice, according to Luce and Russell Davenport, had dissolved into a "broad eclecticism" and needed to be redefined and consolidated. To achieve this end, Luce declared the magazine to be "for private capitalism."[10]

MacLeish resigned from *Fortune* soon after this change, partly for personal reasons: he was exhausted, and he wanted to devote time to his poetry. But the redefinition of *Fortune* also played a part. While he continued to be a capitalist—he told *Fortune*'s editors, in 1938, "I need not tell you that . . . I am very strongly on the side of private enterprise"—he believed that the shift overstressed capitalism as the root of American values and abundance. Rejecting the belief that the unity and character of the United States were built on the "capitalist imagination" of the free marketplace, MacLeish pictured a consensus pluralism in which the democratic people and the land of the United States were the ultimate source of American identity and exceptionalism. In many of MacLeish's best poems and essays of the decade— "The Grasslands," *Frescoes for Mr. Rockefeller's City*, *Land of the Free*, "America Was Promises," and others—the land symbolized the rich possibilities of the United States. To exemplify the true heart of the nation MacLeish described individuals who had direct experience with the land— Crazy Horse in "Wildwest," railroad labor in "Burying Ground by the Ties," the Spanish soldiers in *Conquistador*, and the rural Americans of *Land of the Free*, to name a few—and he excoriated the "empire builders" and others to whom the land was an abstract commodity. The land had largely been taken from the people, and this split had left American democracy in danger. But while the history of the United States had been one of promises denied, MacLeish looked hopefully to the New Deal for redemption. He imagined that Roosevelt was returning a voice to the people. Americans, MacLeish insisted in "America Was Promises," needed to shrug off the yoke of the status quo and "take" the promises of their country through the New Deal government. The Depression had upset the old bal-

ances of power, and if this disaster had not brought the green leaves that dominated MacLeish's visions of pure societies like Tenochtitlán, it did offer opportunity: "The weed between the railroad tracks / Tasting of sweat: tasting of poverty: / The bitter and pure taste where the hawk hovers." MacLeish hoped that the unnatural relationship between the land and the distant "empire builders," which had produced emaciated values and a withered landscape, would crumble in the face of a people who would recognize the promise of the New Era and "take" it.[11]

MacLeish's core disagreement with Luce and *Fortune* about the source of American exceptionalism, however, did not change their desire to articulate a national purpose that would pull the nation into the New Era. Both sides continued in the late thirties and early forties to advocate an affirmative ideal for the professional class. When MacLeish left *Fortune* in 1938, for example, he was angry with Luce. Luce, and *Fortune* itself, seemed to him to be moving away from an idealistic mission of social criticism toward lower journalistic standards and an easy acceptance of capitalism. MacLeish complained in 1936 about Luce's assertion that Harold Ickes, Roosevelt's secretary of the interior, "treated business success as though it were criminal." "It is through the rust spots of bunkum phrases like that," MacLeish commented, "that Hearst works into a publisher." When he resigned, MacLeish confronted Luce with his seeming loss of mission, his loss of an exploratory spirit:

> I wish some things had gone differently with you—though I'd find it hard to say just which. Maybe what I mean is that I wish you hadn't been so successful. Because it's very hard to be as successful as you have been and still keep your belief in the desperate necessity for fundamental change. . . . But I don't know—you were meant to be a progressive—a pusher-over—a pryer-up. You were meant to make common cause with the people—all the people. You would have been very happy I think if you could have felt that the New Deal was your affair. Because it was your affair.

MacLeish saw *Fortune*'s new position—its capitalist-centered consensus pluralism—as an acceptance of the status quo and a rejection of the need for a transforming vision. Luce, he believed, had lost the enthusiasm for change that had linked them together since MacLeish began at *Fortune*.[12]

But while MacLeish worried about *Fortune*'s loss of experimental en-

ergy, Luce damned the New Deal in the same terms. In 1938 the two men exchanged letters comparing Theodore and Franklin Roosevelt. MacLeish, in terms familiar to them both, defended FDR as the innovative overseer of a "period of readjustment to a new order." But Luce blasted the current president, arguing that whereas Teddy Roosevelt's "reformist enthusiasm was against a background of vitality and progress," FDR's reforms were a "substitute for enterprise." Franklin Roosevelt, Luce argued in the midst of the devastating 1937 recession, was to blame for "the current stultification, sterility, psychopathic paralysis, and complete lack of the spirit of adventure, daring, exploration, enterprise, courage" in the United States. Countering MacLeish's complaint that Luce had settled for the status quo, Luce argued that the New Deal had served to squash any truly significant attempts at growth and change.[13]

Even as Luce and MacLeish split politically, their desire for a national purpose led them to criticize each other with the same language. The longing for an American mission still linked their ideals. With the approach of the Second World War, this connection would, in fact, grow even stronger. In the year before the United States entered the war, Luce and MacLeish published two controversial essays that exemplify the spirit of *Fortune's* affirmative professional. For both men, the war threatened the disintegration of Western civilization but also offered the possibility of redemption, and so only exacerbated the combination of anticipation and profound disappointment with American life that characterized their earlier thought. In response, Luce and MacLeish urged their fellow citizens to enter the conflict not so much to defeat Germany but rather to produce a victory for America. The conflict, Luce and MacLeish hoped, would force the nation to overcome its apathy and cynicism, and burst through the current listless transition period into one of abundance and purpose.

Luce's "The American Century" (1941), one of the most influential essays of the American twentieth century, has been heralded as a prophecy of American dominance in the postwar world, and damned as imperialist Cold War propaganda. Rarely, however, have critics recognized the highly personal nature of the essay. Luce was searching, as he did throughout the thirties, for a way to bring meaning to the nation, and particularly to its leaders. The essay begins, oddly, with Luce asserting once again that U.S. citizens had lost their way: "We Americans are unhappy. We are not happy about America. We are not happy about ourselves in relation to America. We are nervous—or gloomy—or apathetic." Projecting his malaise onto the nation, Luce looked to the war for an answer:

> There is a striking contrast between our state of mind and that of the British people. . . . The British are calm in their spirit, not because they have nothing to worry about, but because they are fighting for their lives. They have made that decision. . . . All the mistakes of the last twenty years, all the stupidities and failures that they have shared with the rest of the democratic world, are now of the past.

Luce envied the British, essentially, because they were at war. This "fight for their lives" had not only reduced "mental breakdowns" but had also eradicated the cynicism and apathy—"all the neuroses of modern life"— that had worried Luce over the last twenty years. Twelve years earlier, in "Aristocracy and Motives," Luce had lamented that a graduate of Harvard could no longer aim for military glory—for "the star of a proconsulship." But entrance into the Second World War would eliminate that disappointment, by offering a national purpose that would endow every American's life with meaning.[14]

But "The American Century" did not simply urge its readers to "fight for their lives." In order to eradicate completely the discontent of modern life, Americans would have to imagine an affirmative vision of the future. Combining the democratic ethos of consensus pluralism and the rhetoric of the cultural imagination, Luce called for a conscious reinvention of national purpose:

> Ours cannot come out of the vision of any one man. It must be the product of the imaginations of many men. It must be a sharing with all peoples of our Bill of Rights, our Declaration of Independence, our Constitution, our magnificent industrial products, our technical skills. It must be an internationalism of the people, by the people, and for the people.

Luce's critics have complained that the essay is overbearing toward other nations and self-righteous about American ideals. Such critics worry that, in "aiding" foreign states, the United States has forced inappropriate and harmful policies on less powerful nations. But "The American Century" is more than self-righteous. It is completely self-absorbed. Luce did not intend that the primary beneficiaries of the "American Century" should be anyone but the American people. He argued that the world will benefit from American technology and ideals and, indeed, that the United States would serve as the "Good Samaritan of the entire world." But this Samaritan's good deeds aimed to heal his own soul more than to lift the stranger out of the ditch. "We need most of all to seek and to bring forth a vision of America as

a world power which is authentically American and which can inspire us to live and work and fight with vigor and enthusiasm." Luce recommended, truly, an internationalism "for the [American] people."[15]

Like Luce, MacLeish both worried about Americans' failure to commit to the Allied cause and saw in the war an opportunity to revive his fellow citizens' commitment to traditional American ideals. MacLeish fretted particularly that the nation's cultural and intellectual leaders had abandoned their posts. In the controversial 1940 essay "The Irresponsibles," MacLeish reprimanded American intellectuals for their failure to defend the liberal and democratic ideals of the United States against fascism. Writing as if history were reporting the accomplished victory of fascism, MacLeish imagined future historians judging his peers, and concluded that those historians would have little sympathy. Given ample opportunity to act to protect the liberty necessary for the life of the mind, intellectuals instead had opted to retain their purity. The root cause of their acquiescence to fascism was the specialization of the modern intellectual. In their search for truth, intellectuals had "emerged free, pure and single into the antiseptic air of objectivity," but were unable to provide necessary moral direction. Insisting that they must refrain from political involvement, they failed to realize that their very freedom to think, write, and critique was built on the political ideals of modern liberalism. "By that sublimation of the mind," future historians would conclude, "they prepared the mind's disaster."[16]

"The Irresponsibles," intended to shock intellectuals into action, ends pessimistically. But just as Luce hoped that entrance into the war would end the nation's confusion and self-denial, MacLeish imagined the war as an occasion to discredit the disinterested attitudes of his intellectual peers. In "The Affirmation" (1939), MacLeish urged the creation of an active liberal response to fascism. Liberalism, he claimed, tended "to ask questions and not to answer them," and to "be a disinterested and judicial observer": it concerned itself with "truth" and ideals rather than action. Like the intellectuals in "The Irresponsibles," many liberals seemed only vaguely aware that fascism was not simply a national opponent, but was also the destructive antithesis of liberalism. But the fact that fascism contained a powerful ideological attack on liberalism meant that "antifascism" was an inadequate strategy for dealing with the fascist powers. The Allies might defeat Germany and Italy, even as democracy lost to fascism in the minds of citizens on both sides. The only true defense against fascism required instead a reinvigorated democracy: "A nation moving radically and vigorously toward a believable democratic objective is not a nation in which a fascist coup

d'état is possible. A nation standing still and defending a static and deca-
dent economy is a nation in which a fascist coup is all but inevitable." Cre-
ating this "believable democratic objective" was the work of cultural pro-
ducers. Like Luce, MacLeish hoped that the war would counter malaise
with an invigorating national cause.[17]

Responding to the failure of the nation to awaken to the call of war, both
MacLeish and Luce hoped that their visions of the future, their "affirmative
acts of belief and hope," might pull the United States out of its isolationist
slumber. The disruption of the war offered an opportunity to think deliber-
ately about the nation's future. "We stand at the moment of the building of
great lives," MacLeish noted in 1943, "for the war's end . . . will throw that
moment and the means before us." Luce and MacLeish both enthusiasti-
cally supported efforts to plan a postwar world even as the war raged. "I have
been profoundly impressed," MacLeish wrote to Wendell Willkie in 1942,
"by your self-sacrificing effort to get before the people of this country the
terrible necessity of decision as regards the purpose for which this war is
fought." Most notably, this national vision developed increasingly interna-
tionalist ambitions. Jose Ortega y Gasset, whose descriptions in *The Revolt
of the Masses* (1932) of a potentially vital but tragically leaderless Europe
were a major influence on Luce, had concluded that the continent re-
quired a new, more expansive national goal: to "perfect itself in a gigantic
continental State." Both Luce and MacLeish embraced this logic of in-
creased international unity. Both expressed enthusiasm for the United Na-
tions and for international states such as that proposed by Clarence Streit's
Union Now!, about which *Fortune* published a very positive editorial, and
both strongly supported Wendell Willkie and his vision of "One World."
The war offered an opportunity to remake the world according to a new, in-
spiring vision.[18]

Considering Luce's and MacLeish's enthusiasm for the affirmative
leader, it is not surprising that *Fortune* embraced the same yearning for a
new national goal. Nothing was more characteristic of the magazine before
and during the war than its insistent call for revived national leadership and
purpose. The magazine devoted enormous energy to the problem. Parallel-
ing Luce's "American Century," a primary part of its vision of the American
future was a bold internationalism that saw the United States as the undis-
puted leader of the free world. One particularly hubristic editorial, noting
the numerical similarity between 1492 and 1942, declared that "someday his-
torians may mark it as the beginning of the second salvation of Western Civ-
ilization by America." Months before Pearl Harbor, *Fortune* sponsored a

meeting of a panel of managers and intellectuals devoted to issuing "A Plan for America's Place in the New World Order," and published the results in a pamphlet sent to its subscribers: even in April 1941 the war seemed important as an opportunity to revive national peacetime ambitions and, with those ambitions, economic prosperity.[19]

Presented with an international throne, however, the nation seemed intent on abdicating. In response, *Fortune* dedicated itself as a political and cultural outlet to organizing support for the task ahead. Like Luce and MacLeish, *Fortune* saw in the populace's initial reluctance to prepare for war signs of confusion and division, and it urged Americans to unite behind the Allies. In July 1941 the magazine literally pledged itself to the war effort, even before the United States had entered the contest. Speaking for the "we of industrial democracy," *Fortune* promised "our all-out effort to build a war machine that shall not have equal on the face of the earth." But without an inspiring vision of the future, the magazine argued, no amount of armament would win the war. Insisting that the "power and realism of our imagination is just as important . . . as the power and realism of our industrial effort," *Fortune* called its own journalistic skills into service: the magazine vowed to "devote our talents and our industrial experience to a tireless search of the future, to chart a course if possible toward that great democratic world which we know lies ahead." Foregrounding the contributions it could make, the magazine insisted that the war effort would require not only armament building on the part of business managers but also the imaginative and communicative skills of artistic and literary professionals. Continuing to reject a traditional understanding of writers and intellectuals as marginalized adversary members of the professional managerial class, *Fortune*, like Luce and MacLeish, insisted that imaginative professionals— artists, critics, journalists, and intellectuals—must play a central role in constructing an inspiring vision of national purpose.[20]

James Agee and the Ideal of Radical Art

If the career of MacLeish represents the possible success of the liberal, literary artist at *Fortune*, James Agee provides a model of the struggles of the more traditionally anticommercial adversary artist. Despite the magazine's reputation as a destructive place to work, the experiences of staff members varied widely. MacLeish's fruitful experience at *Fortune*, for example, was not entirely unusual. Since Luce had satisfied himself that neither businessmen nor conservatives could write, the magazine often attempted to

train poets and liberals to write about business, and a number flourished in the magazine's corporate environment. Ralph Ingersoll, who would go on to found the social liberal daily *P.M.* in the early forties, served as the managing editor for the first half of the decade, and his enjoyment of both the magazine's investigative journalism and the opportunities it offered to socialize with the rich and powerful made his time at *Fortune*, in the words of his biographer, the "happiest days of his life." Russell Davenport, a frustrated writer who had quit journalism in the late twenties to write poetry, joined the staff in 1930 and became in the late thirties perhaps the most inspired managing editor of the magazine's first two decades. John Chamberlain, who discarded his leftist politics after joining the staff in the late thirties, maintained that *Fortune* had proven to him and other staff members the foolishness of a "stereotypical" antibusiness stance, and he remained a steady contributor into the early fifties. For a writer willing to accept the corporate environment and artistic limitations of the heavily edited, anonymously written magazine, a tenure at *Fortune* could be, as MacLeish claimed, a "marvelous education."[21]

Others, however, suffered under the workload and business focus of the magazine. Macdonald, who would later describe his writing at *Fortune* as "inflated rhetoric" and his work as "whorish," left the magazine after the editors refused his scathing story on U.S. Steel in 1936, an incident his biographer describes as a deliberate attempt to be fired. The talented Wilder Hobson suffered from writer's block, and the prolific Edward Kennedy from alcoholism. Lawrence Lessing, who worked at the magazine in the late thirties, recalled, more generally, that a "string of novelists," unable to produce usable material, paraded in and out of the magazine in the late thirties. "Hell," Richard Hipplehauser reportedly quipped on leaving the magazine, "with what you put into one paragraph in *Fortune*, I can write a whole story for the pulps." But the most celebrated victim of the magazine was Agee. Directed to the job opening by his friend, Macdonald, after graduating from Yale in 1932, Agee initially welcomed the solid employment and opportunity to write. Soon, however, he grew to resent the work both because of the heavy editing at *Fortune*, and his general resistance to bourgeois respectability and orderliness. In his typically extravagant style, Agee described his attitude toward *Fortune* as ranging from "a hard masochistic liking to direct nausea," and regular journalistic work in general as "a gesture of semisuicide." As a staff member he was sometimes brilliant but often undependable. When one editor noticed the galleys of what would be one of Agee's best-received pieces, "The Great American Roadside," he asked the

managing editor, Ingersoll, why the article had not been typically late. "I had to go down and take eight thousand words off the top of Jim's desk and send them to the printer," Ingersoll reportedly replied, "It's great." (Told that Agee was still in his office adding words to the piece, Ingersoll responded, "Will you be a good fellow and go down and tell Jim everything's fine?") At one point Luce responded to Agee's undependability by having him write only business stories, in order to strengthen his "weak side," but this therapy produced more resentment than improvement in the patient. And while Agee's most famous failed assignment was a piece on sharecropping in the South that he eventually transformed into *Let Us Now Praise Famous Men*, it was only one of a number of pieces on railways and orchids and Brooklyn that the editors declared unusable. The commercial aims and regularized production of *Fortune* grated against the esoteric concerns and passionate enthusiasm of Agee's writing.[22]

Indeed, Agee presents a useful foil to MacLeish, and not just in his inability to shoulder a similar workload at the magazine. Whereas MacLeish modeled *Fortune*'s vision of the affirmative artist, Agee embodied an alternative understanding of the artist's political role. Rejecting the call for a unifying national purpose, Agee sought instead to break up what he believed was the stultifying conformity of American society. Insisting that the artist's task was not to inspire but to upset, Agee demanded that art stress honest detail rather than symbol-creation, individuation rather than unification, and criticism rather than affirmation.

At the core of this difference was a strong disagreement about the cause of the American ennui of the thirties. While MacLeish and Luce pointed to the frustrated hopes of the "calculability of abundance," Agee believed that neither the unfair distribution of wealth nor people's inability to use their wealth satisfactorily (although he lamented both) was the central problem haunting the United States. The difficulty, instead, was a spiritual one. Dulled by standardization, stability, and the inability to get beyond representations to the "real," Americans existed in a state of self-alienation. The religious power of what Agee called "human divinity" had been overwhelmed by the quotidian, by laziness, and by a repressive culture. Accordingly, as William Stott argues of *Famous Men*, Agee "used the form of social documentary"—which normally addressed tangible, visible, material injustice—"to say that social problems, whatever their magnitude and poignancy, were of subordinate concern, and that the true center of man's existence, where he affronted the 'normal predicaments of human divinity,' lay elsewhere." The tenant farmers in *Famous Men* were not unhappy because

they existed in poverty: they were discontent because their natural emotions were harnessed and repressed. In *Famous Men*, Agee recalls listening to a group of black men sing at the command of a landlord. Given free reign, the men sang in a vigorous folk style, "jagged, tortured, stony, accented as if by hammers and cold-chisels, full of a nearly paralyzing vitality." But when the landlord complained about "too much howling and too much religion," the men performed a conventional popular song, "a fast, sassy, pelvic tune." Whereas the first song expressed their "human divinity"—their "nearly paralyzing vitality"—their impersonation of the expected style replicated the standardized, hierarchical, commodity relationships that governed their lives, in which singing the obligatory song simply "earned [them] the right . . . to leave." For Agee, such trained artificiality typified American culture and created a dissatisfied populace. It was this learned falseness, and not unbalanced material relations, that was the central problem of American culture.[23]

The repressive, and repressed, middle class of the singers' landlord exemplified, in particular, this American self-alienation. On his last assignment as a staff member at *Fortune*, Agee, accompanied by his wife, Via, and the photographer Walker Evans, went on a cruise to Havana. The magazine had planned a single-subject issue on shipping, and awarded Agee the cushy task of an essay on the cruise lines. Agee, in the words of a snide sidebar to the article, "came back with [a] human document that [had] little to do with the profound economic problems of the merchant marine." *Fortune*'s editors, who had only recently discarded Agee's sharecropping essay, almost certainly did not expect to receive a detailed economic analysis of the cruise lines, and perhaps even anticipated a piece that would break up two hundred pages on the economic, social, and political aspects of shipping. But, just as surely, they did not foresee the extended critique of the bourgeoisie that Agee submitted. "Six Days at Sea" was a ruthless attack, mocking the pretensions and repressions of the passengers on the cruise and arguing that their self-deceit grew from the conditions of American middle-class life. Obsessed with appearances, dulled by standardization, and unwilling to confront their own emotions, the middle class for Agee existed in an unhappy muddle, vaguely aware, at best, of its distance from "the real."[24]

The passengers' "strongest and most sorrowful trait" was their "talent for self-deceit." The tourists had embarked on the cruise, many of them beyond their means, with extremely high expectations. Allowed only a few weeks' vacation, they hoped for an escape from their numbing occupations. But like George Babbitt vacationing in the Maine woods, the passengers were

unable to leave their Zeniths behind. They had been inculcated with the falseness "of their lifelong environment, of their social and economic class, of their mothers, of their civilization." Agee mocked the passengers' inability to break through their artificial roles and "polite" manners into anything resembling their true emotions. Free to interact outside their middle-class setting, they nonetheless brought the hierarchies and social anxieties of their ordinary lives onto the ship. At the first breakfast, "the appraisals of clothes, of class, of race, of temperament, and of the opposed sexes met and crossed and flickered in a texture of glances as swift and keen as the leaping closures of electric arcs, and essentially as irrelevant to mercy." Even sexual encounters, in which raw emotion came closest to surfacing, were bathed in fake smiles and repressed anger. "In 70 per cent" of the "sexual adventures," Agee rather blindly estimated,

> the gentleman felt it obligatory to fake or even to feel true love and the lady murmured either "please" or "please don't" or "yes I like you very much but I don't feel That Way about you," or all three: and that the man, in every case, took it bravely on the chin, sincerely adopted the attitude of a Big Brother, and went to his own bunk tired but happy.

The tourists were so out of touch with their emotions that even sexual rejection solicited a cliché and a smile.[25]

In other *Fortune* essays Agee highlighted the sterility of the middle class by sentimentally imagining the "realness" of the lower classes, the disenfranchised, and even the aristocracy. In *Fortune*'s "Not to Eat, Not for Love," Agee celebrated the mix of citizens—"gentlemen, breeders, yokels, gangsters—society's highest and lowest, seldom those in between"—who enjoyed the brutal sport of cockfighting. "The timid, weak-spirited bourgeoisie," he asserted, unable to face the courage and natural love for violence exemplified by these contests, "took away cockfighting from both their inferiors and their betters." Similarly, in stories about Saratoga horse racing and Williamsburg, Virginia, Agee waxed nostalgic for a mixed public sphere not dominated by middle-class values. When the state assemblies had been held in Williamsburg's heyday, for example,

> you could reach out your hand and touch every man of any social, political, or economic stature or ambition, and every tinhorn, gyp, and low-lifer, male or female, of any initiative, coalesced from the wild green country into a fortnight's solid apoplexy of politics, commerce, banqueting, bootsniffing, socialization, merrymaking, and hell-raising.

Agee enviously imagined the chaos and passion of this past era, insisting that its inhabitants more closely approached true emotions than did standardized members of the contemporary middle class.[26]

But faced with the eccentricity of the marginalized other, the middle class cloaked it in convention. In a review of Erskine Caldwell's *Trouble in July* (1940), for example, Agee argued approvingly that "the South is a country of incredible extremes," and reprimanded image-concerned southerners who condemned the "real," if sensationalistic, fiction of the region. *Famous Men* argued, furthermore, that most members of the middle class saw tenant farmers only through the eyes of condescending, objectifying journalists. Finally, the tourists in "Six Days" experienced Havana only in prepackaged form. Agee noted of the eighteen-hour stop at the destination, "Almost to a man they spent their short time ashore on conducted tours, streaming at brutal speed through that staggering variety and counterpoint of detail whose sum makes a city as individual as a soul; and pausing only before such items as have merely trifling relevance to the true nature of the place." Distracted by the "absolutely beautiful" marble floors and "just exquisite" trees, they called "one of the whoriest cities of the Western Hemisphere" "quaint" and "cute." The standardized lens of middle-class life simplified and emasculated the "extremes" of the real.[27]

The only hope, Agee believed, was that the self-deceit of the bourgeoisie resulted in a vague sense of emptiness, in a "genuine pathos": "semiconsciously, they would as truly have liked to know [Havana] as they were devoid of any instinct for how to do so . . . they suspected what they were missing." Although products of a class environment that made it impossible to break into the real, still they sensed that the real was there. This semiconscious disappointment haunted the cruise, particularly on the return trip. During the last evening the group finally began to drink more and to loosen up, but the rules of etiquette and a lack of boldness left everyone one step away from their genuine emotions. When the bar closed,

> everyone was troubled and frozen in the sudden silence. Life had warmed up a good deal during the evening but not enough to get on under its own steam. Tentative pacts had been hinted at but not strongly enough. The bafflement sank into embarrassment, the embarrassment into straight tiredness, and very soon nearly everyone, muted and obscurely disappointed, drained off to bed.

Life in the American middle class inculcated a concern for surface appearance and an anxiety for social acceptance that left its members "obscurely

disappointed": unhappy, but not sufficiently aware of it to react against it. For Agee, the futility of this last night on the cruise proved that no vacation could heal the spiritual scars of the passengers.[28]

The failure of the passengers to bring their own frustrations into full consciousness left Agee doubtful of the possibility of any significant change in the bourgeois mind-set. So that while Agee posited a social cause for the "self-deceit" of the middle class, his fatalism sometimes led him to react to it in an extremely individualistic way. In his less insightful moments he seemed to feel that the only suitable response to the lifelessness of the monolithic middle class was a private search for "extremes." Sensing that "the real" existed in strong emotion, he revolted against what Dwight Macdonald called the "smoothly prosperous but deeply frustrating" American life. His enthusiasm and anger were legendary, and he sought out circumstances that would produce passionate reactions. He reportedly had his second wife, Alma, have sex with Evans, so that he could watch and explore the inevitably strong emotions that resulted (Evans denied this). On his trip into rural Alabama he deliberately sought out the discomfort of the tenant farmers' houses, while Evans stayed in nearby towns. Less dramatically, he feared any normalization of his life. His condescension toward women and his mistreatment of his three wives grew from a concern that marriage was a bourgeois trap that would transform him into a member of the middle class. Several of his close friendships with more settled members of the middle class suffered because Agee desired to avoid their complacency. To remain close to the real, Agee felt he had to actively resist the temptations and dictates of middle-class life.[29]

Positing a middle class that was uniformly repressive and repressed, Agee sometimes imagined himself and his friends as martyr-like defenders of emotion and truth, and such a reaction often seems self-indulgent and deeply antipolitical. When his undiluted anger found expression in print, his writing could border on the sophomoric: "Six Days at Sea," despite the credit it gives the passengers for "semiconsciously" recognizing their duplicity, is condescending, presumptuous, and unfair. Agee's search for truer emotions fortunately, however, was not limited to a pursuit of "extremes." As a writer he felt that creative work held the possibility of discovering truth. Genuine art, he argued, had the ability to get beyond representation toward the real. In preparation for *Fortune*'s July 1939 single-subject issue on New York City, the managing editor, Russell Davenport, asked Agee, who had left the staff two years earlier, to write a series of prose poems to introduce

the four sections of the issue. In a draft of the opening poem, Agee placed New York at the end of a list of great cities but claimed that, even among London, Paris, and Tokyo, New York was exceptional: it was "one of the most youthful, one of the less 'like' the others." But reconsidering, he rejected his own assessment "Cities," he wrote in a parenthetical note, "are no more 'like' nor less cryptic than human individuals or the infinite talent of snowflakes." In this aside, Agee expressed his discomfort with representation. New York City was not one in a list of similar cities, but rather was a unique entity. To name and notate this "chord of uncontrollable vitality" would reduce its discordant energy to a lifeless drone. Agee feared that literary tropes—here simile, but also metaphor, symbol, synecdoche—worked to disguise an almost sacred singularity. Indeed, he would argue in *Famous Men* that language itself, by representing rather than being, encouraged a dangerous gap between individuals' consciousness and "the real": "If I could do it, I'd do no writing at all here. It would be photographs; the rest would be fragments of cloth, bits of cotton, lumps of earth." Representation, whether by means of language or figurative thought, paled next to the inherent power of "the real."[30]

This sense that an object itself was more authentic than its representation reiterated a shared concern among modernist artists of the interwar years. When Agee wrote in *Famous Men* that words should aim not for description but for an "illusion of embodiment," he echoed Wallace Stevens, for instance, who had implored his readers to "let be be finale of seem," and even the expatriate Archibald MacLeish, who had declared in the mid-twenties that "a poem should not mean but be." All three asked that art duplicate, rather than imitate, the existential power of the real. But while this sensibility led some artists to celebrate the creative object as an end in itself, and to an accompanying belief that social and political issues were irrelevant to the autonomous work of art, for Agee, the artistic attempt to duplicate the real had a "radical" political power. This political potency had little to do with reform, however. True artists, Agee claimed, were politically powerful not because they spurred change but because they encouraged their audiences to recognize the real. In "Art for What's Sake" (1936), a review essay in *The New Masses*, Agee argued that artists who were not active on the political scene could still have political efficacy. While acknowledging that much contemporary experimental writing was "lousy, quite some of it desperately affected, the bulk of it non-political," he insisted that the "total courage, total honesty" that drove some modernist art could make it

extremely powerful and disruptive. Experimental artists, he asserted, were essentially radical, because they crafted new ways of seeing truth: "any new light on anything, if the light has integrity, is a revolution." A true recognition of reality, he insisted, which confronted the complexity and contradictions inherent in human life, was more powerful, more creative of happiness and change, than any piecemeal shift in material relations.[31]

"Radical" artists aimed to narrow the distance between reality and representation. Unlike apolitical proponents of art for art's sake, however, Agee felt that their art addressed the health of the social whole. Because the cure demanded a concentration on the unique, and because it required so much energy and attention, the artist could only work on an individual level. But because the disease has so completely infected American society, the task had inescapably become a social and political one. The significance of the assignment made the honest, adversary artist a crucial figure in modern society. In a review of a biography of James Joyce, Agee expressed this importance:

> The utmost type of heroism, which alone is worthy of the name, must be described, merely as complete self-faithfulness; as integrity. On this level the life of James Joyce has its place, along with Blake's and Beethoven's, among the supreme examples. It is almost a Bible of what a great artist, an ultimately honest man, is, and is up against.

Choosing three canonical artists as the exemplars of "heroism," Agee integrally linked honesty and bravery to art. The greatest battle, in his mind, was between the "ultimately honest man" and his society. The only large excerpt of Joyce's writing in the review was a satirical poem addressed to the "Dublin Litterateurs," in which Joyce portrayed this conflict: "Where they have crouched and crawled and prayed / I stand, the self-doomed, unafraid, / Unfellowed, friendless, alone." The adversary artist, by refusing the mediocrity and self-deceit of his surroundings, provided the greatest hope for a victory of the real over a self-deceptive middle-class society.[32]

The "radical" project of creative work, unfortunately, was extremely difficult. The primary obstacle for the radical artist was that art, necessarily a representation of reality, was already a step away from the real. Self-conscious of their representative task, artists had to struggle to avoid projecting standardized assumptions and simplifications onto their complex subject. Because of this, Agee admired creative work that approached unself-con-

sciousness. Letters, for instance, suggested unpremeditated emotion and were thus closer to the real. Silent-film comedies, another favorite medium, were successful in part because they "never strove for or consciously thought of anything which could be called 'artistic form,' but they achieved it."[33] Language, then, as a form of representation, was a dangerous tool. Rhetorically packed words such as "tenant farmer" or "art" often transformed a radically complex reality into a vague, easily misused meaning. In the appendix of *Famous Men*, Agee included a two-page list of such "anglosaxon monosyllables" that reduced the complex to the simple. Such words produced the appearance of knowledge but often failed to provide any sense of the "true dimension" of a situation. Photographs, as direct evidence of a moment, could do better, but even these were fraught with danger. Introducing and praising Margaret Bourke-White's 1934 *Fortune* photo essay, "The Drought," Agee maintained that the photographs could help the reader understand "what the whole thing meant; what, simply and gruesomely, it was." By 1941, however, Agee would include "margaret bourke-white" in his list of "monosyllables" and would complain that bad photography had produced a "nearly universal corruption of sight." Language and representational clichés tended to simplify and standardize, and thus destroy the power of the real.[34]

Nevertheless the true artist, despite this difficulty, could still aim for what Agee called the "illusion of embodiment." Artists needed to use corrupted artistic tools—self-consciousness and language—to overcome the pitfalls of representation. This created a certain irony: as David Madden writes, Agee expressed his "antipathy to art . . . in the most artistic context." Representation, normally destructive of the real, could, in the hands of a genuine artist, be a revealing tool: "I dislike allegory and symbolism which are imposed on and denature reality," Agee noted, "as much as I love both when they bloom forth and exalt reality." Paradoxically, by communicating in an inventive, "artistic" manner—a frankly artificial medium—writers, photographers, filmmakers, and others could lead their audiences toward a recognition of the real. And while Agee worried that the "emasculation of acceptance" threatened any great art, an artist like Charlie Chaplin, who "most deeply and shrewdly" realized "what a human being is, and is up against," could, by refusing to adjust his work to the standards of "'nice' people," achieve popular success among the "millions of less pretentious people" who love his "sincerity and sweetness, wild-animal innocence and glorious vitality." Such performers could, at least for a time, produce joy,

passion, even revelation. Honest and creative art could open a moment when its audience would see beyond representation to "the real."[35]

Radical Art and Reform

But while Agee insisted that an emotional, even spiritual, recognition of a complex reality could be "revolutionary," the political and social implications of his ideas were quite the opposite. Enlivening a modernist fascination with idiosyncrasy, ambiguity, and the individual, Agee argued that representation emasculated the power of "the real." But since reform efforts depended heavily on strategies of symbolic representation and synecdoche (as in documentary work), Agee positioned himself politically simply by refusing to countenance those strategies. In embracing an artistic fascination with "the real," Agee spurned the image of the active and politically involved "imaginator" heralded by Luce, MacLeish, and *Fortune*.

Agee's work at *Fortune* demonstrates his distaste for reform, even as a member of a magazine staff devoted to social progress. In March 1934 *Fortune* published perhaps the most famous essay in its history, "Arms and the Men," written by the magazine's future managing editor, Eric Hodgins. The opening of the article, parodying matter-of-fact business journalism and the antigovernment rhetoric of business, indicted the munitions makers of Europe in scalding terms:

> According to the best accountancy figures, it cost about $25,000 to kill a soldier during the World War. There is one class of Big Business Men in Europe that never rose up to denounce the extravagance of its governments in this regard—to point out that when death is left unhampered as an enterprise for the individual initiative of gangsters the cost of a single killing seldom exceeds $100. The reason for the silence of these Big Business Men is quite simple: the killing is their business.

The article created a sensation. It helped to inspire a congressional investigation into the munitions industry and garnered praise even from *Fortune*'s rival, the *New Yorker*. And though some critics noted that the critical edge of the essay was dulled by its almost complete focus on Europe, its appearance was a dramatic demonstration of the magazine's willingness in the thirties to take a moral stand, even against business. "Arms and the Men" established the critical possibilities of this corporate liberal magazine.[36]

An essay on the quinine industry, however, published a month earlier, took little advantage of these possibilities. "Cinchona—Quinine to You,"

written by Agee (but without a byline), addressed a problem similar to "Arms and the Men." As in the munitions essay, a European-based industry was flourishing at the cost of human lives, and justifying itself in the name of the free market. Quinine, the only known preventative and cure for malaria, was under the monopolistic control of the Dutch Kina Bureau. By limiting the supply, the Bureau made enormous profits (averaging 36 percent per year), but also kept the medicine beyond the financial reach of 90 percent of malaria victims. *Fortune*'s research on quinine uncovered enough damning evidence to warrant an attack, and, because it was a European business, such an attack would be unlikely to harm the magazine's circulation or advertising. The story offered a ripe opportunity to harvest the critical praise and cultural capital that "Arms and the Men" produced in such abundance.

But, instead, Agee remained oddly neutral toward, even celebratory of, the Bureau. In the opening the essay seemed poised to grapple with the moral questions created by the monopoly: "For a nice, clean little study in commerce and ethics you will go far to beat the quinine trade." But Agee's "study" was indeed too "nice" and "clean." He cleared the Bureau of any moral culpability for the quinine shortage by simply denying the existence of a moral question: "reflect, with the Dutch," Agee told his readers, "that business and morality are two quite different words, not called synonymous in any dictionary." Instead, the essay concentrated on the stable business success of the cartel: "Perhaps the utopian distribution of quinine at utopian prices must wait upon the utopian state (if such can be imagined to include malaria). Meanwhile the Dutch have a business which, if it falls short of humanitarian perfection, is at least as tidy a little business as you're likely to see in a day's journey." Agee even laughed off, as "fantastic" and "odd," an American attempt to indict the Bureau for a violation of U.S. law. While Hodgins scolded the abuse of economic power in the munitions industry, Agee—even if we read his tone as ironic—fatalistically refused to insist that business consider moral questions, and even praised a similar abuse as clever and profitable.[37]

To Agee, business, and even politics, was a game, and if the Bureau had won, it demonstrated only poor sportsmanship not to acknowledge its skill. It made no more sense to protest the Bureau's advantages than it did to complain that the need to dribble in basketball advantaged quick-handed players or lament that football favored large men. Later, in 1934, Agee wrote an essay on "Arbitrage," a stock-trading practice in which brokers took advantage of momentary, minute differences between the prices of identical

securities in different world markets. The article was structured on sports metaphors, in which the brokers were "sportsmen at heart" who possessed "individual brilliance and perfect mass coordination [that] any football coach would dream twice about." Agee's fascination with this speed and skill relegated questions about the legality and social utility of the arbitrageur to the final page of the essay, where he defended them tersely against impending New Deal controls. In "The Change of the Guard," too, he discussed Benito Mussolini's theories of leadership with the same admiration of gamesmanship and success that suffused the quinine and arbitrage essays. Such game metaphors, Warren Susman argues, signify a sense of meaninglessness. Agee indeed seemed convinced that, within the parameters of establishment business and politics, the moral decisions with which corporate liberals were concerned were irrelevant. The American system, he insisted, would produce the same progress and destruction no matter how responsible particular individuals were. In essays on air pollution and drought, for example, Agee lamented the abuse of the natural world, but in both cases reform seemed an impossibility. We had built our society on technology and capitalism, he implied, and would have to live with the consequences: "It is indeed and literally the breath of our nature and of our need in the shaping of our time," he wrote of smoke, "and it is not strange that no strength of our ingenuity can avail entirely to lift it from us."[38]

This fatalism perhaps found its clearest expression in the closing of the quinine essay. Business demanded certain sacrifices, and produced certain advantages, Agee reasoned, and as long as the current system remained in place, those pros and cons would remain as well:

> And so, to date, it goes: the Dutch have the goods and the great skill and hold the reins and press the buttons; humanitarians complain and deplore; all nations that have anything at stake in the tropics . . . envy and try to raise cinchona and buy it from the Dutch because it makes that part of the world go round smoothly; innumerable thousands, year by year, chatter and fry and not seldom die for want of a remedy money could buy and for want of the money to buy it. So it has gone and goes: a business magnificently coördinated and by no means a heaven on earth. And so, very probably, it will go for a good long time to come.

"So," Agee repeats, "it goes." Withdrawing from any ethical judgments, he placed all the players—the Dutch, the reformers, even the "innumerable thousands"—in a drama whose end has already been written, and so was hardly worth protesting. As long as "business is indeed business," Agee felt

he had no choice but to credit the Dutch for solving a riddle that others had not, and to accept the rules of a world "by no means a heaven on earth." Not quite asserting a doctrine of original sin—it was only "very probable" that the status quo would remain—Agee nevertheless rejected the corporate liberal sense that Eden was only a reform or two away.[39]

In "Dedication," a prose poem in his collection, *Permit Me Voyage* (1934), Agee was even more deliberate in his rejection of *Fortune*-style social criticism and reform efforts. The poem, in the name of a long list of people comprising essentially "the entire hierarchy of the natural God," asked that God "preserve this people." It was an early effort for Agee in expressing what in *Famous Men* he would call the "human divinity" of all individuals. In the fourth section, however, Agee addressed his experience at *Fortune*. The section opened by castigating "those men who make it their business to destroy concord and to incite war and to prolong it, for their profit in the commerce of armament." But after (literally) damning these "merchants of war," Agee turned to the corporate liberals who had written and published "Arms and the Men":

> To those merchants, dealers, and speculators in the wealth of the earth who own this world and its frames of law and government, its channels of advertisement and converse and opinion and its colleges, and most that is of its churches, and who employ this race and feed off it; *to those among these rulers and these owners, these shapers of general thought, who decry these merchants of war: that they see how surely and to what like extent they in themselves are blood-guilty; and how in what manifold ways they are more subtly and terribly and vastly accountable than for life blood alone: and that they repent their very existence as the men they are, and change or quit it: or visit the just curse upon themselves.*

Agee here asked Hodgins, Luce, and others not to fight the conditions they had uncovered but, impossibly, to "repent their very existence." Evil arose not from the moral failure of munitions merchants to accept their social responsibility, as corporate liberals would have it, but from the human society that produced both the criminals and the accusers. Furthermore, the clear-cut evil of these merchants paled beside the "more subtle and terrible" spiritual consequences of the culture that the "rulers and owners" have shaped with their governments, educational institutions, churches, and other sources of authority. *Fortune's* attack on the munitions industry, Agee insisted, was evasive not because it focused on Europe but because it failed to recognize the much deeper culpability of its own class in both the material

violence and spiritual incompetence of modern society. In pointing a finger at a single injustice, *Fortune* had merely distracted its audience from its own guilt.[40]

Because reform addressed symptoms rather than foundational problems, Agee argued that it was misdirected, self-aggrandizing, and futile. More than this, he insisted that it was actually harmful. Contemporary social organization, he wrote his mentor, Father James Flye, in 1938, "is tragic, mistaken, and eccentric from the root up, and cannot come to good; and . . . the effort to manipulate for good within such a framework, no matter how sincerely, can only result in compromise; and can . . . add only to the sum of evil, misfortune, and misapplication of human energy toward goodness." There were two ways in which the liberal attempt at reform obstructed the radical consciousness of "the real" for which Agee aimed. First, the social reformers' successes only strengthened and enlarged the repressive middle class, making truly meaningful change even less likely. To "raise" the lower-class members into that middle class would only deepen the spiritual swamp within which the country struggled. In "Southeast of the Island: Travel Notes," for example, an essay on Brooklyn commissioned but then refused by *Fortune* in 1939, Agee noted with seeming regret that several particularly "hard" neighborhoods in the borough had been "cleared up" by the New Deal: "the skinned land which was formerly a Hooverville, available to the totally derelict, [now] under squarer dispensation wears WPA's usual creditline for having Cleaned this Area." Mocking the "square" attempt to "Clean" up a community, Agee implicitly questioned whether this improvement was really progress. Bringing ghetto residents, tenant farmers, and other marginalized groups into the middle class would deprive them of the few freedoms and true emotions they possessed, and would further standardize the diverse public sphere—what he called in one essay the "crazy quilt" of people—which Agee revered. The creation of an inclusive middle class would not solve Americans' discontents and would only exacerbate them.[41]

More important, however, reform politics depended heavily on representation and synecdoche. It required the simplification and rhetorical power created when a single comprehensible image replaced a complex, ambiguous reality. Thus Agee's rejection of representation, as John Lucaites recognizes, had a significant political implication. "The implicit intention of [*Famous Men*] was to illuminate the reader's understanding of the inherent instability of political (and aesthetic) representation as a rhetorical process, and thus to urge careful consideration and redefinition

of the liberal democratic ideological commitment to the mutual reducibility of the 'individual' and 'the people.'" In other words, Agee protested the tendency among liberal reformers to easily conflate individual and community needs, subsuming them both under the rhetorical structure of the "people" or "America." Reform advocates, hoping to enact large-scale change, had to think in terms of group needs, and convince potential helpers through an empathetic, symbolic portrayal of those needs. This rhetorical strategy eliminated the differences between particular individuals. As Agee lamented, reformers had transformed the subject families of *Famous Men* from unique humans into the "tenant farmer problem." By eliding individual differences and depending on representative symbols, Agee believed, reform strategies obstructed any encounter with "the real."[42]

In adopting this perspective, Agee rejected much of contemporary political strategy. In the late thirties, as we have seen, the internal friction and political uncertainty of the United States encouraged political factions to define their beliefs in terms of unifying images of "America," "Man," and "the People." Kenneth Burke's "Revolutionary Symbolism in America," for instance, argued that an effective cultural propaganda required a set of powerful inclusive symbols. Liberals as different as Henry Luce and Archibald MacLeish tried to unify the community and individual by imagining symbols of national purpose. In "The American Century" and "The Grasslands," Luce and MacLeish transformed conflicts over European intervention and government prairie conservation efforts, respectively, into parables of the American future. In each of these essays, the nation's reaction to a practical problem was reformulated as a statement of self-description: the people's decision, or lack of decision, each author argued, would produce either the solution to an overriding national crisis or the dissolution of the nation's promise. "The war" and "the grass," not simply political problems, were tests of the nation's integrity, strength, and unity. Luce and MacLeish intentionally simplified the overwhelming complexity of those practical problems in order to endow them with purpose and passion. Indeed, as I have argued, culture itself became a tool through which groups could consolidate a large community that supported their political ideals. Corporate liberals, New Deal liberals, and the Popular Front all used outlets such as *Life*, Farm Security Administration photographs, and radical theater to encourage audiences to invest themselves in a particular ideal of "the people" or America.

Agee repudiated this conflation of individual and national needs. In December 1935 Agee's *Fortune* essay, "U.S. Art: 1935," introduced a collection

of seven contemporary paintings that represented the mainstream of American painting, largely in the mode of the American Scene. American Scene painters, Agee explained, expressed a "shift in the common eye." This new way of seeing looked at "humanity as humanity, rather than as a diversity of individuals." "There are no longer men," Agee explained, "there is Man. And Man is a heroic, pathetic, exploited, self-sacrificing, beaten, rising figure seen at a great remove, seen at an almost infinite distance." Read against Agee's idealization of the real in *Famous Men* and elsewhere, this description of the American Scene has a strong critical edge. The particularities of the real were rubbed out of these portraits in favor of sentimentalized, caricatured generalities. This obsession with the symbolic was essentially a blindness: "Fixing their attention on the shape of Man, these painters see no other figure."[43]

Moreover, Agee insisted that this predilection toward the idealized, unifying symbol characterized not just American art, but was also a "concern of their generation" that had political as well as aesthetic expressions. In the poem "Temperance Note: and Weather Prophecy," the second of the "Two Songs on the Economy of Abundance" (1936), Agee wrote:

Watch well The Poor in this late hour
Before the wretched wonder stop:
Who march among a thundershower
And never touch a drop.

In this poem, written a year after "U.S. Art: 1935," Agee mocked more deliberately the image of "Man" as "a heroic, pathetic, exploited, self-sacrificing, beaten, rising figure seen at a great remove." Alluding to the same passage from *King Lear* that would later appear in *Famous Men*, Agee parodied the false sentimentalization of "The Poor" that portrayed those in poverty as simultaneously pure and pitiful, a "wretched wonder" that abides middle-class mores even in the worst of conditions. Reformers, forced to appeal to a large audience and incapable of communicating "the reality" of their subjects, turned instead to false idealizations, and just as Havana through the eyes of middle-class tourists became "quaint" and "cute," the unique individuality of the poor is transformed into a "wretched wonder." By transforming unique and particular realities into powerful, but simplified, rhetorical symbols, Agee maintained, reformers led American society even farther from a recognition of the real.[44]

Agee's artistic "radicalism"—his embrace of complexity and "human divinity"—was therefore political not so much because the recognition of "the

real" was revolutionary, but precisely because it opposed reform and encouraged political withdrawal. Agee's diagnosis of Americans' disease encouraged a fatalistic worldview in which reform seemed provincial and self-congratulatory. Americans' discontent grew, he felt, from a deeply ingrained spiritual and systematic sickness. Unable to imagine a medicine that could address the "racial," human, or systematic roots of the malady, Agee expressed little hope for recovery. In *Famous Men*, for instance, he maintained that "the economic source [of the tenant's problems] is nothing so limited as the tenant system but is the whole world-system of which tenantry is one modification." To insist that reform of tenantry would make the lives of tenant farmers easier, he added, deceptively "persuades that 'a cure' is possible through means which in fact have little effect save to delude the saviors into the comfortable idea that nothing more needed doing." Reform addressed only the symptoms of Americans' pervasive cancer. But, even more, reform actually worked *against* the radical recognition of the real that could bring individuals back to health, because it both depended heavily on representational rhetoric and promised to enlarge the middle class. A country in which everyone experienced the meaningless material comfort of the middle class—the expressed goal of social reform—was a frightful dystopia to Agee. Preferring the "extremes" of the real and of those outside the mainstream, Agee feared that reform would aid the pernicious spread of middle-class equilibrium.[45]

The Clash of Affirmative and Adversary Ideals

MacLeish, Luce, and *Fortune* argued that the intellectual should serve as an "imaginator," as the visionary mind of the body politic. Journalists, poets, editors, and even advertising writers produced the symbols and rhetoric that would direct the nation toward its future. Even in 1931, for instance, *Fortune* compared the positive effects of posters on the national goals of the Soviet Union ("Without posters, the Five-Year Plan would be seriously handicapped") to the importance of advertising to American business. This recognition that advertising functioned holistically to reinforce the values of American commercial culture expanded later in the decade to the larger belief that all art functioned as support for certain ideological values. Discussing the "subtle propaganda" of Russian art, *Fortune* noted in 1937 that "the truth is, every nation's art is propaganda in the sense that it reports that nation's prejudice and hope." In this conception of art, intellectuals and artists played a practical, essential role in the life of the nation. Even in the

face of war, MacLeish argued that creative workers were essential: "the work of American artists and writers and musicians is a national resource, important enough to be mobilized along with men and arms, and the kind of mobilization which is now going forward in America is a mobilization in which the work of writers and artists has its proper part." To MacLeish, Luce, and *Fortune*, intellectuals and artists were workers who produced a powerful, public, and political rhetoric.[46]

As the agreements between Luce and MacLeish suggest, this reconsideration of the importance of the cultural professional was not limited to *Fortune*. In imagining culture as a political tool, both the New Deal and the Popular Front coalition similarly aggrandized the role of the artistic community. If, as Sean McCann suggests, a common national culture was crucial to the attempt by the New Deal to strengthen the "traditional institutions of American liberalism—representative government and individual freedom," then clearly the cultural producer played an important role in New Deal ideology. Indeed, MacLeish praised Roosevelt at his death as the first modern leader to understand that "those who follow learning and the arts are as important to the Republic as those who follow other callings." The Federal Arts Project exemplified this recognition of the artist's status as a productive professional, as Michael Szalay argues, by imagining artists' products not as commodities but as expressions of the nation. "The Federal Writers Project," one proponent of the FSA noted, "at once expresses and seeks in some measure to direct [the nation's] self-determination, to restore America to herself." As we have seen, too, the "cultural front" of the radical Left similarly aggrandized the role of artists. Echoing *Fortune*'s suggestion that art served as the unconscious propaganda of the nation, cultural critics of the Popular Front imagined that in a society increasingly saturated by mass media, artists served as crucial "symbol producers." The activities of these producers, leftist theorists like Kenneth Burke argued, would be central to the creation of the "inclusive propaganda" that would allow the Popular Front coalition to function not only as a social and cultural community but as a political force.[47]

Clearly all three of these political coalitions rejected the ideal of an autonomous artist who needed to remain free from political commitments. Just as important, however, they rejected a focus on the exemplary individual artist and, instead, adopted a vision of art produced on a widespread, social level. On the one hand, as Marcus Klein argues, these groups' simultaneous focus in the late thirties on the political meanings of culture and on the diversity of the American people produced a "democratization of au-

thorship in America" through which "new Americans [could] assert their cultural citizenship." Recognizing the independence and self-determination of various interest groups meant acknowledging their right to their own means of expression, no matter how unrefined. More significant, the New Deal, *Fortune*, and the cultural front insisted on the holistic social effects of artistic production, on the ability of a democratic and participatory mass culture to unify and vitalize the nation. "We must," asserted Joseph Alsberg, the national director of the Federal Writers Project, "get over the idea that every writer must be an artist of the first class, and that the artist of the second or third class has no function." The regular, if unspectacular, productions of Luce's journalists, the screenwriters and cartoonists of the cultural front, and the anonymous writers of the New Deal's state and city guides all served the important function of "symbol producers." The compound effect of their productions, each coalition hoped, would be a diverse citizenry unified through its commitment to business or labor or the New Deal.[48]

For Agee, on the other hand, as we have seen, this vision of cultural production as symbol creation, as affirmative propaganda, was unacceptable. He believed that the "wretchedness" or the "wonder" of the contemporary human condition could only truly be addressed by a courageous determination to see beyond representation, beyond material reform, to the real itself. Social change, if it would come at all, would arise when a sufficient number of individuals had experienced this "radical" contact with the real. Agee ended his draft of the prose poems for the New York City *Fortune* issue with a paean to those who could approach the real:

> Those; they are few; without wife; without income; in most strict and contemptuous choice of gifts and of all paid work; who have yet managed to stay alive year in, and year out: who, alone among all these millions, live as free unfearing human beings: and who alone do the work and perceive the world of free human beings . . .
>
> And who alone are of that company which shall liberate this race.

Whereas MacLeish and Luce imagined intellectuals as the leading conversants in the national discourse, Agee reduced the adversary intellectual to a sort of mystical, yet inexplicably powerful, hermit. Rejecting human company, economic dependence, and binding social relationships—all in the name of integrity and freedom—the "radical" artist climbed to the heights of unencumbered observation and criticism, imagining that his wide vision had provided him with a liberating perception and power.[49]

But, in fact, such self-isolation mandated a depoliticized role for the intellectual. Neither "liberating" nor "radical," this new adversary artist abandoned political discourse in three ways: by turning to a private and/or non-representational art, by preferring the distanced perspective of cultural criticism over the practical chaos of political conflict, and by focusing critical energy on the liberal middle class rather than the capitalist class. First, Agee's art focused almost exclusively on the individual consciousness. As we have seen, he felt that the recovery of the real could only be achieved through personal revelation. His deep concern with the unique individual led him away from social concerns toward an extended analysis of consciousness, particularly his own. Most of Agee's fiction, including the Pulitzer Prize–winning A Death in the Family, which was drafted in the thirties, was autobiographical. The obsessive self-analysis in Famous Men made Agee, rather than the tenant farmers, the primary subject of his portrait, and the idiosyncratic, formally complex organization of the book intentionally rendered it ineffective as political rhetoric. As Susan Hegeman argues, the central project of Famous Men was the "exploration of the interior spaces of the liberal intellectual himself." This focus on his own self-conscious left Agee largely oblivious to political and public concerns of thinkers such as Luce and MacLeish.[50]

When Agee did widen his vision to the larger world, he extended his examination of consciousness to a larger public, and this cultural criticism tended, also, to be apolitical. Victor Kramer argues that the concern that links all of Agee's work together was his interest in cultural criticism. His film reviews, Kramer holds, focused largely on uncovering the culture that created the film, and connecting the movie to "larger movements within the culture." Learning in the mid-forties that Luce was planning a new journal of literature and culture, Agee even formulated a plan for a magazine of cultural criticism. "A best seller, for instance," he envisioned, "should be reviewed not only on its 'entertainment value': we would investigate the causes of that particular 'value'; and we should treat it, chiefly, as the valuably suggestive anthropological exhibit which it essentially is." The connection between this type of criticism and his attempt to recover "the real" was in his hope that such a magazine could work "to undeceive readers of their own—and the editors'—conditioned reflexes." Such cultural criticism aimed to break down the representations that separated Americans from the real. But while there is much to admire in Agee's cultural criticism, it can lead—and, in fact, did lead in the postwar years—to an iso-

lation of the intellectual project from more "affirmative," public discourse. Conceiving of himself as opposed to the middle-class populace rather than as a part of it, Agee provided a model of "anthropological" distance that many artistic and cultural critics adopted in the postwar years. Adversary intellectuals rather than actively rejecting or contributing to mainstream American culture merely separated themselves from it. In his proposal for the magazine, Agee noted that a small group of critics, primarily those who "read *The Dial*, or *Criterion* or *Kenyon Review*," already practiced such cultural criticism: after the war, the critical project of such little magazines (represented not only by these New Critical strongholds but also by the *Partisan Review*) would provide many intellectuals with a justification for their withdrawal from the frustrating sphere of practical politics.[51]

Finally, Agee's understanding of the role of adversary intellectuals undermined their traditionally anticapitalist politics. In Agee's conception, the enemies of radical artists were not exploitative capitalists, or a tyrannical government, but rather the members of a liberal middle class. "Polite society" encouraged individuals to ignore the contradictions that had crept into their lives: unable to articulate their own dissatisfaction, the middle class accepted the "death" that resulted from a life alienated from the real. Agee felt that by institutionalizing duplicity in middle-class life, and undermining any revolt against that duplicity by incessantly categorizing and "emasculating" art, middle-class society had created a repressive stability that offered little hope of real change. It was against this monolithic force, not the abuse of capitalists or even the alienation of commodity relationships, that Agee wished to fight, and the saturation of American society with middle-class values left him fatalistic about the opportunity for significant change.

In prizing "the real" over practical reform politics, Agee helped to formulate a new role for the adversary intellectual. The focus on the private world (what Hegeman facetiously calls the obsession of Cold War intellectuals with their "infinitely complex, fascinatingly ambiguous selves") and on distanced cultural criticism would characterize much of the work of postwar American intellectuals. Following Agee, many intellectuals and artists who had been sympathetic to anticorporate capitalist criticism in the thirties, including the anti-Stalinists surrounding the *Partisan Review* and the Agrarians heralding the New Criticism, turned their attention away from politics toward private, nonrepresentational art and cultural criticism. But this conception of the artist and intellectual did not go uncontested.

Just as Agee and these others were turning away from the public sphere, MacLeish, Luce, and other liberal artists were arguing that mind workers had an important role as national "imaginators." Before and during the war, as the following chapters argue, these two groups struggled to establish a dominant definition of the role of the artist and, in turn, the professional managerial class, for postwar America.[52]

The Triumph of Professionalization,

1940-1952

6 PROFESSIONAL LEADERSHIP AND DEMOCRATIC PARTICIPATION

In the years before the United States entered the Second World War, confusion and frustration dominated the national mood. On the domestic scene, as we have seen, the New Deal had played itself out, and all that remained was squabbling over the remaining chips in the pot. Depression conditions had come to seem normal for many, leaving the reform urge exhausted and undirected, but conservative forces had been unable to rally enough support to do anything but undermine weak liberal initiatives. The foreign arena was, if anything, more dispiriting. The bitterly divisive battle between isolationists and internationalists produced little but national indecision and halfway measures. More startling, the growing aggression and domestic oppression of Nazi Germany, fascist Italy, and the Stalinist Soviet Union convinced many observers that democratic government had reached a crisis point. Germany's anti-Semitic violence and imperialistic aims made it increasingly difficult to imagine a lasting peace in Europe, and the Moscow purges of the mid- and late thirties convinced many on the Left and the Right that communism and fascism were simply different names for totalitarianism. The civil war in Spain, which broke out in 1936 and was fed by the military support of Italy, Germany, and the Soviet Union, built on these fears, and the fiercely brutal war suggested that an end to the crisis would only be reached after a great spilling of blood. "To Americans," *Fortune* admitted, "A.D. 1940 was a year of crashing disillusionment—disillusionment in the strength of their friends, in the motives of their neighbors, in the protective breadth of oceans." The dominance of authoritarian governments in Europe suggested the precarious position of an American democracy already weakened by nearly a decade of economic crisis.[1]

Despite the threat of totalitarian politics outside the

United States, and apathy and cynicism from within, *Fortune* did not waver in its commitment to democratic consensus pluralism. In explaining the nation's exhaustion, *Fortune* pointed to the same lack of imagination that haunted Luce and MacLeish. Like Luce and MacLeish, too, the magazine optimistically insisted that a rearticulated national purpose would lead the country through a difficult transition period toward a renewed vitality. Just as important, the magazine denied that such an inspirational purpose would bring with it the repressive unity of fascism rather than the free agreement of consensus pluralism. While many saw the rise of Hitler, Stalin, and Mussolini as a sign of the dangerous irrationality and malleability of the mass public in an age of spectacle and mass media, *Fortune* argued before and during the war that the American public could balance its nationalist energy with a critical rationality. The intelligent populace had the ability, through its education and a native "horse sense," to limit and control the power of "imaginators" and to balance the inspiration of nationalist idealism with a dedication to the truth. Not a pre-fascist masses, the American people deserved to play a democratic and active role in the fate of the nation.[2]

This combined faith in the self-governing ability of the American people and in the desirability of a unified national culture linked the perspectives of corporate liberals with New Dealers and the Popular Front coalition. But a talented and increasingly influential group of adversary intellectuals, most obviously represented by the critics surrounding the little magazine *Partisan Review*, developed a stinging critique of this democratic idealism. Replacing MacLeish's "the people" with James Agee's alienated middle and lower middle classes, these thinkers worried that the rise of nationalism and totalitarianism in Europe, and of mass culture in the United States, signaled the end of a rational public sphere. Fearing, like Agee, symbolic politics and national myth, they insisted that unity was more dangerous than disintegration, and so blasted *Fortune*'s and MacLeish's naive trust in abstract words like "democracy" and "the people." To these New York Intellectuals, affirmative professionals' optimism looked suspiciously like acquiescence, their inspiration like irrational myth, and their desire for consensus like an abdication of class independence.

These oppositional views of the democratic public led to significantly different understandings of the role of the art and the cultural professional. *Partisan Review* criticized *Fortune*, MacLeish, the Popular Front, and others for their belief that affirmation was a more important function of the brain worker than criticism, and maintained that cultural professionals remain at

a distance from popular society. Contemptuous of the attempts of affirmative professionals to open access to the cultural field, these writers imagined that the primary purpose of artists and critics was to conserve "genuine" art in the face of a degraded and degrading mass culture. And while *Partisan Review* argued, like Agee, that true art could have a revolutionary power, the domination of mass culture meant that the primary task of the adversary artist was to separate and protect that true art. *Fortune*, however, rejected this limited, conservative purpose of the cultural professional. In positing a citizenry frustrated but capable of self-rule, the magazine insisted instead that the affirmative artist should not only imagine the future but should also help to develop the political and social skills of the population. The affirmative myth-making power of the artist would provide an image for a new society, while the teaching and appreciation of art and culture would deepen the understanding and wisdom of the democratic populace. Culture, *Fortune* asserted, would play a key role in transforming the frustration and apathy of 1940 into the abundance and beauty of the American future.

The Affirmative Professional and Democratic Prerogatives

"NINETEEN-THIRTY," the Austin Company had proclaimed in an advertisement in March of that year, was "modernization year in industry." The accompanying image portrayed the corporate liberal future. White skyscrapers rocketed into the sky from their base in an active industrial complex. The buildings framed a single airplane, a representative of the technological triumph of the American twentieth century. The stark contrasts and sharp lines visualized the rationalist temper and materialist concerns of an enlightened industrial society. The New Era in American industry, the ad declared, is "a dramatic age in which industry plays a lead role, for back of all the romantic pageant are the wheels that must turn, ever faster, to set the pace of progress." The actors in this play, however, were not improvising. The homogeneous architecture, the bridges that majestically linked the skyscrapers, and the symmetry of the factories revealed the vision of a far-sighted director. The cooperation of organized capitalism had banished the chaos and waste of a more competitive era. Unified under a centralized authority, this New Era displayed the efficiency and planning of a "designed" society.[3]

Combining efficiency, long-term thinking, artistic vision, and scientific autonomy, the linked concepts of functionalist design and rational reform were central to corporate liberal thought in the early thirties. Industrial de-

NINETEEN N-THIRTY

modernization year in industry

Mighty buildings rear their heads into the clouds . . . sturdy ships of the air drone away to distant ports . . . new products appear overnight on counters and in salesrooms everywhere.

It is a dramatic age in which industry plays a lead role, for back of all the romantic pageant are the wheels that must turn, ever faster, to set the pace of progress.

And so, 1930—*Modernization Year in Industry*, marks a New Era in the design and construction of the Nation's plants . . . an Era in which Austin will be called upon to accomplish still greater achievements in producing plants to supply modern demands.

Austin's nation-wide organization is busy from Coast to Coast . . . designing and building a number of modern plants that herald the New Era in American Industry.

Executives in practically every field of business will find Austin literature, which deals with fundamentals as well as specific building problems, helpful. Wire, phone or write the nearest Austin office for the literature and approximate costs on any project you may be planning.

THE AUSTIN COMPANY

**THE AUSTIN METHOD
OF UNDIVIDED RESPONSIBILITY**
Design, construction and building equipment separate responsibilities ordinarily become one unified responsibility under The Austin Method. One organization handles the complete project under one contract which guarantees in advance, total cost, time of completion with bonus and penalty clause if desired; and quality of materials and workmanship.

THE AUSTIN METHOD

ENGINEERS AND BUILDERS · · · CLEVELAND

New York Chicago Philadelphia Newark Detroit Cincinnati
Pittsburgh St. Louis Seattle Portland Phoenix
The Austin Company of California Ltd.: Los Angeles, Oakland and San Francisco
The Austin Company of Texas: Dallas The Austin Company of Canada, Limited

Austin Company advertisement, "NINETEEN-THIRTY: *modernization year in industry*," Fortune 1 (March 1930): 101. This advertisement from 1930 illustrated the functionalist future. Reproduced with the permission of the Austin Company.

signers had embodied, indeed, the possibilities of the New Era of organized capitalism. But as the Second World War approached design lost much of its appeal to *Fortune*. In July 1939 the magazine published a single-subject issue on New York City. The issue was inspired by the World's Fair, but shied away from the Fair's utopian vision. The Fair, on the one hand, exhibited the world of the future. Prominent industrial designers played a leading role in the construction of these futuristic visions. Henry Dreyfuss built the main exhibit, a scale model of a "perfectly integrated, futuristic metropolis" named "Democracity." Walter Teague designed the Ford building, and Norman Bel Geddes constructed another scale-model city called "Futurama." On the other hand, *Fortune* did not mention these designers in honoring the Fair. Instead, it reported on the "Fair's Greatest Exhibit": New York City itself. This emphasis illustrated its new preference for the varied, profoundly complex and contradictory reality of pluralism. While the visitor to the Fair could look down on the Democracity and Futurama exhibits from an aerial perspective, "New York cannot be seen whole. It can only be felt, sensed, conjectured." New York appeared as a confused but majestic city: its skyscrapers and ghettos, metropolitanites and cab drivers, wealth and poverty, were all part of the "Image of Man" projected by the city. "Mingled, impacted, coupled, interwoven, entangled, infinitely interdependent," the city embodied the simultaneous unity and disjointedness of the liberal pluralistic nation.[4]

A portfolio in the New York City issue called "The Painter's City" closed with George Grosz's *Lower Manhattan*. The painting was oddly similar to the Austin Company's illustration. Both images featured three layers: a grayish sky, a white city, and a dark industrial foreground. A plane in the upper corner of Grosz's painting paralleled the plane in the ad. Smoke rose from boats in the painting, and from a train in the ad. But while the Austin Company envisioned the imaginary future, the 1939 image portrayed a real city in the present. In Grosz's work impressionistic strokes replaced sharp lines. Murky borders supplanted sharp contrasts. His plane was not an idealized representation of the industrial achievement but rather another disconnected yet interdependent part of the city, like the boats churning through the crowded harbor. The chaos of the New York port and the city's architecture contrasted the neatness and order of the advertisement's ideal city. Despite its haphazardness, however, Grosz's city still aimed to inspire. "I know that the past was great," the epigram read, "and the future will be great—Walt Whitman." Eschewing the faith in human rationality of the Austin advertisement, the image and epigram retained its visionary hope-

fulness. The painting voiced a willed optimism, a wonder at the paradoxical order inherent in the chaos of the city. This harmonious cacophony—the belief that among the "infinite" plurality of the United States there was unity—characterized the corporate liberal worldview of the late thirties and early forties. Its clamor drowned out *Fortune's* earlier fanfare for social planning, a unified marketplace, and a functionalist aesthetic.[5]

This new vision of the corporate liberal city represents not only *Fortune's* shifting hopes for industrial design and rational reform, and its embrace of consensus pluralism, but also its changing understanding of the role of professional and managerial leadership. While the designer of the elite coalition had aimed to create a rational and ordered New Era, the affirmative leader of the prewar and war years recognized the impossibility of such organized progress within a chaotic, pluralist society. Professionals and business managers within consensus pluralism would have to balance the need for national direction with a consciousness of the diverse interests of the public. They would have to speak for the people but, just as much, allow the people to speak through them. They would have to follow the injunctions of MacLeish and Luce to articulate an affirmative national purpose in order to provide the country with the inspiration to "be great." Equally important, they would need to temper their own sense of this purpose with the yearnings and ideals of the cab drivers, cosmopolitans, bankers, and burlesque performers who populated the New York City issue. Affirmative leaders, unlike paternalistic designers, would have to integrate their vision of the future with the desires and interests of the larger public.

Fortune's recognition of a diversity of American interests by no means implied an end to the need for professional leadership. Corporate liberals' investment in long-term thinking, efficiency, and rational planning was deeply imbedded in their professional class identity. *Fortune* continued, for example, to support the central tenet of functionalism: products, buildings, and cities, it argued in numerous essays on housing and city planning in the late thirties and early forties, should be built according to logic rather than tradition. Furthermore, the magazine maintained that the need for strong professional leadership was particularly important as the United States prepared for war and for the postwar era. Rejecting the common fear that the end of the war would bring a market glutted with able workers and the return of Depression conditions, the magazine demanded the immediate formulation of a concrete demobilization plan. This trend peaked in 1944, when the magazine enthusiastically printed "The Economics of a Free Society," a declaration of postwar economic strategy made by the Committee

George Grosz, Lower Manhattan, Fortune 20 (June 1939): 144. *In contrast to the advertisement in the previous illustration, this George Grosz painting depicted the pluralist present.* © Estate of George Grosz / Licensed by VAGA, New York, NY.

for Economic Development, a body that would join *Fortune* as a primary exponent of corporate liberal policy in the forties and fifties. Postwar depression could only cripple the economy, the magazine repeatedly asserted, if business managers failed to plan for prosperity.[6]

The responsibility of business managers, however, was not limited to technical planning. Indeed, to insure that the "future will be great," affirmative corporate leaders would have to display a Whitmanesque optimism and vision. During the Second World War, for instance, Suzanne Langer urged corporate liberal managers in *Fortune* to lead the nation toward a policy of international activism. Worried that the public did not understand the desirability of internationalist policies, Langer believed that business managers could persuade the public to accept an international role if they could express the benefits of internationalism in a coherent, powerful manner. "Popular points of view are always inspired, at the outset, by the thoughts of great men. The power that will make the new world must, therefore, be articulate: a power to set a new pattern of thought for men's minds." Postwar recovery depended on the optimism and bold vision of businessmen in the face of an uncertain future. In praising General Electric's plan to "produce for peace at the wartime rate," for example, *Fortune* warned of the need for courageous corporate leadership if the nation was going pull out of the parallel ruts of economic depression and national fear:

> If the capitalist system is to survive, G.E. and the other companies will have to do some optimistic plunging on the day peace is signed. Not even G.E.'s displaced workers can find jobs elsewhere unless they do. As [one G.E. executive] says, "We will have to put up or shut up."

Recovery depended on the profit motive, technical expertise, and competition, but also on the willingness of business to "plunge" into production when profits were uncertain, to lead the nation toward prosperity.[7]

But the capitalist imagination and courage of the affirmative manager differed significantly from the planning urge and expert control of the earlier elite coalition. Even as it sought to unify corporations and the nation, *Fortune* questioned the desirability of authoritative expert control. Professionals' guidance was only one part of the larger national effort to make the future great. A 1942 editorial, for example, clarified the limits of professional power within a pluralist nation. The editorial demanded that Roosevelt lead the nation by proposing a vision of the American postwar society. But while the administration's "brain trust" seemed an obvious starting point for such a task, *Fortune* cautioned that "Messrs. Currie, MacLeish, Bullitt, Berle,

and Lubin" could not bring about the unity necessary for a new future. "They could only do it *with* (and not against) labor and agriculture and management and capital; the retailer and the manufacturer; the educator and the theorist—honest and intelligent representatives of the many basic interests of the U.S. that are now in conflict and in the process of self-destruction." Professional and managerial experts might be the catalyst that could crystallize a volatile pluralist solution into a stable national unity, but the behavior of the democratic majority ultimately determined the success of the experiment. Artists, scientists, and managers would serve as the nation's leaders in imagination, technology, and business, but their inspiration would only be effective if in concert with the desires of an intelligent, attentive populace.[8]

Part of this rejection of expert authority grew from *Fortune's* decisive move away from the market cooperation and expert planning of the corporatist model. The magazine's new emphasis on competition, first of all, distinguished the "industrial statesmanship" of the early thirties and that of the war years. In a 1943 editorial, "The New World Belongs to Risk," *Fortune* mocked the "gentlemen's club" mentality of monopoly capitalism, and warned that the market cooperation would lead eventually to political control of the market. A scathing Saul Steinberg cartoon lampooned this stodgy gentleman's club. A sign in the foreground asked for "STABILITY PLEASE," while a "Blackball List" castigated "Price-cutters," "Outsiders," "Small-fry," and "Blackguards," and "Men named Henry, like Henry Ford or Henry Kaiser." The very "vulgar" forces that the magazine's original prospectus had vowed to eliminate were now grouped with two highly successful, "revolutionary" businessmen. As *Fortune* formulated its hopes for a vigorous postwar economy, it always began with the assumption that the market would have to regain the freedom and competitive spirit that had been eroded by the excesses of New Deal regulation and organized capitalism.[9]

But the new democratic power of the public was just as significant as the return of the competitive market in tempering the magazine's earlier commitment to design and elite authority. While competition eroded the cooperation of associationalism, the democratic allegiances of the pluralist consensus undermined the paternalism of the elite coalition. *Fortune* argued, in the early forties, that no major decisions could be made without popular consent. In doing so the magazine displayed a faith in the ability of the democratic populace to make wise decisions and also placed limitations on the authority of professional leaders. "Our Form of Government," for instance, balanced its argument for a more professionalized administrative

Saul Steinberg, Free Enterprise in Our Time: III. The Anticompetitive Spirit, *Fortune 27 (January 1943): 112. The anticompetitive ideals out of which corporate liberalism grew in the Progressive Era had lost their luster by the late 1930s. While corporate liberals still hoped for a stable market place, and continued to have faith in the large corporation as the ideal economic unit, they rejected the corporatist ideal of associationalism as stifling and pessimistic. © The Saul Steinberg Foundation / Artists Rights Society (ARS), New York.*

corps with an assertion that "no administrator is smarter than Main Street." *Fortune* did not always agree with public opinion (particularly its isolationism), but even in disagreement it insisted always on the governmental capabilities of the populace. The average American, according to one editorial, was "an eminently sensible person." Another essay dismissed surveys purporting to reveal widespread American ignorance, arguing that "while he might stumble on a Quiz Kid program, the contemporary American seems not only to make up his mind but also to have one." The essay "American Man-in-the-Street," insisting that the public was intelligent and thoughtful, castigated political leaders and the mass media for addressing the public as if it had "a minimum sense of responsibility, a congenital distaste for reality."[10]

Fortune's understanding of propaganda helps to define the relationship between the affirmative professional and this capable citizenry. The increasing strength of totalitarianism, which seemed rooted in a mix of ideological certainty, nationalist fervor, and the irrationality of mass society, inflamed discussions in the prewar years about propaganda that had simmered in the American public sphere since the aftermath of World War I. Two theories competed for dominance. One argument, "skeptical of idealism and language," asserted that propaganda was both inevitable and destructive. According to this view, the political sphere was a rhetorical battle aiming to capture allegiances, but with little grounding in truth. Every political group used whatever tools of persuasion it could locate in order to manipulate increased support for its policies. Governments always created myths about their own superiority, these theorists argued, and the rise of mass media and mass cultures had made these myths dangerously powerful and, ultimately, even the cause of war. To defend against such propaganda, a citizenry would have to dispense with nationalistic enthusiasms that were inevitably built on false distinctions and ethnocentric pride.[11]

Another group of critics, however, insisted that propaganda could be either true or false. According to this argument, the proper defense against propaganda was to "expose" misleading information and promote the truth. Indeed, the foolish and indiscriminate dismissal of all national idealism and allegiance, proponents of this idea argued, was as dangerous to democracy as propaganda itself, because it led only to widespread cynicism and apathy. *Fortune*, as well as Archibald MacLeish, who served as the wartime head of the Office of War Information, advocated this latter idea. Both *Fortune* and MacLeish believed that inspiring rhetoric and national myth were essential to American unity. They worried that cynical Americans, overwhelmed

with propagandistic advertising and political rhetoric, would dismiss all idealistic language as bunk. "The propaganda against propaganda," one *Fortune* editorial asserted, referring to arguments that all propaganda was baseless rhetoric, "has led many Americans into a kind of pernicious skepticism." While many intellectuals maintained that any propaganda would lead to a policy of official deception and ultimately to a fascist unity, *Fortune* argued that good, true idealism could be separated from deceptive propaganda. Indeed, it was the work of the affirmative professional to produce this propaganda.[12]

But *Fortune*'s support for "true" propaganda did not mean that it did not trust the public with the truth. On the contrary, the magazine took a strong stand against false propaganda, arguing that the public was mature and intelligent enough to accept reality and still maintain its morale. In 1942, for example, Young and Rubicam ran a series of scare advertisements proclaiming that any piece of information that made one distrust the government, business, or labor was probably a rumor spread by the Nazi propaganda machine. One such overzealous advertisement, asking, "Does it have a slight odor of Goebbels?" ironically appeared in the midst of "A Report to Mr. Roosevelt," an editorial harshly criticizing the war leadership in Washington for its failures of organization. *Fortune* defended such articles in "Who's Winning?" maintaining that "the first step toward 'confidence and inner strength' is an exact knowledge of where we stand." "The deepest duty of a democratic press in wartime," asserted another essay, "is to remain aggressively free, critical, and informative." Certainly the magazine did not live up to this ideal, as surely few magazines did during the war. Yet its affirmative ideals were far from what critics of *Fortune*-style nationalism would call an "official approach to culture." *Fortune* assumed that the intelligent American public could balance its affirmative ideals with its critique of particulars, and avoid the dangers of both apathetic disintegration and fascist unity.[13]

Appropriately, the recognition of diversity and acceptance of democratic control implied by the shift from rational reform to consensus pluralism is nowhere more apparent than in *Fortune*'s changing understanding of industrial design. First of all, the magazine's acceptance of the public's ability to govern itself forced it to recognize the inevitability and even desirability of a wide range of legitimate styles. In the early thirties *Fortune* had argued that standardization of style was not only necessary because of mass production but was also desirable in its expulsion of extraneous decoration. "In all

successful standardization," one contributor argued, "there must be a certain dramatization of the fact of machine repetition, a certain emphasis (instead of half-hearted denial) of the elimination of the unnecessary." But in the late thirties and forties *Fortune* tempered its enthusiasm for a single machine aesthetic. In "Goodbye Mr. Chippendale," for example, the magazine argued that the variety of "climates, materials, and living patterns" in the United States demanded a variety of building approaches. Even more, this acceptance of diversity meant that "style" was no longer a banned concept. After 1936 the magazine continued to complain about traditional facades being pasted unnecessarily onto modern buildings, but it did reject a standardized "scientific" style as a satisfying answer to the problem of cultural lag. Functionalist design, *Fortune* admitted, had been uninviting and "coldly intellectual." Contemporary design would have to reflect "warmth and informality." Thus while the "unity" of design remained important, stylistic purity became unnecessary. By 1946, indeed, *Fortune* unambiguously celebrated the diversity of American tastes. In "Homes of Americans," it juxtaposed photographs of a Shaker doorway and Mrs. Cornelius Vanderbilt's drawing room and celebrated them both: "That Shaker reticence should meet cupids, ormolu, and brocade in the same nation, while no great surprise, is certainly telling. . . . There could scarcely be a more vivid parable concerning the extreme diversity of American manners and character." Decorative style, no longer an indication of a false aesthetic conscious, had become an expression of the American plurality.[14]

This rethinking of standardization and the functionalist aesthetic accompanied a more direct intrusion of the public on the authority of the designer: the acceptance of style was not only a metaphor for American diversity, it was an expression of the public's right to alter and adapt the designer's suggestions. Partly this change reflected a growing anxiety about European politics. The centralized decision making of the designer now evoked the rise of authoritarian governments in Europe. In 1938, for example, the magazine noted that the city planner Robert Moses demanded "absolute control" and his decisions were often of a "dictatorial nature." It qualified its praise of Moses as a "great man" by admitting that while he made an exemplary Park Commissioner, "maybe we wouldn't enjoy his government by fiat so much if he were Governor." But, more important, designers, confident of their own logic, had lost touch with the users of their designs. "The functionalists were too cerebrally functional," noted a 1943 essay on domestic design. "They did not merely break with the past: they

Photographs of Quaker and Victorian homes, Fortune 33 (April 1946): 149. The fascination Fortune had with functionalist design, and its demanding aesthetic, faded in the late thirties, as it recognized the diversity of the American public. By the forties the magazine could celebrate both this Quaker room and its Victorian counterpart as representative of American taste. Text and page layout © 1932 Time Inc. All rights reserved.

kicked the past in the teeth. The reaction of the people was even stronger than their reaction to Henry Ford's aim to give them a car of any color so long as it was black. The people bought something else." While *Fortune* still occasionally insisted that the people would come around to the engineering changes theorized according to functionalist dictates, it recognized that the public's stated needs and desires should not be ignored.[15]

Popular input was particularly important in the more political aspect of design, namely, city planning. In the early forties city planning boomed as an idea and as a practice, and *Fortune* was at the forefront of the movement. Trying to understand how to continue the wartime boom when the war was over, corporate liberals urged federal, civic, and business groups to plan ways to sustain production and consumption levels after an armistice. The magazine even entered into a partnership with the city of Syracuse, New York, furnishing the city with a board of "disinterested expert consultants" in exchange for the opportunity to try out and report on some of its ideas about city planning. But despite its continuing rhetoric of functional city planning and its faith in expert knowledge, the magazine repeatedly argued that the citizens of a city had to have a significant role in the planning effort. "It should be emphasized . . . that Syracuse is being replanned by the citizens, all the citizens, of Syracuse." Democratic control and central planning need not be antithetical:

> [Strategic] planning . . . requires broad vision and foresight. Particularly it requires a strong controlling authority, which must be as broadly based as possible, if the plans are to meet the needs of all the inhabitants. The London squares, built on ninety-nine-year leases under the eye of noble landowners, served only the well-to-do. Haussmann's boulevards, backed by Louis Napoleon, served the better-off French *bourgeoisie*. But in the Netherlands planning became truly public. Every town of 10,000 or more persons was required in 1901 to draw up a plan for its present needs and future expansion. *The controlling authority was the democratic town unit itself.* . . . This aim . . . is fundamental to the Syracuse project.

In the late thirties and early forties public participation became an essential component of city planning, and indeed of all governmental and social activity. No longer envisioned as planned and homogeneous, future American cities, like the New York of Grosz's painting, would be built through a

potent and still vital combination of expert advice, inspirational leadership, capitalist energy, and public participation.[16]

Art and the Democratic Populace

Fortune's democratic idealism allowed the magazine to remain optimistic about the American future. Insisting that the American public was capable of self-rule and linked together through mutual interests and values, the magazine dismissed fears of social disintegration or the approach of fascism. But as with Luce and MacLeish, *Fortune's* willed optimism about the postwar era was balanced with a sense of despair about the apathy and dividedness of the American citizenry in the late thirties and early forties. The difficulties of the current transitional period threatened the promise of future abundance and stability. In answer to this problem *Fortune* urged artists, intellectuals, and journalists to create an affirmative vision. But this affirmative purpose was not the only means through which cultural professionals could strengthen the democratic nation. Indeed, *Fortune* insisted that art and culture could nurture a vital democratic citizenry. Through the reestablishment of a viable humanistic philosophy and the spread of liberal education, cultural professionals could ensure that the democratic public could avoid the cynicism and apathy that currently threatened the material and cultural progress of the nation.

The problem with the American citizenry was not only that it lacked an immediate sense of purpose but also that it had dismissed any basis on which to construct that purpose. In the spring of 1940, for example, *Fortune* reported on the five thousand members of the American Youth Congress who marched in Washington to draw attention to the four million unemployed Americans under the age of twenty-four, and to demand the passage of the American Youth Act. Although much of the press had dismissed the marchers as Communists and fellow travelers, *Fortune* took a more sympathetic view toward this "generation of bewildered, passive, sold-down-the-river youngsters." Although the request for monetary support by the Youth Congress was seen by *Fortune* as a lifeless and knee-jerk reaction to the problem, still the magazine did not dismiss the complaint. A decade of economic disaster, "dead-end jobs that lack the exhilaration of primary creation," and fear of war, *Fortune* reasoned, had dispirited the younger generation and undermined its ambition and imaginative powers. And to its three more conventional explanations for young people's malaise, the magazine added an unusual fourth: the "gutless residue" of modern philosophy. The

mechanistic theories of Marx, Freud, Darwin, and behavioral psychologists, *Fortune* asserted, had convinced contemporary youth that individual will was helpless in the face of historical and biological processes. While eighteenth-century thinkers had purposefully imagined the *"desirable* organization of society," their successors had focused on its "vast and impersonal *processes." Fortune* recognized that the works of Marx and Freud were complex, and could even be liberating, but nevertheless maintained that the unintended psychological effects of their ideas had been disastrous. Vulgarized by popularization and simplified by repetition, these ideas had become a "dope" that made young people passive and unimaginative.[17]

Considering the numerous connections between the affirmative ideals of *Fortune* and Archibald MacLeish, it is not surprising that MacLeish seconded this somewhat far-fetched thesis. In his controversial "Postwar Writers and Prewar Readers," published just one month later in the *New Republic*, MacLeish echoed *Fortune's* assertion that the cynicism of the intellectual community had sapped the power of imagination of a new generation. Regretting the emotional strength of the disillusioned literature of the post–World War I wasteland, MacLeish worried that young people had learned to distrust not only words but all statements of conviction or purpose. Honest words, he lamented, had "borne bitter and dangerous fruit." MacLeish's "The Irresponsibles," too, repeated *Fortune's* worry that the positivist, observational focus of modern scholars, while providing impressive descriptions of the present and past world, failed to produce useful proscriptions for the future world. But MacLeish was not alone in backing *Fortune's* sentiment. Similar concerns animated a large number of intellectuals in the early forties. One prominent group, for example, including Van Wyck Brooks, Franz Boas, Albert Einstein, and Paul Tillich, founded, partly in response to MacLeish's writings, the Conference on Science, Philosophy, and Religion in Their Relation to the Democratic Way of Life. Two particularly enthusiastic supporters of this theory of the failure of intellectuals were the two leaders of the University of Chicago Great Books movement, Mortimer Adler and Robert Hutchins. Adler, who had contributed the essay "God and the Professors" to the above-mentioned conference, argued in his clearly MacLeish-inspired "This Pre-War Generation" that "the present generation has been immunized," by a positivist, amoral academic culture, "against anyone who might really try to argue for democracy in terms of justice." Meanwhile, Hutchins suggested that the irrationalism of Hitler had its roots in the "nineteenth century's anti-intellectual account of empirical science, which placed primary emphasis upon

the accumulation of observed facts" while failing to "understand them" or to "grapple with fundamentals."[18]

The agreement between the Great Books leaders and *Fortune* on this point demonstrates more than just the widespread appeal of affirmative ideals in the immediate prewar years. Rather, it begins to suggest the role of art and culture within affirmative thought. The Great Books movement began at the University of Chicago when Hutchins, a thirty-year-old prodigy, assumed the presidency of the university in 1929. He and the even younger Adler, whom Hutchins installed as a member of the university's resistant philosophy department, worked to reform what they saw as an over-specialized university system by introducing broad humanistic requirements that sought to teach students, to borrow the title of Adler's popular 1940 book, "how to read a book." At the University of Chicago, this idea grew from the basis for a small, select honors course to become the foundation of the curriculum for both the University of Chicago and the renewed St. John's College in Maryland, as well as the source of the successful publishing venture *Great Books of the Western World* and an extensive adult education program. More broadly, it initiated curricular change across the nation, and renewed discussion of educational principles and aims. The core of the Great Books idea was that reading and understanding the classic literature and philosophy of the Western tradition would nullify the amoralism and narrowness of an overly specialized education. Taking part in the "conversations" about religion, ethics, and war that had developed over thousands of years, Adler and Hutchins believed, would convince students of the universal values that linked humanity together, and give them a deeper sense of the role of the individual in the modern world.[19]

The Great Books idea has clear connections to *Fortune*'s earlier cultivation of the business gentleman. In seeking to teach its readers to appreciate art, the magazine had made similar assumptions about the connection between a liberal education and personal depth. Indeed, a central part of Chicago's long-lived adult education program was what Hutchins dubbed the "Fat Man's Great Book Course," a seminar that aimed, through discussion of literary and philosophical texts, to teach successful businessmen to think and communicate more effectively and broadly. In formulating the ideal of the affirmative professional, however, *Fortune* both widened and narrowed its understanding of the purposes of a liberal education. On the one hand, while *Fortune* in the early decade had focused on the cultural education of businessmen, in the late thirties and forties it suggested that this sort of

learning would be beneficial to a broad range of professional leaders and democratic citizens. An understanding of the great works was no longer useful just in creating a publicly responsible business culture but was also crucial for the defense of democratic society against the threat of cynicism and fascism. On the other hand, the magazine moved away from a vague ideal of aristocratic broadening toward a more directed search for a set of values on which modern society could be built. The universal values of Western philosophy, including Christianity, would serve both as the means through which individual citizens would learn to recognize their own responsibility for American democratic society, and as the basis for a national purpose that would inspire the nation to defeat fascist irrationalism. The spread of humanist education to not only what Adler called "the great intellectually unwashed of America: the businessman" but to the entire citizenry would serve as the true bulwark against fascism.[20]

The clearest indication of *Fortune*'s commitment to reestablishing the importance of humanist values was an extraordinary series of essays that appeared in the first half of the forties. Penned by scholars, philosophers, and administrators, these articles all addressed the moral crisis of American society. Even a list of the titles demonstrates the determination to combat contemporary directionlessness through affirmative intellectual work: "What Man Can Make of Man," "Christian Humanism: Life with Meaning and Direction," "A Faith for History's Greatest Crisis," and "The Edge of the Abyss," for example, all appeared in 1942. Most of the essays, like "Challenge and Response" in 1943, attempted to answer the "philosophical challenge to our civilization": "why serve anything but one's self?" The solution to this puzzle varied, but only within a small range. Some echoed Wendell Willkie's assertion regarding the importance of the liberal mission: the "most difficult thing in the world—namely, to strike a true balance between the rights of the individual and the needs of society." Others expressed conviction in Christianity, proclaiming with "The Edge of the Abyss" that "a godless world can result only in an inhuman world." A number of essays deliberately wedded the worldly ideals of liberal democracy with the Christian ethos. But even when they disagreed the essays all argued that the most important point was the identification of a usable set of modern values, and they almost always looked to the liberal and Christian traditions as their primary sources. After Hutchins contributed "Toward a Durable Society," for example, in which he argued that only a reinvestment in "vital democratic ideals" could save American society, *Fortune* chose to publish a rejoinder

from one of Hutchins's strongest critics, John Dewey. "Challenge to Liberal Thought" strongly rebutted Hutchins's condemnation of empirical science, and contrasted Hutchins's universalism to his own pragmatism. But despite their different approaches, as James Allen notes, both Hutchins and Dewey remained strongly committed to "a humanistic society open to ideas, values, democracy, and the growth of the human personality."[21]

Just as *Fortune*'s broad demand for an art that grew from engagement with the modern commercial world allowed for varying artistic styles under the larger rubric of "designed realism," so did its search for an affirmative vision utilize a range of philosophical styles, all linked by their commitment to liberal humanism. The central aim was to revive American society's collective sense of purpose by establishing an intellectual justification for a democratic, capitalist society. Charles Hendel articulated this mission in his 1943 article, "Agenda for Philosophers." In a passage that strikingly resonates both with MacLeish's entreaties to the poets and *Fortune*'s vision of postwar business leadership, Hendel urged the "imaginators" of the professional managerial class to use their specialized knowledge both to serve community needs and to unify themselves with the democratic "plain man."

> [Philosophers] are committed first of all to the task of helping to build community among men. "Helping to build," for they can do only one vital portion of the work. There are other builders with whom they must work, those who will reconstruct the economic life, the political institutions, the practical means of obtaining a good life. . . . They need to work with the poets, men of letters, artists, men consecrated to religious life, and not least with the plain men who can make themselves known by their native sense and judgment, for all these contribute to the vision that can guide a generation to its right way of life. . . . They must have fellowship with men of science and men of religion and seek the unity of their wisdom so that the plain man will not be confused and distracted by the claims of science and religion.

This understanding of the power of intellectual conception, and the need to make its fruits accessible to the average citizen, was central to *Fortune*'s effort to chart a course for a postwar future.[22]

Fortune's commitment to a humanist defense of the pluralist consensus, however, was not limited to constructing philosophical justifications for a new world order. More broadly, *Fortune* continued to see art and culture as essential parts of any successful polity. Not only could generalist education

and an appreciation of art make the daily lives of Americans more enjoyable, but it could transform a cynical and mechanistic thinker into an active, valuable citizen. A caption to a William Blake drawing, illustrating William Dixon's "Civilization and the Arts," explained the broadening effects of art: "Poetry, painting, and music, says Mr. Dixon, disclose a depth and mystery in the world beyond all physical investigation." Dixon maintained that art could heal a society dominated by materialism, and could transfer "affectations from possession to admiration, from immoderate craving for wealth and power to an intense longing for beauty and excellence." *Fortune*, in printing literary writing, philosophical and historical essays, and artistic illustrations, hoped that art would develop in its readers a new depth of vision.[23]

Painting, in particular, offered a personalized, truthful vision of reality. In the early forties the magazine increasingly depended on drawings and paintings rather than photographs, arguing that these documents offered more insight into material reality than photographs. "Paris at War" maintained that a series of sixteen paintings of Paris could "bring out the present mood of Paris as perhaps no other medium of expression could." Another particularly elaborate portfolio, "The Face of Christ," insisted that modern painting reflected "the intricate dilemmas of twentieth-century self-consciousness." On a number of occasions the magazine published the work of soldiers and war participants to provide an authentic picture of the experience of war (including the drawings of the Japanese American internee Miné Okubo), arguing that such images provided those on the domestic front a glimpse of a war "whose magnitude can be grasped only in terms of those who serve in it." As *Fortune* quoted Charles Sheeler in its portfolio of his paintings, "Photography is nature seen from the eyes outward, painting from the eyes inward." This projection of spiritual values onto the material world was exactly what the magazine desired from artists.[24]

The personal depth and understanding provided by art and a generalist education would help produce not only a stronger democratic public but also a new generation of national leaders. During the early forties the magazine consistently described the mix of philosophical depth and public involvement of its "great men," from Thorstein Veblen to Charlie Taft, Stonewall Jackson to Henry David Thoreau. Announcing, for example, that the "American Need" was "not bureaucrats but men of ideas," *Fortune* praised John Maynard Keynes as "an intellectual who has not been afraid to mix in practical affairs" and as a "writer, critic, economist, Cambridge don,

Jean Helion, untitled painting of prisoners of war, Fortune *27 (February 1943): 111. Artistic creation was not limited to theoretical abstractions or calm still lifes. Instead,* Fortune *insisted it offered all citizens a way to understand their world. Participant art, such as this untitled painting by former Nazi prisoner of war Jean Helion, offered viewers a particularly useful window into an experience. Modern artists,* Fortune *claimed in another essay in October 1943, were capable of "recording the unreal reality . . . which words cannot articulate." © 2003 Artists Rights Society (ARS), New York / ADAGP, Paris.*

gentleman farmer, government servant." The great majority of twenty-four profiles in the prominent series of "Notes on Americans Whose Careers Are Relevant Today" (alternately titled "Notes on American Heroes") stressed the devotion to truth, generalist versatility, and nonconformity of their subjects. William Penn, for example, offered a model of "a man of conscience" but at the same time "threw himself into the violent controversies of the day," and flourished not only as a church leader and a reformer but also as "a colonizer and a statesman, even a city planner." William James was "that eternal rarity, a great human being" who had a profound effect on the world of philosophy, and "yet was supremely a man of action." *Fortune* hoped that readers, buoyed by these exemplars of vitality, generalist curiosity, and social responsibility, would both sharpen their sense of personal and national purpose and increase their appreciation of well-roundedness.[25]

Perhaps, however, the most important source of liberal broadmindedness—more accessible than philosophy, more dependable than art, more sustained than the admiration of heroes—was liberal education itself. In supporting widespread cultural education, *Fortune* again asserted its belief in the ability of the public to govern itself. A faith in liberal education, "Our Form of Government" claimed, was really a "belief in the improvability of mankind, in the capacity of the human race as a whole to grow in wisdom and moral strength." Broad liberal training cultivated the intellectual rigor and liberal ideals that would win both war and the postwar peace for the United States. "Education for War," for example, addressed the new emphasis on science and technology in the universities. But to refute the suggestion that this shift might bring an end to liberal education, the article presented six quotes from college presidents unequivocally supporting generalist education. Duplicating *Fortune*'s parallel between specialized knowledge and passive thinking, Harold Dobbs of Princeton University commented, "the failures of this generation have been in the area of will, not technology." The president of Notre Dame argued that unless engineering was supplemented with liberal arts, "we develop mechanics, not leaders—automatons, not men." Liberal education even benefited technological advance: in an article and accompanying editorial about the development of microwave radar during the war, the magazine argued that "longhair" scientists, trained in "flexible and analytical methods of thought" rather than on "how to design a piece of equipment," had outperformed "hairy eared" engineers even in the most technical work. The success of the nation ultimately depended on the wisdom of individual citi-

zens, and widespread liberal education provided the most certain social method for ensuring those citizens' intellectual and emotional depth.[26]

Partisan Review *and the Theory of the Adversary Class*

George Grosz's *Lower Manhattan* provided a helpful visual metaphor for the corporate liberal conception of the relationship between society and cultural professionals. On the one hand, its style and content, its impressionistic lines and bustling industrial scene, celebrated the chaotic unity of consensus pluralism: what seems at first to lack all order actually embodied the pragmatic purpose of the competitive market and the diverse democratic population. Beyond this, on the other hand, the painting suggested the two key roles of art and culture in democratic capitalist society. First, the epigram from Whitman, both in its words and its source, represented the visionary optimism of the affirmative professional: "I know the past was great, and the future will be great." Second, the very fact that *Fortune* chose to include a series of paintings in its New York issue indicated its faith in the power of art to deepen experience. Artists and poets, the introduction to "The Painter's City" asserted, "alone have been able to reveal to each individual the city he knows." The spiritual depth inculcated through culture and liberal education, *Fortune* maintained, played a vital role in creating an active democratic citizenry.[27]

But if Grosz's New York represented the social ideals of corporate liberalism in the late thirties and the war years, James Agee's "Southeast of the Island: Travel Notes," a word portrait of Brooklyn Agee penned for the New York City issue but which *Fortune*'s editors rejected, provided an alternative vision of the modern metropolis. The city, lacking both the chaotic energy of Grosz's Manhattan and the utopian order of the Austin advertisement, was dominated by the "drive of an all but annihilative, essential uniformity." Its middle classes, susceptible to the false pressures of advertising and social achievement, struggled forward in a "lethal effort to Carry On." Its mood was one of "narcotic relaxation," and its inhabitants characterized by a "drugged softness." This Brooklyn, not Grosz's Manhattan, was the borough within which the New York Intellectuals of the early forties resided. Denying both the hidden energy and democratic idealism of *Fortune*'s vision of the nation, the critics surrounding *Partisan Review* pictured a country teetering on the edge of totalitarianism. Recognizing in the population the same frustration and anomie that bothered Luce, MacLeish, and other affirmative artists, they insisted that this loss of energy resulted not from the

lack of a national purpose but rather from the numbing effects of mass culture and the ill-fitted, coercive "overmastering reality of the bourgeoisie." Alienated from their own interests and even their own tastes by a commercialized culture, the masses offered no hope for positive popular change.[28]

This rejection of democratic pluralism led *Partisan* critics also to dismiss the artistic ideals that *Fortune* embraced. In a society on the edge of collapse, they reasoned, the affirmative intellectual served only to patch up the tattered justification for bourgeois superiority. Like Agee, they insisted that the goal of the truly radical artist was to disrupt this false reality, not strengthen it. At the same time they condemned popular outlets for high culture or avant-garde art as deceptive "kitsch." Agee, for example, saved his most castigating remarks in "Southeast of the Island" for an artist who displayed "a renegade taste for the smuggest and safest in modernism." Attempts to broaden the cultural knowledge of the nation resulted not in more capable citizenry, as *Fortune* claimed, but rather in a degraded and unchallenging culture. The distribution of art and culture to the larger public, in fact, often seemed to the *Partisan* crowd in the early forties merely another way for the ruling class to control the populace. Mass culture, Macdonald argued in 1944, was "imposed from above . . . [and] manipulated the cultural needs of the masses in order to make a profit for their rulers." Many of the *Partisan* critics were so despairing of the possibility of mass-mediated culture to effect social change that they even expressed regret for the advent of universal literacy. Macdonald asserted in 1942 that control of the mass media by the ruling classes meant that even universal literacy, rather than increasing the self-governing capabilities of the public, had become "a means of *preventing* people from having 'opinions of their own.'" Clement Greenberg claimed that universal education was a key prerequisite for the development of kitsch, and thus a key to the destruction of genuine folk art and the creation of the mass society. After the war Lionel Trilling worried that "mechanical literary" had replaced "the real thing" with "what looks like the real thing," and R. P. Blackmur complained of the "new illiteracy." The belief that cultural education could prepare the masses for government, these intellectuals believed, was a result of liberal ineffectiveness and naïveté.[29]

In the late thirties and early forties, alarmed by the growth of what seemed to be a prefascist mass society and dismissive of the capacity of art or culture to improve the alienation of the public, the New York Intellectuals developed a new understanding of the identity and social function of an adversary professional class. With Agee, they rejected the possibility of reform and claimed that avant-garde writing itself was a revolutionary act. But

whereas Agee had imagined the adversary artist as a loner, the New York In-
tellectuals insisted that thinkers and cultural producers had to recognize
their allegiance to a larger class of adversary intellectuals. Nevertheless, as
with Agee, the primary effect of this theory of radical art was the increasing
withdrawal of the *Partisan Review* from contemporary politics. Imagining a
public incapable of shedding the numbing power of kitsch, *Partisan* writers
left themselves little option but to separate themselves as a marginalized
elite. Instead of attempting to integrate modernist aesthetics and radical
politics as they had originally sought to do, they worked to "conserve" the
frail tradition of genuine American culture. Building partly on Trotsky's lit-
erary ideals, which stressed the need for intellectuals to "lead in artistic con-
tributions and in guarding standards and traditions," *Partisan* critics con-
cluded that the function of the intellectual class in the present day was to
protect genuine culture from the corruptions of a mass society.[30]

In its first years *Partisan Review*, created by Phillip Rahv and William
Phillips as an outgrowth of the John Reed Clubs of the Communist Party,
had aimed to establish a place for intellectuals within a workers' revolution.
"I have thrown off," Rahv proclaimed in 1934, "the priestly robe of hypocrit-
ical spirituality affected by bourgeois writers, in order to become an intel-
lectual assistant of the proletariat." The editors, however, soon rankled
under the irrational and contradictory communist dictates about both art
and politics. For example, the Communist Party's orthodoxy concerning
artistic content contradicted Rahv's and Phillips's belief in intellectual free-
dom. The *Review*, they later claimed, "strove from the first against [the
Communist Party's] drive to equate the interests of literature with those of
factional politics." Just as important, the editors became increasingly suspi-
cious of Soviet policies, which they viewed as authoritarian and coercive.
The Moscow trials of the middle and late decade, in which the Stalinist
government concocted fantastic tales of mass conspiracy in order to purge
itself of most of the heroes of the Bolshevik Revolution, persuaded many in
the American Left that the Soviet Union no longer represented the forces of
progressive change. Even more upsetting to anti-Stalinists like Rahv and
Phillips was that many American radicals sought to justify Soviet violence
and coercion. The failure of progressives to condemn the Party, Rahv in-
sisted, demonstrated their "moral collapse." Convinced that the Commu-
nists had no real interest in either political honesty or intellectual explo-
ration, Rahv and Phillips reorganized the magazine in 1937, severing its ties
to the Party.[31]

The central symbol of the failure of the Communist Party in the United States was the Popular Front. To *Partisan* critics, the Party's attempt to broaden its appeal through the language of Americanism represented a dangerous and cynical betrayal of ideological honesty in the name of political gain. They worried that the welcoming by the Front of a wide range of leftists and liberals into an antifascist unity represented an accommodation to the New Deal status quo and a loss of critical independence. Seeking to retain harmony, Popular Front thinkers repressed their more critical views, and even their anticapitalist principles, for fear of offending the general public or disturbing the coalition's unity. The Popular Front's hope of creating a national culture that contained the political values of the Party, Rahv complained, meant that it "suppressed intellectual freedom in the name of the defense of culture." Even more distressing, *Partisan* writers maintained that the Front, in concocting what Terry Cooney calls a "national-democratic myth," aimed to duplicate the irrational nationalist mania that Stalin and Hitler had nurtured. Because *Partisan Review*, like Agee, already feared that the public had lost contact with reality and with its own interests, this type of mythmaking, which the magazine opposed to its own rationality, seemed particularly dangerous. The success of a broad-based leftist Popular Front, it feared, would not be the popularization of communist ideals, but rather the creation of a repressive, potentially demagogic, and ideologically unsound political movement.[32]

The dependence of the Popular Front on culture to further its political aims particularly threatened these writers. "The area of Popular Front penetration that most alarmed the *Partisan Review* critics," Harvey Teres notes, "was culture." The Popular Front coalition had established itself in the production centers of mass culture, and the New York Intellectuals viewed this acceptance of mass production as evidence of a decision to forgo independence for easy affirmation and popular success. Popular Front culture, Rahv argued, was comparable to Hollywood film and melodrama in its betrayal of the integrity of the true writer and its "conveyer-belt" production. The consequence of this adaptability to the institutions of capitalism was degraded culture. In combining leftist politics with mass production, *Partisan* critics insisted, the cultural front had revealed the same preference for popular support over critical integrity that made its political thought so muddled and platitudinous. The culture of the Popular Front, as Rahv wrote, flourished through the "inflation of artificial values" that "have been transcended and deflated a thousand times." Because of its unwillingness to

accept the rigors of honest intellectual production, the empathetic liberals and populist leftists of the Popular Front produced art that was neither radical nor powerful.[33]

Partisan Review's antagonism toward Popular Front members combined a severe disapproval of its attitude of appeasement toward Soviet and Communist authoritarianism, and a hatred for their reformist, popular, and often commercial art. Both these sentiments were so strong that it is difficult to separate them, and, indeed, *Partisan* critics insisted that they *could not* be separated but were both signs of the same refusal to apply proper critical values. But the Popular Front was not the only example of the failure of cultural professionals in the late thirties in the eyes of *Partisan Review*. In fact, the magazine's disgust with Popular Front culture was only part of a larger critique of the nationalist mythmaking of the affirmative professional. The productions of the New Deal and corporate liberals revealed the same disturbing preference for emotional affirmation and mass appeal over critical intelligence. Agee, for example, writing in *Partisan Review* in 1944, bemoaned the "mock primitive, demagogic style of the WPA," and Macdonald asserted that *Fortune* exhibited the same budget, abuse of talent, and "lack of results" as Hollywood, and lamented that these "assembly-belt productions" deliberately sought to perfect the "mass production of tripe." The cumulative consequence of these attempts to create a mass culture around a set of affirmative political values was a failed culture. "Our liberal ideology," Lionel Trilling argued in the late forties, "has produced a large literature of social and political protest, but not, for several decades, a single writer who commands our literary admiration; we all respond to the flattery of agreement, but perhaps even the simplest reader among us knows in his head the difference between that emotion and the real emotions of literature." The "inclusive" rhetoric and clichéd thought of affirmative productions, the New York Intellectuals averred, prevented them from becoming genuine art.[34]

Thus while *Fortune* heralded the triumphs of a unified "culture of democracy," while the Popular Front coalition participated in the "laboring of American culture," and while the New Deal sought to build a national consensus around citizenship and culture, the *Partisan Review* maintained that American culture was hopelessly divided between an "ersatz culture" and the genuine article. Although the masses and the elite had enjoyed the same art in earlier, more stable societies, Clement Greenberg contended in his influential "Avant-Garde and Kitsch," the contemporary period of decline had produced a deeply fragmented culture. Mass-produced

"kitsch," because it demanded nothing of its audience and answered the boredom of the urban masses, had captured the majority of the market. Dominated by mechanical formulas and watered-down genuine art, "kitsch is the epitome of all that is spurious in the life of our times." The only holdout against the onslaught of kitsch had been the avant-garde. The avant-garde, recognizing that bourgeois values were not natural or eternal, searched for new workable values instead of covering up the failure of old social ideals. Although Greenberg acknowledged certain weaknesses of the avant-garde, including its tendency to avoid politics and its dependence on the ruling class, he maintained that it was crucial because it separated itself from kitsch, and this critical independence allowed it to "keep culture moving."[35]

The tragedy of the avant-garde, however, was that in order to sustain this role it had to "retire from the public altogether." Despite its aesthetic failures, the appeal of kitsch seriously imperiled the avant-garde. "It is not enough," Greenberg declared, "to have an inclination towards [genuine culture]; one must have a true passion for it that will give him the power to resist the faked article that surrounds and presses in on him. . . . Kitsch is deceptive." Only the most careful and acute observer, Macdonald added in "Theory of 'Popular Culture'" (1944), could differentiate the "phoney avant-gardism" of MacLeish or the middlebrow intellectualism of a Great Books course from the real thing. Recognizing the perilous situation of the avant-garde, Greenberg asserted that the avant-garde had to accept its separation and aim simply to "preserve whatever living culture we have right now." Macdonald, although more hopeful of the possibility of building a holistic "*human* culture," repeated this narrative of an undesirable but necessary isolation. The "cheapening of cultural production" that had turned Folk Culture into Popular Culture, he warned, threatened High Culture. Only separation from the mainstream had guaranteed avant-garde survival. In their "desperate attempt to fence off some area where the serious artist could still function," Macdonald maintained, avant-garde artists had protected genuine art from the corruptions of mass culture. While Kay Boyle prostituted herself to the *Saturday Evening Post*, for example, and a host of talented writers had been "absorbed by the Luce organization," avant-gardists had established a "new compartmentation of culture, on the basis of an aristocracy of talent rather than social power." For Greenberg and Macdonald, popular culture, born of industrialization, capitalism, and mass education, was both an infected and infecting body. Genuine artists, in order to remain healthy, had been forced to quarantine themselves.[36]

So even as Greenberg and Macdonald yearned for a more unified culture, *Partisan* critics placed their hopes instead in an intellectual class that would create a space for the preservation and production of genuine art. This burgeoning class identity explains why the magazine increasingly directed its fierce anti-Stalinist venom not toward conservative politicians but rather toward affirmative intellectuals who purportedly allied themselves with the masses. In particular, the magazine directed an inordinate amount of its criticism at Archibald MacLeish and Van Wyck Brooks. Both MacLeish and Brooks had scolded American intellectuals for failing to rally the nation against the fascist threat. MacLeish, in "The Irresponsibles" and "Postwar Writers and Prewar Readers," had asserted the responsibility of artists to support mass political movements by creating inspirational works of the imagination. Brooks had assaulted the cynicism, clannishness, and political apathy of "coterie" writers, insisting that "primary" artists dealt with issues central to their society. Directly refuting the professional identity of *Partisan Review*, he had lamented that writers had come to represent "the expression of self-conscious intellectuals" rather than "the voices of the people." Both writers called for artists and writers to throw their enthusiasm and work behind the war effort. As quintessential affirmative artists, they insisted that the world, having suffered a great fall, "*had* to be put together, and the only way to do it was to see it again—and see life—in the light of ideas." Literature, Brooks contended, was one venue in which "the regeneration of our country can have a substantial beginning."[37]

But to *Partisan Review* writers, Brooks and MacLeish were fighting fascism with fascism and, in doing so, represented the multiple failures of affirmative art. Interpreting their critique of cynicism as a call to ignore the real conditions of the United States, Macdonald, in "Kulturbolschewismus Is Here," claimed that, "in attacking those whose work exposes [the] decomposition [of bourgeois society]," these writers "expressed [that society's] farthest totalitarian reaches." Welcoming the accusations of Brooks and MacLeish that "coterie" writers were "doubters, scorners, and skeptics," Macdonald argued that "positive, constructive, optimistic, popular" primary writers were mere voices for the official, reactionary policy of a dissolving society. These affirmative artists, he argued, accepted the "*specific* and *immediate* values of society" but consequently lost sight of "*general* and *eternal* human values." The result was work that "turns out to be worthless as literature and also profoundly anti-human." Ultimately Macdonald exposed the "Brooks-MacLeish thesis" to be an attack on intellectual freedom in the vein of Stalinism and fascism: "'Kulturbolschewismus,' 'formalism,'

'coterie writing,' 'irresponsibles'—the terms differ for strategic reasons, but the content—and The Enemy—is the same." Heaping further abuse on these affirmative writers, Lionel Trilling, Alan Tate, James Farrell, and John Crowe Ransom all contributed two months later to a forum in which they mocked the democratic idealism and naïve "Affirmation of Values" at the heart of Brooks's and MacLeish's writings.[38]

But while loose accusations of fascist tendencies were as common in the late thirties as souvenirs from the World's Fair, the vitriol of *Partisan Review*'s attacks did have a more substantive basis. The true crime of the affirmative artists was their desire to join mainstream culture, and their resulting abdication of class authority. Beginning in 1939 the magazine developed a sustained and consistent critique of the failure of affirmative professionals to define themselves as a class separate from the bourgeoisie. As James Farrell averred in the "Brooks-MacLeish" forum, the bourgeois citizen and the artist must be understood as antithetical figures. F. W. Dupee began the volley in 1939 with the "Americanism of Van Wyck Brooks." Revealing what the magazine often denigrated as the "religious" need of liberal writers for national unity, Brooks's pastoral portrait of the nineteenth century in *The Flowering of New England* represented the foolish attempt of the artist to join bourgeois culture. Brooks had "accomplished his great purpose of reconciling the artist with American society" only by relying on an "already distant past . . . which is largely the projection of his own fancy." Dupee blasted Brooks for abandoning the role of the distanced intellectual, for "permitting the spiritual New Englander in him to absorb the modern critic, the visionary to consume the skeptic." Phillips developed this attack further, claiming that the "militant provincialism" of Brooks and others was a cowardly attempt by intellectuals at "self-abnegation," an attempt bound not only to destroy a nascent intellectual self-consciousness but also to further the massification of contemporary society. For the *Partisan Review*, as for Agee, reconciliation with the mainstream was an act of self-destruction.[39]

Instead, artists had to distance themselves from society as an independent social class. In 1939 Agee had lauded the "free unfearing human beings" who, steadfastly avoiding contamination by commercialization and the bourgeoisie, might eventually "liberate" the human race. In the same year Rahv repeated Agee's assertion that artists and intellectuals must separate themselves from mainstream society. "The dissident artist, if he understands the extremity of the age and the voices that it tries to stifle, will thus be saved from its sterility and delivered from its corruption." But while Agee

celebrated these adversary figures as heroic loners, Rahv maintained that the language of artistic individualism hid the class solidarity of intellectuals. Exploring the ideals of early adversary artists, Rahv corrected their romanticization of the individual "soul": "Flaubert and other protestants of art and thought did not so much retire into themselves . . . as into their group lives and group cultures." Modern art, in fact, flourished only when a "separate intellectual class emerged conscious of itself as standing apart from society and as possessing special and superior interests and ideals." In another essay William Phillips agreed that while modern European literature had focused on the "alienation of the artist figure," it had flowered only following "the formation by the intelligentsia of a distinct group culture, thriving on its very anxiety over survival and its consciousness of being an elite." This argument for an adversary class identity among artists and intellectuals appeared repeatedly in *Partisan Review,* creating what Terry Cooney calls the magazine's "heightened emphasis on intellectuals as a special social grouping and on their traditions and integrity." Agee's adversary artist, independent though he might seem, could only prosper when his thoughts and ideals were nurtured within a community of like-minded individuals. Intellectuals, artists, and other highly educated citizens, *Partisan* critics insisted, had to recognize their connections to a larger adversary class and ally themselves with its rigorous critical values.[40]

The attacks on liberal writers by New York Intellectuals in the early forties represented not a simple preference for avant-garde art or a malevolent cultural elitism but a defense of an ideal of class behavior. The adversary class, these intellectuals asserted, had to separate itself from a mass society in order to create a free space for intellectual activity. As I have suggested in earlier chapters, such attempts to define the proper behavior of artists and intellectuals symbolized a larger struggle to control professional managerial identity. This is not to say that *Partisan* critics necessarily thought of themselves as professionals, although in the postwar years they would increasingly do so. Nonetheless it is clear that the debates in the war years between affirmative cultural professionals within the New Deal, corporate liberal and Popular Front camps, and the adversary intellectuals in avant-garde and anti-Stalinist communities continued a tradition of conflict concerning the relationship between the professional class and the forces of bourgeois modernity, including bureaucracy, commercialism, the mass media, and material abundance. *Partisan Review* critics, in a tone of defeat common among adversary professionals, did not express a desire to convert the majority of professionals to its ideals. They did not aim, as H. G. Wells or

Thorstein Veblen had, to create a professional class that would serve as the leader of society or industry. Indeed, these writers imagined other nonadversary professionals as primary opponents, and sought only to defend their territory from both the dominant culture and from those professionals who foolishly associated themselves with bourgeois society. Nonetheless, in attacking affirmative professionals, they did insist that the honest, *true* relation of the cultural professional, and indeed the educated citizen, to the larger society was an adversary one. In criticizing the affirmative, nationalist rhetoric of Brooks and MacLeish, they argued, essentially, that such writers betrayed their responsibilities to other intellectuals and professionals.

The ideological clash between the adversary class of *Partisan Review* and the affirmative professionals of Brooks, MacLeish, and *Fortune*, therefore, was a continuation of *Fortune*'s struggle in its first years to replace the anticommercial and autonomous values of the professional ideal with the worldliness and power of the corporate professional. The lines of contestation had been redrawn by a decade of turmoil: the discovery of the American public and the growing political importance of national culture, most crucially, meant that *Fortune*'s ideas about professional responsibility had much more in common with professionals on the political Left than had been true in the early decade. Indeed, as we have seen, the key difference between the affirmative ideal of *Fortune* and the adversary intellectual of *Partisan Review* was a radically different understanding of the relation between highly educated citizens and the mass public. Whereas affirmative professionals imagined themselves as a part of a pluralist public—if a part that had a particular leadership responsibility—adversary intellectuals insisted on a deliberate distance from a hopelessly alienated citizenry. Their ideas about the purpose of art and culture followed from these suppositions. Despite these shifts in position, however, still at stake was the dominant definition of professional achievement. In the years immediately following the war, as the next, and final, chapter demonstrates, the battle lines in this conflict would shift radically once more.

PROFESSIONALIZING PLURALISM

During the late thirties and early forties the momentum in the cultural battle within the professional class swung to the champions of the affirmative ideal. As their adversary foes prepared to defend a gravely threatened genuine high art, the affirmative intellectuals of the Popular Front coalition, the New Deal, and corporate liberalism predicted the rise of a more accessible, democratic American culture. While *Partisan Review* lamented the contaminating rise of kitsch, *Fortune* gloried in the imminent merger of high and low culture. Van Wyck Brooks renewed his call for an integrated national culture, while affirmative artists and critics both sought a larger audience for poetry, painting, and drama, and invited a wider range of citizens to participate in artistic appreciation and production. Even as it absorbed the slings of retreating adversary intellectuals, the affirmative ideal, supported by both corporate liberals and the mainstream Left, seemed ready to drive elitist adversary standards into the margins of the cultural field.

Poised on the edge of this victory, however, support for affirmative ideals crumbled, and adversary artists and critics swooped in to save art from the threatening masses. Indeed, in the early forties it would have been difficult to imagine the success that adversary intellectuals would experience in establishing their cultural authority in the following decade. By the early fifties universities, museums, and even corporations had rejected affirmative ideals and instead had embraced the distant, critical, liberating artistic model heralded by the New York Intellectuals, the New Critics, and abstract expressionists. In painting, literature, and even jazz, esoteric, allusive, timeless, and difficult productions were widely recognized as "real" art, while the strengths of *Fortune*'s modernism, of the Works Progress Administration, and of the "Cultural Front"—their political astuteness, nationalism,

timeliness, and accessible "designed realism"—were redefined as weak-
nesses. Even as the corporate liberal coalition became the dominant politi-
cal and economic authority in the postwar years, *Fortune*'s cultural ideals
largely disappeared.

The explanation for this irony lies in the professionalization of the pub-
lic sphere that occurred in the years after the Second World War. During
the war corporate liberals and the liberal coalitions surrounding Roosevelt
and Henry Wallace shared a vision of affirmative leadership, national
growth, consensus pluralism, and international (American-led) unity. After
the war, however, these affinities dissolved amid political struggles. On the
domestic front social liberals, joined by labor, pushed for legislation that
would secure what Roosevelt, before his death in 1945, had dubbed the
"economic bill of rights": full employment legislation, a national health
care plan, larger housing subsidies, and increased social security support,
among other goals. Internationally they criticized the rise of cold war rhet-
oric, exemplified by Winston Churchill's "Iron Curtain" speech in 1946,
and advocated a policy of coexistence with the Soviet Union. To *Fortune*,
however, the domestic aims of social liberals threatened to stall the postwar
economy, while their foreign policy was naïve and dangerous in its trust of
Stalin and Soviet Russia. The magazine attacked both positions with a rhet-
oric of antistatism and "freedom." Joining *Partisan Review* critics in labeling
social liberal professionals as "totalitarian liberals," *Fortune* insisted that
support for both an increased welfare state and for a stabilized relationship
with the Soviet Union were not only indications of intellectual and moral
softness but were also the first steps toward reactionary socialism and sta-
tism in the United States. Seconding the earlier criticisms of social liberals
by adversary intellectuals, *Fortune* and other corporate liberals began to
argue that democratic idealists lacked a realistic understanding of the dan-
gers of a mass society.

By ambushing the ventures of former Popular Front and New Deal lib-
erals into the territory of economics and culture, these marksmen not only
repelled the political initiatives of the liberal-labor coalition but also se-
cured the vocational territory of professionally trained workers. In response
to the imagined political threat of this renewed leftist front, both adversary
intellectuals and *Fortune* worked to create an autonomous space for their
professional prerogatives. In the late forties and fifties the adversary critics
adopted the university as a home for an independent avant-garde. Scrupu-
lously professionalizing themselves, they aimed to exclude less specialized
affirmative intellectuals from the primary sites of artistic authority and, in

doing so, closed down the affirmative vision of an open, democratic artistic sphere. In the course of this professionalization, however, these critics largely withdrew from the political debates that had been central to their identity in the thirties and early forties. Corporate liberals, meanwhile, made great strides in furthering their economic and social ideals, and, in fact, corporate liberalism became the business common sense of the postwar era. But to achieve these gains, *Fortune* resorted increasingly to claims of professional authority. Having redefined business managers as specialists, the magazine largely withdrew from the cultural field. In 1948 *Fortune* declared its intention to reduce its commitment to cultural issues and, instead, to explore the day-to-day business activities that its initial prospectus had specifically eschewed. The magazine would replace its generalist approach with a tactic more useful to professional managers. Establishing an "uneasy alliance," as James Allen names it, between business and intellectuals, these groups created a newly professionalized society, justified by a rhetoric of individualism and freedom, in which both corporate liberals and adversary intellectuals gained significant institutional power. *Fortune*'s pluralist consensus had become a professional consensus.

This process of professionalization helped to ensure the economic and political authority of corporate liberals in the postwar era. However, even as it celebrated this triumph, *Fortune* became hesitant about its impact. As organized capitalism blossomed, it became increasingly difficult to ignore the key tensions within corporate liberal thought: between corporatism and individualism, efficiency and competition, management and entrepreneurialism, in short, between professional rationalization and capitalist disorganization. As the economy drifted closer and closer toward the first terms in each of these pairings—that is, toward organized capitalism—a voice of opposition arose within the magazine, complaining that the government, unions, and indeed business suffered from too much bureaucracy, too much conformity, and too much organization. This dissent within the magazine was only one facet of a similar anxiety about conformity and bureaucracy that existed across the professional managerial class. The causes of this uncertainty, ironically, were the very bureaucratic institutions and consensus ideology that *Fortune* and adversary intellectuals had helped to create. As the fifties moved into the sixties, these anxieties would explode into the rebellion of the counterculture and the New Left. Their presence in *Fortune* demonstrates that the seeds of dissent from the postwar consensus germinated not only in the outlying fields of adversary intellectuals and in

unplowed ditches of the American underclass but also among the abundant crops of mature organized capitalism.

This disquiet about bureaucracy, expert control, and rationalization had more immediate effects, however, on the professional culture of the fifties. Out of this fear among professionals about over-professionalization grew both a changing sense of the use of art and a new dominant model of professional managerial identity. Faced with the threat of conformity while also insisting that the United States' "imperfect" society was defined by consensus rather than conflict, members of the professional managerial class in the fifties increasingly defined themselves not by their adversary or affirmative relation to society, but rather in individual, private terms. Rejecting a defined social role for the professional managerial class, these professionals sought instead to individuate themselves against the backdrop of a mass society. Culture became one of several routes through which individuals could distinguish themselves, and the idiosyncratic, individualistic art celebrated by *Partisan* writers and New Critics was ideally suited to this purpose. The professionalization of the public sphere in the late forties had both assisted the rise of corporate liberal economic thought and solidified the power of adversary cultural critics. In the fifties, however, this same process produced a backlash against excessive organization that led to a changed social use for art and a new understanding of professional class identity.

The Threat of "Totalitarian Liberalism"

During the Second World War *Fortune* shared a surprising amount of common ground with the social liberals and progressives who had formerly comprised the Popular Front. Despite their significantly different political aims, both celebrated, as we have seen, democratic diversity and national commitment with much the same rhetoric. In addition, the social liberal coalition, like *Fortune*, encouraged its artists and intellectuals to take an active role in social and political issues, and to dissolve barriers between art and everyday life. Both camps celebrated a "culture of democracy" that encouraged unity and participation in the political and cultural life of the nation. These similarities not only overshadowed their considerable differences but also made both of them targets of the adversary intellectuals' barbs. As the former *Fortune* writer Dwight Macdonald complained in "The (American) People's Century," the spiritual and political affinities between the visions of the corporate liberal Luce and the social liberal Henry

Wallace made them both threats to a healthy society, one not dominated by the masses. Their similarities were revealed not only in their rhetoric, Macdonald argued, but also in their "conjunction of imperialism and domestic liberalism," a political combination that manifested itself in support for private enterprise, a focus on material progress, the hope that the United Nations would police the postwar world, a belief in the need for improved civil rights and race relations, and a vision of a world "refashioned in the image of America." Their parallel faiths in national solidarity, flourishing especially during the war, often overwhelmed, or at least obscured, the opposing political aims of the two groups.[1]

In claiming that the "American Century" and the "Century of the Common Man" were essentially the same, however, Macdonald clearly sidestepped the significant conflicts between these two visions of the future. Corporate liberalism based itself squarely on capitalism and aimed to broaden the market freedoms of businesses and corporations. Social liberalism concentrated instead on the "economic bill of rights," and on the expansion of the same New Deal welfare state that corporate liberals had increasingly begun to fear and even despise. The internationalism of corporate liberals was driven by their desire to expand the markets of the world, and was limited, particularly toward the end of the war, by the framework of anticommunism. Social liberals, however, imagined internationalism largely as a way to spread material abundance through a "New Deal for the world," and hoped that the United States would develop an nonantagonistic relationship with the Soviet Union. Because both groups imagined the end of the war as an opportunity to re-create the political world according to their own vision, it was inevitable that their differences would manifest themselves in the postwar years in conflicts over policy. After the war national unity gave way to battles over welfare programs, government regulation, and relations with the Soviet Union. While the liberal-labor coalition worked for a government guarantee of full employment, labor union advances, an expanded social welfare system, and a policy of international peaceful coexistence, corporate liberals sought to open international markets and stall the New Deal while containing "statism" both abroad and at home. Even as enthusiasm to reorder the nation and the world continued to fill the discourse of both camps, the affirmative bond that had linked corporate liberals like Henry Luce and social liberals like Archibald MacLeish loosened under the weight of their political differences.[2]

The conflict between corporate liberals and the left-liberal coalition shifted the political geography of the nation. As the common ground be-

tween corporate liberals and social liberals dissolved, *Fortune* aligned itself with adversary intellectuals in their attack on the remnants of the Popular Front coalition. Rallying themselves with a rhetoric of "freedom," both groups contended that social liberals failed to recognize the loss of liberty inherent in the ideal of the socialist state. This strategy was nothing new for the New York Intellectuals, who had disparaged Popular Front intellectuals and New Deal liberals as unthinking and gullibly optimistic throughout the war. The liberal mind, Lionel Trilling observed in 1942, was "a kind of New Deal agency which intends to do good but cannot always cope with reactionary forces." The intensity of these attacks only increased in the postwar era. Macdonald's attacks were particularly fierce. According to Macdonald, the tension between world realities and liberal affirmation led "totalitarian liberals" to paradoxically combine the ideals of traditional liberalism with the methods of totalitarianism. In criticizing recent editorials in the social liberal magazine *The New Republic*, Macdonald complained, for example, that "slave labor, Nazi propaganda methods, and imperialism are justified, respectively, in the name of social progress, democratic re-education, and world peace." The New York daily *PM*, he added, was "uncritical to the point of irrationality." "Wallaceland," he jibed in a third piece, "is the mental habitat of Henry Wallace plus a few hundred thousand regular readers of the *New Republic*, the *Nation*, and *PM*. It is a region of perpetual fogs, caused by the war winds of the liberal Gulf Stream coming in contact with the Soviet glacier." The idealistic "children of light," as Reinhold Niebuhr would label social liberals, were incapable of recognizing and defending themselves from the dangers of communism and Soviet totalitarianism.[3]

After the war *Fortune* joined this attack, diligently separating its competitive liberal ideals from the misguided welfare hopes of Wallace liberals. In the pages of *Fortune*, socialism loomed as a major threat to American prosperity after the war. Declaring, in 1946, that the "Communist Party has a significance in the U.S. far beyond its small numerical membership," "Hammer and Tongs" described Communists as devious, thoughtlessly responsive to Moscow, and ruthlessly justifying authoritarian means by supposedly progressive ends. More often, however, the threat of statism appeared not in the guise of the Communist Party but in the supposedly innocent calls for an expanded welfare state. As with the *Partisan* critique, it was the unintended consequences of the policies of gullible social liberals that produced the most significant problems. The magazine's two most celebrated books of the mid-forties, for example, were Friedrich Hayek's best-selling *Road to Serfdom* (1944) and W. A. Orton's *Liberal Tradition* (1945).

Both these works, aiming to reestablish what *Fortune* often called a "libertarian economics," argued that state planning was the first step on the way to fascism. Maintaining that only the revival of respect for individual liberty could avert the "worship of the modern state," the magazine praised Orton for excoriating leftists such as Henry Wallace and Harold Laski who sought to replace the competitive market with a controlled one. Calling Hayek's book "one of the great liberal statements of our time," *Fortune* criticized those (like "our own Vice President Henry Wallace") who claimed to fight fascism while working for increasingly socialist economic policies. Reacting to this perceived threat to the freedom of the market and the larger society, *Fortune* attacked social liberalism by claiming that it aimed to replace traditional liberal values with statist ones.[4]

In retrospect, it is surprising that *Fortune* concerned itself so intently with the social liberal threat. It is clear, looking back, that the tug-of-war between these competitors was not a fair contest. By the end of the war the power of social liberals had been significantly weakened. The official Popular Front had dissolved in late 1939 in the wake of the Nazi-Soviet Pact and the Soviet Union's subsequent indefensible invasions of Poland and Finland. Perhaps even more painful, the shock of these Soviet debacles had convinced many American progressives either to adopt anticommunism or to drop out of politics altogether. At the same time, the influence of social liberals within the American government was waning. Roosevelt's decision to drop Wallace from the ticket in 1944 only reiterated his already clear intention not to further expand the New Deal after the war, and to further reconcile his administration with the business community. Unbalanced by the loss of both the organizational support of the Popular Front and the institutional influence on the New Deal government, social liberals were in no position to pull corporate liberals off their feet.

During the early forties, however, the political power and public support of corporate liberals grew steadily. World War II was particularly important in this rise. First, the enormous and successful overseas commitment of personnel, emotion, and resources made the public much more receptive to economic internationalism. Corporate liberal internationalism, evident in postwar policies like the Marshall Plan, had its intellectual roots in the thirties but received little popular support until the war. After the war isolationism no longer seemed a legitimate option for the United States. Second, the huge increase in government-business cooperation provided the base for postwar corporate liberal policy. The federal government grew 300 percent in size in the four years of the war, and only a fraction of this growth

disappeared afterward. As Kim McQuaid notes, the war provided a lengthy education "in centralized industrial planning under loose government auspices." More business managers learned how to work with government, and many recognized the advantages of a long-term collaboration. "The experience of a world war," the historian Robert Collins argues, "strengthened the belief that cooperation between public and private spheres was both desirable and feasible."[5]

More specifically the war years saw the return of corporate liberals to government and public policy councils, in groups such as the Committee for Economic Development (CED) and the War Advertising Council. The CED, which, according to Collins, was "one of the nation's most glamorous spokesmen for 'enlightened business sentiment,'" would play an especially crucial role in U.S. domestic policy in the postwar years. Founded in 1942, the Committee was rooted in earlier corporate liberal groups, including the Business Advisory Council, that group of "far-sighted" business managers who had convened largely to advise the corporatist National Recovery Administration, and the American Policy Commission, a short-lived organization dedicated to communication between academics, politicians, and businesspeople, of which Luce was an invited member. Fully corporate liberal in its roots, the CED advocated a strategy of "commercial Keynesianism," which used tax cuts and increases, rather than increased spending, to encourage economic recovery, and over the next twenty years there would be "striking parallels between CED and government policy." *Fortune*, not surprisingly, was a key supporter of the CED, reprinting the Committee's "Declaration of American Economic Policy" in 1944 and supporting its policies and vision of abundance throughout the postwar period. In fact, the authors of *Managers vs. Owners* name the CED and *Fortune* as the two main voices of the "corporate liberal alliance" between managers, policy analysts, and academics that "characterized the postwar period, at least until the Johnson administration." The roots of this dominance took hold first during the war years.[6]

Despite the changing power relations between corporate liberals and social liberals during the war, however, *Fortune*'s attacks on social liberals in the postwar years are not without explanation. Perhaps most important, the immediate postwar years in the United States were years of great uncertainty. The war had been won, but the atomic bomb created new fears about the ability of mankind to destroy itself, and the rumblings of the next war could already be heard in the words of Stalin and Churchill. The economy had flourished during the war, but with the return of millions of

working-age soldiers there was no guarantee that a return to peace would not also be a return to unemployment and depression. On the political front, the death of Roosevelt had undermined the strength of the Democratic coalition and left the fate of the New Deal unclear, but the "American Century" had not yet triumphed over the "Century of the Common Man." Many progressive intellectuals and professionals, despite their experience with the Communist Party, continued to believe in the benefits and possibilities of united front politics, and both labor unions and social liberals looked with hope toward an expansion of the New Deal spirit. Social liberals had a substantial public voice in the media, most clearly represented by the *New Republic*, the *Nation*, and *PM*, and labor unions displayed both their power and their willingness to use it in the massive wave of strikes in 1946. Finally, Henry Wallace, rather than disappearing after his dismissal from Truman's cabinet, continued to garner support as a leftist leader and unifier, to such an extent that he decided to run for president in 1948. Only after the Republican's rout of the Democrats in the 1946 elections and the subsequent passage of the antilabor Taft-Hartley bill did the weaknesses of this social liberal coalition become truly apparent to contemporary observers. The immediate postwar years, as Nelson Lichtenstein concludes, were a crossroads for a nation choosing between social democracy and consensus capitalism, and contemporary participants could not be sure which path the nation would follow.[7]

This sense of uncertainty about the national future helps to explain why both *Partisan* critics and *Fortune* expended so much energy to undermine the seemingly negligible political power of social liberals. Beyond this, however, it is clear that both *Fortune* and the New York Intellectuals, still stinging from the prewar affronts of New Deal liberals and Popular Front professionals, considerably overestimated the staying power of the social liberals. Even when their threat to the business authority had faded, *Fortune* continued to worry about "directionless" liberals duped by communism and socialism. Even in 1949, for example, just months after Wallace's humiliating performance in the presidential elections, Eric Johnston's "How America Can Avoid Socialism" and John Davenport's "Socialism by Default" both insisted that, despite the economic and political success of business over the previous four years, socialism in the United States was still a pressing danger. "The Truman administration (and social legislation more generally)," Davenport declared, "is giving the U.S. another push toward socialism." Similarly, as Harvey Teres observes, the New York Intellectuals mistakenly imagined in the postwar years that "totalitarianism was making

major inroads into American life." Largely because they insisted that social liberals were dupes of the Soviet Union, Judy Kutulas adds, "anti-Stalinists always overestimated the size and the strength of Communism in the United States." The lingering authority of New Deal and Popular Front institutions, combined with a consistent overestimation of the hidden power of social liberals, convinced both corporate liberals and adversary intellectuals to fear the rise of statism in the United States.[8]

Professional Containment

In exaggerating the power of the left-liberal coalition, both *Fortune* and the *Partisan* critics created a monster whose deception and strength, like that of the Soviet Union itself, warranted a strategy of containment. Their response, however, involved more than just political attacks and a celebration of American "freedom." Attempting to control this perceived threat, *Partisan* critics and *Fortune* enveloped themselves further in the contest to define the social role of the professional class. In defending the "freedom" of the cultural sphere and the market, both magazines not only fought for their political visions but also worked to establish the professional authority of their constituency. The democratic idealism and pluralism of social liberals threatened to undermine the professional power of both literary professionals and corporate liberals. Arguing that the economy should be planned to serve the interests of workers and the "common people," and that art and culture should be produced by and geared toward a wide democratic society, social liberals sought to limit the authority of both these communities. Not surprisingly both responded to this threat. Working to contain social liberal ideals in order to defend a free space for professional activity, these two groups simultaneously attacked the political policies of the left-liberal coalition and undermined that coalition's threat to professional power. Focusing their critique on the professional members of the left-liberal coalition, *Fortune* and *Partisan Review* defended themselves not only from socialist ideals and the dangerous naïveté of "totalitarian liberals" but also from the sacrifice of professional-class priorities implied by a genuine democratic pluralism.

For the New York Intellectuals, this strategy of containment focused on the cultural sphere, the primary area of adversary vocational expertise. To *Partisan Review*, culture seemed to be the last bulwark protecting the adversary class from the mass society. In response, adversary intellectuals sought to make themselves the sole owners of true art, even as affirmative

intellectuals insisted that the general public play a role in artistic production and criticism. "To speak of modern literature," Rahv wrote in "Twilight of the Thirties," is to speak of that "particular social grouping, the intelligentsia, to whom it belongs." Arguing that the intellectuals' "only real property" was in "the realm of technical and spiritual culture," Rahv claimed art for an elite group of adversary professionals who defined themselves through "the proud self-imposed isolation of a cultivated minority."[9]

Through the forties adversary critics worked to institutionalize this connection between true art and the adversary class, and to build a secure home for genuine culture. This new home allowed them to stake out a plot for interwar avant-garde (modernist) art as well as to construct the professional fences that could protect their cultural property from other claimants. In the postwar era the New York Intellectuals aimed, writes Neil Jumonville, to "redefine and reshape the meaning of the term *intellectual* in order to exclude, undermine, and discredit those they thought at least partly responsible for the uneasy postwar situation." They used three strategies to achieve this exclusionary goal. First, they designated their role as a conservationist one and, in so doing, defined the "literary" in opposition to the "timely" art of the Popular Front and of mass culture: genuine art, they claimed, addressed universal rather than spurious "specific and immediate" values. Second, they specified the necessary difficulty of genuine art, which allowed the adversary critics to reject those without the intellectual training necessary to traffic in the specialized language and esoteric allusions of avant-garde art. Finally, they established themselves in universities in order to authenticate and reproduce their understanding of art and literature.[10]

First, the fear of mass culture and political fatalism among the New York Intellectuals led them increasingly to see the role of the adversary critic not as innovative but rather as conservationist. As we have seen, this attitude surfaced as early as 1939, when Greenberg argued that the state of contemporary culture and society was so dire that socialists could only hope to "*preserve*" rather than create genuine art. Lamenting the attacks by MacLeish and Brooks on the avant-garde, Macdonald echoed Greenberg in 1941: "Looking over back issues of this magazine, I am struck with how continuously we have been fighting a rear-guard action against this growing official aesthetic." Rahv even officially shifted the *Partisan Review*, as Harvey Teres notes, from an "activist" to a "custodial function" in the early forties, in line with Trotsky's understanding of artists as "culture-bearing." Finally, in 1947 Lionel Trilling argued that the "function of the little magazine" was to keep

alive the seed of great literature until it could blossom again into public art. In claiming this conservationist role, the New York Intellectuals defined genuine art *against* the example of contemporary culture. The art of the Popular Front, of the Works Progress Administration, and of *Fortune*'s modernism could be dismissed not because they disagreed with their politics (which they did), but because it was infected with the "specific and immediate values of society." Assuming that the imminent collapse of contemporary society made genuine culture impossible, they could categorically dismiss mass culture, and the affirmative art that prided itself on its engagement with contemporary society.[11]

In addition to defining politically engaged art as inauthentic, the New York Intellectuals worked to undermine the authority of critics who contested their understanding of art. The adversary critics performed this task through their fetishization of "difficulty." Thomas Strychacz argues that professional groups, including writers, "preserve a form of cultural authority within the development of mass culture" by institutionalizing an inaccessible discourse in order to create "communities of competence." Again, Greenberg first expressed the importance of difficulty to the New York Intellectuals. "Kitsch," he argued,

> predigests art . . . and detours what is necessarily difficult in genuine art. . . . The ultimate values which the cultivated spectator derives from Picasso are derived at a second remove, as a result of reflection upon the immediate impression left by the plastic values. It is only then that recognizable, the miraculous and the sympathetic enter.

According to this perspective, any work of art that provided a clear imitation of experience—that could be interpreted without the tools of the "cultivated spectator"—would fail to spur the reflection necessary to genuine art. Thus, to Macdonald, the philosophical histories of Will Durant and the economics of Stuart Chase were debased forms in effect, because they made the ideas of the "cultivated" accessible to a larger audience (even if that audience was still largely the nonadversary professional managerial class). Criticizing the "clear and direct" prose of the Revised Standard Version of the Bible, for example, Macdonald commented later in the fifties, "indeed, the R.S.V. does slip more smoothly into the modern ear, but it also slides out more easily; the very strangeness and antique ceremony of the old forms make them linger in the mind." But while Macdonald claimed that "any literate person knows what the old forms mean," he really meant, like Green-

berg, that any "cultivated" person knows. By insisting that genuine art had to be difficult, adversary intellectuals hoped to diminish the authority of critics or artists who hoped to converse with a wide public audience.[12]

Finally, adversary critics institutionalized their ideas in the university. In the years after the war, argues David Shumway, "the literary" was "captured by the university." Although Shumway's argument that literary capital was institutionalized is valid, I disagree with his causation. The university did not "capture" adversary critics: these thinkers, eager for institutional authority, sought the university as a professional home. Holding prestigious positions at Brandeis, New York University, California-Berkeley, and Columbia, among others, they achieved the "official" status that in MacLeish and others had galled them. "Everyone on PR [Partisan Review] is now teaching," Rahv noted approvingly in 1950, "which shows you how far things have gone." Even more important than the individual successes of the Partisan critics, the New York Intellectuals, together with the New Critics, dominated literary discourse in the universities in the postwar era. The establishment of adversary intellectuals within the university granted their artistic tastes an automatic authority: the university functions, as Strychacz argues, like a "museum of literature" that endows the texts discussed with "literariness," just as a pile of bricks in the Tate Museum becomes art. By 1950, as Marian Janssen notes, the critical, evaluative approach to culture and literature that these adversary critics had developed had become "a part of the regular university curriculum."[13]

The Partisan critics in the postwar years were, as Jumonville sums up, a "professional group intent on upholding correct vocational standards." In creating a social space for the adversary intellectual class, they not only preserved "freedom" for avant-garde creative artists, but they also established their own authority as critical experts. But as I have alluded, they were not alone in furthering the professionalization of the cultural field. The New Critics, despite different regional and political affiliations, were allied with the New York Intellectuals in their antinationalism, anticommunism, literary elitism, and professionalizing drive. These two groups of critics, as Shumway contends, were "two sides of the same coin." As early as the late thirties the New Critics echoed Partisan's calls for an independent group of professional critics, as in John Crowe Ransom's essay, "Criticism, Inc.," and, in their efforts to realize this goal, they engaged in the same strategies of professionalization in the postwar era that Partisan critics did. Declaring with Allen Tate that "standards" had to be maintained in the face of mass society, the New Critics focused on the evaluative duties of the critic and,

in doing so, imagined themselves as protectors of genuine artistic values. Echoing Trilling's pronouncements about the purpose of the little magazine, for example, Philip Rice, the associate editor of the New Critical stronghold *Kenyon Review*, asserted in his "Intellectual Quarterly in a Non-Intellectual Society" that the key work of a literary quarterly was establishing and enforcing critical standards. Second, the New Critics, perhaps even more than the New York Intellectuals, gained a reputation for making a fetish out of the difficulty of genuine art, to such an extent that, as Janssen notes, "for some [practitioners of New Criticism], obscurity became an essential characteristic of good poetry." Finally, the New Critics were similarly intent on institutionalizing their power and, as Shumway asserts, "conducted an organized campaign to make [aesthetic] criticism an academic enterprise." The New Critics joined the New York Intellectuals in their attempt to establish the power of an adversary professional class in the war and postwar years.[14]

The efforts of adversary critics to stake out a space for avant-garde culture were largely successful. "The New Criticism seems to have triumphed pretty generally," Norman Mailer noted in *Partisan Review* in 1952, "and PR's view of American life is indeed partisan." By the fifties the adversary critics and their formalist, professionalized criticism had displaced affirmative intellectuals as the "official" voice of the American artistic scene. *Kenyon Review*, *Partisan Review*, and other similar quarterlies, as Janssen notes, had become by the fifties "the acknowledged leaders of the literary world." Some critics have attributed this success to the increasing support of adversary critics for the hegemonic postwar powers. But despite their withdrawal from the political scene, it is by no means clear that their cultural ideals were friendlier to the "American Century" coalition of the fifties than those of affirmative artists. Indeed, as this book has demonstrated, affirmative cultural ideals were an essential part of corporate liberal ideology. Shumway has suggested alternately that the institutional victory of adversary critics could be accomplished only because "the literary" had lost its cultural force: "It is the marginal condition of criticism in the 1930s that allowed it to be dominated by groups to the right and left of mainstream American politics." But this theory, too, posits unquestioned authority to "hegemonic" powers: if the artistic criticism had been worth fighting over, Shumway presumes, more central groups would have gained control over it. Again, *Fortune's* entrance into these cultural struggles belies this easy presumption. In fact, art and literature continued to wield significant cultural force, and, as Thomas Strychacz persuasively argues, their institution-

alization within the university helped to sustain that force into the post-modern era.[15]

The explanation for the triumph of the adversary critics lies, instead, in the professionalization of the public sphere. Adversary intellectuals, led by *Partisan Review* and the New Critics, were able to establish themselves as professional authorities and thus were able to reduce the influence of affirmative ideals, both because the professionalization of the field denied the ability of nonspecialists to produce and understand "genuine" art, and because adversary intellectuals could denigrate the art of the social liberal and corporate liberal factions with whom they disagreed politically. In the late forties, while mass culture flourished, few debated the essential divide between that mass culture, with its middlebrow offspring, and genuine high art. The rise of adversary professionalism, as John Guillory argues, allowed the coexistence in the postwar years of an honored but unread literature, and a popular but "derogated" mass culture. In this separation of American culture into a series of "brow" categories, the loser was art that aimed both to be "serious," whether politically or artistically, and to address a wide audience.[16]

Fortune, which for almost two decades had sought to undermine the "reversed" logic of the cultural field that rewarded prestige precisely to that art which proved itself esoteric, anticommercial, and unpopular, acknowledged the triumph of the adversary class by largely withdrawing from the cultural field after 1948. This retreat, however, was not a complete defeat. The same professionalization of the public sphere that allowed adversary intellectuals to regain control of artistic definition allowed corporate liberals to wrest control of economic discourse from its populist political opponents. *Fortune*, opposing the "totalitarianism" of social liberalism with the "freedom" of democratic capitalism, worked to create a professional space for business managers. While the New York Intellectuals established a free space for avant-garde art, *Fortune* moved to protect the freedom of the marketplace from excessive government interference. In the late forties *Fortune* redefined itself as a professional business magazine. Beginning in 1947 *Fortune*'s editors reformulated the purpose, layout, and content of the magazine to better serve its role as a leader in the economic realm. As at the inception of the magazine, the editors insisted that business had matured. But this postwar maturation went one step further. "It is not just that Babbitt became Dodsworth (that happened in '29), but that Dodsworth became Paul Hoffman." In the thirties *Fortune* had hoped to integrate business with art, and had been anxious, like Sinclair Lewis's Dodsworth, to reconcile the

technological advances of business with the adversary creative traditions of American civilization. Business and art had been two ill-fitting sides of the professional managerial class that *Fortune* wanted to merge. Now, however, business could stand on its own. The ideal business manager, no longer a literary character, was now Paul Hoffman, president of the Committee for Economic Development and head of the Marshall Plan. Hoffman's political prowess demonstrated the return of uninhibited business leadership. "It was inevitable," *Fortune* continued, "that a businessman should be picked for 1948's key world job."[17]

This new maturation of the business manager spurred a shift in the content and emphasis of the magazine. In its reformulation of the magazine's purpose in 1948, the editors promised to devote increased attention to reports on the business news, trends, and advice that the original prospectus had declared unfit for *Fortune*. "It seems to be the general feeling (which I strongly share)," Russell Davenport wrote in 1948, "that the new *Fortune* should be far more professional in its treatment of business, industry, and finance than anything hitherto attempted by Time Inc." This change in focus manifested itself in fewer and shorter feature essays, and an increased number of regular sections devoted to day-to-day business issues. In 1947 and 1948 the magazine introduced a number of regular sections, including "Business Roundup," "Executive Forecast," and "Consumer Outlook," that addressed the business "news" and predictions that the magazine had avoided in its first two decades. This attempt to provide information that would be immediately useful to businessmen and managers affected the feature essays as well. Davenport suggested in an internal memo, for example, that one feature per month should provide an "analysis of a 'situation' or business as business problem, written with *professional* insight for active capitalists." At the same time Davenport argued for a reduction in "glamour" pieces, and, indeed, while *Fortune* continued publishing artistic portfolios well into the fifties, they were moved to the back of the magazine, rarely featured the critical commentary of earlier portfolios, and appeared less often. These trends continued into the fifties. By 1952, for example, while portfolios were no longer listed in the table of contents with the feature articles, a new section entitled "Short Stories of Enterprise" appeared, and advice articles, with titles like "Should Management Move to the Country?" "When Should Workers Retire?" and "Are Executives Paid Enough?" took up a larger and larger share of the magazine's space.[18]

Fortune's assertion of the professional authority of business leaders also manifested itself in the magazine's re-embrace of unilateral, nongovern-

mental business leadership. The central dilemma of modern economics, the magazine claimed, was that while social welfare programs were necessary, an excessively active government would lead to socialism, stagnation, and eventually even totalitarianism. Russell Davenport, in opening a series of essays entitled "The Greatest Opportunity on Earth," presented the magazine's answer to this problem: a return to elite business leadership. Private business should serve as the main provider of security for workers, he maintained, because only business managers and industrialists had the professional expertise and experience to merge economic enterprise with social welfare. Suggesting the division of expert responsibilities that was the foundation of the magazine's new ideal of professional consensus, Davenport asserted that business managers "must take responsibility for [economic rights], just as educators, artists, and religious leaders take responsibility for the cultural and spiritual rights." Ignoring the conflicts of interest and democratic participation fundamental to the magazine's earlier consensus pluralism, Davenport demanded that business lead in the economic field.[19]

This vision of a revived business leadership replaced the more modest calls for consensus and affirmative leadership that characterized the previous decade. The paternalistic language of corporate welfare and the elite coalition returned to the magazine. "If business doesn't want more government in business—and I don't—the way out isn't too tough," wrote Eric Johnston, the corporate liberal leader of the U.S. Chamber of Commerce. "As business attains greater social-mindedness, there will be less social legislation. The voluntary way is wide open to industry." Similarly postwar confidence revived the rhetoric of New Capitalism: what *Fortune* repeatedly called the "transformation of American capitalism" again promised an era in which business leaders would look past the demands of short-term profit to larger social and economic goals. Finally, the sense that business and industry was the primary moving force of modern civilization—the "largest planet in our solar system"—again dominated, whether in an essay on the Middle Ages explaining that while "the warriors and nobles took the limelight . . . the businessmen who extended trade and increased wealth and knowledge were the unsung heroes of the age," or in Luce's "The American Century" redux in the twentieth anniversary issue, which claimed that American business was "the chief instrument of *constructive* activity" in the world. The early *Fortune* had supported voluntary business regulation and an elite business-professional coalition, hoping to establish a business civilization characterized by widespread abundance. After 1948 *Fortune* echoed those desires, but based its claims for business leadership

more squarely on professional expertise in production, human relations, economics, and engineering rather than on aristocratic obligations and artistic depth.[20]

Abandoning Generalism

The professionalization of both the business and literary fields by corporate liberals and adversary intellectuals produced a more highly specialized society. At the same time, however, generalism had been, and continued to be, a compelling ideal to both adversary literary critics and to *Fortune*. On the one hand, *Partisan Review,* in its early days, had nurtured hopes for a revolutionary art and for the "genuine human culture" of socialism, and even in the postwar era the New Critics and New York Intellectuals lamented the lack of cultural unity and the loss of vitality within the university. As Macdonald consistently argued in the postwar years, the generalist curiosity of the cultivated "amateur" offered an escape from corruption of commercialism and mass culture, and the overspecialization of the positivist academic. *Fortune,* on the other hand, before the end of the war, had sought to dissolve the intimidating cultural distinctions surrounding high art, and the magazine's "culture of democracy" had celebrated the appearance of a wide range of citizens in the cultural field. In the postwar years *Fortune* continued to support the benefits of cultural education, praising Goethe, for example, as the embodiment of generalist interests and humanist "wholeness," and arguing that "higher education can be construed as an effort to overcome the ill effects of training in our highly specialized society."[21]

Driven by different motivations, both adversary critics and corporate liberals imagined overspecialization as a threat to the quality of American life. In the years after the war, however, the commitment on the part of both *Partisan* writers and *Fortune* to the ideal of the "whole man" gradually faded even as both continued to lament the effects of an excessive division of labor and knowledge. Seeking to establish their own authority and to protect their freedoms from "totalitarian liberals," both groups supported a professional pluralism in which expert leadership, rather than democratic discussion, eased the minor conflicts of interest endemic to a diverse society. As they shored up their authority in their fields, they necessarily betrayed their generalist positions. In the late forties and fifties, corporate liberals and adversary critics increasingly withdrew from conversations outside their professional fields.

The New York Intellectuals, imagining themselves as professional cultural critics, became increasingly apolitical. This process began in the early forties, as *Partisan* writers increasingly stressed their separation from mainstream society rather than their political opposition to it. After 1940, as the historian Harvey Teres notes, the New York Intellectuals formed exceedingly few political ties, opting instead to cultivate the autonomy they thought essential to intellectual production. Part of this movement away from politics was rooted in a growing sense of hopelessness in the face of a momentous and inscrutable American society. While Macdonald, for example, had insisted, in his 1944 version of "A Theory of Popular Culture," that socialism could produce a "genuine human culture," in his later revisions he abandoned his hope for such a unified culture and insisted that the only way to preserve genuine culture was to assiduously guard the border between the avant-garde and mass culture. Complaining in 1952 that "modern society is just not understandable," Macdonald admitted that he felt "helpless and confused" in the face of political realities. The result of these feelings of intellectual distance and political impotency was that politics and economics received less and less attention from American thinkers. "The intellectuals' focus of attention," Jackson Lears notes of the postwar era, "shifted from Wall Street to Madison Avenue, from the financial power behind advanced capitalism to the cultural values associated with its products." No longer wide-ranging, politically active generalist intellectuals, *Partisan* writers and other American thinkers increasingly abandoned the role of what David Shumway calls the "humanist intellectual" in favor of the more limited ideal of the "literary professional."[22]

But just as the rise of professional power among adversary critics accompanied a withdrawal from the political sphere, *Fortune*'s reassertion of business authority paralleled the magazine's retreat from the cultural field. While *Fortune* did not completely discontinue its publication of art and literary writing (the well-known photographer Walker Evans, for example, joined the staff in the late forties), culture became much less important to its understanding of a successful business manager in the postwar era. The depth and long-term vision of postwar business managers, the magazine now declared, came from their professional training and their commitment to material progress, not from their artistic development. This stress on professionalization as the justification for managerial and business authority made it less necessary to justify public faith in business through reference to art and culture, as well as more difficult for the magazine to protest the specialization of the artistic field. The result was a reduced concern with

art. Lamenting in 1948 that "the American intellectual is hopelessly out of touch with the spirit of great events," the magazine became increasingly less devoted to closing the gap between the artistic and business spheres. The editors, fearing with Davenport that the economic focus of the magazine had been "distracted . . . by glamour (and the art department)," devoted less attention to art and culture. "There is a change in *Fortune*'s focus and line," "Fortune's Wheel" announced in October 1948:

> *Fortune* ceases to be merely a magazine about American business, and becomes as well a magazine in behalf of American business enterprise. At the same time, in adding this new function, we reduce somewhat the area of our concern. Originally *Fortune* set out to cover "industrial civilization," and anything relevant to it, which took in a lot of ground. Henceforth we are more strictly a review of business and of the political economy in which its fate is cast. That assignment is big enough.

Fortune, enjoying increased business authority in political and economic fields, dropped its earlier focus on the relationship between business and art.[23]

By the end of the 1940s the parallel professionalization of both the cultural and business fields had resulted in a reestablishment of the gap between the two spheres, the very gap that *Fortune* had worked for two decades to close. The story of the ill-fated *American Review*, a magazine that aimed to bridge the disparity between *Partisan Review*'s cultural criticism and *Fortune*'s economic and social concerns, illustrates this point. Beginning in 1945 a group of editors at Time Inc., perhaps inspired by the series of philosophical and religious essays in *Fortune*, explored the possibility of publishing a journal of cultural criticism. But the editors were divided regarding the focus of the *American Review*. Willi Schlamm, Luce's assistant and the originator of the idea, argued that it should be strictly intellectual. Modeled on "little magazines" such as *Partisan Review*, his periodical would combine the financial clout of Time Inc. with contributions from such notable intellectuals as Reinhold Niebuhr, W. H. Auden, Erich Fromm, and Wallace Stegner. Davenport, however, disagreed. Echoing the 1929 *Fortune* prospectus, he argued that the journal should combine the work of literary contributors with nonliterary topics. The *American Review*, Davenport insisted, would merely be another marginal "little magazine" if it ignored "the world of production."[24]

This editorial stalemate delayed production for more than two years. By 1948 no magazine had emerged, and Davenport was clearly frustrated. Re-

porting that the "literati," whom the editors had imagined as the magazine's primary writers, refused to write articles on General Motors or U.S. labor policy, Davenport groused:

> If we are to broaden our field beyond the literary magazine that Willi first had in mind . . . we shall have to adjust our standards downward for the [main] pieces. At this point, this concept of *The American Review* clashes irreconcilably with Willi's concept. Indeed, the two are so irreconcilable in this and other respects that I have reluctantly come to the conclusion that there is no practical compromise between them.

Projecting his own experience with the journal onto the American intellectual scene, Davenport complained of a great divide within American society. "The intellectuals have written off that which is most distinctive about America, and the result is that this civilization has become a kind of headless monster, a being of enormous power, whose brains are occupied elsewhere, with faddist art movements, neurotic psychological theories—or, as I think Willi's MSS indicate, the culture of Europe." Davenport's hope of combining literary writing with economic, social, and political subjects in a demonstration of the vitality of American industrial civilization—the *Fortune* ideal since 1930—no longer seemed possible.[25]

Davenport was not alone in seeing the divide between intellectuals and "the world of production" as irreparable. Dwight Macdonald, who disagreed violently with Davenport about the value of avant-garde concerns, nevertheless expressed a remarkably similar opinion about the viability of the *American Review*. In a 1945 "Memo to Mr. Luce," Macdonald facetiously complimented Schlamm's proposal for its affirmative tone and middlebrow sensibilities: "Schlamm proposes . . . to gently guide [the intellectuals], aided by three-figure pay checks, away from the rocks of despair and the shoals of disillusionment into the safe harbor of constructive Respect for Fundamentals." But, in the end, Macdonald echoed Davenport's sense that an ideological gorge separated the magazine from its contributors. Noting that many of the prospective writers were associated with *Partisan Review*, Macdonald argued that these intellectuals actively opposed Time Inc.'s "Philistine 'constructiveness,'" and would refuse to work for the magazine. "The dilemma," he concluded, "seems fatal: [constructive] sentiments . . . are calculated to alienate precisely those who are appealed to as contributors; while sentiments of a different order would alienate you, sir, and your Executive Committee. . . . The intelligentsia are demoralized, confused, even a bit frightened, but I doubt that they are yet ready for Schlammism."

Macdonald agreed with Davenport that intellectuals and businesspeople had little to say to one another.[26]

By the late forties the professionalization of both the business and cultural fields had made intercourse between the two spheres seem impossible. But while the exchange between Davenport and Macdonald might seem to signal an increased antagonism between adversary professionals and corporate liberals, it actually represented the beginnings of what James Allen termed the "uneasy alliance" between cultural professionals and businessmen in the fifties. At the same time that each side continued to express resentment toward the other, they both acknowledged the professional authority of the other and, more generally, supported the postwar social order.[27]

Central to this unstable peace was the new embrace of the American society by adversary intellectuals. Nowhere was this changed attitude more evident than in *Partisan Review*'s 1952 symposium, "Our Country and Our Culture." American capitalist democracy, the introduction to the symposium argued, was overwhelmingly preferable to Communist totalitarianism. The world was a "tragic" and "imperfect" place, and given the range of repressions and strife that people around the globe suffered at the hands of their governments and leaders, the relatively minor failings of the United States seemed a blessing. But the contributors to the symposium did not just accept the economic and political principles of the American system. Projecting their satisfaction with their own professional success onto the nation's larger artistic and intellectual community, the editors even insisted that American society had proven itself capable of supporting a vital culture. "Until little more than a decade ago," they wrote, "America was commonly thought to be hostile to art and culture. Since then, however, the tide has begun to turn, and many writers and intellectuals now feel closer to their country and its culture." Convinced by their experiences with totalitarianism that corporate capitalism was more desirable than despicable, many leading American intellectuals ceased their attacks on business. Writing in *Fortune* in 1952, for example, John Jessup compared the anticapitalist criticisms of adversary professionals to a rusted gun:

> The gun that I speak of is a certain influential portion of public opinion that has been hostile or skeptical toward business management and the free enterprise system for the last twenty years. This gun was forged in the Gilded Age, rifled during several decades of minority discontent, and then loaded in the great depression, of which it is now a rusting memo-

rial. The crew of this gun was made up of various intellectuals, church groups, professors, and bureaucrats. I need not remind you how harassing their fire used to be. It is more instructive to note that it has virtually ceased.

No longer imagining the American political and economic systems as the primary source of its problems, adversary intellectuals ceased in the postwar years to direct their fire against business forces.[28]

But the acceptance by adversary artists of the "imperfect" United States did not mean that they hoped to merge into the mainstream. On the contrary, they hoped to keep alive a tradition of "nonconformism" that would separate them from a democratic populace they still imagined as a "mass." The tension between acceptance and distance manifested itself in the introduction to "Our Country": the first half of the essay celebrated intellectuals' embrace of the United States, while the second half complained that these intellectuals were on the brink of disappearance because of the rise of mass culture. Dissenting younger voices in the symposium, like Norman Mailer and C. Wright Mills, castigated the *Partisan Review* for its "exhaustion" and "shrinking deference to the status quo." The United States, they claimed, could not be a healthy country for artists if mass culture threatened the elimination of independent art. But to Phillips, Rahv, Trilling, and most other contributors, there was no contradiction between acceptance and dissent. Terry Cooney argues that "alienation" was a key concept for the New York Intellectuals in the postwar era, because it expressed both distance from society and an intimate connection to that society. "The alienated could live neither with existing culture nor without it." This pose allowed them to have it "both ways: they could continue to think of themselves as outsiders and radicals even as they began to experience intellectual, political, and economic integration into American society."[29]

The key that allowed the adversary intellectual to be both critical and integrated was the free (professional) space of the specialized intellectual class. Because of this space, the adversary artist could retain a distance from the mainstream but still appreciate the benefits of a free society. Insisting, as Trilling did in "Our Country," that a "new intellectual class" had coalesced in the postwar years, adversary intellectuals could celebrate a sphere of artistic autonomy and freedom within the larger mass society. When Ezra Pound received the Bollingen Prize for poetry in 1948, despite his support for Italy during the war, for example, Macdonald celebrated the freedom of the artistic community to praise genuine art, even when that art was offen-

sive to the larger population and even to the government. "We have a committee composed of eminent American writers and appointed by a high Government official, giving an important literary prize to a man under arrest for treason. I think there are not many countries today, and certainly none east of the Elbe, where this could happen." Even as "totalitarian" liberals complained that the prize implied that the United States was soft on fascism and mass culture voices dismissed Pound's esoteric poetry, the American intellectual class had the artistic freedom and professional authority to defend Pound and the Bollingen judges. The adversary artist in the postwar era retained a distance from the mainstream culture but embraced the political structure of the United States as an "imperfect" but noble system.[30]

Trading generalist ideals and democratic commitments for professional authority, corporate liberals and adversary intellectuals welcomed in the postwar years a newly professionalized society. But the emergence of this "uneasy alliance" within the professional managerial class produced a narrowing of the artistic field. In the thirties and early forties the variety of artistic production in the United States had exploded, spurred largely by the entrance into the cultural field of politically interested nonspecialists, ranging from proletarian novelists to documentary journalists, from industrial photographers to WPA dramatists, and *Fortune* had announced an American "culture of democracy" in which the line between artists and other citizens disappeared. But, as the forties closed, the cultural possibilities of the thirties had died away, and the magazine had largely abandoned its hopes for a unified culture. Art and business no longer seemed to be unified. Instead, they were complementary parts of a divided, professionalized "consensus" society.

Organized Capitalism and Its Discontents

Not surprisingly *Fortune*'s enthusiasm for the postwar American order exceeded even that of the adversary intellectuals. The stability and rapid growth of the U.S. economy, combined with a dominant feeling of national consensus, more than fulfilled the magazine's wartime hopes for a renewed sense of purpose expressed in terms of material progress. But just as *Partisan* writers' approval of American institutions was mixed with fears of a mass society, so, too, was *Fortune*'s celebration of the American economy darkened by doubts about the effects of bureaucratic organization and overprofessionalization. Recognizing with adversary intellectuals that the nation's demo-

cratic capitalism was "imperfect," corporate liberals were nagged, like their adversary counterparts, by the suspicion that those imperfections might undermine and nullify the gains of the postwar era.

The political and economic triumph of organized capitalism had been a long time coming. Roosevelt's landslide victory in 1936 had initiated more than fifteen years of electoral frustration for corporate liberals. Even as their institutional power grew, corporate liberals consistently fell short of the public approval after which they strove. Roosevelt's defeat of Wendell Willkie in 1940 demonstrates, for instance, both the growth and the limitations of the corporate liberal bloc in the early forties. First of all, the very fact that Willkie was nominated illustrated corporate liberals' increasing strength within the partisan political sphere. Willkie's candidacy, one historian noted, was "launched in the editorial offices of *Fortune* magazine," and staff writer Robert Coughlan recalled that "[Russell] Davenport got him the Republican nomination." Willkie's internationalism, skill at public relations, professional background, "enlightened" business policy, and belief in a capitalist, pluralist consensus all made him the ideal corporate liberal choice. However, the power of corporate liberals within the Republican Party far outweighed their public influence. During the campaign the magazine stumped energetically for its candidate. It printed numerous articles in praise of Willkie, including the utility executive's statement of his political platform, "We, the People." But the public was not quite ready for a corporate liberal leader. As *Fortune* suspected, Willkie's private utility background, political platform, and relative anonymity frustrated his presidential ambitions.[31]

Through the forties, however, the power of corporate liberals grew, even as their election disappointments continued. In 1944 Willkie threw his hat in the ring again, but this time conservative Republicans were able to undermine his nomination. In 1948 *Fortune* was so confident of a victory by its candidate, Thomas Dewey, that it began to speculate about the policies of the coming Republican administration even before the election, but, like much of the nation, it was to be stunned by the victory of the incumbent Harry Truman. Still corporate liberals continued to struggle for public support. *Fortune*, in 1938, had urged business to accept a "new concept of public relations" through which the American economic system itself would be sold to the public, and, after the war, corporate liberals continued in this effort. "Only good Public Relations—i.e. good performance that's understood and appreciated—will ensure [the] future [of business]," the magazine asserted in 1949. The corporate liberal Advertising Council, which had its

roots in the propagandistic War Advertising Council, took this mission seriously, and aimed to "reteach a belief in a dynamic economy." As one Council president remarked, "While the Council for Economic Development is concerned with the *manufacture* of information in the public interest, the Advertising Council is concerned with the mass *distribution* of such information." Corporate liberals, through *Fortune*, the Advertising Council, and other outlets, sought to sell the American public on their business ideals.[32]

But only with the election of Dwight D. Eisenhower in 1952 did corporate liberals establish their ideas as the dominant American worldview. The growth and stability of the U.S. economy after the war, combined with the deliberate attempt to sell corporate liberal ideals to the public, resulted in unprecedented public support for American business, and in 1952, for the first time in two decades, the United States had a "business administration" in the White House. More important for corporate liberals, Eisenhower represented the liberal elements of the Republican Party. As James Jensen notes in his study of the magazine, Eisenhower's administration "espoused many points of view which had previously appeared in the pages of *Fortune*." Eisenhower not only displayed a strong trust in the leadership abilities of business by filling his cabinet with businessmen, but he imagined government as a vehicle through which the pluralist interests of the nation could realize their common ground. Rejecting the concept of a necessary conflict between labor, government, and business, Eisenhower embraced the capitalist consensus ideal embedded in the infamous assertion of his defense secretary, corporate liberal Charles E. Wilson, that "what was good for our country was good for General Motors, and vice versa." The election of Eisenhower indicated that corporate liberals, no longer a powerful minority within the business community, constituted the influential majority of "the forces of the American Century."[33]

Crucial to this election victory, of course, was the establishment of corporate liberalism as the dominant ideology of the postwar years. Perhaps most important, corporate liberals preached what Robert Griffith called the "consensual character of modern American capitalism, the stake which everyone was presumed to hold in the economic order." The Committee for Economic Development, a key corporate liberal institution, claimed, for instance, to act in a " 'general interest' which could be ascertained through the application of expert knowledge to the problems of modern life." This belief in a professionally led, capitalist-driven consensus in the United States came to be one of the hallmarks of postwar ideology. Even

New Deal liberals in the postwar era dropped the critique of capitalism that had been so central to earlier American liberalism and, instead, committed themselves to a government that, as Alan Brinkley noted, would "compensate for capitalism's inevitable flaws." Social liberals either dropped out of politics, as Wallace did, or drifted toward the Cold War liberalism of the "vital center." The American public in the postwar era did not unanimously agree with the direction of the country—McCarthyism and the Civil Rights movement, among other things, demonstrate that—but members of the professional managerial class, including most contemporary social critics, politicians, historians, and business managers, largely imagined that America was united in striving for material "progress" and individual freedoms. The "businessman's intellectual reconquest of America" after World War II, as one labor journalist called it, created a near consensus belief in the desirability of material abundance as the primary national goal, in the promise of technological advance, in professional business authority, and in an ideological commitment to individualism.[34]

Bolstered by the economic growth of the postwar era and this sense of a capitalist consensus, *Fortune* celebrated the further possibilities of organized capitalism. Although *Fortune* never returned to the rhetoric of market cooperation, the combination of a faith in professional leadership and the assumption of a consensus belief in material progress produced a renewed belief in the planning and corporatization of organized capitalism. The "transformation of American capitalism," as the magazine never tired of preaching in the fifties, had created the controlled, profitable, and equitable market that corporate liberals had been awaiting for nearly half a century. Organizational control seemed to offer even further advancement. Some of the magazine's enthusiasm was directed toward the continued organization of the market as a whole, particularly in terms of Keynesian fiscal policies and industrial relations. "A great number of businessmen have changed their thinking about fiscal policy and wage policy," the magazine noted in 1949. "A liberalizing process has been at work that increases the chances of fending off depression in the future; or of preventing recessions from turning into depressions." Another essay asserted approvingly, "More and more executives are publicly stating that unions are 'here to stay,' and that management should learn to work with them." Government control of monetary policies and an amicable relationship between corporations and labor unions seemed to offer ways to organize the marketplace without shutting down competition.[35]

Perhaps even more essential to the success of organized capitalism than individual policy changes, however, had been what James Burnham, in 1940, had called the "managerial revolution." Even the two essays cited above, "The Education of the Businessman" and "The Management of Men," stressed the changed attitudes of managers as the key to the overall change. "THE TYCOON IS DEAD," announced one advertisement for *Fortune* in inch-high letters in 1951:

> Today's businessman brings a new professional responsibility to his day-to-day problems. And because he measures himself more in what he does than what he owns, industry, itself, has achieved a greater stature in the life and progress of the country.

The real promise of organized capitalism, *Fortune* believed, lay in the continued training of managers and the reorganization of corporations. Management training and a scientific approach to corporate organization promised both increased stability and a more efficient use of resources. In the past, for example, the task of training executives had been "an undertaking best left to the individual." *Fortune* insisted, however, that "the signs have been getting clear that these orthodox methods of management succession could not furnish industry with either the quantity or quality of executives it needed." The production of management would have to be rationalized in the same manner that the production and distribution of goods had been organized in the previous fifty years. Schools and businesses needed to formulate long-term plans for the professional training of capable managers. The modern manager, combining training, social responsibility, a knack for cooperation, and an understanding of human behavior, stood at the center of organized capitalism.[36]

Key to the success of these managers was their replacement of instinctual market decisions with scientifically determined strategies. A range of applied sciences, from Planning and Control, to Operations Research, to Organization Planning, received the editors' approval. These new disciplines offered to replace the haphazardly built hierarchies of the past with rationally constructed bureaucracies and, in the process, to eliminate the inefficiencies and instabilities of the earlier systems. The magazine even showed enthusiasm for the possibilities that could be gained by conducting psychological testing on supervisors and top executives, proclaiming that such testing "could do more for business efficiency than all the psychological testing of employees that has been done in the last thirty years." In order

to sustain the increasingly complex world of organized capitalism, *Fortune* argued, the rationality, planning, and social responsibility associated with the managerial revolution would have to be expanded to the production of professional managers and efficient organizations. Through the leadership of this corps of trained managers, business could stabilize a growing economy and express the consensus desires of the whole American population.[37]

This vision of a self-reproducing, increasingly bureaucratized economy, however, did not appeal to all corporate liberals. Accompanying the enthusiasm were growing doubts about the desirability of organized capitalism. As early as the mid-thirties, corporate liberals, separating themselves from the more corporatist ideals of the early thirties, had felt it necessary to reestablish their support for competition and free markets. The tension between organization and competition, as I have argued, was a central ambiguity within corporate liberal thought. In the fifties, however, the relationship between these ideals, which had previously been vague and shifting, became a central point of contention and disagreement within *Fortune*.

Initially the magazine directed the bulk of its antiplanning animus toward the government. Russell Davenport opened "The Greatest Opportunity on Earth," an important statement of corporate liberal ideals in the postwar era, with a statement of the fearful possibilities of the socialized state. "The conclusion can hardly be escaped," he noted, "that the 'welfare state' is of necessity a prelude to a *total* state." The bureaucratic organization of government, such arguments concluded, had no way of controlling its own growth and, furthermore, had no incentive to do so. In the end, the growth of the state would result not only in a business environment that discouraged innovation but also in a social environment that suppressed individuality. *Fortune* worried in 1949:

> Throughout the world the energies of free men are being thwarted by the insidious growth of bureaucracy. This growth stems from the fallacy, promulgated by almost 11 modern reformers, that men in government are somehow better able to cope with problems of modern life than men outside government. The result . . . is that human liberty becomes bound by bureaucrats, as Gulliver was bound by the Lilliputians.

The governmental support and planning in government proposed by "authoritarian" liberals, *Fortune* told its readers, threatened the liberty at the heart of the American mission.[38]

But the specter of bureaucracy haunted more than just the statehouse, and, as corporate liberals gained influence, many of them began to recog-

nize zombies and other bureaucratic undead within their own corporate hierarchies. The most common fear about young managers was that their specialized training had taken the life out of them. An editorial in 1953, for instance, chastised businesses for failing to recruit managers from the liberal arts. College students, it argued, had learned from the upperclassmen that an English major had poor employment prospects, and so an increasing number of them were choosing to focus on accounting or engineering from the start. This was business's loss: "The most difficult problems American enterprise faces today," one executive claimed, "are neither scientific nor technical, but lie chiefly in the realm of what is embraced in the liberal arts." While specialists were important to an economy increasingly driven by science, the magazine often argued, broad-minded managers were needed to tell the specialists what needed to be done. But even a larger emphasis on liberal arts, some articles fretted, could not save young managers from their bureaucratic fate. "On the whole," Peter Drucker complained in an essay on business graduate schools, "it looks very much as if the 'integrated' business education tends to make a man unfit to be an entrepreneur by paralyzing his intellectual muscles, just as the training in mere technical skills of the business school of yesterday tended to unfit a man by destroying his vision." A focus on the human skills and long-term thinking of the manager—on "'administration,' 'organization,' 'policy,' 'analysis,' etc."—seemed to produce employees who depended on "the accepted, the safe, the bureaucratic way." Similarly a later essay on extended manager training programs worried that, despite its overall support of such institutions, trainees tended to take the lessons about fitting in too seriously. "Well-roundedness, certainly, can be a very respectable ideal. As trainees translate it, however, well-rounded means just that, rounded. No sharp edges obtrude." The replacement of "brilliance" with "character" as the key trait of a high-level manager threatened to dim the future of American entrepreneurship.[39]

Beyond these concerns about the quality of corporate managers, however, voices appeared in the fifties suggesting that the "transformation of American capitalism" had created worrisome social problems. In particular, the imminent widespread critiques of middle-class life as stiflingly conformist appeared in *Fortune*, suggesting a growing dissatisfaction with the professionalization and bureaucratization of organized capitalism. In 1951 "Individualism Comes of Age" optimistically dismissed a contradiction between the "American individual . . . and the corporation into which his life is geared" by arguing that the teamwork required of modern capitalism "has the power to challenge the individual to seek his self-expression, not along

purely egoistic channels, but in dynamic relationship to others, that is to say, mutually." This optimism, however, was difficult to sustain. In 1953 Clark Kerr contributed "What Became of the Independent Spirit?" in which he argued that the union and the corporation both contain "a pattern of life [that] goes along with the job" and that these lifestyles depended chiefly on stability, loyalty, and conformity. He compared the "all-embracing party of the Communists and Fascists," not with the welfare state but with the "all-absorbing corporation of Elton Mayo." And while an editorial note asserted that *Fortune* was "not in entire agreement with the author," Kerr's fears certainly offered a contrast to the corporate liberals' more normal enthusiasm—a positive piece about "Organization Planning" preceded Kerr's essay—for the highly organized corporation.[40]

But while Kerr wondered whether a loss of individualism would injure entrepreneurialism, he worried more about the effects of organized capitalism on individual personalities. This concern caused the most consternation at *Fortune*. In 1952, for example, a decade before Betty Friedan complained of the "Problem with No Name," Ethel Ward McLemore outed the "Great Loneliness" in her scathing "Manifesto from a Corporation Wife." Managers' wives, McLemore argued, had acquiesced to a culture of "group integration" that demanded they treat strangers as friends and open their private lives to the business needs of their husbands. She asked:

> What have we to show for our stupidity? Broken homes, suicides, physical and moral breakdowns. There is no greater indictment of the present-day corporation "system" than the confusion, nervousness, and unhappiness among experienced executives and their families.

The chief failing of corporations, McLemore insisted, was that the shallow and all-inclusive social interactions necessary for business advancement cost the individual manager a meaningful family and social life. McLemore was not alone in blaming the "corporation system" for the personal woes of managers and their families. The most consistent and well-known voice in this chorus was staff member William Whyte, whose contributions in the early fifties led him to publish the influential *Organization Man* in 1956. Whyte's first major targets were social engineers and "Groupthink." Calling organizational sociology *"rationalized* conformity," Whyte lambasted professional managers and academics who believed they could "benevolently manipulate us into group harmony." Like Kerr, he warned his readers of the dangers of "the cult of factory sociology."[41]

Whyte's more developed and original thesis, however, originated in 1953 in a series of essays entitled "The Transients." The series, which began as a report on suburban communities, argued that the suburbs were merely an outgrowth of a larger demographic and social change. Corporations, scrambling to train and develop middle and upper managers, had created a class of migratory workers. The suburbs, not a "synthetic way of life 'sold' by mass producers," were, instead, an expression of the needs and desires of this generation. But the effects of this new way of life were profound. Their transience forced managers and their families to develop group social skills in order to establish quick, shallow roots, and also encouraged them to identify themselves with their corporation. Accepting their lack of control over their own destiny, they valued their adaptability and eschewed idealism for a more pragmatic approach. Finally, they redefined conflict and solitary activity, both for themselves and for their children, as abnormal and undesirable. Whyte, charged by his editors to determine what these changes meant for the future of business, concluded that the suburbs threatened to turn Americans' traditional virtues—their pragmatism and equality—into defects. "Given the fact of organization society, what is in order is not the impossible cliché of rugged individualism," he concludes in one piece. "But it is very much in order that we recognize that we are moving toward the other extreme."[42]

The particular social institutions of organized capitalism, suggested Kerr, McLemore, Whyte, and other dissenting *Fortune* writers, were creating a new type of American, one who would not only injure the future of entrepreneurial capitalism but whose imbalanced personality created personal and social dissatisfaction.

Organized Capitalism and Professional Managerial Identity

Clearly complaints in the 1950s about bureaucratic conformity were not confined to *Fortune*. Nonetheless, their appearance in the primary vehicle of corporate liberal thought suggests that these criticisms grew from internal as much as external dissatisfaction with organized capitalism. Thomas Frank argues in *The Conquest of Cool* that cutting-edge advertising firms resoundingly rejected bureaucratic organization and "square" corporate culture in the late fifties. Their embrace of the anti-institutionalism and iconoclasm associated with the political and cultural Left in the sixties, then, was not a matter of some sinister co-optation of youth culture. Rather, their "in-

fatuation with youthful cultural insurgency came almost as naturally for them as it did for Charles Reich and Theodor Roscak." The conflicts within *Fortune* in the fifties about the relationship between individualism and corporatism tell a similar story and, in doing so, suggest that the counterculture of the sixties should be seen not as a deep division within American society between the "hips" and the "squares," or the young and the old, but as an outgrowth of the discomfort of the newly powerful professional class with its own world. The very professionalization, training, and specialization that had been a key to corporate liberal authority began to look at times like a threat to American individualism and market vitality. The intellectual exchanges corporate liberals had made in the late forties—the affirmative leader for the professional authority, a chaotic democratic public sphere for an organized bureaucratic hierarchy, consensus pluralism for professional pluralism—helped them to establish their authority in the late forties. Those same trade-offs, however, left them troubled about the future of an American society obsessed with professional opinion, social adaptability, and group organization.[43]

Out of this combination of professionals' new authority and their anxiety about over-professionalization grew a new dominant model of professional managerial identity. This book has traced a struggle for control over that identity between corporate and adversary professionals. As I have argued, the professionalization of the public sphere after the Second World War initiated a cease-fire in this battle. More than this, however, the postwar era brought a new way of conceiving of professional identity. The United States, both groups acknowledged, had its problems, but nonetheless was better than the alternatives. Both celebrated the abundance, and political and social freedom, of mature American democratic capitalism, but both also distanced themselves as individuals from the bureaucratic culture and groupthink characteristic of organized capitalism. The new model of professional identity, then, unlike the models of the thirties and forties, was not focused on the individual's relationship to corporate society—professionals did not primarily distinguish themselves as being either "corporate" or "adversary." Instead, professionals' self-identity depended increasingly on the expression of individuality outside the workplace. Wary of becoming just another middle-manager or being trapped in the bureaucratic cage or falling prey to a mass society, professionals in all fields sought ways to ward off the threat of conformity, whether through high art, politics, style, or a particular pattern of consumption. A conscious effort at "self-actualization,"

as Michele Lamont names it in her comparative study of the French and American upper middle classes in the eighties, joined education and vocational expertise as a key marker of American professional class identity.[44]

Not surprisingly this changing ideal manifested itself in the changing cultural meaning of art. *Fortune*, and certainly Henry Luce, did not give up on the idea that liberal humanism could combat specialization and single-mindedness. In the late forties and fifties the magazine applauded efforts, like Corning Glass's conference, "Living in Industrial Civilization," that aimed to bring academics and business managers into conversation, and Alfred Heidenreich argued in *Fortune* that a liberal education could provide a "concept of wholeness, without which . . . the American businessman cannot achieve what he himself would consider the good life." Luce himself continued to support Walter Paepcke's Aspen Festival, which aimed to bring the ideas of the Great Books movement to a public audience, and to campaign for the ideals of liberal arts throughout the fifties. But in the postwar years support for these types of programs was fading. James Allen argues that as Luce's generation gradually withdrew from public culture, the Great Books movement, as well as its understanding of the value of art, lost support. The consolidation of professional status in the postwar years, John Guillory adds, made it less important for professionals to distinguish themselves through such cultural self-improvement. For younger professionals, the connection between a full life and a broad education in art, literature, and philosophy became increasingly slim.[45]

In the fifties art adopted an alternate, but still powerful, symbolic meaning. The triumph of American abstract art, Serge Guilbaut demonstrates, arose from its use as a symbol of the freedom and individualism of the American system. It represented "the freedom to create controversial works of art, the freedom symbolized by action painting, by the unbridled expressionism of artists completely without fetters." In a similar manner, the U.S. State Department supported exhibitions of contemporary American art and toured American jazz groups throughout Europe and Africa, hoping to demonstrate the fecundity and freedom of American democracy. Like Ezra Pound's poetry, these esoteric and difficult forms of art may have confused and even offended many Americans, and yet, as with Pound's Bollingen Prize, their postwar prestige throughout the world served as a powerful representation of the nation's ideological freedom and cultural depth. Once professional critics had proclaimed Pound and Jackson Pollack and Miles Davis as great artists, it mattered little whether nonspecialized audiences

could appreciate or understand them. The cultural meaning of their works grew not from the particular content of each piece, but rather from their mere existence as expressions of American genius.[46]

This change altered the way that business approached art. Instead of investing in art as a way to educate consumer tastes or to gather the aura of Culture around their corporations, business managers used art to individualize themselves or their firms. Advertisers, unable consistently to find a use for contemporary abstract art, decreased their interest in high art. Many corporations, however, opted instead to support artists by building private collections. The fifties and sixties saw an explosion in the number and size of corporate collections, whose contents, Michele Bogart notes, "often reflected the personal tastes and visions" of chief managers. Moving away from the tendency to imagine art as a social tool or as humanistic self-improvement, business managers collected art, as one *Fortune* essay noted, "for purely personal satisfaction or as an escape from the pressures of business . . . or to encourage the artist . . . or [because] he just likes modern art." Such collectors might have to deal with "scoffing friends and neighbors," but even in weathering that storm they were demonstrating their healthy distance from conformist tastes.[47]

This self-definition through art lay at the heart of the new ideal of professional identity. Because difficult art could be used to define one's individuality, as Guilbaut argues, it was "cozily installed at the center of the [American] system," despite the fact that it was inspired by and representative of alienation from that system. But while art and Culture had been central to professional identity before World War II, it was now only one of a number of different paths to self-actualization. As Barbara Ehrenreich demonstrates, fascination with *Playboy* and with the Beats in the mid- and late fifties grew from the increasing anxiety among professional men that "what the Beats thought about everyone else was, after all, not too far from what many men already suspected about themselves." Because both symbolized a rejection of bureaucracy and conformity, hanging up a *Playboy* centerfold offered the same assurance of individuality that reading Allen Ginsberg's *Howl* did (and it was a lot easier to do). A copy of *Playboy*, too, was not the only purchase that a middle manager could make to declare his freedom. The explosion of consumer spending in the fifties, in fact, fueled a growing tendency to seek personal identity in consumption, and as Jackson Lears argues, this tendency, far from characteristic of the entire society, manifested itself primarily among the professional managerial class.[48]

In addition to art and consumption, politics, too, served increasingly as a route to self-actualization. Van Gosse, for instance, locates the birth of the New Left in the fifties in a movement among young middle-class men attracted to Fidel Castro, who represented "spontaneous action for its own sake, what Norman Mailer defined as Hipsterism." These youths of the professional class, whose embrace of the Cuban cause was not so much "subversive or oppositional" but "simply nonconformist," would in a few years form the demographic base for the Students for a Democratic Society and other New Left organizations. Thomas Frank claims an even stronger (and more condemning) connection between "self-actualization" and the counterculture of the sixties. Maintaining that its growth was rooted in the same dissatisfaction with the "square" society that spurred revolutions in the advertising and fashion industries, Frank argues that "the counterculture may be more accurately understood as a stage in the development of the values of the American middle class, a colorful installment in the twentieth century drama of consumer subjectivity." The intimate connection between "the personal" and "the political," as Goss, Frank, and others have noted, was key to the emergence of the counterculture in the late fifties. An important point, however, is that "the personal" also became closely tied to art and consumption during the same period. All three provided routes through which professionals (and the children of professionals), no longer defining themselves primarily through their relation to corporate society, could achieve an individualized selfhood.[49]

This new model of professional identity did more than help professionals escape suspicions of their own "squareness." The gradual separation of self-identity from work and industry among the upper middle classes, Scott Lash and John Urry argue, was a central development of disorganized capitalism. The effect of this change, on the one hand, was to decrease the political importance of traditional understandings of class. Class itself was now more often described in terms of lowbrow and middlebrow tastes rather than of income or power. Even in detailing a theory of the "new class" in the early sixties, neoconservatives actually described only a section of the professional managerial class distinguished by middlebrow and highbrow cultural tastes and liberal political commitments. The new model of professional identity combined with the corporate liberal ideology of consensus to undermine the political importance of class identity. On the other hand, the separation between class and identity helped to create a different type of politics, by spurring the influential movements based on youth, eth-

nicity, and gender widely associated with the sixties. These movements clearly have produced significant political changes. At the same time, however, they have often been blind to issues of class, and favored strategies and solutions that appealed to their largely professional managerial–class leadership. The decline of the relationship to the corporate world as a dominant source of identity for professionals has remapped the American political landscape, as markers such as gender, ethnicity, and age have increasingly defined key borders.[50]

The changing self-identity of the professional managerial class has played a key role in the development of the United States' public culture in the twentieth century. Its public voice, in fact, has often been powerful enough to be easily mistaken for the voice of the nation. As Jackson Lears noted of the fifties, "nearly all traits that were alleged to characterize American culture as a whole were projections of hegemonic values" of the "professional/managerial groups." In foregrounding the conflicts and anxieties of this class, this book has demonstrated how debates about professional responsibilities and social roles structured the ideological development of corporate liberalism. *Fortune*, indeed, might be fruitfully read as a long conversation between Luce, MacLeish, Davenport, Agee, Macdonald, and a host of professional-class thinkers and corporate managers about how to merge their inheritance of professional ideals with the realities and opportunities of corporate capitalism.[51]

Thus, even as many historians dismiss business ideology as self-serving and facile, it is crucial to recognize that *Fortune*'s editors and contributors earnestly sought answers to difficult questions. Certainly corporate liberals often celebrated policies that favored their own power and prestige. When corporate liberals held the most public influence, for instance, as in the late twenties and early thirties, and then after 1948, *Fortune* posited an easy alliance between the public good and capitalism that was based on the moral behavior of individual managers. This, however, does not mean that *Fortune*'s writers were not sincere in their search for a "moral base" for business and a national purpose for the country. Indeed, Luce, Davenport, MacLeish, and others were engaged in the process of defining themselves and defending their identity against others within and outside the professional managerial class. In this sense, *Fortune*'s approach not only to art but also to corporate liberalism itself qualifies for Marshall Berman's definition of modernism: "an attempt by modern men and women to become subjects as well as objects of modernization." In describing and reimagining the relationships between business, managers, professionals, artists, and the gen-

eral public, the magazine's editors and writers engaged in a process of adapting their self-definition and their sense of their own social role to the radical social changes of the thirties and forties. Indeed, throughout the first half of the century, the development of corporate liberalism was intimately tied to attempts by professionals to understand their place in a rapidly changing world.

NOTES

INTRODUCTION

1. See "American Workingman," *Fortune* 2 (August 1931): 54; and Ernest Hemingway, "Bullfighting, Sport, and Industry," *Fortune* 1 (March 1930): 83.

2. Archibald MacLeish, "The First Nine Years," in Daniel Bell et al., *Writing For "Fortune"* (New York: Time Inc., 1980), 7; Dwight Macdonald, "*Fortune* Magazine," *The Nation* (May 8, 1937): 528. This narrative has its roots in the experience of the magazine's three most famous writers: Agee, Macdonald, and MacLeish. Macdonald, who quit in 1936 after his article on U.S. Steel was rejected by his editors, first articulated the "rise and fall of *Fortune*" story in a series of articles for the *Nation* in 1937, in which he reported on a divide between the conservative editors and radical writers at the magazine, and suggested that the political mood of the mid-thirties had forced the magazine temporarily into a more critical stance. MacLeish, who resigned in 1938 soon after a bitter battle with the foreign affairs department of *Time* over that magazine's friendly treatment of the fascist forces of the Spanish Civil War, similarly looked back to a golden day at the magazine, lamenting to Luce in 1938 that now "not more than a dozen or so people know each other's names" (Scott Donaldson, *Archibald MacLeish: An American Life* [Boston: Houghton Mifflin, 1992], 280). Finally, Agee dropped from the magazine in the late thirties as well, soon after the editors rejected his essay on southern sharecropping. That this essay eventually became *Let Us Now Praise Famous Men* has created the impression that the *Fortune* offices were a rather ruthless and uncultured place by 1937, despite the fact that the writing in *Famous Men* would clearly have been inappropriate copy for the magazine. The experience of these three writers has then been taken as symptomatic of larger changes at the magazine in the late thirties, both by these writers themselves and by later critics. I would argue both that the influence of these writers on the magazine's overall direction was smaller than has been assumed, and that their disgruntled feelings with *Fortune* had more to do with their own personal and political changes than with those of the magazine.

3. Circulation numbers are from Robert Elson, *Time Inc.: The Intimate History of a Publishing Enterprise, 1923–1942* (New York: Atheneum, 1968), 220.

4. On the characteristics of "organized capitalism," see Scott Lash and John Urry, *The End of Organized Capitalism* (Cambridge: Cambridge University Press, 1987). On the transformation in the early century from a competitive to a corporate model of capitalism, see Gabriel Kolko, *The Triumph of Conservatism: A Re-Interpretation of American History, 1900–1916* (New York: Free Press of Glencoe, 1963); and Martin Sklar, *The Corporate Reconstruction of American Capitalism, 1890–1916: The Market, the Law, and Politics* (Cambridge: Cambridge University Press, 1988), 1–40. "Corporate liberal," a term coined only in the sixties, is a slippery phrase. On the one hand, it designates a group of American businesspeople and professionals in the first half of the twentieth century. Although they never used the term to describe themselves, both *Fortune* and independent business managers did recognize themselves as a community, often referring to a "new breed of business managers," the "young men" of business, or "enlightened" business interests. On the other hand, "corporate liberal" has a pejorative sense as well: it is closely connected with a revisionist argument (made by Sklar and Kolko, among others) that big business successfully co-opted the reform initiatives of the early twentieth century in the interest of status quo social relations. While I adopt the term of these revisionist historians, I replace their portrayal

of an all-powerful, manipulating corporate hegemony with the more chaotic, pragmatic, and multisided "institutional matrix" of the so-called organizational thesis argued for by historians such as Ellis Hawley, Louis Galambos, and Olivier Zunz.

5. Perkins quote in James Weinstein, *The Corporate Ideal in the Liberal State: 1900–18* (Boston: Beacon, 1968), 10.

6. David Eakins, "Policy Planning for the Establishment," in *A New History of the Leviathan: Essays on the Rise of the American Corporate State,* ed. Murray Rothbard and Ronald Radosh (New York: Dutton, 1972), 189–91.

7. James Nuechterlein, "Bruce Barton and the Business Ethos of the 1920s," *South Atlantic Quarterly* 76 (Summer 1977): 307–8. On Owen Young's idea of a "cultural wage," see Zunz, *Why the American Century?* (Chicago: University of Chicago Press, 1998), 81–83. For more on the attempts of business to sustain wage levels early on in the Depression, see Murray Rothbard, "The Myth of the New Deal," in *New History,* ed. Murray Rothbard and Ronald Radosh, 128–30; Sanford Jacoby, *Employing Bureaucracy: Managers, Unions, and the Transformation of Work in American Industry* (New York: Columbia University Press, 1985), 216–17; and Robert McElvaine, *The Great Depression, 1929–1941* (New York: Times Books, 1984), 72–74.

8. Unnamed director quoted in David Brody, "Rise and Decline of Welfare Capitalism," in *Change and Continuity in Twentieth Century America: The 1920s,* ed. John Braeman, Robert Bremner, and David Brody (Columbus: Ohio State University Press, 1968), 147. On extent of welfare capitalism in twenties, see Brody and Stuart Brandes, *American Welfare Capitalism* (Chicago: University of Chicago, 1976), 28.

9. Luce quoted in Elson, *Time Inc.,* 129; "Preface to *Fortune,*" August 1929, in Time Inc. archives, 4, 8. On *Forbes's* reputation as a voice for "enlightened business," see Morrell Heald, *The Social Responsibility of Business: Company and Community 1900–1960* (Cleveland: Case Western University Press, 1970), 48.

10. "The Servant in the Home," *Fortune* 4 (December 1931): 116; Henry Luce, "Art in American Life," in *The Ideas of Henry Luce,* ed. John K. Jessup (New York: Atheneum, 1969), 272.

11. Newspaper quotes are from the *New York Times* and *Boston Transcript,* and appeared in a *Fortune* advertisement, "U.S. Newspaper Editors Look at *Fortune,*" *Fortune* 1 (March 1930): 137; Marshall Berman, *All That Is Solid Melts into Air: The Experience of Modernity* (New York: Penguin, 1982), 5.

12. Ross Gregory, ed., *Almanacs of American Life: Modern America, 1914 to 1945* (New York: Facts on File, 1995), 61, 101.

13. Herrymon Maurer, "The Age of the Manager," *Fortune* 51 (January 1955): 84; Michael Denning, *The Cultural Front* (London: Verso, 1997), xx. See Dwight Macdonald, "The (American) People's Century," *Partisan Review* (July–August 1942): 306–9.

14. John Chamberlain, "The Businessman in Fiction," *Fortune* 38 (November 1948): 138, 140, 135.

15. Pierre Bourdieu, "The Field of Cultural Production, or: The Economic World Reversed," in *The Field of Cultural Production* (New York: Columbia University Press, 1993), 29, 39.

16. Harold Stearns, "The Intellectual Life," in *Civilization in the United States: An Inquiry by Thirty Americans,* ed. Harold Stearns (New York: Harcourt, Brace, 1922), 139.

17. Chamberlain, "The Businessman in Fiction," 142.

18. Robert Wiebe, *The Search for Order, 1877–1920* (New York: Hill and Wang, 1967), 111;

Gregory, *Almanacs of American Life*, 85–86; Barbara and John Ehrenreich, "The Professional-Managerial Class," in *Between Labor and Capital*, ed. Pat Walker (Sussex: Harvester, 1979), 25–30; Ohmann, *Selling Culture*, 121–54.

19. See Bruce Kimball, *"True Professional Ideal" in America* (Cambridge, MA: Blackwell, 1992), 7–16; and William Sullivan, *Work and Integrity* (New York: HarperCollins, 1995), 30–36.

20. On "adversary culture," see Lionel Trilling's preface to his *Beyond Culture* (New York: Harcourt, Brace, and Jovanovich, 1978).

21. Chamberlain, "The Businessman in Fiction," 148; Editors of *Partisan Review*, "Our Country and Our Culture," *Partisan Review* (May–June 1952); Michele Lamont, *Money, Manners, and Morals: The Culture of the French and American Upper Middle Classes* (Chicago: University of Chicago Press, 1992), 99–100.

CHAPTER I. THE BUSINESS GENTLEMAN

1. "Purpose," *Fortune* 1 (February 1930): 38; "A Note on *Fortune*," *Fortune* 1 (February 1930): 180; advertisement for Young and Rubicam, *Fortune* 1 (February 1930): 105. Details concerning the physical magazine are from Robert Elson, *Time Inc.: The Intimate History of a Publishing Enterprise, 1923–41* (New York: Atheneum, 1968), 134–35, 141.

2. Roland Marchand, *Advertising the American Dream: Making Way for Modernity, 1920–1940* (Berkeley: University of California Press, 1985), 162, 179; "Preface to *Fortune*" (August 1929), from Time Inc. Archives.

3. Prospectus quoted in Elson, *Time Inc.*, 130.

4. Michael Parrish, *Anxious Decades: America in Prosperity and Depression, 1920–1941* (New York: Norton, 1992), 228–30.

5. T. H. Watkins, *The Great Depression: America in the 1930s* (Boston: Little, Brown, 1993), 45, 72; Parrish, *Anxious Decades*, 30–31; Ross Gregory, ed., *Almanacs of American Life: Modern American 1914 to 1945* (New York: Facts on File, 1995), 61, 130, 65, 72, 66.

6. Parrish, *Anxious Decades*, 31; Gregory, *Almanacs*, 101, 161; William Leuchtenburg, *The Perils of Prosperity* (Chicago: University of Chicago Press, 1958), 180. Steffens quoted in Leuchtenburg, *Perils*, 202. On the improving public image of business in the twenties, see Louis Galambos, *The Public Image of Big Business in America, 1880–1940: A Quantitative Study in Social Change* (Baltimore: The Johns Hopkins University Press, 1975), 195.

7. Coolidge quoted in Parrish, *Anxious Decades*, 61; Michael Denning, *The Cultural Front: The Laboring of American Culture in the Twentieth Century* (London: Verso, 1997), 84 (on *Time*); Leuchtenburg, *Perils*, 187 (on Ford); Frederick Allen, *Only Yesterday: An Informal History of the Nineteen-Twenties* (New York: Blue Ribbon, 1931), 177, 178 ("redemptive"), 179; Sinclair Lewis, *Babbitt* (New York: Penguin, 1996), 13.

8. Young and Cason quoted in Herman E. Krooss, *Executive Opinion: What Business Leaders Said and Thought on Economic Issues, 1920s–1960s* (Garden City, NY: Doubleday, 1970), 43, 42; Henry Luce, "The Tycoon," in *The Ideas of Henry Luce*, ed. John Jessup (New York: Atheneum, 1969), 223–24.

9. *New York Times* quoted in James Nuechterlein, "Bruce Barton and the Business Ethos of the 1920s," *South Atlantic Quarterly* 76 (Summer 1977): 295; *The Nation* quoted in Kim McQuaid, "Young, Swope, and General Electric's 'New Capitalism': A Study in Corporate Liberalism, 1920–33," *American Journal of Economics and Sociology* 36 (July 1977): 331; Irving Babbitt, *Democracy and Leadership* (Boston: Houghton Mifflin, 1924), 239; Mencken quoted in Chip Rhodes, *Structures of the Jazz Age: Mass Culture, Progressive Education,*

and Racial Disclosure in American Modernism (London: Verso, 1998), 32; Harold Stearns, "The Intellectual Life," in *Civilization in the United States: An Inquiry by Thirty Americans,* ed. Harold Stearns (New York: Harcourt, Brace, 1922), 137; Burke quoted in Arthur Schlesinger Jr., "The Revolt of the Intellectuals," in *Intellectual Alienation in the 1920's,* ed. Milton Plesur (Lexington, MA: Heath, 1970), 76; John Dewey, "The Crisis in Culture," in Plesur, *Intellectual Alienation,* 22. For an extended comparison of the similarities between Babbitt and Mencken, see Rhodes, *Structures of the Jazz Age,* 26–43.

10. Van Wyck Brooks, *America's Coming-of-Age* (New York: Octagon, 1975), 111–12; "Package as Merchandiser," *Fortune* 3 (May 1931): 78.

11. Lawrence Levine, *Highbrow/Lowbrow: The Emergence of Cultural Hierarchy in America* (Cambridge, MA: Harvard University Press, 1988); Harold Laski, *The American Democracy: A Commentary and an Interpretation* (New York: Viking, 1948), 612; James Sloan Allen, *The Romance of Commerce and Culture: Capitalism, Modernism, and the Chicago-Aspen Crusade for Cultural Reform* (Chicago: Chicago University Press, 1983), 14.

12. Janice Radway, *A Feeling for Books: The Book-of-the-Month Club, Literary Taste, and Middle-Class Desire* (Chapel Hill: University of North Carolina Press, 1997), 141.

13. Barton quoted in Roland Marchand, *Creating the Corporate Soul: The Rise of Public Relations and Corporate Imagery in American Big Business* (Berkeley: University of California Press, 1998), 162; David Brody, "The Rise and Decline of Welfare Capitalism," in *Change and Continuity in Twentieth Century America: The 1920s,* ed. John Braeman, Robert Bremner, and David Brody (Columbus: Ohio State University Press, 1968), 154.

14. Chicago Association of Arts and Industries quoted in Allen, *Romance,* 4. On development of industrial design in the United States in the twenties, see Jeffrey Meikle, *Twentieth Century Limited: Industrial Design in America, 1925–1939* (Philadelphia: Temple University Press, 1979), 13–22.

15. Marchand, *Creating the Corporate Soul,* 167.

16. Michelle Bogart, *Artists, Advertising, and the Borders of Art* (Chicago: University of Chicago Press, 1995), 125; "Good Taste in Advertising," *Fortune* 1 (March 1930): 60. For more on "symbolic" advertising, see Marchand, *Advertising the American Dream;* and Jackson Lears, *Fables of Abundance: A Cultural History of Advertising in America* (New York: Basic Books, 1994). On the appeal of modernism to advertisers, see Allen, *Romance,* 10–12.

17. Luce quoted in Elson, *Time Inc.,* 141; Henry Luce, "The Press Is Peculiar," *Saturday Review of Literature* (March 7, 1931): 646; "New York in the Third Winter," *Fortune* 5 (January 1932): 41.

18. On Hoover's corporate liberal ideals, see Parrish, *Anxious Decades,* 19–21; Robert McElvaine, *The Great Depression, 1929–1941* (New York: Times Books, 1984), 53–60; and Murray Rothbard, "Herbert Hoover and the Myth of Laissez Faire," in *A New History of the Leviathan: Essays on the Rise of the American Corporate State,* ed. Murray Rothbard and Ronald Radosh (New York: Dutton, 1972), 111–27.

19. The President's Organization on Unemployment Relief advertisement is available in Watkins, *Great Depression,* 66; McElvaine, *Great Depression,* 77. Statistics are from Watkins, *Great Depression,* 53, 51, 55.

20. Luce quoted in Elson, *Time Inc.,* 127; Luce quoted in Elson, *Time Inc.,* 126.

21. "Obsolete Men," *Fortune* 6 (December 1932): 25; Gifford quoted in Krooss, *Executive Opinion,* 42–43.

22. Cloak and Suit," *Fortune* 1 (June 1930): 92; "Oil Abroad: Teagle," *Fortune* 3 (March 1931): 35, 35. On the efforts of business to squelch competition, see Colin Gordon, *New*

Deals: Business, Labor, and Politics in America, 1920–1935 (Cambridge: Cambridge University Press, 1994), 15.

23. Aluminum Company of America," *Fortune* 1 (March 1930): 68; "Columbia and United," *Fortune* 2 (July 1931): 77–78.

24. McQuaid, "Young, Swope," 328; "Life of Owen Young, Part III," *Fortune* 3 (March 1931): 90, 113–14; Dwight Macdonald, "Against the Grain," in Daniel Bell et al., *Writing for "Fortune"* (New York: Time Inc., 1980), 151. On Time Inc.'s treatment of employees in the thirties, see Thomas Griffith, *Harry and Teddy: The Turbulent Friendship of Press Lord Henry R. Luce and His Favorite Reporter, Theodore H. White* (New York: Random House, 1995), 96.

25. Schwab quoted in Brody, "Rise and Decline," 157; McQuaid, "Young, Swope," 330; "Burlesque Tyrant," *Fortune* 2 (November 1930): 59. On unions in the garment industry, see "Cloak and Suit," 92; and "American Federation of Full-Fashioned Hosiery Workers," *Fortune* 5 (January 1932): 49.

26. H. A. Overstreet, "Business as a Creative Unity," in *Business Management as a Profession*, ed. Henry Metcalf (Chicago: Shaw, 1927), 372.

27. Luce, "Aristocracy and Motives," in Jessup, *Ideas*, 95–96, 95, 98, 99. For the core of Brooks's argument, see "Highbrow and Lowbrow," in Brooks, *America's Coming-of-Age*, 1–18.

28. Luce, "Aristocracy and Motives," 99.

29. Olivier Zunz, *Making America Corporate, 1870–1920* (Chicago: Chicago University Press, 1990), 72; "Air and Rail," *Fortune* 1 (April 1930): 80. On the importance of the professional managerial class to American organized capitalism, see Scott Lash and John Urry, *The End of Organized Capitalism* (Cambridge: Cambridge University Press, 1987), 7–11, 81–82, 162–78; and Olivier Zunz, *Why the American Century?* (Chicago: Chicago University Press, 1998), 3–25.

30. See "Life of Owen D. Young," 38; McQuaid, "Young, Swope," 326; and Leo Ribuffo, "Jesus Christ as Business Statesman: Bruce Barton and the Selling of Corporate Capitalism," *American Quarterly* 33 (Summer 1981): 208–9.

31. Klein quoted in Krooss, *Executive Opinion*, 39; Young quoted in Marchand, *Creating the Corporate Soul*, 164; Gifford quoted in Krooss, *Executive Opinion*, 18–19.

32. Seymour Lipset, *Political Man: The Social Bases of Politics* (Garden City, NY: Doubleday, 1960), 319–21; G. William Dumhoff, *Who Rules America?* (Englewood Cliffs, NJ: Prentice Hall, 1967), 55–65.

33. Luce, "Aristocracy and Motives," 96; "Genus Simplissimus: The Trout Fisherman," *Fortune* 3 (June 1931): 88; Cason quoted in Krooss, *Executive Opinion*, 44–45; "Portrait of (Another) Tycoon," *Fortune* 2 (September 1930): 51 ("desire"); "Columbia and United," *Fortune* 2 (July 1930): 77 ("vision").

34. For a discussion of "character," see Joann Shelley Rubin, *The Making of Middlebrow Culture* (Chapel Hill: University of North Carolina Press, 1992), chap. 1.

35. Luce, "Aristocracy and Motives," 101; idem, "The Tycoon," 221, 222, 223.

36. Richard Hofstadter, *Anti-Intellectualism in American Life* (New York: Knopf, 1963), 251.

37. "Maksoud of Kashan and Mrs. McCormick of Chicago," *Fortune* 2 (October 1930): 46, 50.

38. "Sand into Glass," *Fortune* 1 (February 1930): 69; "Orchids," *Fortune* 1 (February 1930): 97; "Skyscrapers," *Fortune* 2 (July 1930): 33.

39. "For $100,000," *Fortune* 7 (May 1933): 66, 58; "Wine," *Fortune* 1 (May 1930): 50; "The Magnificence of Morgan," *Fortune* 2 (October 1930): 98.

40. "Diamond v. Emerald, Ruby, and Sapphire," *Fortune* 1 (March 1930): 49.

41. "A Panel of GM Executives," *Fortune* 1 (April 1930): 68.

42. *The Christian Science Monitor* is quoted in an advertisement for *Fortune, Fortune* 1 (April 1930): 137.

43. Luce, "Aristocracy and Motives," 100 ("insignificant").

44. "Portrait of a Contented Man," *Fortune* 3 (May 1931): 73; "Modern Stained Glass," *Fortune* 2 (December 1930): 76. On the artists' responses to the threat of emasculation, see Burns, *Inventing*, chaps. 1–3, 6.

45. The illustrator John Mitchell quoted in Burns, *Inventing*, 279; "Jade," *Fortune* 3 (March 1931): 60; "The Package as Merchandiser," *Fortune* 3 (May 1931): 78.

46. "The Executive in His Office," *Fortune* 3 (January 1931): 39; "Maksoud of Kashan," 46; "Ming," *Fortune* 3 (July 1931), 68.

47. Walter Benjamin, "Unpacking My Library," in *Illuminations*, ed. Hannah Arendt (New York: Schocken, 1968), 61; "Wine," 50; "Ming," 75.

48. "Eating and Drinking the Imperial Dinner," *Fortune* 1 (April 1930): 62–63.

49. Benjamin, "Unpacking," 60–61, 67; "Rembrandt's Painting of Solomon's Mother," *Fortune* 1 (June 1930): 62.

CHAPTER 2. THE CONTEST OVER PROFESSIONAL IDENTITY

1. White quoted in Thomas Kunkel, *Genius in Disguise: Harold Ross of the New Yorker* (New York: Random House, 1995), 204; "The New Yorker," *Fortune* 10 (August 1934): 82, 85, 74.

2. "The New Yorker," 73.

3. Ross quoted in John Kobler, *Luce: His Time, Life, and Fortune* (Garden City, N.J.: Doubleday, 1968), 75, from a letter Ross wrote to Henry Luce justifying the *New Yorker's* decision to print Wolcott Gibbs's satirical biography of Luce in 1936; *New Yorker* circulation information and "cosmopolitan" quote in Mary Corey, *The World through a Monocle: "The New Yorker" at Midcentury* (Cambridge, MA: Harvard University Press, 1999), 5–6; *Fortune* circulation numbers reported in Robert Elson, *Time Inc.: The Intimate History of a Publishing Enterprise, 1923–1942* (New York: Atheneum, 1968), 220; and in an advertisement for *Fortune* in the February 1938 issue.

4. Thomas Griffith, *Harry and Teddy: The Turbulent Friendship of Press Lord Henry R. Luce and His Favorite Reporter, Theodore H. White* (New York: Random House, 1995), 85; Dwight Macdonald, "Against the Grain," in Daniel Bell et al., *Writing for "Fortune"* (New York: Time Inc., 1980), 153; "The New Yorker," 85; "Both Fish and Fowl," *Fortune* 9 (February 1934): 43; "Women in Business: III," *Fortune* 12 (September 1935): 81.

5. Cecelia Tichi, *Shifting Gears: Technology, Literature, Culture in Modernist America* (Chapel Hill: University of North Carolina Press, 1987), 98–99, 131, 122.

6. Thomas Haskell, "Professional *versus* Capitalism: R. H. Tawney, Emile Durkheim, and C. S. Pierce on the Disinterestedness of Professional Communities," in *The Authority of Experts*, ed. Thomas Haskell (Bloomington: Indiana University Press, 1982), 200, 182; Herman E. Krooss, *Executive Opinion: What Business Leaders Said and Thought on Economic Issues, 1920s–1960s* (Garden City, NY: Doubleday, 1970), 18. On the status of American professionals in the early twentieth century, see Eliot Freidson, *Professional Powers: A Study of the Institutionalization of Formal Knowledge* (Chicago: University of Chicago Press, 1986),

27; and Bruce Kimball, *The "True Professional Ideal" in America* (Cambridge, MA: Blackwell, 1992), 317.

7. For a detailed discussion of the formation of the "institutional matrix," see Olivier Zunz, *Why the American Century?* (Chicago: University of Chicago Press, 1998), 3–69.

8. David Noble, *American by Design: Science, Technology, and the Rise of Corporate Capitalism* (New York: Knopf, 1977), 35, 322.

9. Alfred D. Chandler Jr., *The Visible Hand: The Managerial Revolution in American Business* (Cambridge, MA: Harvard University Press, 1977), 8–11, 464–68; C. Wright Mills, *White Collar: The American Middle Classes* (New York: Oxford University Press, 1956 [1951]), 100–106.

10. Scott Lash and John Urry, *The End of Organized Capitalism* (Cambridge: Cambridge University Press, 1987), 163. On Hoover's use of his "engineer" image, see Tichi, *Shifting Gears*, 169–70.

11. Lionel Trilling, preface to his *Beyond Culture* (New York: Harcourt, Brace, and Jovanovich, 1978), vi; Norman Podhoretz, "The Adversary Culture and the New Class," in *The New Class?*, ed. B. Bruce-Briggs (New Brunswick, NJ: Transaction, 1979), 20–22. See also the essays by Daniel Bell and by B. Bruce-Briggs in B. Bruce-Briggs, *The New Class?*

12. Luce, "The Press Is Peculiar," *Saturday Review of Literature* (March 7, 1931), 646; "Preface to *Fortune*," August 1929, Time Inc. Archives, 4.

13. "Life of Owen D. Young, Chapter One," *Fortune* 3 (January 1931): 40, 38, 90; "A Socialistic State under the Constitution," *Fortune* 9 (February 1934): 68. For other examples of the withdrawn professor, see "A Panel of General Motors Executives," *Fortune* 1 (April 1930): 68; and Roswell Magill, "The Too Well Remembered Man," *Fortune* 11 (April 1935): 100.

14. "Lawyers Looking at You," *Fortune* 3 (January 1931): 61.

15. "Properties v. Principles," *Fortune* 1 (June 1930): 84–85.

16. "Lawyers Looking at You," 61; "Properties v. Principles," 85; Stephen Vincent Benet, "The United Press," *Fortune* 7 (June 1933): 67–68; "A Panel of General Motors Executives," *Fortune* 1 (April 1930): 67.

17. Luce quoted in Elson, *Time Inc.*, 137.

18. For an extended discussion of the managerial styles at Du Pont and Ford, see Olivier Zunz, *Making America Corporate, 1870–1920* (Chicago: University of Chicago Press, 1990), 77–79.

19. On the growth of personnel management as a profession, see Sanford Jacoby, *Employing Bureaucracy: Managers, Unions, and the Transformation of Work in American Industry, 1900–1945* (New York: Columbia University Press, 1985), 7–8, 126–33, 260. On the anxieties of artists and illustrators, see Michelle Bogart, *Advertising, Artists, and the Borders of Art* (Chicago: University of Chicago Press, 1995), 9–11, 143–50, as well as Jackson Lears, *Fables of Abundance: A Cultural History of Advertising* (New York: Basic Books, 1994); and Roland Marchand, *Advertising the American Dream: Making Way for Modernity, 1920–1940* (Berkeley: University of California Press, 1985).

20. Edmund James of the Wharton School quoted in Morrell Heald, *The Social Responsibility of Business: Company and Community 1900–1960* (Cleveland: Case Western University Press, 1970), 72. Statistics on the growth of engineering and industrial research professions are from Zunz, *Why the American Century?* 4–11; and Jay Gould, *The Technical Elite* (New York: Augustus Kelley, 1966), 172–73. On the growth of business schools in the first quarter of the twentieth century, see Heald, *Social Responsibility*, 67–82.

21. Statistics on executives in Gould, *Technical Elite*, 169.

22. Trilling, preface to *Beyond Culture*, iv; Christopher Wilson, *The Labor of Words: Literary Professionalism in the Progressive Era* (Athens: University of Georgia Press, 1985), 8–9.

23. Frederick Allen, *Only Yesterday: An Informal History of the Nineteen-Twenties* (New York: Blue Ribbon, 1931), 227–28, 236, 237; Sinclair Lewis, *Babbitt* (New York: Penguin, 1996), 352; idem, *Dodsworth* (New York: Dell, 1962), 21. For more on Lewis's celebration of the values of the adversary professional, see my essay "Sinclair Lewis' Primers for the Professional Managerial Class: *Babbitt, Arrowsmith, and Dodsworth*," *Journal of the Midwest Modern Language Association* 34 (Spring 2001): 73–97.

24. *Culture and the Crisis* quoted in Michael Denning, *The Cultural Front* (London: Verso, 1997), xvi, 98–99. Irving Babbitt, *Democracy and Leadership* (Boston: Houghton Mifflin, 1924), 303, 313; Ransom quoted in James Dorman, *Revolt of the Provinces: The Regionalist Movement in America, 1920–1945* (Chapel Hill: University of North Carolina, 1993), 111. On socialist writers' attack on the "Cult of Unintelligibility" in the twenties, see Marcus Klein, *Foreigners: The Making of American Literature, 1900–1940* (Chicago: University of Chicago Press, 1981), 47–48.

25. Haskell, "Professionalism *versus* Capitalism," 216.

26. William Sullivan, *Work and Integrity* (New York: HarperCollins, 1995), xv–xvii, 63–5.

27. Thorstein Veblen, *The Engineers and the Price System* (New York: Augustus M. Kelley, 1965), 164, 79, 79, 74.

28. "Portrait of a Contented Man," *Fortune* 3 (May 1931): 75.

29. Michael Murphy, " 'One Hundred Percent Bohemia': Pop Decadence and the Aestheticization of the Commodity in the Rise of the Slicks," in *Marketing Modernisms: Self-Promotion, Canonization, and Rereading*, ed. Kevin Dettmar and Stephen Watts (Ann Arbor: University of Michigan Press, 1996), 63; Jay Satterfield, " 'The World's Best Books': Taste, Culture, and the Modern Library" (Ph.D. diss., University of Iowa, 1999), 82–84.

30. "Modern Stained Glass," *Fortune* 2 (December 1930): 76; Dwight Macdonald, "A Theory of 'Popular Culture,' " *Politics* 1 (February 1944): 22; Sisson quoted in "Contents," *Fortune* 43 (March 1951): 3; "*Cosmopolitan* of Ray Long," *Fortune* 3 (March 1931): 51.

31. "In Our Time," *Fortune* 5 (February 1932): 40–41; Terry Smith, *Making the Modern: Industry, Art, and Design in America* (Chicago: University of Chicago Press, 1993), 207. For another similar treatment of Rivera's work in *Fortune*, see "Industrial Detroit," *Fortune* 7 (February 1933): 49. In this case, the caption recognizes the anticapitalist sentiment of some of Rivera's work but insists that Rivera is a painter of "human industrialism" and that the theme of these murals is the "union of man and earth and machine in vivid reality."

32. "In Our Time," 40–41.

33. Janice Radway, *A Feeling for Books: The Book-of-the-Month Club, Literary Taste, and Middle-class Desire* (Chapel Hill: University of North Carolina Press, 1997), 15; Pierre Bourdieu, "The Field of Cultural Production; or, the Economic World Reversed," in idem, *The Field of Cultural Production* (New York: Columbia University Press, 1993), 41.

34. On the two dominant literary models of the early twentieth century (professional and romantic), see Joyce Wexler, "Selling Sex as Art," in Dettmar and Watt, *Marketing Modernism*, 91.

35. "Bel Geddes," *Fortune* 2 (July 1930): 51.

36. "Cleveland's Orchestra," *Fortune* 3 (November 1931): 56; "Craftsman and Salesman," *Fortune* 3 (February 1931): 88; "Bel Geddes," 51; "U.S. Organ," *Fortune* 3 (April 1931): 128.

See "Methodical Muralist," *Fortune* 2 (November 1930): 60–61; "Modern Stained Glass," 75–82; and "Wine," *Fortune* 1 (May 1930): 54.

37. "Max Kalish," *Fortune* 4 (August 1931): 58.

38. Bourdieu, "The Production of Belief: Contribution to an Economy of Symbolic Goods," in idem, *The Field of Cultural Production*, 102.

39. Donald Stabile, *Prophets of Order* (Boston: South End, 1984), 29, 35, 58; Frederick Winslow Taylor, *The Principles of Scientific Management* (New York: Harper, 1911), 5.

40. John Jordon, *Machine-Age Ideology: Social Engineering and American Liberalism, 1911–1939* (Chapel Hill: University of North Carolina Press, 1994), 7. Lippmann quoted in Jordan, *Machine-Age Ideology*, 73. See also Walter Lippmann, *Drift and Mastery: An Attempt to Diagnose the Current Unrest* (New York: Kennerley, 1914); Veblen, *Engineers*; and Herbert Croly, *The Promise of American Life* (New York: Macmillan, 1909).

41. Jordon, *Machine-Age Ideology*, 213; John Stromberg, "Art and *Fortune*: Machine-Age Discourse and the Visual Culture of Industrial Modernity" (Ph.D. diss., Boston University, 1999). On rational reformers' political and institutional activities in the twenties, see Jordon, *Machine-Age Ideology*, 129–84.

42. Ellis Hawley, *The New Deal and the Problem of Monopoly: A Study in Economic Abundance* (Princeton, NJ: Princeton University Press, 1966), 43; see also 6–12.

43. "Bel Geddes," 51. See "What D'You Mean, Modern," *Fortune* 12 (November 1935): 97, for an example of *Fortune*'s acknowledgment of the debt of "modernism" to Sullivan.

44. "The Bed Significant," *Fortune* 2 (November 1930): 58, 55, 55, 58.

45. Gropius quoted in James Sloan Allen, *The Romance of Commerce and Culture: Capitalism, Modernism, and the Chicago-Aspen Crusade for Cultural Reform* (Chicago: University of Chicago Press, 1983), 49; Lewis Mumford, *Technics and Civilization* (San Diego: Harcourt Brace, 1963), 356.

46. "Windowless, Odorless, Noiseless, but Not Colorless," *Fortune* 2 (December 1930): 104; "Tobacco, Tea, Coffee," *Fortune* 2 (November 1930): 100.

47. "The Bed Significant," 58.

48. "Bel Geddes," 54; "Package as Merchandiser," *Fortune* 3 (May 1931): 78.

49. Package as Merchandiser," 78, 78, 79; "Color in Industry," *Fortune* 1 (February 1930): 93; "Bel Geddes," 54; "There Are No Automobiles," *Fortune* 4 (October 1931): 73.

50. "Package as Merchandiser," 78; "The Bed Significant," 55; Catherine Bauer, "Prize Essay: Art in Industry," *Fortune* 3 (May 1931): 110.

CHAPTER 3. CORPORATE LIBERALISM IN CRISIS

1. On Hoover's decline in popularity, see William Leuchtenburg, *The Perils of Prosperity* (Chicago: University of Chicago Press, 1958), 255, 262–63; and Michael Parrish, *Anxious Decades: America in Prosperity and Depression, 1920–1941* (New York: Norton, 1992), 240–61.

2. Robert Elson, *Time Inc.: The Intimate History of a Publishing Enterprise, 1923–1941* (New York: Atheneum, 1968), 206; Archibald MacLeish, "The First Nine Years," in Daniel Bell et al, *Writing for "Fortune"* (New York: Time Inc., 1980), 7.

3. "The Aluminum Co. of America," *Fortune* 10 (September 1934): 108; "Pennsylvania Railroad: II," *Fortune* 13 (June 1936): 150; "Arms and the Men," *Fortune* 9 (March 1934).

4. "U.S. Corporate Management," 47, 51, 51.

5. "Trade Associations," *Fortune* 8 (August 1933): 40.

6. "A.T.&T. as Citizen," *Fortune* 4 (October 1931): 69. See also John Dewey, *The Public and Its Problems* (New York: Holt, 1927); Thorstein Veblen, *The Engineers and the Price Sys-*

tem (New York: August M. Kelley, 1965); and Adolf Berle and Gardiner Means, *The Modern Corporation and Private Property* (New York: Macmillan, 1932).

7. H. L. Mencken, "The National Letters," in H. L. Mencken, *The American Scene*, ed. Huntington Cairns (New York: Knopf, 1965), 89.

8. "Rembrandt's Painting of Solomon's Mother," *Fortune* 1 (June 1930): 122.

9. "Good Taste in Advertising," *Fortune* 1 (March 1930): 60–61.

10. Herman E. Krooss, *Executive Opinion: What Business Leaders Said and Thought on Economic Issues, 1920s–1960s* (Garden City, NY: Doubleday, 1970), 42.

11. For Marchand's argument that internal corporation advertisements could change a corporate culture and managerial behavior, see Marchand, *Creating the Corporate Soul*, 179.

12. Colin Gordon, *New Deals: Business, Labor, and Politics in America, 1920–1935* (Cambridge: Cambridge University Press, 1994), 132, 162; Taylor quoted in David Brody, "The Rise and Decline of Welfare Capitalism," in *Change and Continuity in Twentieth Century America: The 1920s*, ed. John Braeman, Robert Bremner, and David Brody (Columbus: Ohio State University Press, 1968), 177.

13. "U.S. Corporate Management," *Fortune* 7 (June 1933): 104, 102.

14. MacLeish, "The First Nine Years," 7–8. Two examples of *Fortune*'s tendency to think in terms of national character are the single-subject issues on Italy (1934) and Japan (1936). Both these issues addressed the industrial situation of each nation. But the Italy issue contained articles on the state, the church, the old aristocracy, agriculture, the Italian love of cars, the fitness program of the Fascists, the empire, Naples, and Venice.

The percentages in the text were calculated by the author. Many of the articles did not fit easily into a single category, so the percentages should be read as estimates. Articles on art stayed about the same, at 8 percent. Essays on foreign countries increased from 3 percent to 6 percent, and although this change is probably insignificant statistically, there is no question that *Fortune* increased its interest in foreign affairs in the mid-thirties, as the Japan and Italy issues suggest.

15. Ellis Hawley, *The New Deal and the Problem of Monopoly: A Study in Economic Abundance* (Princeton, NJ: Princeton University Press, 1966), 25, 53–54; Barton quoted in Leo Ribuffo, "Jesus Christ as Business Statesman: Bruce Barton and the Selling of Corporate Capitalism," *American Quarterly* 33 (Summer 1981): 224; "Franklin Roosevelt," *Fortune* 8 (December 1933): 24.

16. "U.S. Corporate Management," 104; Robert Collins, "Positive Business Responses to the New Deal: The Roots of the Committee for Economic Development, 1933–1942," *Business History Review* 52 (Autumn 1978): 371; Gordon, *New Deals*, 4; "Housing: The Need," *Fortune* 5 (February 1932): 67. On corporate liberal support for social security, see Robert Collins, "Positive Business Responses," 375.

17. Marshall Berman, *All That Is Solid Melts into Air: The Experience of Modernity* (New York: Penguin, 1982), 62; "Reign of Meiji," *Fortune* 8 (July 1933): 32; "Port of New York Authority," *Fortune* 8 (September 1933): 118.

18. Leuchtenburg, *Franklin D. Roosevelt and the New Deal* (New York: Harper and Row, 1963), 63, 64 ("brain trust" quote); Luce quoted in W. A. Swanberg, *Luce and His Empire* (New York: Scribner's, 1972), 106; "The Wonder Boys in Washington," *Fortune* 8 (July 1933): 119.

19. Felix Frankfurter, "The Young Men Go To Washington," *Fortune* 13 (January 1936): 62; "The Wonder Boys in Washington," *Fortune* 8 (July 1933): 23; "1500 Scholars," *Fortune* 9 (March 1934): 98. On American civil service, see also "Our Ambassadors," *Fortune* 9 (April 1934): 108–22; Leonard White, "Toward a New U.S. Civil Service," *Fortune* 10 (November

1934): 76–77, 150–61. On academic pursuits, see "The Science of Man," *Fortune* 9 (October 1933): 66–70, 98–103; "Seat of Science," *Fortune* 6 (July 1932): 18–23, 100–101; and "Fifteen Thousand Years," *Fortune* 14 (December 1936): 129–37, 162–72.

20. "New Murals in Iowa," *Fortune* 11 (January 1935): 66, 66.

21. "U.S. Organ," *Fortune* 3 (April 1931): 73; "Here Are the Steinways and How They Grew," *Fortune* 8 (December 1933), 99; "All Because They're Smart," *Fortune* 11 (June 1935): 80.

22. "The Business of Burlesque," *Fortune* 11 (February 1935): 67, 153; "Introducing Duke Ellington," *Fortune* 8 (August 1933): 90.

23. "20,000% Increase," *Fortune* 9 (January 1934): 104 ("overly"), 102 ("dry-rot"), 102 ("I like you"), 102 ("young, vigorous"); "Doubleday, Doran, and Co.," *Fortune* 13 (February 1936): 73 ("new fields"), 73 ("tumultuous . . . great rock"), 74 ("vigorous"); The *Cosmopolitan* of Ray Long," *Fortune* 3 (March 1931): 49; "The Funny Papers," *Fortune* 7 (April 1933): 98.

24. "Introducing Duke Ellington," 47; "The Big Bad Wolf," *Fortune* 10 (November 1934): 91, 92; "New Murals in Iowa," 60.

25. On labor's new radicalism, see Leuchtenburg, *Franklin D. Roosevelt*, 107–17.

26. Laura Browder, *Rousing the Nation: Radical Culture in Depression America* (Amherst: University of Massachusetts Press, 1998), 16; Marcus Klein, *Foreigners: The Making of American Literature, 1900–1940* (Chicago: University of Chicago Press, 1981), 130; Hicks quoted in Klein, *Foreigners*, 135.

27. MacLeish, "The First Nine Years," 10.

28. "New York in the Third Winter," *Fortune* 5 (January 1932): 41, 41, 43, 121, 48.

29. "No One Has Starved," *Fortune* 6 (September 1932): 22–23.

30. "Faces of Harlan Country," *Fortune* 5 (February 1932): 130; "200,000 Wandering Boys," *Fortune* 7 (February 1933): 47.

31. On the ability of big business to control the NRA, see Hawley, *The New Deal*, 62.

32. Ellis Hawley, "The New Deal and Business," in *The New Deal: The National Level*, ed. John Braeman, Robert Bremner, and David Brody (Columbus: Ohio State University Press, 1975), 59; "Trade Associations," 40; McQuaid, "Corporate Liberalism in the American Business Community, 1920–40," *Business History Review* 52 (Autumn 1978): 350. On the collapse of the NRA, and the retreat of business associationalists, see Hawley, *The New Deal*, 90, 149–51.

33. Dwight Macdonald (unsigned), "The Communist Party," *Fortune* 10 (September 1934), 69; Charles Murphy, "I Wish My *Fortune* Years Were Just Beginning," in Bell et al., *Writing for "Fortune,"* 43. On Macdonald's late turn to the Left, see Michael Wreszin, *A Rebel in Defense of Tradition: The Life and Politics of Dwight Macdonald* (New York: Basic Books, 1994), chap. 2. On the troubles of the *Fortune* staff in the mid-thirties, see Elson, *Time Inc.*, 254–55.

34. "Note on 'Arms and the Men,'" *Fortune* 9 (May 1934): 190–92; "All Because They're Smart," 80; "*Fortune*'s Award," *Fortune* 12 (August 1935): 57. See also "Social Security by Any Other Name," *Fortune* 11 (March 1935): 82; "Strikebreaking," *Fortune* 11 (January 1935): 56.

CHAPTER 4. CONSENSUS PLURALISM AND NATIONAL CULTURE

1. *London Economist* quoted in Herman E. Krooss, *Executive Opinion: What Business Leaders Said and Thought on Economic Issues, 1920s–1960s* (Garden City, NY: Doubleday, 1970), 186; Chamber of Commerce quoted in George Wolfskill and John Hudson, *All But the People: Franklin D. Roosevelt and His Critics, 1933–39* (London: Macmillan, 1969), 157.

2. On labor's successes in the late thirties, see William Leuchtenburg, *Franklin D. Roosevelt and the New Deal* (New York: Harper and Row, 1963), 240–43; and Michael Parrish, *Anxious Decades: America in Prosperity and Depression, 1920–1941* (New York: Norton, 1992), 356–59.

3. Unnamed journalist quoted in Krooss, *Executive Opinion*, 184; "Business-and-Government: Business, Faced with an Overwhelming Political Fact, Should Favor a More Socialized State," *Fortune* 17 (June 1938): 52. On the resistance of business to Roosevelt's campaign, see Alan Brinkley, *Liberalism and Its Discontents* (Cambridge, MA: Harvard University Press, 1998), 40–41.

4. "Business-and-Government," *Fortune* 17 (June 1938): 52.

5. My account of the slowdown of the New Deal in the late thirties owes much to Richard Polenburg, "The Decline of the New Deal, 1937–1940," in *The New Deal: The National Level*, ed. John Braeman, Robert Bremner, and David Brody (Columbus: Ohio State University Press, 1975), 246–66.

6. Alan Brinkley, *The End of Reform: New Deal Liberalism in Recession and War* (New York: Knopf, 1995), 3.

7. James Baughman, *Henry R. Luce and the Rise of the American News Media* (Boston: Twayne, 1987), 63 ("passion"); Thomas Griffith, *Harry and Teddy: The Turbulent Friendship of Press Lord Henry R. Luce and His Favorite Reporter, Theodore H. White* (New York: Random House, 1995), 90; Robert Elson, *Time Inc.: The Intimate History of a Publishing Enterprise, 1923–1942* (New York: Atheneum, 1968), 314, 317–18, 314. On the intellectual consolidation of New Deal liberalism in the late thirties, see Brinkley, *End of Reform*, 3–8.

8. Henry Luce, "Calculability of Abundance," in *The Ideas of Henry Luce*, ed. John Jessup (New York: Atheneum, 1969), 235; John Jessup, "The Best Writing Job in the Country," in Daniel Bell et al., *Writing for "Fortune"* (New York: Time Inc., 1980), 19; Charles Murphy, "I Wish My Fortune Years Were Just Beginning," in Bell et al., *Writing*, 47.

9. Luce quoted in Elson, *Time Inc.*, 316.

10. "Business-and-Government," *Fortune* 18 (December 1938): 55; *Fortune* 19 (January 1939): 48; "Wendell S. Willkie," *Fortune* 15 (May 1937): 89; "Fortune's Wheel," *Fortune* 17 (May 1938): 36.

11. "Business-and-Government," *Fortune* 17 (June 1938): 52; *Fortune* 17 (February 1938): 58.

12. "Wendell S. Willkie," 83.

13. Kenneth Burke, "Revolutionary Symbolism in America," in *American Writers' Congress*, ed. Henry Hart (London: Martin Lawrence, 1935), 93, 93, 87.

14. Bruce Barton, "Business Can Win Public from Politician," *Printers' Ink* (December 12, 1935): 17, 20, 24, 24.

15. Erika Doss, *Benton, Pollack, and the Politics of Modernism: From Regionalism to Abstract Expressionism* (Chicago: University of Chicago Press, 1991), 154.

16. Susan Hegeman, *Patterns for America: Modernism and the Concept of Culture* (Princeton, NJ: Princeton University Press, 1999), 11.

17. Warren Susman, "Culture and Commitment," in *Culture as History: The Transformation of American Society in the Twentieth Century* (New York: Pantheon, 1984), 154; Marcus Klein, *Foreigners: The Making of American Literature, 1900–1940* (Chicago: University of Chicago Press, 1981), 37; on "national-popular rhetoric," see Jonathan Harris, *Federal Art and National Culture: The Politics of Identity in New Deal Culture* (Cambridge: Cambridge University Press, 1995), 20–21; Hegeman, *Patterns for America*, 127–28.

18. Laura Browder, *Rousing the Nation: Radical Culture in Depression America*

(Amherst: University of Massachusetts Press, 1998), 177; Terry Smith, *Making the Modern: Industry, Art, and Design in America* (Chicago: University of Chicago Press, 1993), 285. See Susman, "Culture and Commitment," 153–83.

19. Roosevelt quoted in Sean McCann, *Gumshoe America: Hardboiled Crime Fiction and the Rise and Fall of New Deal Liberalism* (Durham, NC: Duke University Press, 2000), 6; Scott Donaldson, *Archibald MacLeish: An American Life* (Boston: Houghton Mifflin, 1992), 225.

20. Harris, *Federal Art*, 44 ("culturally"), 9. On the WPA's redefinition of the artist as a professional civil servant, see Michael Szalay, *New Deal Modernism: American Literature and the Invention of the Welfare State* (Durham, NC: Duke University Press, 2000), 65–74.

21. On the Communist Party's Americanism as an attempt to "compete for the masses," see Andrew Ross, *No Respect: Intellectuals and Popular Culture* (New York: Routledge, 1989), 12. On the limited successes of the Popular Front strategy, see Judy Kutulas, *The Long War: The Intellectual People's Front and Anti-Stalinism, 1930–40* (Durham, NC: Duke University Press, 1995), chap. 3. On the formation of the "cultural front," see Michael Denning, *The Cultural Front* (London: Verso, 1997). Denning describes Burke's speech as a "key formulation of the theory" of the Popular Front (102).

22. Roland Marchand, *Creating the Corporate Soul: The Rise of Public Relations and Corporate Imagery in American Big Business* (Berkeley: University of California Press, 1998), 202–3; J. Walter Thompson advertisement, "How to Make a Cow Give 'More for the Money,'" *Fortune* 16 (December 1937): 151; J. Walter Thompson advertisement, "Who gets the fruits of Private Capitalism?" *Fortune* 16 (November 1937): 147.

23. "The Public Is Not Damned," *Fortune* 19 (March 1939): 83; "Business-and-Government: What Business Needs Is a New Concept of Public Relations: Herewith Suggested," *Fortune* 18 (October 1938): 49; "Business-and-Government: American Business Can Avoid Committing Suicide Only by Practicing Some Sound Public Relations," *Fortune* 19 (March 1939): 57.

24. "Business-and-Government," *Fortune* 18 (October 1938): 51.

25. Burke, "Revolutionary Symbolism," 92.

26. "A New Technique in Journalism," *Fortune* 12 (July 1935): 65, 66. For a sampling of some of the more ambitious surveys, see "What Business Thinks," *Fortune* 20 (October 1939): 52; "The *Fortune* Survey: XXII," *Fortune* 19 (June 1939): 68; "The *Fortune* Survey: XXVII," *Fortune* 21 (February 1940): 14.

27. William Stott, *Documentary Expression and Thirties America* (Chicago: University of Chicago Press, 1986), 152–55; "Fortune's Wheel," *Fortune* 16 (October 1937): 42; "Unemployment in 1937," *Fortune* 16 (October 1937): 103, 99, 101, 101–3. The article defended both the federal relief programs and those who depended on them.

28. "Unemployment in 1937," 99; "A Farm in Illinois," *Fortune* 12 (August 1935): 39. On migrant workers, see "I Wonder Where We Can Go Now," *Fortune* 19 (April 1939): 91; and "Along the Road," *Fortune* 19 (April 1939): 97. For examples of the "Life and Circumstances" series, see "Success Story," *Fortune* 12 (December 1935): 115; "Family on Relief," *Fortune* 13 (February 1936): 63; and "A Railroad Fireman," *Fortune* 19 (July 1939): 78.

29. David Peeler, *Hope among Us Yet: Social Criticism and Social Solace in Depression America* (Athens: University of Georgia Press, 1987), 33; "The Melting Pot," *Fortune* 20 (July 1939): 75; Davenport Papers, U.S. Library of Congress, Washington, D.C., box 52.10.1; "Servant Problem," *Fortune* 17 (March 1938): 85; "Fortune's Wheel," *Fortune* 17 (May 1938): 30. See also "Oskaloosa vs. The United States," *Fortune* 17 (May 1938): 55; and "The County Agent . . . in the Person of J. V. Morris," *Fortune* 18 (July 1938): 45.

30. Supplement to "The *Fortune* Round Table," *Fortune* 19 (March 1939): 1.

31. Supplement to "The *Fortune* Round Table," 2; "Fortune's Wheel," *Fortune* 19 (March 1939): 51. The reader quoted was Frederic A. Delano. Other readers quoted included the New Dealer Harold Ickes, the historian Charles Beard, and RCA president David Sarnoff.

32. "Tennis Courts and Swimming Pools," *Fortune* 19 (May 1939): 81, 82; "A Club for Sailors," *Fortune* 20 (August 1939): 96, 53.

33. "The Pied Piper of Toledo," *Fortune* 17 (January 1938): 71, 71, 69, 109; "The Museum of Modern Art," *Fortune* 18 (December 1938): 74, 75, 131.

34. "The Museum of Modern Art," 134; "The Pied Piper," 112, 70; "Unemployed Arts," *Fortune* 15 (May 1937): 108, 112, 113.

35. "The Museum of Modern Art," 127; "The Pied Piper," 75; "Toscanini," *Fortune* 17 (January 1938): 66, 67, 116.

36. "Toscanini," 63, 114; "The Pied Piper," 71.

37. "The Melting Pot," 73, 75, 177, 177.

38. "To Heaven by Subway," *Fortune* 18 (August 1938): 63, 61, 64, 62.

39. "Big League Baseball," *Fortune* 16 (August 1937): 37, 112, 44, 39, 116. The same tension between popular culture and capitalism appeared regularly in the articles on mass culture in the late thirties. For other examples, see "The Business of Burlesque," *Fortune* 11 (February 1935): 67–73, 140–53; "For Six Days," *Fortune* 11 (March 1935): 89–93, 121–24 (on marathon bike races); "Doubleday, Doran and Co.," *Fortune* 13 (February 1936): 73–77, 161–81; "Theatre Business," *Fortune* 15 (February 1937): 66; and "Radio: A $140,000,000 Art," *Fortune* 15 (May 1937): 47.

40. "The *Fortune* Survey: XXVII," *Fortune* 21 (February 1940): 14.

41. "The Culture of Democracy," *Fortune* 21 (February 1940): 76, 76, 76, 83, 84, 86.

42. Ibid., 79, 85, 86.

43. Ibid., 86, 86, 87.

CHAPTER 5. AFFIRMATIVE VISIONS AND ADVERSARY DOUBTS

1. Henry Luce, "Calculability of Abundance," in *The Ideas of Henry Luce*, ed. John Jessup (New York: Atheneum, 1969), 229–30.

2. Archibald MacLeish, "In Challenge, Not Defense," in *A Time to Speak: The Selected Prose of Archibald MacLeish* (Boston: Houghton Mifflin, 1941), 3.

3. Luce, "Calculability," 233; MacLeish, "In Challenge, Not Defense," 6.

4. Louis Untermeyer, ed., *Modern American Poetry*, 5th ed. (New York: Harcourt, Brace, 1936), 635. I thank the James Agee Trust (James Sprecher, trustee) for allowing me to reprint this poem.

5. Richard Pells, *Radical Visions and American Dreams: Culture and Social Thought in the Depression* (Middletown, CT: Wesleyan University Press, 1973), 290.

6. MacLeish, "Nevertheless One Debt," in *A Time to Speak*, 57–58; Malcolm Cowley, "Poets and Prophets," *New Republic* (May 5, 1941): 639; Luce, "How I Make My Living," in Jessup, *Ideas*, 52; Letter from Luce to MacLeish, Letters, April 2, 1943, MacLeish Collection, U.S. Library of Congress, Washington, D.C., container 14.

At the time of the MacLeish's inquiry, the essay, then called "The Act of Imagination," had already been accepted by the *Atlantic Monthly* for publication in June 1943. MacLeish, on the advice of an editor at the *Washington Post*, was seeking a larger audience. "The Unimagined America" appeared, as scheduled, in the *Atlantic Monthly* (June 1943): 59–63. I have also corrected (in brackets) two obvious typographical errors in the original letter.

7. MacLeish, "To the Young Men of Wall Street," *Saturday Review of Literature* (January 16, 1932): 454.

8. Luce, "Calculability," 234; MacLeish, "Preface to an American Manifesto," in *A Time to Speak*, 24. On "socialized individualism," see MacLeish (unsigned), "What's to Become of Us," *Fortune* 9 (June 1934): 117–18. See also "Skyscrapers," *Fortune* 2 (July–December 1930); "Unemployed Arts," *Fortune* 15 (May 1937): 109; "American Workingman," *Fortune* 4 (August 1931): 54; "No One Has Starved," *Fortune* 6 (September 1932): 19; "The Case against Roosevelt," *Fortune* 12 (December 1935): 102.

9. MacLeish (unsigned), "The Grasslands," *Fortune* 12 (November 1935): 60, 62 ("murder"), 65, 65 ("story").

10. Russell Davenport, "Memorandum to Writers," October 26, 1937, Russell Davenport Collection, U.S. Library of Congress, Washington, D.C., box 55, folder 19; Luce quoted in Robert Elson, *Time Inc.: The Intimate History of a Publishing Enterprise, 1923–41* (New York: Atheneum, 1968), 314. On the principles behind *Fortune*'s reorganization in 1937, see chapter 4 of this volume as well as Davenport, "Respectus," May 10, 1937, Davenport Collection, box 54, folder 39.

11. Letter from MacLeish to Davenport and Eric Hodgins, April 26, 1938, Davenport Collection, box 54, folder 41, page 3; MacLeish, "America Was Promises," in *Collected Poems, 1917–1952* (Boston: Houghton Mifflin, 1952), 337–38.

12. MacLeish, *Letters of Archibald MacLeish, 1907–1982* (Boston: Houghton Mifflin, 1983), 281, 293.

13. MacLeish, letter to Luce, January 7, 1938, MacLeish Collection, container 8; Luce, letter to MacLeish, January 4, 1938, MacLeish Collection, container 8.

14. Luce, "The American Century," *Life* 10 (February 17, 1941): 61; Luce, "Aristocracy and Motives," in Jessup, *Ideas*, 96.

15. Luce, "The American Century," 64, 65.

16. MacLeish, "The Irresponsibles," in *A Time to Speak*, 120.

17. MacLeish, "The Affirmation," in *A Time to Speak*, 13.

18. Ibid.; MacLeish, "The Unimagined America," 89; MacLeish, letter to Wendell Willkie, November 30, 1942, MacLeish Collection, container 23; Jose Ortega y Gasset, *The Revolt of the Masses* (New York: Norton, 1932), 181. Ortega's influence on Luce is well established; see, for instance, Robert Herzstein, *Henry R. Luce: A Political Portrait of the Man Who Created the American Century* (New York: Scribner's, 1994), 83; and W. A. Swanberg, *Luce and His Empire* (New York: Scribner's, 1972), 105.

19. "America and the Future," *Fortune* 25 (April 1942): 97; "A Plan for America's Place in the New World Order," *Fortune* 23 (April 1941): insert.

20. "Prelude to Total War," *Fortune* 24 (July 1941): 35.

21. Roy Hoopes, *Ralph Ingersoll: A Biography* (New York: Atheneum, 1985), 104, 85; John Chamberlain, "How I Really Learned about Business," in Daniel Bell et al., *Writing for "Fortune"* (New York: Time Inc., 1980), 30; MacLeish, *Reflections* (Amherst: University of Massachusetts Press, 1986), 80.

22. Dwight Macdonald, "Against the Grain," in Bell et al., *Writing for "Fortune,"* 152 ("inflated"); Macdonald quoted in Michael Wreszin, *A Rebel in Defense of Tradition: The Life and Politics of Dwight Macdonald* (New York: Basic Books, 1994), 47 ("whorish"); Lawrence Lessing, "A Free State of Christian Anarchy," in Bell et al., *Writing for "Fortune,"* 133; Hipplehauser quoted in Lessing, "Free State," 133; Agee quoted in Robert Fitzgerald, "A Memoir," in *Remembering James Agee*, ed. David Madden and Jeffrey Folks (Athens: University of Georgia Press, 1997), 49 ("masochistic"); Agee quoted in Genevieve

Moreau, *The Restless Journey of James Agee* (New York: William Morrow, 1977), 116 ("gesture"); Ingersoll story in Hoopes, *Ralph Ingersoll*, 99–100; Fitzgerald, "Memoir," 50 ("weak").

23. William Stott, *Documentary Expression and Thirties America* (Chicago: University of Chicago Press, 1986), 266; James Agee and Walker Evans, *Let Us Now Praise Famous Men* (Boston: Houghton Mifflin, 1988), 29, 30, 31.

24. Agee (unsigned), "Six Days at Sea," *Fortune* 16 (September 1937): 117.

25. Ibid., 119, 119, 117–18, 210.

26. Agee (unsigned), "Not to Eat, Not for Love," *Fortune* 9 (March 1934): 91, 146; Agee (unsigned), "Mr. Rockefeller's $14,000,000 Idyl," *Fortune* 12 (July 1935): 69. See also Agee (unsigned), "August at Saratoga," *Fortune* 12 (August 1935): 63–69, 96–100.

27. Agee (unsigned), "Lynching Comedy," *Time*, March 11, 1940; Agee, "Six Days," 120 (caption), 216.

28. Agee, "Six Days," 120, 220.

29. Dwight Macdonald, "Jim Agee, a Memoir," in Madden and Folks, *Remembering James Agee*, 177. On Agee's relationships with his three wives and his friends, see Laurence Bergreen, *James Agee: A Life* (New York: Dutton, 1984).

30. James Agee, draft of New York City prose poems (1939), in the Russell Davenport Papers, container 53, folder 4, pp. 2–3; Agee and Evans, *Famous Men*, 13, 238.

31. Wallace Stevens, "The Emperor of Ice Cream," in *The Palm at the End of the Mind* (New York: Knopf, 1971), 79; MacLeish, "Ars Poetica," in *Collected Poems*, 41; James Agee, "Art for What's Sake," *The New Masses* (November 15, 1936): 48.

32. James Agee, "Portrait of an Artist," *Time* (February 19, 1940).

33. James Agee, *Agee on Film* (New York: Grosset and Dunlap, 1967), 6. See "Plans for Work: October 1937," in *The Collected Short Prose of James Agee*, ed. Robert Fitzgerald (Boston: Houghton Mifflin, 1968), 134–36, for Agee's description of a proposed project to publish a collection of random letters, and see Bergreen, *James Agee: A Life*, 220–21, for an account of his attempts to complete it.

34. Agee and Evans, *Famous Men*, 456–58, 11; "The Drought," *Fortune* 10 (October 1934): 76.

35. David Madden, "The Test of a First-Rate Intelligence: Agee and the Cruel Radiance of What Is," in *James Agee: Reconsiderations*, ed. Michael A. Lofaro (Knoxville: University of Tennessee Press, 1992), 33; Agee quoted in Victor Kramer, *Agee and Actuality: Artistic Vision in his Work* (Troy, NY: Whitson, 1991), 58; Agee, *Agee on Film* (New York: Grosset and Dunlap, 1967), 6, 9.

36. Eric Hodgins (unsigned), "Arms and the Men," *Fortune* 9 (March 1934): 53. For an account of the writing and response to "Arms and the Men," see Robert Elson, *Time Inc.: The Intimate History of a Publishing Empire, 1923–1941* (New York: Atheneum, 1968), 216–19.

37. Agee (unsigned), "Cinchona—Quinine to You," *Fortune* 9 (February 1934): 76, 77, 77, 84.

38. Agee (unsigned), "Arbitrage," *Fortune* 9 (June 1934): 94, 96; idem (unsigned), "The Change of the Guard," *Fortune* 10 (July 1934): 126–27; idem (unsigned), "Smoke," *Fortune* 15 (June 1937): 130. See also idem (unsigned), "The Drought," *Fortune* 10 (October 1934): 76–83. On "game" metaphors in the thirties, see Warren Susman, "Culture and Commitment," in Susman, *Culture as History: The Transformation of American Society in the Twentieth Century* (New York: Pantheon, 1984), 163.

39. Agee, "Cinchona—Quinine to You," 86, 77.

40. Agee, *Permit Me Voyage*, 19–20 (emphasis added); Agee and Evans, *Famous Men*, xlvi.

41. Agee, *Letters of James Agee to Father Flye* (New York: Bantam, 1963), 89–90; idem, "Southeast of the Island: Travel Notes," in *The Collected Short Prose of James Agee*, ed. Robert Fitzgerald (Boston: Houghton Mifflin, 1968), 182, 187; idem (unsigned), "August at Saratoga," 64 ("crazy quilt").

42. John Louis Lucaites, "Visualizing 'The People': Individualism vs. Collectivism in *Let Us Now Praise Famous Men*," *The Quarterly Journal of Speech* 83 (August 1997): 275.

43. Agee (unsigned), "U.S. Art: 1935," *Fortune* 12 (December 1935): 68.

44. Ibid.; "Temperance Note: and Weather Prophecy," in Untermeyer, *Modern American Poetry*, 635. I thank the James Agee Trust (James Sprecher, trustee) for allowing me to reprint "Temperance Note: and Weather Prophecy."

45. Agee and Evans, *Famous Men*, 207–8.

46. "Soviet Posters," *Fortune* 4 (November 1931): 62; "State Art," *Fortune* 11 (March 1935): 64, 65; MacLeish speech, October 27, 1940, in MacLeish Collection, container 24.

47. Sean McCann, *Gumshoe America: Hardboiled Crime Fiction and the Rise and Fall of New Deal Liberalism* (Durham, NC: Duke University Press, 2000), 30; MacLeish, "He Cherished American Culture," *The New Republic* (April 15, 1946): 540; George Biddle quoted in Michael Szalay, *New Deal Modernism: American Literature and the Invention of the Welfare State* (Durham, NC: Duke University Press, 2000), 74; see also 69–74. On artists as "symbol producers," see Denning, *The Cultural Front* (London: Verso, 1997), 104.

48. Marcus Klein, *Foreigners: The Making of American Literature, 1900–1940* (Chicago: University of Chicago Press, 1981), 181; Joseph Alsberg quoted in Szalay, *New Deal Modernism*, 73.

49. Agee, New York City prose poems, Davenport Collection, container 53, folder 4, pp. 12–13.

50. Susan Hegeman, *Patterns for America: Modernism and the Concept of Culture* (Princeton, NJ: Princeton University Press, 1999), 191.

51. Kramer, *Agee and Actuality*, 14, 63; Agee quoted in Victor Kramer, "'Notes and Suggestions on the Magazine . . .' and Criticism of Culture," in *Agee: Selected Literary Documents*, ed. Victor Kramer (Troy, NY: Whitson, 1996), 288–89, 289.

52. Hegeman, *Patterns for America*, 191.

CHAPTER 6. PROFESSIONAL LEADERSHIP AND DEMOCRATIC PARTICIPATION

1. "A.D. 1940," *Fortune* 23 (January 1941): 30 (caption).

2. "Government by Horse Sense," *Fortune* 27 (June 1943): 128.

3. "NINETEEN-THIRTY: modernization year in industry," advertisement for the Austin Company, *Fortune* 1 (March 1930): 101.

4. *Official Guide Book: New York World's Fair 1939* (New York: Exposition Publications, 1939), 27; quoted in Jeffrey Meikle, *Twentieth Century Limited: Industrial Design in America, 1925–1939* (Philadelphia: Temple University Press), 190; introduction to New York City issue, *Fortune* 20 (July 1939): 65, 65; "Part III: They Earn a Living," *Fortune* 20 (July 1939): 107.

5. "The Painter's City," *Fortune* 20 (July 1939): 144.

6. For examples of *Fortune*'s continued interest in functionalist ideals, see "Robert (Or-I'll-Resign) Moses," *Fortune* 17 (June 1938): 71; "Houses for Human Beings," *Fortune* 27 (April 1943): 101; "Syracuse Tackles Its Future," *Fortune* 27 (May 1943): 121; "City Planning:

Battle of the Approach," *Fortune* 28 (November 1943): 164–65. On its commitment to post-war planning, see "After the War—What?" a roundtable pamphlet published with *Fortune* 24 (November 1941); William B. Benton, "The Economics of a Free Society: A Declaration of American Economic Policy," *Fortune* 30 (October 1944): 163; "America and the Future," *Fortune* 25 (April 1942): 97; and "A Plan for America's Place in the New World Order," a pamphlet published with *Fortune* 23 (March 1941).

7. Susanne Langer, "Make Your Own World," *Fortune* 31 (March 1945): 194; "GE Does It," *Fortune* 25 (March 1942): 165.

8. "The American Struggle," *Fortune* 25 (January 1942): 35.

9. "The New World Belongs to Risk," *Fortune* 28 (July 1943): 110–12.

10. "Our Form of Government," a pamphlet published with *Fortune* 28 (November 1943): 13; "Management in the Transition," *Fortune* 30 (July 1944): 147; "Government by Horse Sense," 128; "American Man-in-the-Street," *Fortune* 26 (December 1942): 142.

11. My discussion of the debates over the nature of propaganda in the thirties and forties owes much to Ken Cmiel, "On Cynicism, Evil, and the Discovery of Communication in the 1940s," *Journal of Communication* 46 (Summer 1996): 88–107.

12. Cmiel, "On Cynicism," 90; "Business-and-Government," *Fortune* 21 (March 1940): 39.

13. "A Report to Mr. Roosevelt," *Fortune* 25 (March 1942): 10; "Who's Winning?" *Fortune* 26 (November 1942): 138; "Censorship," *Fortune* 23 (June 1941): 88; Dwight Macdonald, "Kulturbolschewismus Is Here," *Partisan Review* 8 (November–December 1941): 450 ("official").

14. Catherine Bauer, "Prize Essay: Art in Industry," *Fortune* 3 (May 1931): 110; "Goodbye to Mr. Chippendale," *Fortune* 25 (January 1942): 57, 62; "Homes of Americans," *Fortune* 33 (April 1946): 157.

15. "Robert (Or-I'll-Resign) Moses," 72, 141; "Fortune's Wheel," *Fortune* 17 (June 1938): 26; "Houses for Human Beings," *Fortune* 27 (April 1943): 101.

16. "Syracuse Tackles Its Future," 121, 121, 158.

17. "Youth," *Fortune* 21 (May 1940): 90–92.

18. MacLeish, "Postwar Writers and Prewar Readers," *New Republic* (June 10, 1940): 780; Adler quoted in James Sloan Allen, *The Romance of Commerce and Culture: Capitalism, Modernism, and the Chicago-Aspen Crusade for Cultural Reform* (Chicago: University of Chicago Press, 1994), 95; Hutchins quoted in Allen, *Romance of Commerce*, 87. On the Conference on Science, Philosophy, and Religion in Their Relation to the Democratic Way of Life, see Susan Hegeman, *Patterns for America: Modernism and the Concept of Culture* (Princeton, NJ: Princeton University Press, 1999), 161. See also Archibald MacLeish, "The Irresponsibles," in *A Time to Speak: The Selected Prose of Archibald MacLeish* (Boston: Houghton Mifflin, 1941), 105–20.

19. My summary of the Great Books movement owes much to Allen, *Romance of Commerce*, 81–101.

20. Adler quoted in Allen, *Romance of Commerce*, 225.

21. "Challenge and Response," *Fortune* 28 (July 1943): 105; Willkie quoted in "Valedictory," *Fortune* 30 (November 1944): 103; Alfred Noyes, "The Edge of the Abyss," *Fortune* 26 (September 1942): 125; Robert Hutchins, "Toward a Durable Society," *Fortune* 27 (June 1943): 159; Allen, *Romance of Commerce*, 93.

22. Charles W. Hendel, "Agenda For Philosophers," *Fortune* 28 (November 1943): 163.

23. William Dixon, "Civilization and the Arts," *Fortune* 27 (April 1943): 113, 134.

24. "Paris at War," *Fortune* 21 (May 1940): 65; "The Face of Christ," *Fortune* 33 (January 1946), 144; "U.S. around the World," *Fortune* 30 (July 1944): 121; Sheeler quoted in "Power," *Fortune* 22 (December 1940): 78.

25. "Baron Keynes of Tilton," *Fortune* 29 (May 1944): 147; "A Man of Conscience," *Fortune* 29 (June 1944): 162–63; "Native Philosopher," *Fortune* 27 (March 1943): 114–15.

26. "Our Form of Government," pamphlet published with *Fortune* 28 (November 1943); "Education for War," *Fortune* 26 (December 1942): 136; "Long Hairs vs. Hairy Ears," *Fortune* 32 (November 1945): 225; "Long Hairs and Short Waves," *Fortune* 32 (November 1945): 163.

27. "The Painter's City," *Fortune* 20 (July 1939), 133.

28. James Agee, "Southeast of the Island: Travel Notes," in *The Collected Short Prose of James Agee*, ed. Robert Fitzgerald (Boston: Houghton Mifflin, 1968), 191, 180, 177; "overmastering" in Dwight Macdonald, "Kulturbolschewismus Is Here," 446.

29. Agee, "Southeast of the Island," 194; Macdonald, "Theory of 'Popular Culture,'" *Politics* 1 (February 1944): 20; Dwight Macdonald, "The (American) People's Century," *Partisan Review* 9 (July–August 1942): 295; Lionel Trilling, "The Function of the Little Magazine," in *The Liberal Imagination* (New York: Harcourt, Brace, and Jovanovich, 1978), 99. See also Clement Greenberg, "Avant-Garde and Kitsch," *Partisan Review* 6 (Fall 1939): 39.

30. Terry Cooney, *The Rise of the New York Intellectuals: "Partisan Review" and Its Circle* (Madison: University of Wisconsin Press, 1986), 127. On the revolutionary aspects of avant-garde art, see S. A. Longstaff, "*Partisan Review* and the Second World War," *Salmagundi* 43 (Winter 1979): 115; and Cooney, *Rise*, 206.

31. Rahv quoted in Cooney, *Rise*, 41; Rahv and Phillips quoted in Judy Kutulas, *The Long War: The Intellectual People's Front and Anti-Stalinism, 1930–40* (Durham, NC: Duke University Press, 1995), 127; Rahv quoted in Kutulas, *Long War*, 125.

32. Rahv quoted in Kutulas, *Long War*, 128; Cooney, *Rise*, 143. On the New York Intellectuals' belief that the Popular Front strategy required a repression of critical thought, see Longstaff, "*Partisan Review*," 112.

33. Harvey Teres, *Renewing the Left: Politics, Imagination, and the New York Intellectuals* (Oxford: Oxford University Press, 1996), 137; Rahv quoted in Cooney, *Rise*, 112–13 ("conveyer-belt"); Rahv quoted in Cooney, *Rise*, 135 ("inflation").

34. James Agee, "Pseudo-Folk," *Partisan Review* 11 (Spring 1944): 221; Macdonald, "*Fortune* Magazine," *The Nation* (May 8 1937): 530; Lionel Trilling, "The Function of the Little Magazine," 94.

35. Clement Greenberg, "Avant-Garde and Kitsch," *Partisan Review* 6 (Fall 1939): 39 ("ersatz"), 40, 36.

36. Clement Greenberg, "Avant-Garde and Kitsch," 36, 40, 49 ("preservation"); Macdonald, "Theory," 22 ("phoney"), 23 ("human"), 21, 21, 21, 21.

37. Van Wyck Brooks, *The Opinions of Oliver Allston* (New York: Dutton, 1941), 204, 206–7, 192. See also MacLeish, "The Irresponsibles."

38. Macdonald, "Kulturbolschewismus Is Here," 446, 443, 448, 449, 450. See "On the 'Brooks-MacLeish Thesis,'" *Partisan Review* 9 (January 1942): 38–47.

39. James Farrell, "On the 'Brooks MacLeish Thesis,'" 44; F. W. Dupee, "The Americanism of Van Wyck Brooks," *Partisan Review* 6 (Summer 1939): 85; William Phillips, "The Intellectuals' Tradition," *Partisan Review* 8 (November–December 1941): 490.

40. James Agee, draft of New York City prose poems (1939) in the Russell Davenport Papers, U.S. Library of Congress, Washington, D.C., container 53, folder 4, part 3; Philip

Rahv, "Twilight of the Thirties," *Partisan Review* 6 (Summer 1939): 15, 13, 11–12; Phillips, "The Intellectuals' Tradition," 483; Cooney, *Rise*, 196.

CHAPTER 7. PROFESSIONALIZING PLURALISM

1. Dwight Macdonald, "The (American) People's Century," *Partisan Review* 9 (July–August 1942): 306–9.

2. For another account of the similar spirit of the two camps, see David Brinkley, "Legacies of WWII," in *Liberalism and Its Discontents* (Cambridge, MA: Harvard University Press, 1998), 107–9.

3. Trilling quoted in Norman Markowitz, *The Rise and Fall of the People's Century: Henry A. Wallace and American Liberalism, 1941–1948* (New York: Free Press, 1973), 218; Dwight Macdonald, "Curiouser and Curiouser" (originally June 1945), in idem, *Memoirs of a Revolutionist* (New York: Farrar, Strauss, and Cudahy, 1957), 292, 291; idem, "What Is Totalitarian Liberalism?" (August 1945), in *Memoirs*, 296; idem, "A Note on Wallese" (May–June 1947), in *Memoirs*, 298.

4. "Hammer and Tongs: The New C.P. Line," *Fortune* 33 (May 1946): 105; "Books and Ideas," *Fortune* 32 (November 1945): 211; "Books and Ideas," *Fortune* 30 (November 1944): 218.

5. Kim McQuaid, "Corporate Liberalism in the American Business Community, 1920–40," *Business History Review* 52 (Autumn 1978): 365; Robert Collins, *Business Responses to Keynes, 1929–1964* (New York: Columbia University Press, 1981), 206.

6. Robert Collins, "Positive Business Responses to the New Deal: The Roots of the Committee for Economic Development, 1933–42," *Business History Review* 52 (Autumn 1978): 370, 385–86, 379; Collins, *Business Responses*, 142 ("striking"); William Benton, "The Economics of a Free Society: A Declaration of American Economic Policy," *Fortune* 30 (October 1944): 163; Allen Kaufman, Lawrence Zacharias, and Marvin Karson, *Managers vs. Owners: The Struggle for Corporate Control in American Democracy* (New York: Oxford University Press, 1995), 126.

7. See Nelson Lichtenstein, "From Corporatism to Collective Bargaining: Organized Labor and the Eclipse of Social Democracy in the Postwar Era," in *The Rise and Fall of the New Deal Order: 1930–1980*, ed. Steve Fraser and Gary Gerstle (Princeton, NJ: Princeton University Press, 1989), 122–28. On the hopes of progressives and social liberals for a leftist united front in the immediate postwar years, see Judy Kutulas, *The Long War: The Intellectual People's Front and Anti-Stalinism, 1930–1940* (Durham, NC: Duke University Press, 1995); and Paul Milkman, *PM: A New Deal in Journalism* (New Brunswick, NJ: Rutgers University Press, 1997).

8. Editorial accompanying "The Communist Party," *Fortune* 33 (June 1946): 2–3 ("directionless"); John Davenport, "Socialism By Default," *Fortune* 39 (March 1949): 69; Harvey Teres, *Renewing the Left: Politics, Imagination, and the New York Intellectuals* (Oxford: Oxford University Press, 1996), 136; Judy Kutulas, *Long War*, 125. See also Eric Johnston, "How America Can Avoid Socialism," *Fortune* 39 (January 1949).

9. Philip Rahv, "Twilight of the Thirties," *Partisan Review* 6 (Summer 1939): 10, 11–12.

10. Neil Jumonville, *Critical Crossings: The New York Intellectuals in Postwar America* (Berkeley, University of California Press, 1991), xi, xiii.

11. Dwight Macdonald, "Kulturbolschewismus Is Here," *Partisan Review* 8 (November–December 1941): 451; Teres, *Renewing the Left*, 89–90 ("activist"); Macdonald, "Kulturbolschewismus," 448.

12. Thomas Strychacz, *Modernism, Mass Culture, and Professionalism* (Cambridge: Cambridge University Press, 1993), 22, 24; Clement Greenberg, "Avant-Garde and Kitsch," *Partisan Review* 6 (Fall 1939): 44; Dwight Macdonald, "Theory of 'Popular Culture,'" *Politics* 1 (February 1944): 20; idem, "Updating the Bible," in idem, *Against the American Grain* (New York: Random House, 1962), 273.

13. David R. Shumway, *Creating American Civilization: A Genealogy of American Literature as an Academic Discipline* (Minneapolis: University of Minnesota Press, 1994), 29; Rahv quoted in Kutulas, *Long War*, 226; Strychacz, *Modernism, Mass Culture*, 205–6; Marian Janssen, *The Kenyon Review, 1939–1970: A Critical History* (Baton Rouge: Louisiana University Press, 1990), 171.

14. Jumonville, *Critical Crossing*, 183; Shumway, *Creating American Civilization*, 262; Tate quoted in Frank Ninkovich, "The New Criticism and Cold War America," *Southern Quarterly* 20 (Fall 1981): 2; Janssen, *Kenyon Review*, 36.

15. Norman Mailer in "Our Country and Our Culture," *Partisan Review* (May–June 1952): 298; Janssen, *Kenyon Review*, 265; Shumway, *Creating American Civilization*, 226. On the continuing authority of the university, see Strychacz, *Modernism, Mass Culture*, particularly the introductory chapter.

16. John Guillory, *Cultural Capital: The Problem of Literary Canon Formation* (Chicago: Chicago University Press, 1993), 175.

17. "Fortune's Wheel," *Fortune* 38 (October 1948): 35.

18. Ibid.; Russell Davenport, "The Relation between the Original *Fortune* and the New *Fortune*: Being Preliminary Notes for a Prospectus," February 20, 1948, Russell Davenport Papers, U.S. Library of Congress, Washington, D.C., container 56, folder 7, page 4; idem, memo to Luce, November 17, 1947, Davenport Papers, container 56, folder 7, page 2.

19. Russell Davenport, "The Greatest Opportunity on Earth," *Fortune* 40 (October 1949): 68.

20. Johnston, "How America Can Avoid Socialism," 126; "The Businessman in the Middle Ages," *Fortune* 45 (January 1952): 77; Henry Luce, "Reformation of the World's Economies," *Fortune* 41 (February 1950): 59. On the "transformation of American Capitalism," one of the magazine's favorite phrases during the early fifties, see, among others, Gilbert Burck, "The Jersey Company," *Fortune* 44 (October 1951): 98; and "The Transformation of American Capitalism," *Fortune* 43 (February 1951): 79.

21. "Goethe and Enterprise," *Fortune* 40 (September 1949): 72; Survey on Higher Education (supplement), *Fortune* 40 (September 1949): 2.

22. Teres, *Renewing the Left*, 77–78; Dwight Macdonald, "The Mills Method," in *Discriminations: Essays and Afterthoughts, 1938–1974* (New York: Grossman, 1974), 298; Jackson Lears, "A Matter of Taste: Corporate Cultural Hegemony in a Mass-Consumption Society," in *Recasting America: Culture and Politics in the Age of the Cold War*, ed. Lary May (Chicago: University of Chicago Press, 1989), 39; Shumway, *Creating American Civilization*, 231.

23. "The State of the Novel," *Fortune* 36 (October 1947): 3; Davenport, memo to Luce, November 17, 1947, Davenport Papers, container 56, folder 7, page 3; "Fortune's Wheel," *Fortune* 38 (October 1948): 35.

24. Davenport, internal Time Inc. memo, September 30, 1947, Davenport Papers, container 71, folder 3.

25. Ibid., Davenport, letter to Luce, 1948, Davenport Papers, container 70, folder 3, pages 3, 5.

26. Dwight Macdonald, "Memo to Mr. Luce" (October 1945), in idem, *Memoirs*, 256, 261.

27. James Sloan Allen, *The Romance of Commerce and Culture: Capitalism, Modernism, and the Chicago-Aspen Crusade for Cultural Reform* (Chicago: University of Chicago Press, 1994), 229.

28. "Our Country and Our Culture," *Partisan Review* (May–June 1952): 282.

29. Mailer, "Our Country," 300; Mills, in "Our Country and Our Culture II," *Partisan Review* (July–August 1952): 446; Cooney, *Rise*, 264, 264.

30. Trilling in "Our Country," 320; Macdonald, "Homage to Twelve Judges" (Winter 1949), in idem, *Memoirs*, 216.

31. McQuaid, "Corporate Liberalism," 365; Robert Coughlan, "A Collection of Characters," in Daniel Bell et al., *Writing for "Fortune"* (New York: Time Inc., 1980), 79. For *Fortune*'s reaction to Willkie's loss, see "Business-and-Government," *Fortune* (April 1940): 47.

32. "Business-and-Government," *Fortune* 18 (October 1938): 49; "Business Is Still in Trouble," *Fortune* 39 (May 1949): 67; Robert Griffith, "The Selling of America: The Advertising Council and American Politics, 1942–1960," *Business History Review* 57 (Autumn 1983): 390, 393 ("While the . . .").

33. James Jensen, "The 'New Conservatism' of *Fortune* Magazine, 1930–1952" (Ph.D. diss., University of Iowa, 1956), 8.

34. Griffith, "Selling of America," 394; Collins, *Business Responses*, 205; Alan Brinkley, *The End of Reform: New Deal Liberalism in Recession and War* (New York: Knopf, 1995), 6; quoted journalist is Bert Cochran, quoted in Elizabeth Fones-Wolf, *Selling Free Enterprise* (Urbana, Illinois: University of Illinois Press, 1994), 285.

35. "The Education of the Businessman," *Fortune* 40 (August 1949): 49; "The Management of Men," *Fortune* 39 (February 1949): 105.

36. *Fortune* advertisement, *Fortune* 44 (September 1951): 184–85; "Bringing up the Boss," *Fortune* 43 (June 1951): 119.

37. "The Tests of Management," *Fortune* 42 (July 1950): 92. On management training, see also "The Education of the Businessman"; "Management of Men"; "The Business Schools: Pass or Flunk?" *Fortune* 49 (June 1954): 112–14, 240–45; "Should a Businessman Be Educated?" *Fortune* 47 (April 1953): 113; and "The Crown Princes of Business," *Fortune* 48 (October 1953): 150–53, 266–68. A number of these pieces mix their enthusiasm for training with worries about overspecialization and bureaucratization but all support job training or liberal arts training or both for upper-level management.

38. Russell Davenport, "The Greatest Opportunity On Earth," *Fortune* 40 (October 1949): 65; "The Attack of the Lilliputians," *Fortune* 39 (May 1949): 73.

39. "Should a Businessman Be Educated?" 113–14; Peter Drucker, "The Graduate School Business," *Fortune* 42 (August 1950): 92; "Crown Princes," 266–68. For more on the need for liberal arts training in colleges and business schools, see "Should Business Support the College," *Fortune* 44 (December 1951); "Corporate Profits and the College Budgets," *Fortune* 46 (December 1952); "The Business Schools: Pass or Flunk?"; and "The Crown Princes of Business."

40. "Individualism Comes of Age," *Fortune* 43 (February 1951): 178, 176; Clark Kerr, "What Became of the Independent Spirit?" *Fortune* 48 (July 1953): 111, 136, 110.

41. Ethel Ward McLemore, "Manifesto from a Corporation Wife," *Fortune* 45 (March 1952): 83; William Whyte, "Groupthink," *Fortune* 45 (March 1952): 114. See also William Whyte, "The Social Engineers," *Fortune* 45 (January 1952): 88–91, 108.

42. William Whyte, "The Transients," *Fortune* 47 (May 1953): 113; idem, "The Outgoing Life," *Fortune* 48 (July 1953): 160. See also idem, "The Future, c/o Park Forest," *Fortune* 47 (June 1953): 126–31, 192–96.

43. Thomas Frank, *The Conquest of Cool* (Chicago: University of Chicago Press, 1997), 20.

44. Michele Lamont, *Money, Manners, and Morals: The Culture of the French and American Upper Middle Classes* (Chicago: University of Chicago Press, 1992), 99–100.

45. Alfred Heidenreich, "Goethe and Enterprise," *Fortune* 40 (September 1949): 74. On *Fortune*'s hope for conversation between intellectuals and businesspeople, see "Conference at Corning," *Fortune* 44 (August 1951): 89–91; Peter Viereck, "The Future of Business Baiting," *Fortune* 47 (February 1953): 109–10, 238–40; and "Aspen Conference on Design," *Fortune* 46 (September 1952): 113–15.

46. Serge Guilbaut, *How New York Stole the Idea of Modern Art: Abstract Expressionism, Freedom, and the Cold War* (Chicago: University of Chicago Press, 1983).

47. Michele Bogart, *Artists, Advertising, and the Borders of Art* (Chicago: University of Chicago Press, 1995), 292; "The Businessman and Picasso," *Fortune* 41 (June 1950): 102. On the declining use of fine art by advertiser after 1950, see Bogart, *Artists, Advertising*, 290–92. On the growth of corporate collections, see Neil Harris, "Designs on Demand: Art and the Modern Corporation," in *Cultural Excursions: Marketing Appetites and Cultural Tastes in Modern America* (Chicago: University of Chicago Press, 1990), 376.

48. Guilbaut, *How New York Stole the Idea*, 203; Barbara Ehrenreich, *The Hearts of Men: American Dreams and the Flight from Commitment* (New York: Anchor, 1983), 64; see also chaps. 2–5. See also Lears, "A Matter of Taste." Lears also addresses the tendency among intellectuals in the postwar era to redefine political and intellectual ideas in terms of taste and consumption.

49. Van Gosse, *Where the Boys Are: Cuba, Cold War America, and the Making of a New Left* (New York: Verso, 1993), 1; Frank, *Conquest of Cool*, 29.

50. For more on the "new social movements" associated with the rejection of class by the upper middle class, see Scott Lash and John Urry, *The End of Organized Capitalism* (Cambridge: Cambridge University Press, 1987), 296–300. On the "new class" theory as descriptive of a culturally and politically distinguished portion of the professional managerial class, see Ehrenreich, *Fear of Falling*, 151.

51. Lears, "Matter of Taste," 51.

INDEX